Stories from the

NERVE BIBLE

LAURIE ANDERSON

Stories from the
NERVE BIBLE

A Retrospective 1972–1992

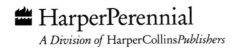 **HarperPerennial**

A Division of HarperCollins*Publishers*

This book is dedicated to my fellow artists.

HarperCollins books may be purchased for educational, business, or sales promotional use. For information, please write: Special Markets Department, HarperCollins Publishers, Inc., 10 East 53rd Street, New York, NY 10022.

FIRST EDITION

Designed by Carolyn Cannon
Production assistants: David Bemis and Julie Jaycox

Library of Congress Cataloging-in-Publication Data
Anderson, Laurie.
 Stories from the nerve bible: a retrospective 1972–1992 / Laurie Anderson.
—1st ed.
 p. cm.
ISBN: 0-06-055355-3
 0-06-095050-1 (pbk.)
 1. Anderson, Laurie. 2. Artists–United States–Biography. 3. Arts, Modern–20th Century–United States. I. Title.
NX512.A54A2 1993
700'.92—dc20 92-52597

94 95 96 97 98 ❖/HC 10 9 8 7 6 5 4 3 2 1

94 95 96 97 98 ❖/HC 10 9 8 7 6 5 4 3 2 1 (pbk.)

CONTENTS

Dear Reader,

Almost twenty years ago I began to work on something I called "The Talking Book," a wildly free-form anthology of stories on tape which included fragments of songs, letters, theories about motion, history, and vision. As the narrator spoke and sang, her voice constantly changed into other peoples' voices, among them a two-hundred-pound baby, JFK, and Dixie Lee Ray (head of the Atomic Energy Commission). At the time, I could never really figure out exactly who was talking or how to organize this cacophonic talking orchestra, so I abandoned the project. When I finished *Stories from the Nerve Bible,* I realized this was the Talking Book.

As an artist I have made many things: performances, prints and drawings, films, records, comics, sculpture, videos, computer animations, and books. But it's spoken language that has always interested me the most. I believe it's possible that language is a virus, as William S. Burroughs claims. But to believe that language is a disease, first you have to believe that it is alive. So, is language alive?

Every book is an alchemical creation, and I'm thinking back to 1857 when Herman Melville arrived in Greece and saw the Parthenon for the first time sitting there like a great beached whale, its big white bones exposed to the winds. But how can this happen? How can a whale turn into a building? Or into a book? In what way can words be alive?

As an artist, I have used my body in my work. But I can no longer really remember being the shy Midwesterner who shuffled into an art gallery in 1974 wearing ice skates with their blades frozen into clumps of ice, sat down with some homemade electronics and her mother's bronzed baby shoes, started talking about language and memory and telling very personal stories about her past. I do take some responsibility for her though, sort of like a distant country cousin I haven't spoken to in a while.

But this book is not an autobiography. It's an account of many of the performances and projects I've done in the last twenty years, roughly chronological, although it keeps jumping back and then forwards in time. It's a collection of the various voices I've used to speak for me. Some of them speak foreign languages or stutter. Others mutter, complain, lecture, and yell. Some sing. And I've written them down, trying to bring them back to life.

Stories from the Nerve Bible also has a kind of plot. It's an account of how the voices I've used have changed, of how I started as an "autobiographical" artist, ran out of stories, taught my violin to speak, learned to talk in drag, changed "I" to "you," sold out, lost and found my voice. It's the story of the various bodies I've invented to walk and talk for me.

What I mean by the "nerve bible" is, of course, the body, and this book is my way of looking for something, of frisking myself, like looking for keys. Parts of the body appear and reappear throughout the book adding up to a kind of self-portrait, although not a very naturalistic one. This portrait most resembles that drawing in medical books of the human body called "The Sensory Homunculus," a depiction of the relative proportions of the sensory neurons as they're represented in the brain. And it's a kind of freakish, emaciated elf with ears the size of cars and an enormous mouth. But the bodies I relate to the most are the No Bodies. I've written many songs and stories for these "people." They have no names, no histories. They're outside of time and place and they are the ones who truly speak for me.

In This Dream I'm Not a Person, I'm a Place

In 1972, I wrote a series of pamphlets about time and motion. In "Transportation Transportation" there is a short story about the easterly direction of the winds, tides, and currents during the Flood. According to the calculations of a certain American religious sect, if the Ark started out in the Holy Lands, drifting east at a rate of forty miles per day, it would have ended up somewhere on the west coast of Japan instead of Mount Ararat. Believing that the Ark didn't just

swirl around in place for five months, they calculated that, in fact, it must have started out from a point further west, thus locating the Pre-Deluvian Era somewhere in upstate New York and the Garden of Eden in roughly the spot where New York City stands today. Now, in order to get from one place to another, something must move. But since there are no reliable accounts of the Ark's journey and no traces of biblical history in the upstate New York area, this religious sect was led to the only available conclusion: the Ark has simply not left yet.

This story has continued to haunt me as I've tried to understand what it means to look at time and place and how they change each other. This book begins with many stories about growing up in the Bible Belt and ends with a series of performances in Israel. These are the starting and ending points of the journey I'm trying to describe.

Stories from the Nerve Bible is also a series of landscapes. I've tried many times to picture the United States, which is also a background for everything my work is about: memory, language, technology, politics, utopia, power, men and women. I've tried to understand and describe some of the ways this country continues to remake itself, and I have always been interested in its many co-existing contradictions like puritanism and violence, mass culture and art. It is also a collection of the many voices and talking styles that characterize English as spoken by Americans: the voices of machines, politicians, sitcom stars, nuns, and ouija boards. Along the way, I've tried to touch on related topics such as the invention of ventriloquism, the relationship of music and architecture, technology as a primitive form of parasite, animation, esthetics, and fanaticism.

In preparing this book, I've had to sift through endless scores, photographs, audio and videotapes. I've left a lot out. All the performances described here are excerpts since the complete scores would run many times the length of this book. I have tried to keep the excerpted sections intact even when they sound sort of strange.

For example, in a lot of the early performances there are numerous stage directions:

PERFORMER DIPS THE CROSS-SHAPED SPONGE IN WATER.
CROSS INFLATES.

These are meticulously printed in capital letters with accompanying diagrams, as if I had thought that someone might want to reconstruct these performances at a much later date. (Feel free to try, of course.) I also discovered a tendency to pyromania, as well as a real knack for calling all sorts of things by the same name; sometimes a song title will also be the title of a performance, an installation, and a lithograph. I still do this, by the way. *Stories from the Nerve Bible* is the title of this book; it's also the title of a performance I recently presented in Germany and Israel. Also, because many of the themes are recurrent, I have shuffled things around so that sometimes the image from a performance in 1992 accompanies a text from the early '70s. When this gets confusing, I suggest having a look at the chronology, which may or may not help.

I've also included many "asides" to locate the work in time or place.

They look like this and include comments and explanations.

Finally, even though I have written many songs, I've found that it's almost impossible to talk about music. One of my favorite quotations is something that the comedian Steve Martin said: "Talking about music is like dancing about architecture." So the songs drift in and out soundlessly, in fragments, like the dreams they really are. And last, one question that people often ask me is, "Is this stuff actually true?" The answer is yes. Except for the songs, of course. For example, I never really saw a host of angels mowing down my lawn. I don't even have a lawn. It just seems like I do sometimes.

Laurie Anderson
September 10, 1993
New York City

1. THE DREAM BEFORE

Last night I woke up,
and I had that dream again
the one where I'm trying
to find the door
I'm trying to get in.
But all the hinges are broken.
They're in pieces on the floor
and all the keys are bent
still bent
from the dream before.

from "Progress" 1989

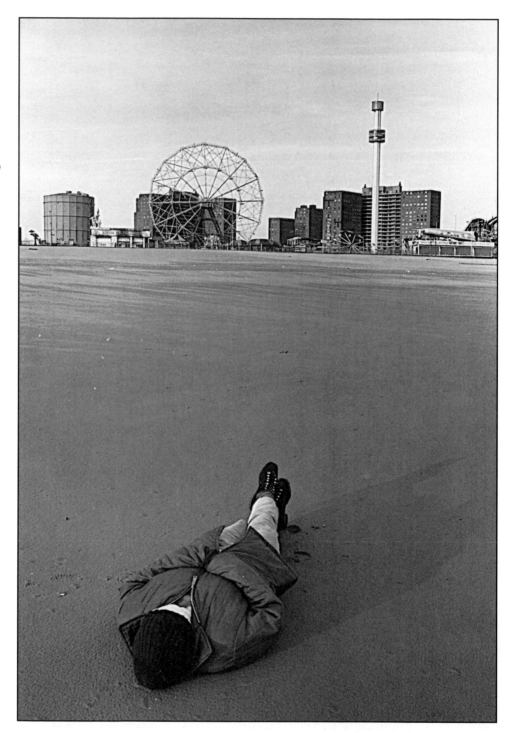

Last night I dreamed I died
and that my life had been
rearranged into some kind of
theme park.

And all my friends were
walking up and down the
boardwalk. And my dead
grandmother was selling
cotton candy out of a little
shack.

And there was this huge ferris
wheel about half a mile out in
the ocean, half in and half out
of the water. And all my old
boyfriends were on it, with
their new girlfriends. And the
boys were waving and
shouting, and the girls were
saying "Eeeeeek!!"

Then they disappear under
the surface of the water and
when they come up again
they're laughing and gasping
for breath.

from "Empty Places" 1989

Institutional Dream Series
Sleeping in Public, 1972

Coney Island
January 14, 1973
4 - 6 pm

I lie down near the water which is at low tide. It is bitterly cold and the sand is damp. I pull my turtleneck sweater over my face. After several minutes I begin to relax and lose consciousness.

I am trying to sleep in different public places to see if the place can color or control my dreams. At the moment this seems like a crazy idea. I can hear the tide coming in. The water is beginning to cover my frozen feet. I'm not sure whether I'm asleep or awake so I keep my eyes shut tight.

After a couple of hours, I hear a loud rushing drone. It sounds like a giant wave is rolling toward shore. I jump up and start to run. A large helicopter is hovering directly overhead.

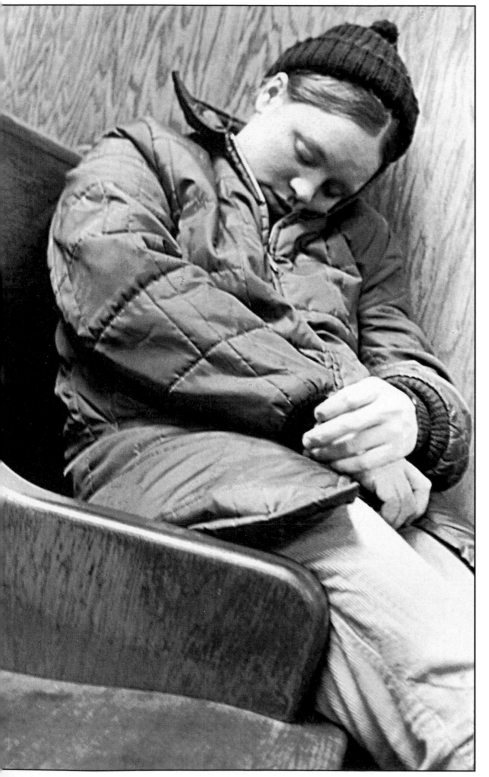

Night Court
100 Centre Street
December 29, 1972 10:30 pm - 1 am

The first case up is Robbery and Assault. The courtroom is noisy and full of people. I rest my head against a wall running the length of the room. I drift off slowly.

I have the impression that dark shadows or clouds are scudding through the courtroom just below the ceiling. When I wake up, I realize that this sensation is produced by the peaked knit cap I'm wearing which, with my head's periodic bobbing, alternately obscures and reveals the bright lights which hang near the ceiling.

I wake up just as the judge is confiscating our camera "You understand of course. Blackmail is illegal," he is saying. But he only makes a show of taking the film out of the camera and then hands it back.

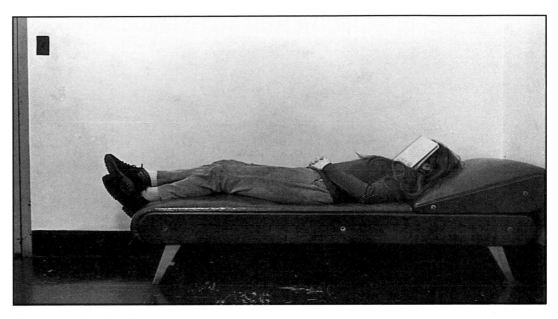

Women's Bathroom

Schermerhorn Library, Columbia University April 3, 1972 1 - 4 pm

I lie down on the couch where I can see the women coming in and out of the bathroom. I put a notebook over my face and place my contact lenses under my tongue. I dream that the library is an open air market and all the stacks are stalls stocked with vegetables.

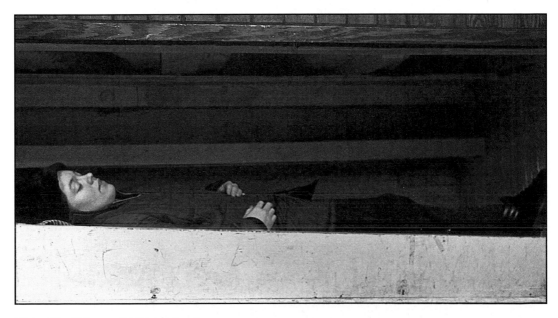

South Street Seaport

The "Lettie G. Howard" starboard berth December 10, 1972 11 am - 2 pm

I lie down in a starboard berth and dream about a bright white desert.

2. THIS IS THE TIME
AND THIS IS THE RECORD OF THE TIME

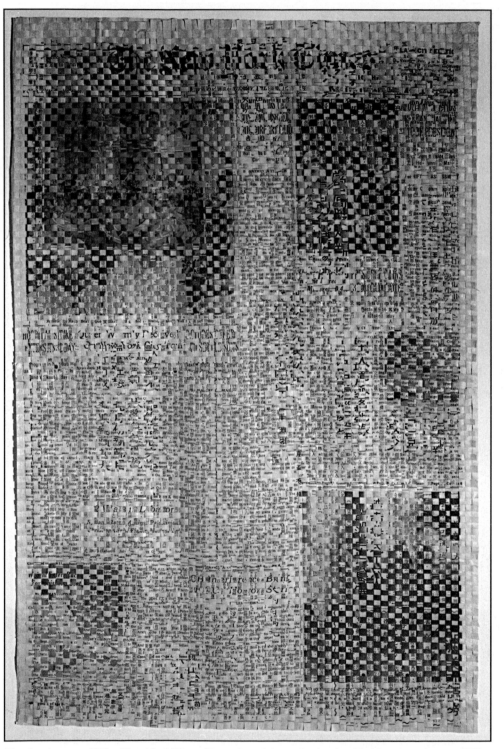

The front page of "The New York Times" is cut into thin vertical strips and the same issue of "The China Times" is cut into thin vertical strips and they are woven together.

I worked with newspaper because it was cheap and because my studio was next door to a newsstand that carried all sorts of foreign and unusual newspapers.

I was getting a degree in sculpture at Columbia where the esthetic was that sculpture should be a) heavy and b) made of steel. I didn't fit into this esthetic very well.

"Seven Weekends: Saturdays Horizontal, Sundays Vertical," newspaper, 1972

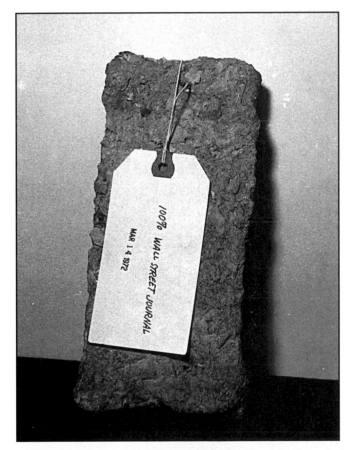

"Ten Days in May," newspaper, 1972

"Tuesday Was Cancelled," newspaper, 1972. Each day's edition of "The New York Times" was pulped and molded into a brick. I sent this one to myself through the mail.

"Wrap Up," newspaper, 1972. Some days the pulped paper was wrapped in its own front page.

Periodically, I burned my work.

*The March edition of "x's" was the first "calendar."
Because I was still experimenting with glues, the
pulp grew a bright green furry mold which I scraped
and then used as the pigment for a shellac.*

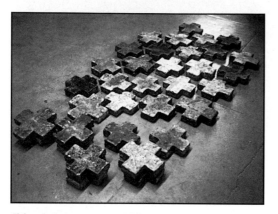

"March," newspaper, 1972

October, 1972

excerpts from a book privately published, 1972

On Canal Street, I do not understand the sexual pantomime
of the dog trotting by my side.

October 1

In New York, a rubbery rain is falling.

October 5

At home, I fear the despair that will inevitably follow that action.

October 6

On Church Street, I decide to name my daughters Luncheonette
and Delicatesse.

October 7

In the mirror, my auxiliary hands can feel the cold,
hard, reflective plane.

October 10

At the fruit stand, the owner's son yells at me, "Hey Cereal Lady!";
I don't know why and try to look as neurotic as possible.

October 18

In my dream, Eva Hesse's husband tells me how half her face slid off
and how her brain dripped like acid into a paper cup she kept
pinned to her neck.

October 18

At my desk, I feel the radio waves vibrating in the wood.

October 21

In Queens, I meet my sister's blind lover whose hands
are like rays on mine.

October 23

In my memory, my childhood merges with the Old Testament: a
series of obscure events in a distant and barbarous land.

October 28

*I have always kept a diary, detailed accounts of all the important things
that happen. As an art student, I tried to think more concisely. I wrote
several monthly diaries restricting myself to a sentence a day.*

"Boat"

"Prison"

"Way"

"Nature"

In 1972, I began to read about mudra. In Buddhist meditation, both posture and hand gestures (mudra) represent states of higher consciousness. One book described how to make words using these hand gestures. Each day, after reading the paper, I pulped "The New York Times" and shaped it into a single word made from a hand gesture.

"Memory," 1972. The word "memory" in pulped newspaper.

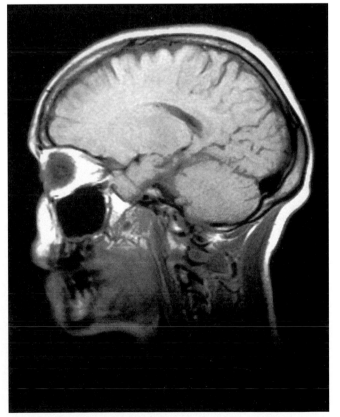
An MRI (Magnetic Resonance Image) of my head from a portrait by Annie Leibovitz, 1992

3. MY FATHER'S BACK POCKET

I'm thinking back to
When I was a child
Way back to when I was a tot

When I was an embryo
A tiny speck, just a dot

When I was a Hershey bar
In my father's back pocket

from "Smoke Rings" 1984

Dearreader

Super 8 film, 1974

How to turn a book into a movie.
Dedicated to Lawrence Sterne.
Co-directed with Bob George.

Dearreader is shot in a single room. It consists of nine autobiographical short stories told in voiceover by the narrator.

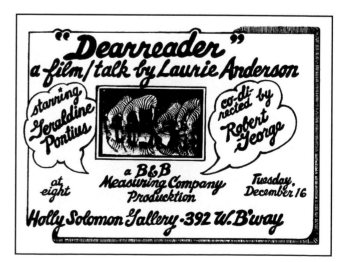

Invitation to a screening of the film

This is a sex film. Sex of the forties. It was the kind of room that was a movie set for sex scenes in the late '40s. Some of the objects are still identifiable as wedding gifts. They've always been married about two years. It's always 9:30.

Of course it begins with a love scene. In the bedroom, HUSBAND and WIFE are in their bathrobes ready for bed. They embrace, begin to kiss. The camera immediately pans over to the window where curtains are blowing.

A stiff breeze begins to rip pages off the nearby calendar. The HUSBAND begins to wind the clock. Nine pages are torn from the calendar. A newborn shrieks. Time goes backwards, then forwards again.

BIG BAND FORTIES TUNES ON THE RADIO; HOWLING WIND

THE SOUND OF THE CLOCK BEING WOUND
DROWNS OUT THE NARRATOR'S VOICE

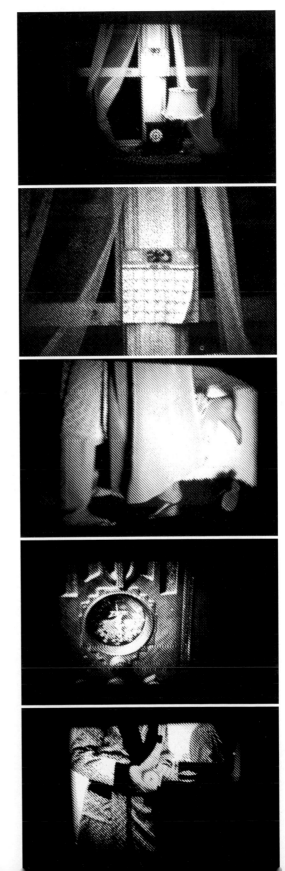

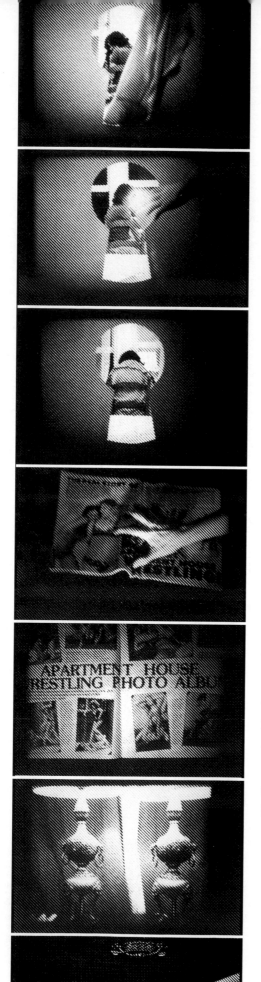

BOOKS, CLOTHES, AND KNICKKNACKS ARE SUCKED THROUGH THE KEYHOLE...

When we were kids, my sister and I used to fight and steal each other's clothes. Sometimes she would steal my diary, memorize it word for word and then, right in the middle of a fight, she would quote it to me in a flawless imitation of my voice.

THUMPING, GRUNTING, SCREAMING; COCKTAIL MUSIC

It's a typical apartment up in the Bronx. I'd been invited there to do some lady wrestling. I'd read about this new kind of living room sporting event where women strip to their underwear and wrestle each other while the husbands and boyfriends watch. I was eager to find out about it, even if it meant I had to do it myself.

The furniture in the apartment was made of wood and brass. Most of the drawers were just painted on.

At first I thought I'd be paired up with this enormous woman who was hulking ominously over in the corner. But as it turned up I was paired up with a woman who was about my size and weight.

I was pulled down almost immediately. My opponent and I rolled around and after a few minutes, she cracked my head against a bureau. Everything faded and I blacked out.

It seems to be a sport that's catching on now in the Bronx.

"Hey you! Puffball!! Whasa' matta'? Can't smoke a cigar? Huh? Huh?!"

He said that if he ever had a kid he would hire a midget, a guy about the same height and weight as the child, as a kind of tutor. "Helps the kid grow up faster," he said. "Kids can relate to midgets, 'ya know, learn from 'em."

ARABIC HORN SOLO AS GOOSE NECK LAMP SWAYS IN FRONT OF THE CLOCK, ILLUMINATING IT, THEN ECLIPSING IT.

JUNGLE BIRD CALLS

My father said there were a lot of geese in his wheat fields last summer and that only their necks stuck out above the wheat and that they looked like cobras dancing around out there.

When I moved into this loft, it was empty except for a Franklin stove. All the windows were broken, birds were flying in and out. There were piles of pigeon shit on the floor. So I called my mother and I asked her to send me a few things. She sent eight enormous packages. Inside were: zebra skin bongo drums, zebra skin stools (small and large), a zebra skin purse, a zebra skin headband, a zebra skin belt, and an entire zebra skin. I tried to arrange them in various ways so they'd take up less space.

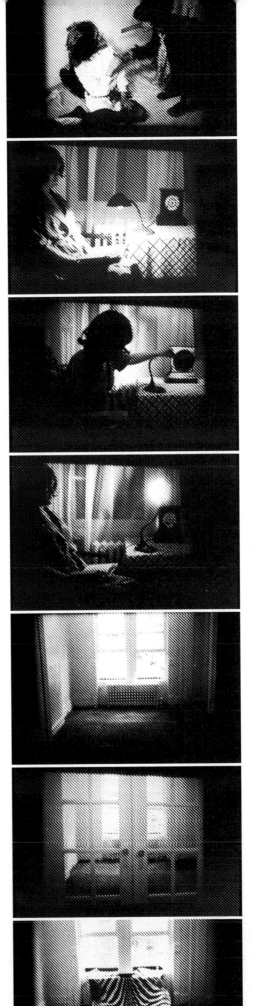

STRIPES BEGIN TO COVER THE ROOM.

AFRICAN DRUMS

But the stripes began to overpower everything else.

STRIPED LIGHT MOVES DOWN THE VENETIAN BLINDS,

BARRING THE WINDOW, THEN CREEPING ACROSS THE WALL,

AROUND THE ROOM, OVER THE FURNITURE.

And I began to feel like a prisoner in my own house.

STRIPES RUN ACROSS THE BED.

A HAND MOVES INTO THE FRAME. PULLS THE COVERS DOWN.

SILENCE

FREEZE FRAME

I used to know a painter who lived over by South Street Seaport. She said that she almost went crazy because every time a ship went by its shadow would curve around the room. It was the kind of low-ceilinged room that Melville must have lived in when he was a customs inspector in that neighborhood, the kind of room where he wrote all those songs about whales, all those stories about fast fish and loose fish. And I loved the way he talked to his readers all the time:

"Dear reader, dear reader.
Some fish are fast and some fish are loose
and you dear reader
are a fast fish and a loose fish."

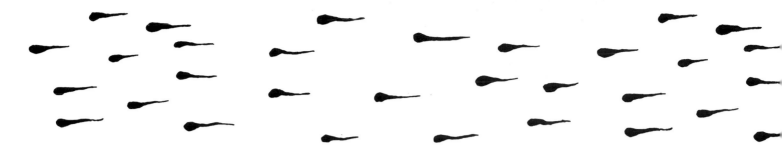

Mach 20

Ladies and gentlemen, what you are observing here are magnified examples or facsimiles of human sperm.

Generation after generation of these tiny creatures have sacrificed themselves in their persistent, often futile, attempt to transport the basic male genetic code. But where is this information coming from? They have no eyes. No ears. Yet some of them already know that they will be bald. Some of them know that they will have small, crooked teeth. Over half of them will end up as women.

Four hundred million living creatures, all knowing precisely the same thing, carbon copies of each other in a kamikaze race against the clock.

Some of you may be surprised to learn that if a sperm were the size of salmon it would be swimming its seven-inch journey at 500 miles per hour.

If sperm were the size of a whale, however, it would be traveling at 15,000 miles per hour, or Mach 20.

Now imagine, if you will, four hundred million blind and desperate sperm whales departing from the Pacific coast of North America swimming at 15,000 mph and arriving in Japanese coastal waters in just under 45 minutes.

How would they be received?

Would they realize that they were carrying information, a message?

Would there be room for so many millions?

Would they know that they had been sent for a purpose?

from "United States 4" 1983

1,000,000,000 X

1,000,000,000,000 X

And down in the ocean where nobody goes.
Some fish are fast, some are slow.
Some swim 'round the world, some hide below.
This is the ocean, so deep, so old.

from "Kerjillions of Stars" 1989

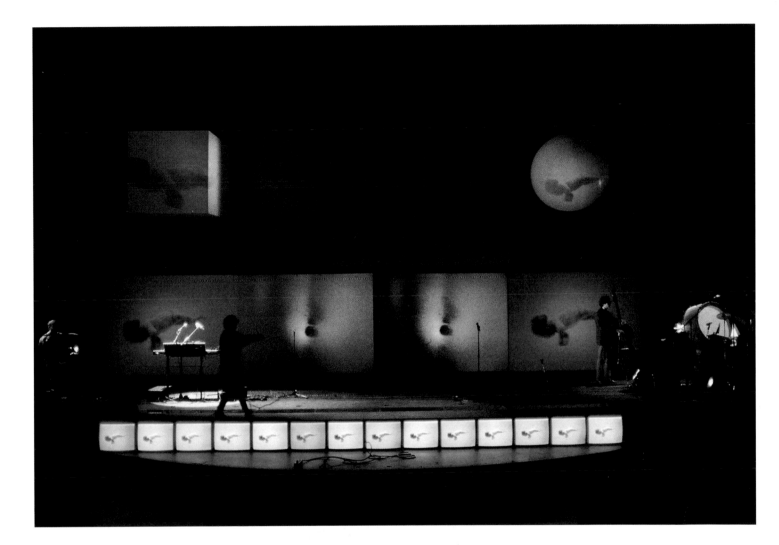

Daddy daddy it was just like you said
Now that the living outnumber the dead.
Where I come from it's a long thin thread
Across an ocean down a river of red
Now that the living outnumber the dead
Speak my language.

from "Stories from the Nerve Bible" 1992

4. SPEAK MY LANGUAGE

Ihren Klang. Ich verstehe die Sprachen.
Ich verstehe die Sprachen nicht. Ich hore nur
Ihren Klang.

Your sound. I understand the languages.
I don't understand the languages.
I hear only your sound.

from "United States 1" 1979

But the voice, my voice, what is it? It's a kind of mixture of my father's and my mother's voices. My father's voice, well, he learned English from Jimmy Cagney and Bob Hope and, way back, Abe Lincoln. He was getting a lot from the Lincoln style. (You know when that lawyer was teasing Abe about not having an office and schlepping everything around on his horse and Abe said, "My office? My office is in my hat.") And my mother's voice too, well it's more of an academic voice, a Church of England voice. And I've mixed those up and found my own voice. Of course, that's not to say I've got only one. Everyone has at least twenty, bottom line, at least twenty. They have their hail-a-cab voice, they have their interview voice, and their most intimate voice talking to their dearest loved ones on the phone, to name just a few.

from an interview with Nicholas Zurbrugg 1991

Beginning French

Lately, I've been doing a lot of concerts in French. Unfortunately, I don't speak French, I memorize it. I mean, my mouth is moving but I don't understand what I'm saying.

It's like sitting at the breakfast table and it's early in the morning and you're not quite awake. And you're just sitting there eating cereal and sort of staring at the writing on the box, not reading it exactly, just more or less looking at the words. And suddenly, for some reason, you snap to attention, and you realize that what you're reading is what you're eating, but by then it's much too late.

After doing these concerts in French, I usually had the temporary illusion that I could actually speak French, but as soon as I walked out on the street, and someone asked me simple directions, I realized I couldn't speak a single word. As a result of this inadequacy, I found that the people I had the most rapport with there were the babies. And one of the things I noticed about these babies was that they were apparently being used as some kind of traffic testers. Their mothers would be pushing them along in their strollers, and they would come to a busy street with lots of parked cars, and the mother can't see what the traffic is like because of all the parked cars, so she just sort of edges the stroller out into the street and cranes her head out afterwards.

And the most striking thing about this is the expression on these babies' faces

as they sit there in the middle of traffic
stranded
banging those little gavels they've all got
and they can't even speak English.
Do you know what I mean?

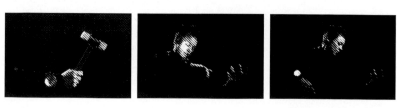

from "United States 2" 1980

Speaking Japanese

A couple of years ago I did some concerts in Japan, and I decided to sing all the songs in Japanese. So I learned them phonetically by ear and it took a couple of months, but I was pretty proud of myself. Then after the first concert the Japanese promoter came back stage and said,

"Excuse me, pardon me, but you speak English really well but, excuse me, pardon me, in Japanese you have quite a bad stutter."

I couldn't believe it! Later I discovered that the guy who had made the cassette for me to copy had a really bad st-st-stutter and I'd copied everything perfectly, carefully noting that this particular word was "ts ts -tsuru" and this other one "ts-TZ ts tsuru."

Anyway, it was impossible to unlearn the s-s-ongs because the st st stuttering had become so much a p-p-part of the rrrhythm of m-my m-m-music.

from "Empty Places" 1989

At "Media World" in Tokyo where the Video Hair Salon was being promoted. Before cutting or re-styling your hair, you could preview the effect. Left to right: Tsuromoto, the Japanese concert promoter, Bob Bielecki, Phil Ballou, and Eddie Marritz from the "Natural History" tour, 1986.

Two Stories from "For Instants"
1977

A collection of twelve stories, each attempting to have exactly the same number of words.

▪ I'm hiking through the woods in northern Canada. I haven't seen anyone for days. It's growing dark. Near a lake, I see six white canvas tents pitched on a steep gravel slope. There is no other sign of life. I walk up to the biggest tent. I can hear rattling and banging going on inside. There are voices too, and some whistling. I knock on the canvas flap, then realize this is making no sound. Suddenly, the flap is pulled back and I am face to face with a squint-eyed man in white. "TABERNACLES! UNE FEMME!" he says and drops a stack of plates. At the table, six large men in red plaid shirts stop eating and stare at me. There is stew in their open mouths. They begin talking all at once in French. "Il y a trois mois quand j'ai vu une femme," the squint-eyed man whispers in my ear as he hands me a cup of tea with soap bubbles floating lightly on the surface. After dinner, the geologists insist I be their guest for the night in "La Musée de Balzac." They light a lantern and lead me into a small tent filled with samples of soil, rocks, crystals, petrified wood, all wrapped in canvas bags and labeled. In the refrigerator, chunks of ice are stored in plastic bags. "We are studying the rates of the glaciers which will have been coming down," explains the only geologist who knows English. He tells me this tent is called "Balzac's Museum" because a few months ago an Englishman had stumbled on their wilderness camp. He stayed for five weeks, cooking dishes he called "Turkish" and "Moroccan" which were basically mixtures of Cream of Wheat, blueberries, and chocolate chips. He says the Englishman was traveling light, except for the complete works (in paperback) of Balzac. Late every night they heard him singing songs from Balzac.

"Ma fanchette est charmante dans sa simplicité
O Richard! O mon roi! L'univers t'abandonne
Broum Broum Broum," he sings.

The other geologists join in the song.
"J'ai longtemps parcouru le monde
Et l'on m'a vu. Tra la la la la la."

I am no longer sure who's imitating who.

▪ I am trying to read *Rapid Italian for Students and Tourists*. The 707 is rocking back and forth. The only other people on the plane are members of an all-drum band from Ghana. The forearm of the man sitting next to me keeps dropping heavily onto the page of my book. Each time the arm drops, I look over at him but he turns his head away. I can see his shiny black face reflected in the window. He is laughing to himself. The stewardess brings dinner. It is chicken cacciatore wrapped in foil, spaghetti marinara, salad, a stumpy loaf of bread, wine, aqua minerale, assorted pastries. "Wey bok home," he says, turning towards me, "we have good food." He is tearing off bits of foil, rolling it into tiny balls. "You know, I can't eat this food. At home we have good food. Yes, delicious. We have fufu." He is arranging the foil balls around the edge of the tray, alternating them with bits of wadded-up bread. "Yes, I have not eaten fufu for six month ago. Now we go to Ghana and oh! wot a day! We eat and eat fufu." He is drumming on the pastries with his fork, smashing down the sugared roses. "Now fufu is we have some corn meal and we put some water with it and mix it up so good. And oh! it is the most good!" Little rivers of aqua minerale are running

through the divisions of his tray. He looks startled. He is whistling now, up and down the scale, almost words. I hear an answering sound, low and soft, as if all the wing bolts had jolted loose and were whistling in the wind. About twenty rows ahead, a man is whistling. "Twi," says the man sitting next to me. "We speak Twi. Twi is, we whistle. I teach you Twi song." He writes in my notebook.

"Love is a very important thing
but people don't know how to go about it.
But for me I'll always be with you even in death!
Darling try to give me a reply."

"Hand Writing," 1972. The word "writing" is shaped from pulped newspaper.

It was an ancient Japanese pot incised with grooves. Thin-ridged grooves. Grooves all around it. It looked like one of those collapsible paper lanterns. It was an experiment. The pot was placed on a turntable and the turntable began to revolve. A needle was set into the groove. A stereo needle.

They were waiting to hear the voice of the potter potting the pot 2,000 years ago. They were hoping the sounds of the potter had somehow been embedded into the wet clay. The pot turned around and around like a record being treadled into the third dimension. It turned. They listened. They were listening. Some of them heard an unidentifiable Japanese dialect, rapid and high. Some of them heard high pitched static. The needle dug into the pot. The needle was getting blunt. More and more blunt. It was that scientific. Blunter and scientific. More blunt, and more scientific.

from "Words in Reverse" 1979

The Pillow Speaker

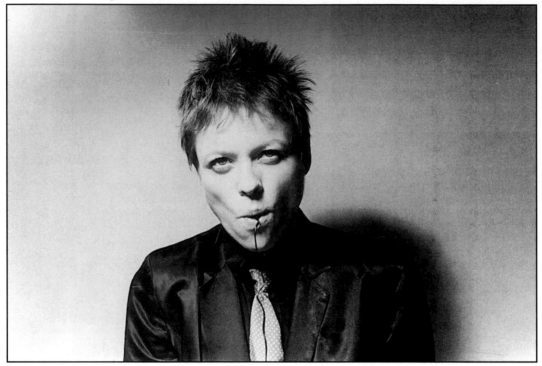

The pillow speaker is commercially available and usually used at night. You put the speaker in your pillow and learn German in your sleep. I tried this but when I woke the next morning, I didn't know any more German than I had the night before. I did however feel anxious, depressed, and paranoid. So anyway, being an oral person, I decided to put the speaker in my mouth. Also, the potential for electrocution is always a thrill.

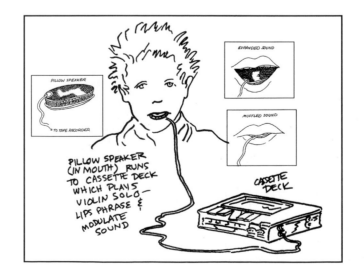

As:If

Performance excerpts
Artists Space, New York City, 1974

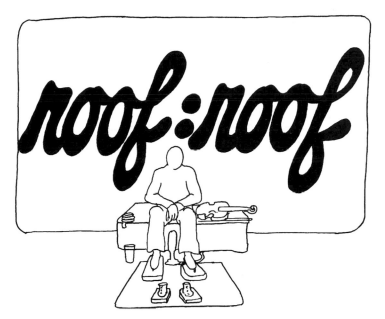

THE GALLERY IS DARK EXCEPT FOR ONE AREA WHICH IS LIT WITH A SPOTLIGHT.
PERFORMER SLIDES IN, WEARING ICE SKATES
(THEIR BLADES FROZEN INTO BLOCKS OF ICE).

My voice is usually soft and sometimes when I'm nervous, I stammer. I've cut out most of the flat midwestern "a" from my speech but I still sometimes say "rough" for "roof," "hoood" for "hood," and "warsh" for "wash."

I muffle my words a lot, and in conversations, I'll say "through" and she'll hear "thoreau" and the conversation will just sort of flow along anyway, each of us using our own definitions, back to back.

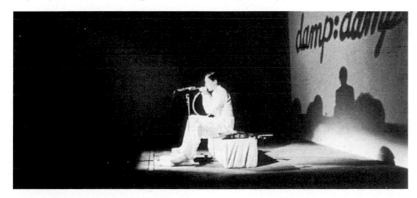

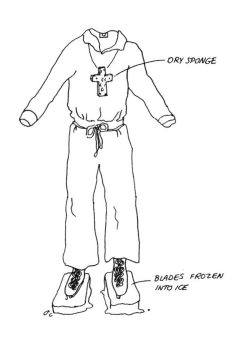

ORY SPONGE

BLADES FROZEN INTO ICE

AS PERFORMER TALKS,
SLIDES OF WORDS ARE
PROJECTED ON THE
WALL BEHIND.

roof: roof
hood: hood
wash: wash

similar: same
mean: say
word: water

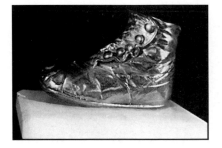

(ON TAPE, AMPLIFIED THROUGH SPEAKERS)

TELEVISION COMMERCIAL FOR LAUNDRY SOAP. WHILE THIS TAPE IS ON, PERFORMER POURS WATER ON EACH KNEE, THEN CUTS OUT WET PATCHES WITH SCISSORS, PUTS SOGGY PIECES INTO BRONZED BABY SHOES.

I mean, for example, a lot is said about soap but the word "water" is never even mentioned and after all it's really the water that does the job.

The day after my grandmother died, we went out to skate on the pond. The temperature had dropped suddenly the night before. There were a lot of ducks out on the ice and I got close to them and they didn't move. When I got closer, I saw that their feet had been frozen into the new layer of ice. They were honking and flapping their wings. I remember thinking of the ducks' feet as little conductors that carried the honking down into the ice, turning the frozen surface into a giant sounding board.

ON TAPE

"How to use your new Philip S. Olt Duck Caller: pick a spot with minimum visibility and concealment. With your finger on the long protruding piece, produce a long, low, quavering sound, as if you yourself were a duck. If you don't get immediate results, move to another stand."

PERFORMER FOLLOWS INSTRUCTIONS, BLOWS DUCK CALLER. THEN A LONG PLASTIC TUBE IS INSERTED INTO THE END OF THE CALLER. THIS TUBE EXTENSION LOWERS THE SOUND THREE OCTAVES. AFTER A MINUTE, THE OTHER END OF THE TUBE IS INSERTED INTO A GLASS OF WATER, DROWNING THE SOUND.

Are words soft?

Some words are soft.

Which words are soft?

The word "soft" because you're

saying it's "soft."

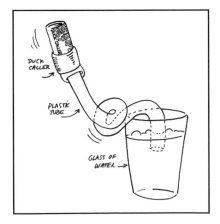

LIVE: We talked about simultaneity. He said, now

 TAPE: We talked about simultaneity. He said, now

think about what you're saying and just

 think about what you're saying and just,

say it. But I always seemed to be a little

 say it. But I always seemed to be a little

in front of or behind the words. It was

 in front of or behind the words. It was

hard to synchronize. Words would surface,

 hard to synchronize. Words would surface,

the flow would go on, then other words would

 the flow would go on, then other words would

surface.

 surface.

My violin teacher told me the same thing.

 My violin teacher told me the same thing.

Concentrate on the sound, hear it, play it,

 Concentrate on the sound, hear it, play it,

all at once.

 all at once.

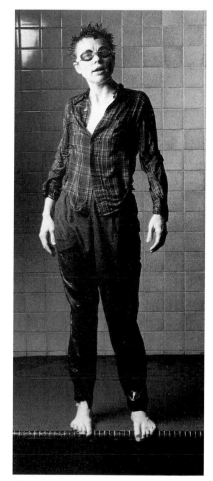

Portrait as a drowned rat by
Annie Leibovitz, 1984

In 1958, I was baptized by total immersion in the First Church of Christ. I wore a thin white robe with nothing underneath. After the baptism, I had to stand there soaking wet in this see-through robe in front of the whole congregation and give a speech. My grandmother always said, "The cure for nerves in public speaking is to think of something else while you talk." But all I could think of was Bobby Darin's hit "Splish Splash" and my speech became more and more disjointed, garbled, more and more like speaking in tongues.

splish: splash

bing: bang

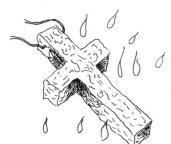

sink: synch
door: door
here: hear
drowned: sound
hymn: hum
grimmer: grammar
here: hear

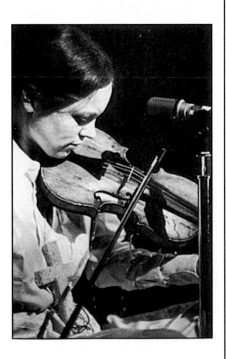

"SPLISH SPLASH" ON TAPE DROWNS OUT PERFORMER'S VOICE.

Splish splash I was takin' a bath—'long about a Saturday night.
Rub Dub—just relaxin' in the tub—thinkin' everything was alright
Well, how was I to know there was a party goin' on?
Reelin' with the feelin'—Rockin' and a rollin'. Eeeee-ya!

PERFORMER DIPS THE CROSS-SHAPED SPONGE IN WATER. CROSS INFLATES.

In 1971, I tried to seduce someone through a door. This guy was going out with my roommate and I wanted to sleep with him. He would come over to our apartment and they would go into her room, shut the door, and start to make love. Then I would get my violin and go into the living room, which was next to her bedroom, and play Tschaikovsky.

I hoped he would hear me and recognize how sensitive, and sensual, I was and want to be with me instead of her.

ON TAPE: FIRST 30 BARS OF TSCHAIKOVSKY VIOLIN CONCERTO
PLAYED BY OISTRACH; THEN A PRE-RECORDED TAPE OF PERFORMER
PLAYING SAME PASSAGE.

The only thing I didn't count on was that it sounded one way when Oistrach played it, another way when I played it, and still another way when it was coming through a door while fucking.

VIOLIN IS FILLED WITH WATER;
FIRST 30 BARS OF TSCHAIKOVSKY PLAYED ON IT.
PERFORMER HUMS HYMN. PERFORMER MOUTHS WORDS TO HYMN. LEAVES.
IN SILENCE, WORDS FROM HYMN APPEAR ON SCREEN.

the ties
that bind
of kindred minds
is like
is: like
as: if

5. THE VENTRILOQUIST'S DUMMY

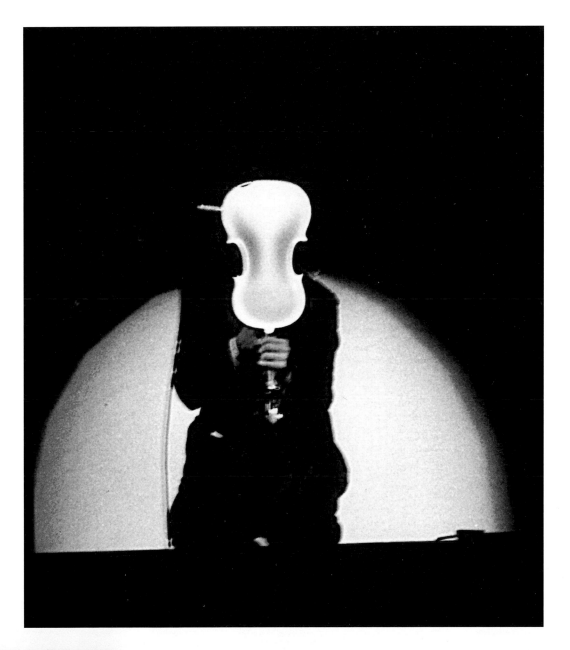

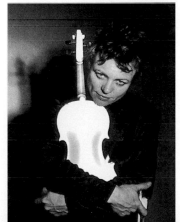

For me, the violin is the perfect alter ego. It's the instrument closest to the human voice, the human female voice. It's a siren. A lot of the imagery in performances has involved fires, and the violin has been both a way to fan them and to put them out.

I've spent a lot of time trying to teach the violin to talk. I love the violin because it's a romantic, nineteenth-century instrument, and because you can hold it, walk around with it.

Fire from "Stories from the Nerve Bible," 1992

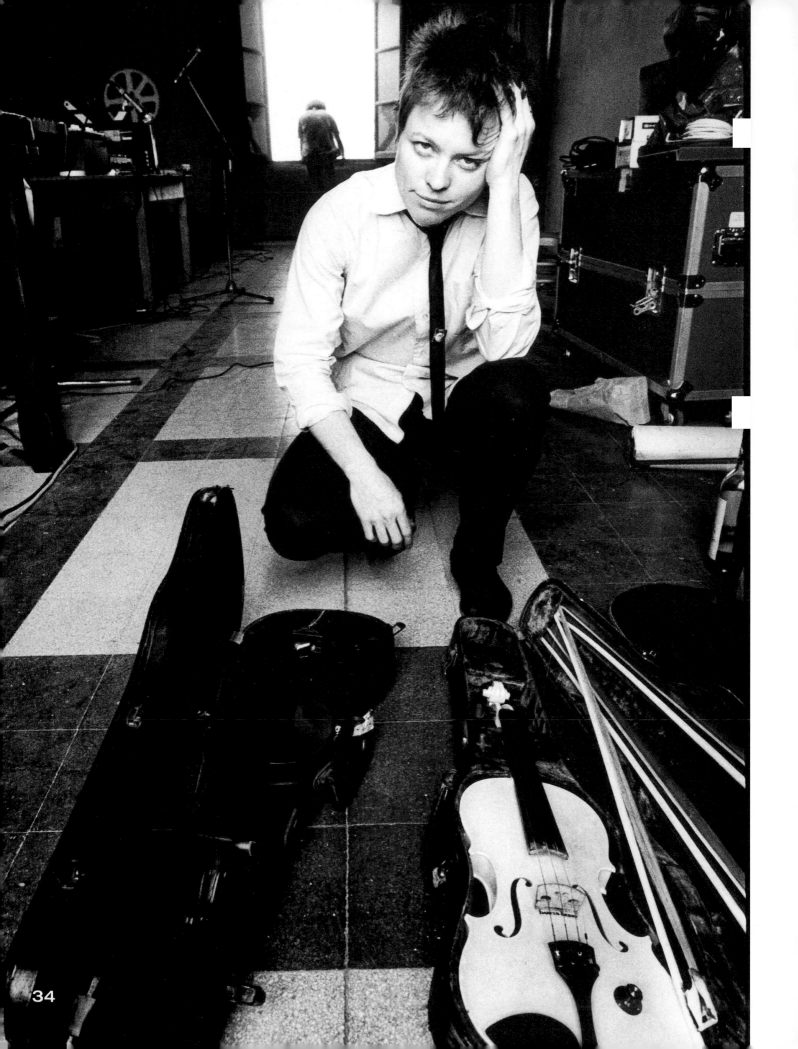

I began to play the violin as a child and was pretty serious about it, really. I spent a few summers in Michigan at Interlochen National Music Camp, and that was really a very competitive situation which eventually put me off. I realized that to be a professional musician you have to practice all the time, it's like sports. And there were other things I wanted to do—speak German, learn about physics. Looking back, I still don't know any German and not a thing about physics but I'm still glad I made that decision. Anyway, I wasn't good enough.

But I loved walking around Chicago with my violin case. It sort of blended in to the romantic gangster mentality there. Also when I walked to rehearsals with the Chicago Youth Symphony, I passed all these great trick shops. Chicago is sort of famous for that, exploding pens, plastic dog poop, we found things like this really funny in Chicago. And maybe it was passing those shops that made me want to do things like see what would happen if I filled my violin with water or used it as a frying pan.

KH: Chicago definitely has its own style as far as art. Do you see Chicago in your work at all?
LA: Oh, yeah. Most of the reviews start with that as a premise. "This is really mid-western stuff"—which I like 'cause the sleekness of New York is something I've really been trying to get away from.

video interview with Kate Horsfield, Video Data Bank, 1977

Violins as Props

When Alan and I play music together, sometimes we stop and talk (sort of absentmindedly plucking our instruments in time to the words, like sailors on leave, still lurching down the dry streets).

One day he said, "Laurie, I just don't see how you can use your violin as a prop." "Well…," I said. I noticed his chin was propped in his hand. We were awkward, with no words attached. There must be—um—reasons why I've sanded a violin to the bone, covered a violin with camouflage material and yodelled with it, dressed a violin in imitation leopard, popped popcorn in a half-size tin violin (which barely made it through the TWA x-ray machine. *Rattle Rattle* "What's in here? Smells like popcorn!") There must be—yeah—reasons why I installed a speaker inside a violin so it would play duets with me, filled a violin with water, burned a violin, mounted a turntable on the body and a needle into the bow (the Viophonograph and its "No Strings" records with fiddling instructions), reasons why I've tuned it, polished it, sung to it (songs of praise, songs of guilt), taken it on trips, taken it to bed, to the beach, to the woods.

Now I'm ransacking my past (that is, my notebooks) for reasons and I just found a few scribbled notes from November. One says, "Balzac, for a woman to give herself to a man is like putting a violin into the hands of a gorilla." Then

below this and smaller, "A violin can't hear itself sing: is this true?" But these "quotes" from I don't know where now, don't help, too sexist and well, sort of Malapropos. But as for props, what instrument isn't? The sound, the feeling, the music have only a temporary, almost incidental relationship to the source, elegant as the instrument itself might be, as object. When I decided to build my own Strad, I got a book called, *How to Build Your Own Stradivarius*, but abandoned the project when I saw that the first six chapters were titled "How to Build the Tools to Build Your Own Stradivarius." It was getting too removed. Props for Props. What I really want to say is that if instruments are props, then human bodies are too.

from "Confessions of a Street-Talker" 1975

Self-Playing Violin

The Self-Playing Violin, 1975. There is a speaker inside the violin so that it can play by itself or you can play duets with it, adding the live part.

Viophonograph

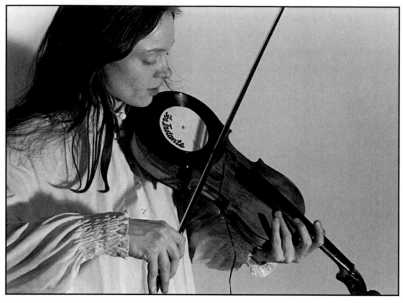

The Viophonograph, 1976, has a battery-powered turntable mounted on the body and a stereo needle attached to the bow. It's played by lowering the arm, like the arm of a record player. The records I cut for it were one sustained note per band.

Tape Bow Violin

A Revox tape playback head is mounted where the bridge would be. On the bow, instead of horsehair, there is a strip of pre-recorded audiotape so that as you move the bow back and forth across the head sound is produced.

At first, I used this instrument to play with the relationship of sight and sound. What you see is a string quartet in tuxedos. And what you hear (for example) are saxophones, drums, and barking dogs.

But later, because the bow is drawn both ways, I got interested in reversible sounds. In written form, palindromes are immutable ("GOD" spelled backwards is always "DOG"). But with audio palindromes it's hard to predict what something will sound like backwards.

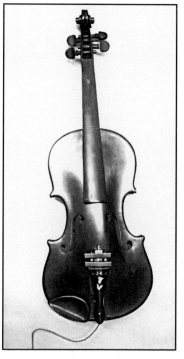

The Tape Bow Violin, 1977, was designed by Bob Bielecki.

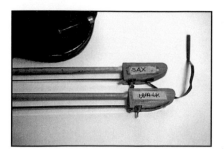

Two bows for Tape Bow Violin.

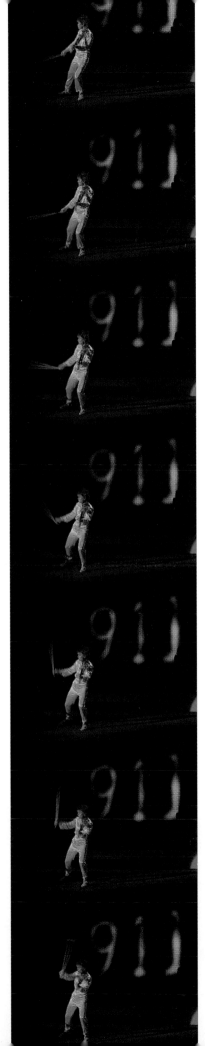

Bob Bielecki customizing a violin designed by Max Matthews of Bell Labs

Digital Violin

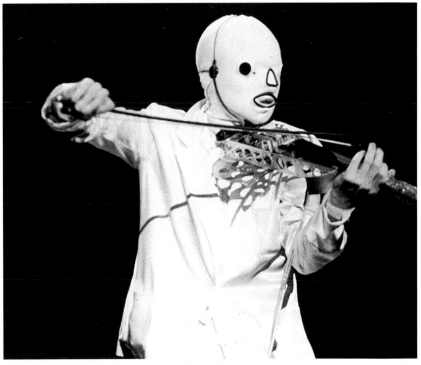

This digital violin was interfaced with the Synclavier and was capable of playing any sound stored in the system. In the song "Smoke Rings" the violin plays something that sounds like a violent storm. Actually this sound was made by a computer crashing.

Dummy Violin

In "Stories from the Nerve Bible" a dummy plays a 1/32-size Suzuki. The sound was heavily processed so that it sounded almost symphonic.

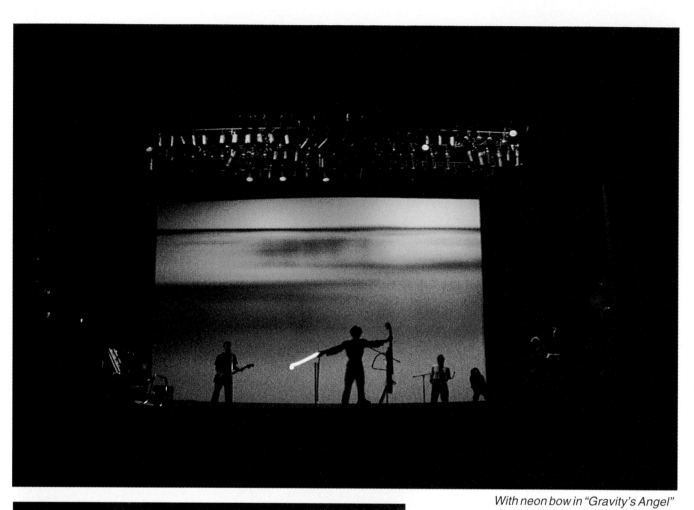

With neon bow in "Gravity's Angel"
"Home of the Brave," 1986

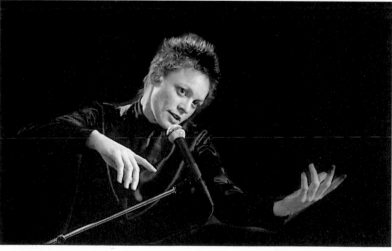

A while ago, I had this stiff neck. I couldn't get it out of this one position.
 I went to a doctor and he said, "Show me where it hurts."
And I said, "Well, it sort of starts in my neck here, and runs down
 my arm, and kind of crumples up the fingers on this hand."
And he said, "Exactly what is it that you do for a living?"

from "Stiff Neck" "United States 4" 1983

6. DUETS ON ICE

A series of performances
in Genoa, Italy and New York City
1974/75

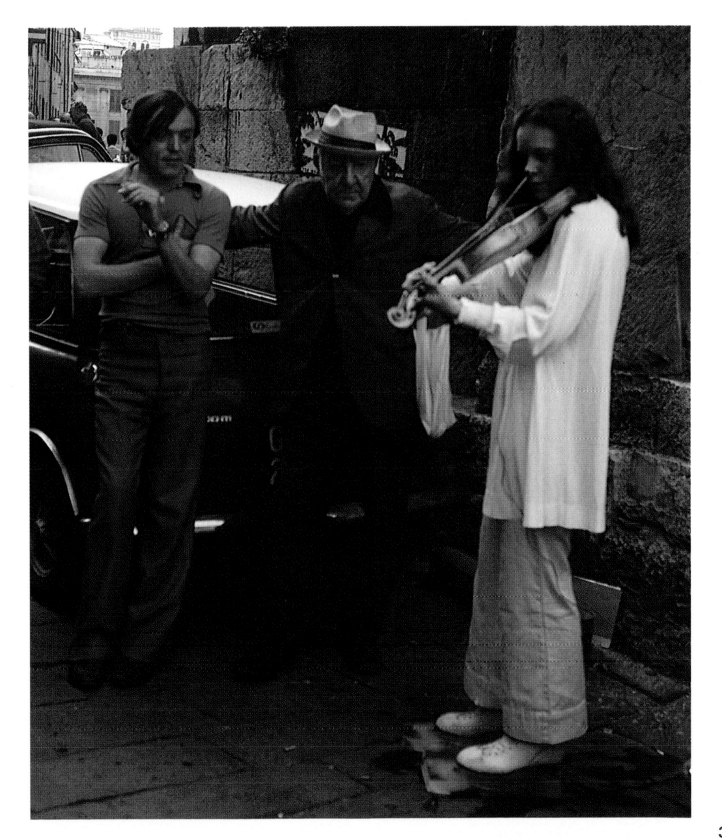

MUSIC.

The music-hall singer attends a series Of masses and fugues and 'ops' By Bach. *[The remainder of this left-hand column is a photographic reproduction of an Oxford English Dictionary entry for "Music," "Musical," etc., rendered too faintly and in too degraded a form to transcribe reliably.]*

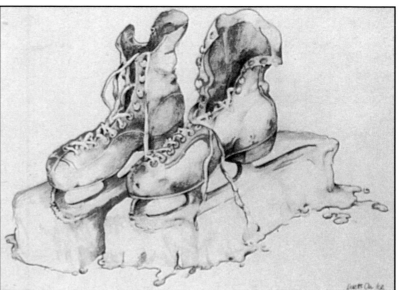

DUETS ON ICE

I used *The Self-Playing Violin* in "Duets on Ice." The pre-recorded material was mostly cowboy songs recorded on ninety minute cassettes. So I'd play along but since it was a loop, there was no definite way to end the concert. So the timing mechanism was a pair of ice skates with their blades frozen into blocks of ice (from "As:If"). When the ice melted and I lost my balance, the concert was over.

In between songs I talked about the parallels between ice skating and violin playing: blades over a surface, balance, simultaneity, the constant state of imbalance followed by balance followed by imbalance, like walking, like music, like everything.

In Genoa, the songs were half-Italian, half-English, spaghetti western style. The first Italian words I ever saw were written on music scores: "fermata" "tempo al fine." Later, when I began to learn Italian, I found that many of these words were architectural terms as well as musical ones.

Canto is "song" and "corner." *Scala* is "stairway" and "scale." *Stanza* is "room" and "stanza." And the purpose of these words is to direct you through works of art that are about time, to show you how to move through music or how to walk through a building.

Pencil sketch, 1975

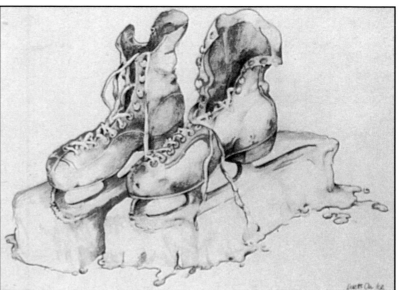

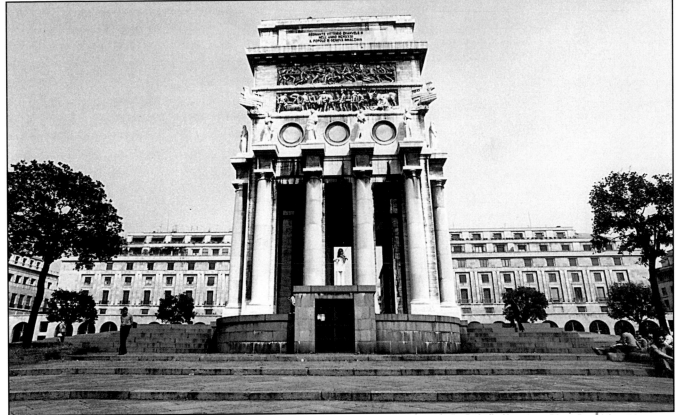

Concert at The Monument of the Eternal Flame, Genoa, Italy, 1975

Sometimes it took a long time for the ice to melt. So I chose this site to speed things up. Standing by the fire cut the concert time in half.

Putting my shoes back on after the concert

ARCHITECTURE.

Sc. III. xv. viii. § 1. 207 Classification is the architectonic science, to which Crystallography and the Doctrine of External Characters are subordinate. 1877 CAIRD *Philos. Kant* II. xvi. 575 The architectonic impulse of reason, which seeks to refer all science to one principle.

B. sb. Architectonic, s [F. *l'architectonique*]: the science a. of architecture; b. *Metaph.* of the systematic arrangement of knowledge.

1660 H. MORE *Myst. Godl.* III. vi. 70 The Invention of Letters, of Munick, of Architectonicks. 1890 LEITCH *Muller's Anc. Art* § 42 A style of architectonics .. which aimed

1681-83 *Ord. R. Hons.-k.* 42 The office of Jewell-house hath an architectour, called. keeper of the king's Jewells.

Architectress (ä·rkitektres). [f. prec. + -ESS: cf. *director, directress.*] A female architect.

1602 CORNWALLYES *Ess.* II. xxxviii. This Architectress shewes the first ground of Policy. 1651 *Relig. Wotton.* (1672) 139 If Nature herself (the first Architectress) had .. windowed your breast. 1860 H. MARRYAT *Resid. Jutland* I. v. 62 Queen Thyre Danebod, architectress of the Danevirke.

Architectural (ä·rkite·ktiŭrāl), a. [f. ARCHITECTURE + -AL 1.] Of, relating to, or according to, architecture.

1760-94 J. STUART *Antiq. Athens* (R.) No fragment of sculpture or architectural ornaments was to be found there. 1841 SPALDING *Italy & Isl.* I. 31 The architectural monuments of the Romans. 1868 GEO. ELIOT *F. Holt* 11 A folio volume of architectural engravings.

Architecturalist (-ist). [f. as next + -IST.] A professed student of, or connoisseur in, architecture.

1861 A. B. HOPE *Eng. Cathedr.* 19th C. viii. 278. I have also been arguing as an architecturalist.

Architecturalisation (-izā·tʃən). [n. of action f. next: see -ATION.] Adaptation to the purposes of architecture.

1879 G. SCOTT *Lect. Archit.* I. 103 A very valuable element in the architecturalisation of foliage.

Architecturalise (-ai·z), v. [f. ARCHITECTURAL + -IZE.] To adapt to architectural purposes or design.

1879 G. SCOTT *Lect. Archit.* II. 135 To architecturalise the arched opening.

Architecturally, adv. [f. as prec. + -LY 2.] In an architectural manner; as regards architecture.

1843 *Penny Mag.* 409 The east end .. is treated architecturally. 1876 MRS BRADDON *J. Haggard's Dau.* I. 29 Architecturally Mr. Haggard's dwelling-place had no claim to be admired.

Architecture (ä·rkitektiŭr), sb. [a. F. architecture (1 or It. architettura), ad. L. architectūra, f. architect-us: see ARCHITECT and -URE.]

1. The art or science of building or constructing edifices of any kind for human use. Regarded in this wide application, *Architecture* is divided into *Civil, Ecclesiastical, Naval, Military,* which deal

41

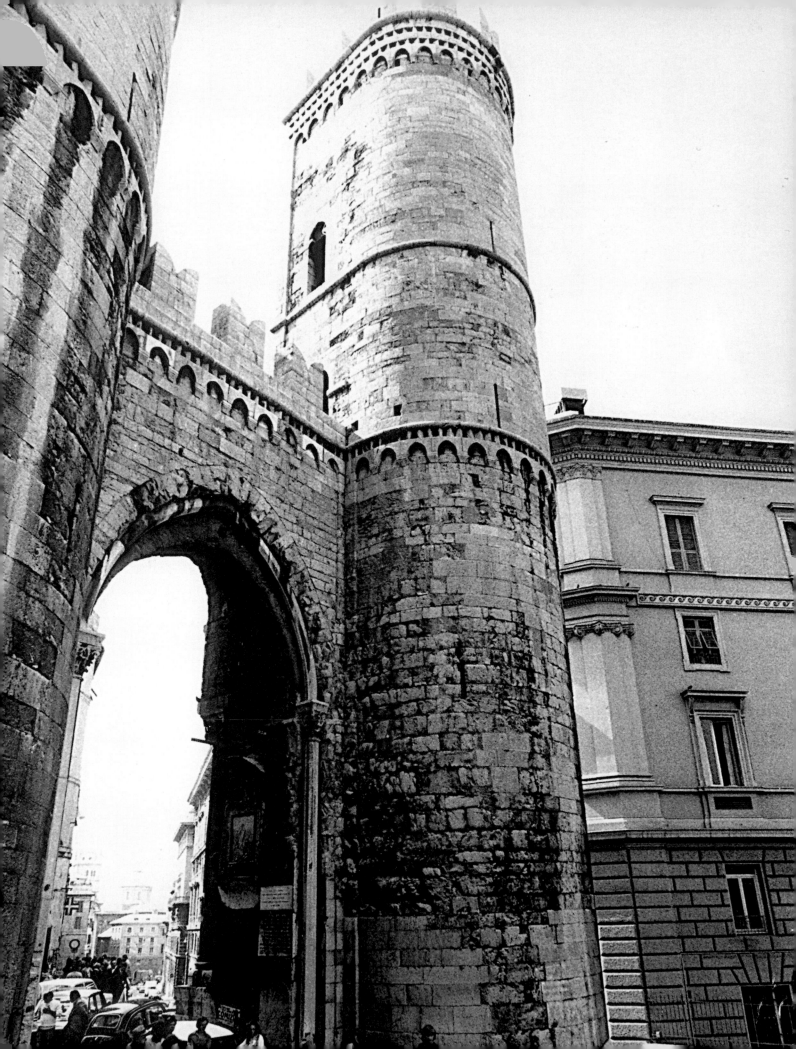

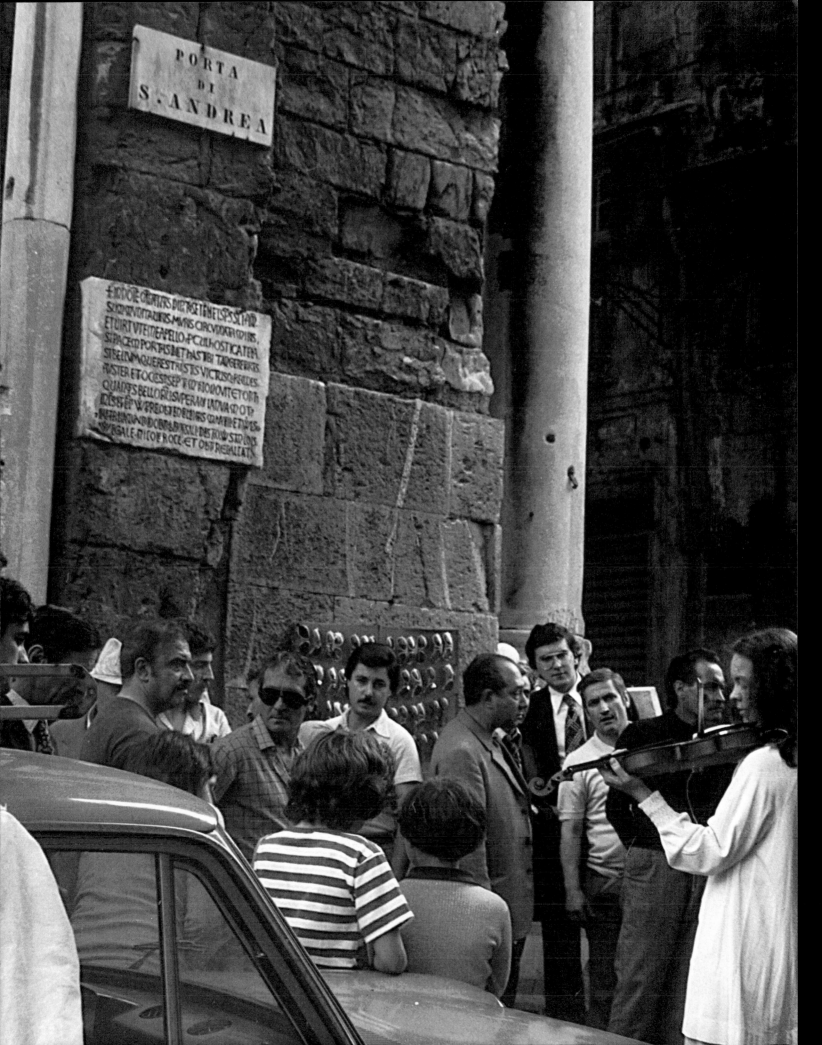

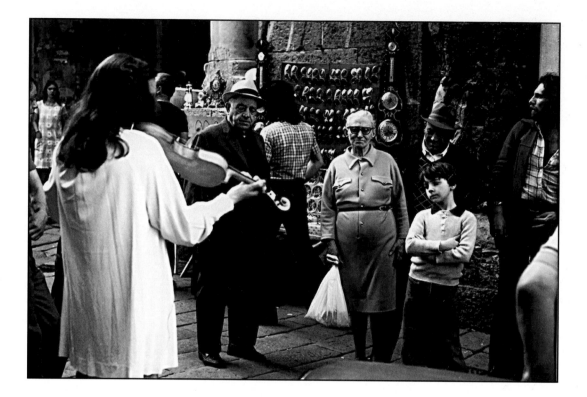

In awkward Italian, I told a group of people in Genoa that I was playing these songs in memory of my grandmother because the day she died I went out on a frozen lake and saw a lot of ducks whose feet had frozen into the new layer of ice.

One man who heard me tell this story was explaining to newcomers, "She's playing these songs because once she and her grandmother were frozen together into a lake."

On the previous pages:
Concert at the Porta di S. Andrea, Genoa, Italy, 1975

Duets on Ice was also presented in New York City, 1974.

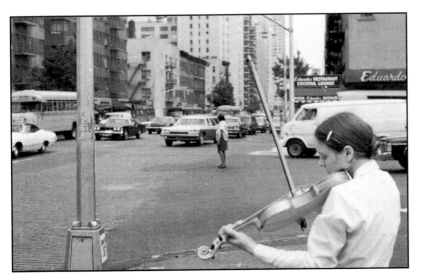

Fifty-ninth Street. Traffic sounds usually drowned out most of the concerts.

This man saw me playing and decided to team up.

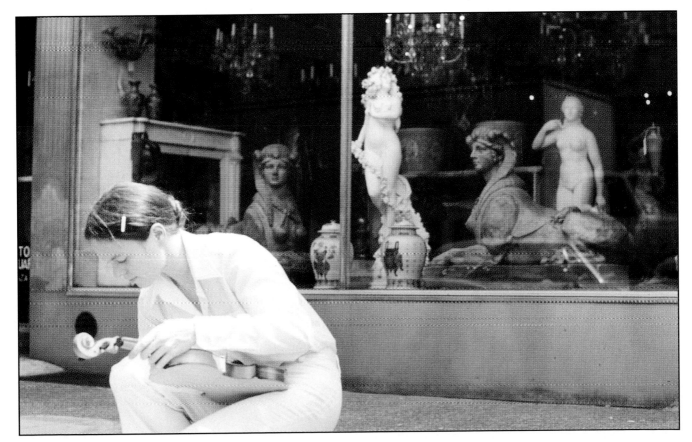

First Avenue

45

7. EARSHOT

I've always thought that one of the most serious defects of the human body was that you couldn't close your ears. You can't point them anywhere or close them, they just sort of hang there on the sides of your head. But an acupuncturist explained to me that the pressure points in ears are very important because the whole body is represented right there in the ear. The ears, he said, are vestigial fetuses, little versions of yourself, one male and one female. And he showed me here's the lobe, that's the miniature upside down head, and this curve here is the spine and right here are the little genitals and that was when I went back to wearing hats.

from "Voices from the Beyond" 1990

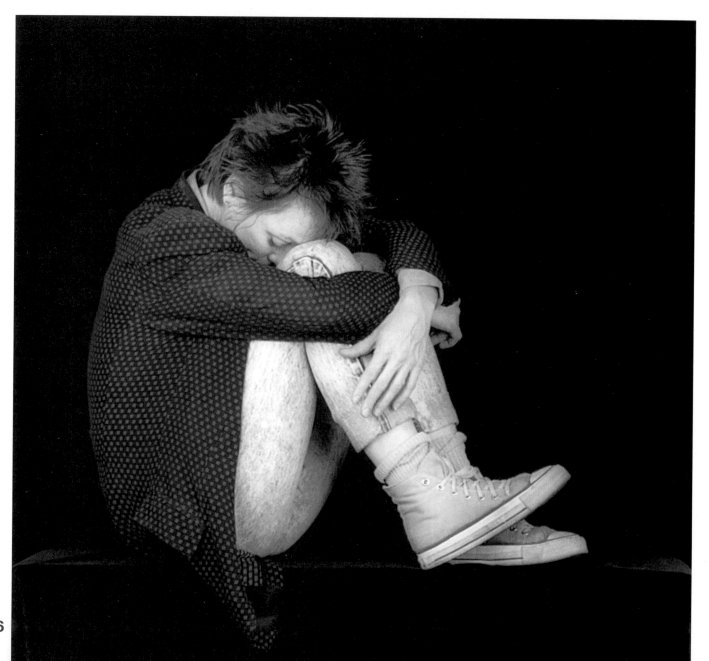

WHEN YOU WE'RE HEAR

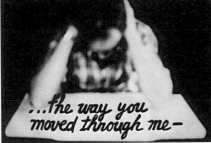

...the way you moved through me—

Handphone Table

Projects Gallery, Museum of Modern Art
New York City 1978
Dedicated to Nikola Tesla;
Electronics by Bob Bielecki

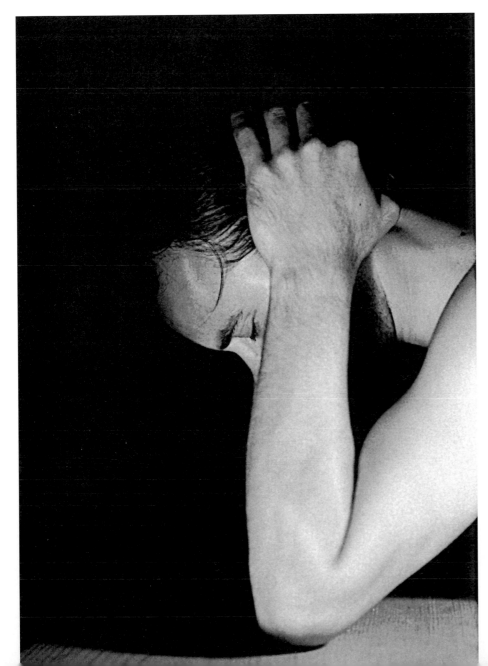

I got the idea for The Handphone Table when I was typing something on an electric typewriter.

It wasn't going very well and I got so depressed I stopped and just put my head in my hands. That's when I heard it: a loud hum coming from the typewriter, amplified by the wooden table and running up my arms, totally clear and very loud.

47

So I built a table and rigged it for sound. Inside the table were cassette decks and powerful drivers which compressed the pre-recorded sounds and drove them up steel rods. The tip of these rods touched four plugs resembling pine knots embedded in the surface of the table. When you put your elbows on these plugs, the sound rose through your arms via bone conduction. When you put your hands over your ears, it was like putting on a pair of powerful stereo headphones.

So it was about your whole head becoming a speaker and in a sense, an amplifier; and it's more like remembering sound than hearing it really because it's not out here in the air, you know, it's inside your head. I wanted to make songs that were more like remembering than listening. So it would seem like you'd heard them somewhere before. And in the end, the same physical gesture—the head in the hands—was used in its invention as well as its reception.

Because the Handphone Table had a rather high "science fair" quotient anyway, I didn't want to put a technical explanation on the wall. ("Put your elbows on the table and you will hear via bone conduction...etc etc etc.") So I just put a big photograph on the wall, a man holding his head in his hands, and some text and hoped that people would get the idea.

I wrote three songs for The Handphone Table. The first song was a duet for two baselines; one was on an acoustic piano with all the ringing harmonics, the other was a very pure Fender Rhodes sound. These were split left and right but very gradually traded places. Another song was for violin which was panned very extremely so it seemed like the bow was being drawn right through your head.

Both songs used the lowest ranges of the instruments, since bass frequencies, being wide and slow, travel well. Treble is more skittish and tends to evaporate. Since much of language is shaped by treble sounds, for example (it's the t's and s's and other fragile pointy sounds that define words), it was difficult to make the table speak clearly. Finally I was able to make language work by slowing it down and using elaborate equalization.

I used a line from George Herbert, a seventeenth-century English metaphysical love poet.

"Now I in you without a body move."

So with panning it sounded like

NOW I		*IN YOU*
WITHOUT		*A BODY*
	M O V E	

And I loved the symmetry: you heard the final piece using the same gesture involved in its invention, closing the circuit, your head in your hands, listening, listening through your bones.

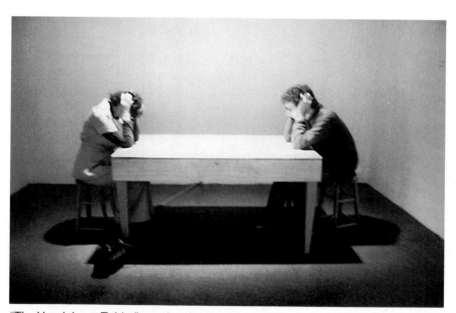

"The Handphone Table," wood and electronics, 1978

Note/Tone

Installation, Holly Solomon Gallery 1978

A sidewalk of projected light bisects the gallery. As the listener walks forwards along the path, the word "Note" is audible. Backwards, the word "tone" is heard.

Four light sensitive photo cells are positioned along the ceiling parallel to the line of light. As the listener walks, s/he breaks the beam, triggering the audio playback of portions of the word.

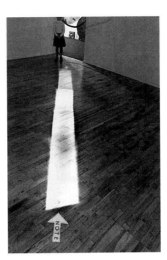

Forwards: NNNN...OOOOO...T-T-T

Backwards: T-T-T...OOOOO...NNN

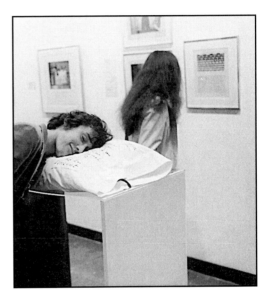

Talking Pillows

Pillows with speakers inside
1977/1985

I'm lying in the dark now listening to a tape of gibberish recorded by a little girl who came over last week. She loved the "Talking Pillow" and wanted to make her own version. She recorded about an hour's worth and I'm hearing it all now but it's waking me up instead.

"What Burns" Talking Pillow, 1977

There's something very quiet going on in this pillow but it's buried under all the noise and I'm waiting here, just waiting, for something that, most likely has already happened.

Numbers Runners

Installation, 1978

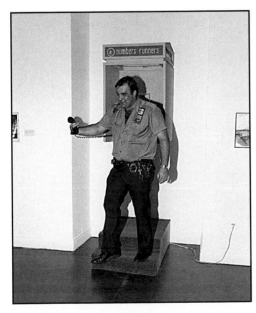

An altered phone booth. The listener picks up the phone and responds to a series of questions and stories. Gaps were left for the listener's responses, which were on time delay.

from "Confessions of a Street Talker" 1975

Stereo Decoy (A Canadian/American Duet)

Artpark, Lewiston, N.Y.,1977. Artpark commissions outdoor works by artists which are on exhibit all summer.

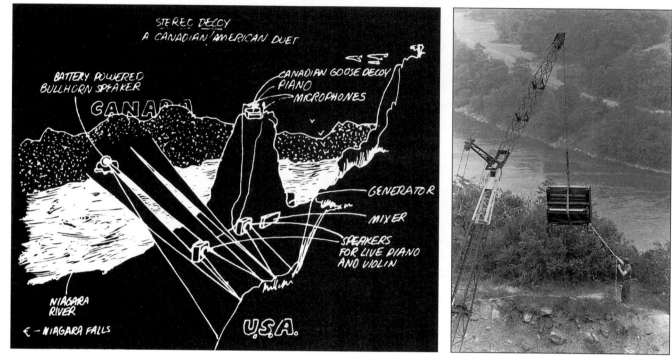

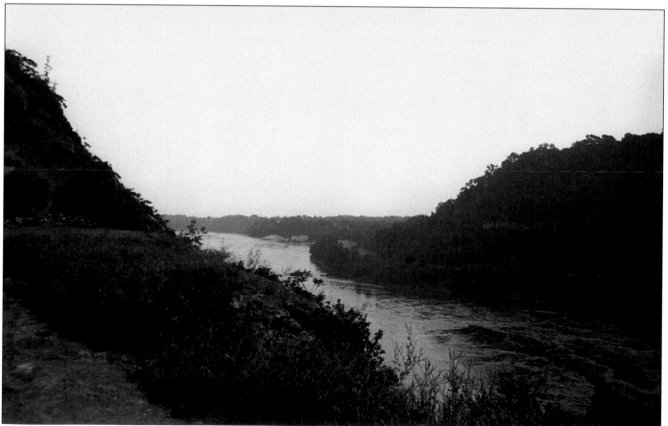

When I first came to Artpark in March to look around, I was struck by all the activity over the river. White birds shrieking and swooping down to scoop up fish, barking black birds wheeling above, and camouflaged blue-grey snub-nosed bombers from the nearby Air Force base whining in formation, like sharks racing near the surface of an ocean. And it was these layers of sound that got me interested in the acoustics of the gorge: the clarity of sound traveling across water, the confusion of feedback from the rocky outcrops.

In July I composed a piece for tape and live sound that would ricochet back and forth across the gorge. On both sides of the river there were violin-piano duets; the Canadian side was on tape, broadcast through a battery-powered bullhorn speaker, the American side was live. The idea was that the two countries would do a kind of call and answer duet.

After a few days of preparation, I noticed that the artists who were getting the most assistance and access to equipment were the sculptors who were doing large scale "move the earth" sort of projects. My piece was going to be rather modest, but when I saw what was going on, I decided that I'd put the piano on top of the bluff and would, naturally, need a ten-storey crane. The commissioners were ecstatic. "Now you're talking!" they said and within hours enough equipment to move and feed a small Central American army began to arrive: trucks, walkie-talkies, a huge sound system, landscaping crew, cars, and the crane.

We wrapped the piano, attached it to the crane by a thread-like cable and watched as it levitated, spinning slowly, and finally alighted exactly on the bald spot where the landscapers had hacked the poison ivy away from the bluff.

On the night of the concert, as soon as the audience arrived, the wind picked up, whipping around the top of the bluff. I began to play the piece accompanied by the pianist George Bayer, an intern at the park. It was George's piano debut (that is, he had begun to play the piano three days before) and he had carefully numbered the keys in magic marker.

About ten minutes into the piece, I began to realize that something was definitely wrong. Finally I stopped and climbed down the cliff a little to listen. I suddenly realized that the person running the Canadian sound system was playing the same two minutes of tape, over and over. "I'll be right back," I shouted to George. "Improvise!"

We ran out on the outcrop and could see our playback man in Canada, a tiny figure perched on the river bank. Every two minutes he scrambled up to the sound truck, conscientiously rewinding the tape, his walkie-talkie dead to the world.

To get his attention, we turned the speakers around towards the cliff. Suddenly the sound was thunderous, earsplitting. The songs bounced back and forth from side to side. The entire gorge had become a mammoth speaker, an enormous hallway. Signals were jamming. The treble was screeching. The bass was rolling in long magnificent waves back and forth across the border. It seemed like the gorge had taken over, shaping the sound into a huge rebounding mass, its banks like switchers out of control.

Later that night I went out on a boat with the crane operators. We cruised up and down the Niagara River in the dark, swirled along by its powerful currents, drinking beer and talking about smugglers. "Yep, a lot of stuff comes across this river at night," said Ralph. "And neither side wants to hear about it. That's international relations for you!"

from the Artpark catalog 1977

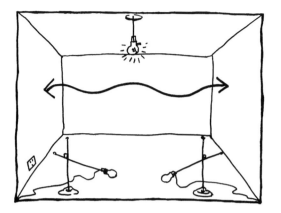

In this experiment, two people have a conversation. Then the room is sealed off but the sound waves keep moving bouncing back and forth between the walls, back and forth, growing fainter and more garbled. Sometimes it can take fifty years for words to slow down and finally to stop. In this experiment, we listen with our microphones, trying to translate these waves back into words.

from "Some Experiments" 1976

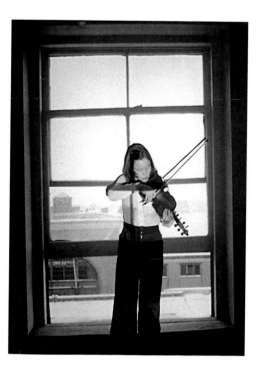

Is Anybody Home?

Sound effects accumulate to create the rhythm track.

BOATHORN

I live by the Hudson River and a lot of boats go by. I've spent a lot of time trying to film them, so I set up a camera near the window, but miss almost every one.

CAMERA CLICKING

They glide by so quickly on the other side of the river, camouflaged against the Jersey shore. Sometimes it's hard to tell which is moving, the river or the shore, and it seems like all of Manhattan has come unanchored and is slowly drifting out to sea.

FEET RUNNING UPSTAIRS

It's the kind of timing, the kind of synching, that's been getting into the songs I've been writing. It's like walking upstairs in the dark when you think there's one more step than there actually is and your foot comes pounding down with too much force and nothing underneath. Or like the piano we got a few months ago, only a few keys worked so we put it out in the hallway near the door and when people come in they rake their hands over the keyboard, hitting the few notes that work. It's kind of a doorbell now.

DOORBELL

I was trying to work on a song for a performance but all the sounds around were so distracting. It was impossible to concentrate. My mother called and said, "Why don't you come out here and write your song? It's real quiet—we've just put new carpets down." When I got there, I noticed that the carpets were so thick that none of the doors closed. The only door that still moved was the door to the parrot's room. It was a swinging door and every time someone opened it, it whacked into the parrot's cage and the parrot screamed and the scream filled the house through all the open doors.

PARROT SHRIEKS

And this is the song I finally wrote.

VIOLIN

from "Is Anybody Home?" "For Instants Part 3" 1976

Chord for a Room

"Chord for a Room" in Jean Dupuy's exhibition
"About 405 East 13th Street" 1972

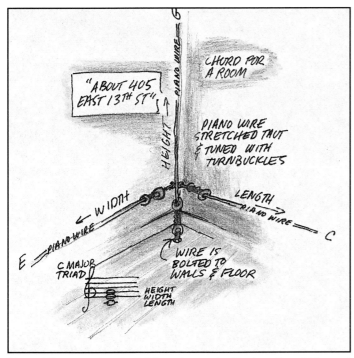

I tuned the room by stretching piano wire the length, width, and height of the room. In the corner, the wires produced a major triad when struck with a hammer.

Door Mat Love Song

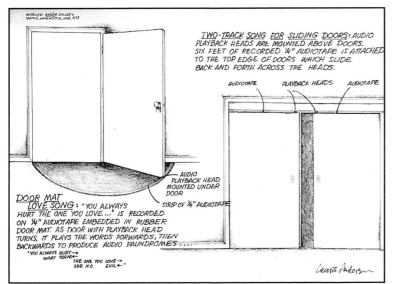

I've been on the road for months now, away from home, and I'm finally beginning to understand a French woman I met in New York last fall. She was very disoriented, didn't like the food, she didn't have any friends. And she had this habit of going around and picking up dead leaves that had fallen off the trees and taking them home and trying to revive them. Her house was crammed with jars of moldy water and rotting leaves.

It was a lot like a house I stayed in in Albuquerque last week. The guy who lived there loved clocks and the house was full of clocks of all kinds: grandfather clocks, grandmother clocks, alarm clocks, table clocks. He was very particular about synchronizing the clocks, not only so that they all told the same time, but so that they all ticked at precisely the same second on exactly the same beat. His house was like an enormous time bomb TICK!…TICK!…TICK! and time was passing with a kind of authority I'd never heard before.

The same kind of synching is happening over at the Gondoleer Inn where I've been staying the last few days. All the guests here seem to have the same taste in TV programs: cop shows and car chases. You know, everyone's just sitting around watching people get shot in time to the music. The walls are paper thin at the Gondoleer and I've been trying to practice the violin without disturbing the other guests so I try to synchronize my playing to the action. Last night the guy next door began to pound on the wall, yelling, "If you want to do a sound track, why don't you just make your own damn movie?"

from "Notebooks" unpublished 1977

Duet for Door Jamb and Violin

1976

The duet is performed on the threshold. The length of the bow stroke is determined by the width of the door. Contact microphones are attached to the jambs at the impact points, amplifying the staccato, knocking sound as the bow moves back and forth.

When the violin is electric, the violin speakers are located in one room and the door jamb speakers in the adjoining room. During the performance, tonal and percussive are mixed by kicking the door open and shut.

CONTACT MIKE **CONTACT MIKE**

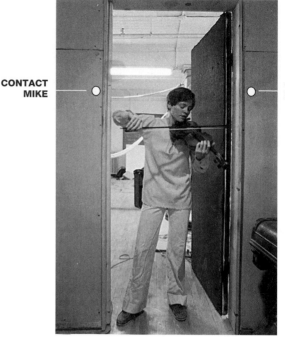

Acoustic Lens

Moore College of Art, Philadelphia 1978

While we were working on the project, we wandered around Philadelphia looking for a place to install the lens. We stopped by the Franklin Institute, the museum that houses a huge walk-in

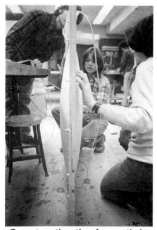

heart with amplified heart beats as well as a lot of Ben Franklin's musical instruments and acoustic experiments. A man at the institute took an interest in the project and offered to install it there as soon as we could get it working.

At the entrance to the Institute there is an enormous, dramatically lit statue of Franklin, sitting there looking half-scientific, half-inscrutable. My dream since then has been to install the lens

Constructing the Acoustic Lens with Bob Bielecki

there, just at the exact point where you establish eye contact with the statue. So you stand on that spot with no visible means of amplification and you hear these whispered slogans sotto voce: "He who hesitates. . . . is late..." and other re-written words to the wise.

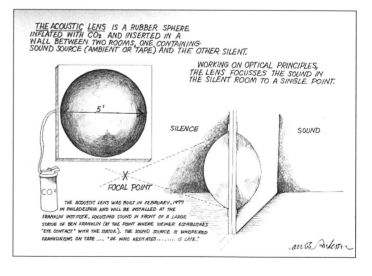

THE ACOUSTIC LENS IS A RUBBER SPHERE INFLATED WITH CO_2 AND INSERTED IN A WALL BETWEEN TWO ROOMS, ONE CONTAINING SOUND SOURCE (AMBIENT OR TAPE) AND THE OTHER SILENT.

WORKING ON OPTICAL PRINCIPLES, THE LENS FOCUSSES THE SOUND IN THE SILENT ROOM TO A SINGLE POINT.

5'

CO_2

SILENCE SOUND

X
FOCAL POINT

THE ACOUSTIC LENS WAS BUILT IN FEBRUARY, 1977 IN PHILADELPHIA AND WILL BE INSTALLED AT THE FRANKLIN INSTITUTE, FOCUSING SOUND IN FRONT OF A LARGE STATUE OF BEN FRANKLIN (AT THE POINT WHERE VIEWER ESTABLISHES "EYE CONTACT" WITH THE STATUE). THE SOUND SOURCE IS WHISPERED FRANKLINISMS ON TAPE ... "HE WHO HESITATES........ IS LATE."

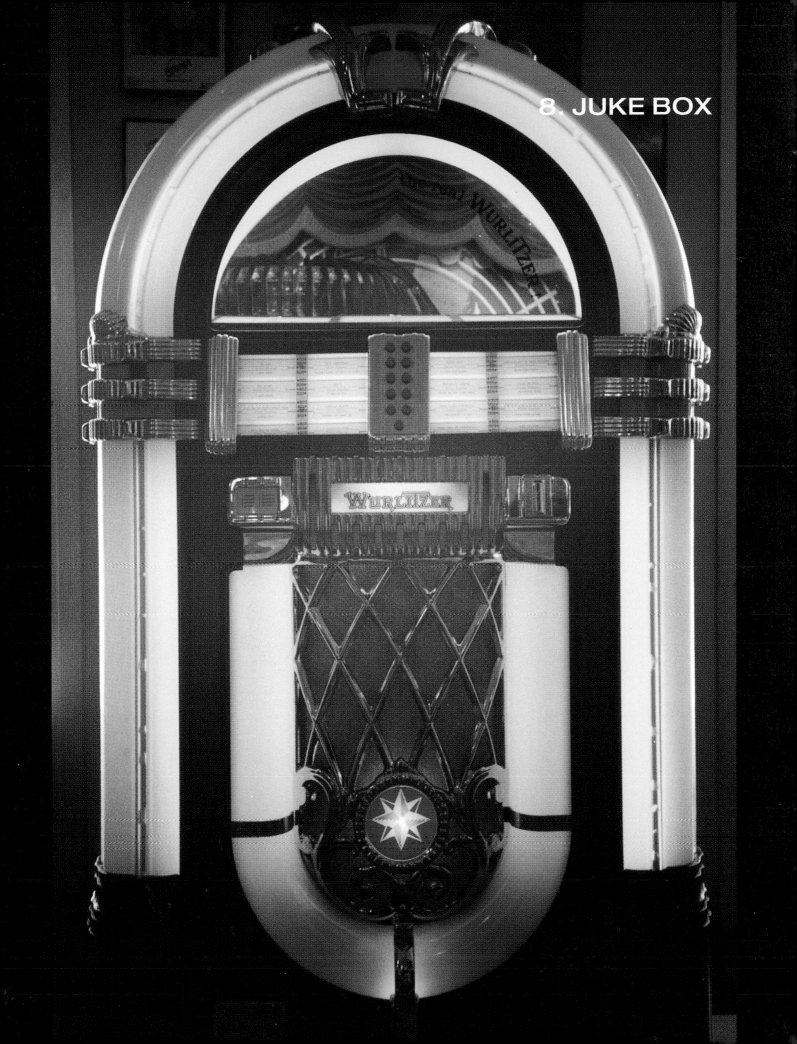

Juke Box

The Holly Solomon Gallery, New York City 1977

"Juke Box" was an exhibition of texts with photographs and 45 rpm records in a juke box. At first the gallery was charging 25 cents for each song but there were a lot of complaints at the opening so after that they were free.

Selection:

1. Speak Softly, But Carry a Big Stick
 (Turn the Other Cheek,
 But Carry a Big Stick) — 3:07
2. The Wind-oh! — 4:10
3. Talk to Me (Lucille) — 3:00
4. Like a CB — 3:01
5. Break It — 4:37
6. Stereo Song for Steven Weed — 1:55
7. Flies in the Eyes of a Baby — 4:03
8. Time to Go (for Diego) — 2:45
9. Man in the Empty Space — 4:40
10. New York Social Life — 3:20
11. Art and Illusion — 3:40
12. Is Anybody Home? — 4:25
13. If You Can't Talk About It, Point to It
 (For Screamin' Jay Hawkins and
 Ludwig Wittgenstein) — 1:30
14. Video Double Rock — 1:58
15. One Day in Dallas — 5:29
16. Quartet for Sol Lewitt — 3:23
17. On the BBC — 2:15
18. It's Not the Bullet That Kills You
 (It's the Hole) — 3:00
19. And Besides — 3:16
20. Photography and Other Good Designs — 5:47
21. Plants Are Sucked Back Underground — 3:22
22. Joshua — 5:40
23. Fast Food Blues — 3:34
24. Unlike Van Gogh — 2:50

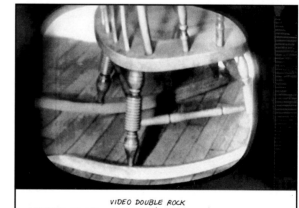

VIDEO DOUBLE ROCK

I USUALLY WATCH T.V. IN A ROCKING CHAIR, AND I'VE NOTICED THAT AS THE CHAIR MOVES BACK AND FORTH, THE IMAGE BENDS AT THE EDGES, DISAPPEARING AROUND THE CURVED TOP AND BOTTOM OF THE SCREEN. I FOUND THAT A GOOD SOLUTION IS TO PUT THE T.V. SET IN ANOTHER ROCKING CHAIR, AND IF YOU CAN GET THEM ROCKING IN SYNCH, THE IMAGE STABILIZES. VIDEO DOUBLE ROCK IS SCORED FOR TWO VIOLINS WHICH GO IN AND OUT OF PHASE. CURVES COMPENSATE FOR CURVES.

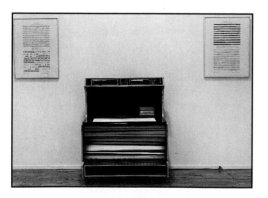

(excerpts from)
It's Not the Bullet that Kills You (It's the Hole)

I used to use myself as a target, I used myself as a goal.
I've been digging myself so much, digging me so much,
I dug myself right into a hole.
Now in a hole it's so dark, can't see a thing
It's easy to lose sight of your goal.
It's not the bullet, not the bullet that kills you. Oh no!
It's the hole, it's the hole, it's the hole!

Like a ventriloquist, I've been throwing my voice
Long distance is the story of my life.
And in the words of the artist Joseph Beuys
"If you get cut you better bandage the knife."
Cause in a hole it's so dark, can't see a thing
It's easy to lose sight of your goal.
It's not the bullet, not the bullet that kills you. Oh no!
It's the hole, it's the hole, it's the hole!

BLACK HOLES

I READ ALL ABOUT THOSE BLACK HOLES, HANGING OUT THERE IN SPACE
BUT THERE'S JUST ONE THING I WANT TO KNOW
AND THAT IS : HOW CAN A HOLE BE BLACK ?
HOW CAN NOTHING BE BLACK ?

I MET A BLIND MAN, HE WAS SELLING PENCILS
HE WAS YELLING OUT "BUY BUY THESE PENCILS!
WHAT YOU CAN'T USE YOU SHOULD ALWAYS SELL -
SO BUY THESE PENCILS - BUY BUY THEM " .
I BOUGHT A PENCIL AND HE YELLED AS I WENT BY
"BYE BYE NOW! AND DON'T FORGET TO WRITE!"
(IT'S SO BLACK AT NIGHT)

HOW COME YOU TELL ME YOUR DREAMS
LIKE YOU'D JUST BEEN TO THE MOVIES?
LIKE YOU HADN'T MADE IT UP ALL BY YOURSELF
(AND IN THE DARK TOO!)

January '77 Laurie Anderson

In 1976 and '77, I wrote a lot of songs for, and about, my friends. I wrote "It's Not the Bullet That Kills You" for Chris Burden after being on a panel with him. Chris had talked about many of his recent pieces, being nailed to the hood of a Volkswagen, getting locked in lockers, crawling over beds of glass.

But it was odd, he didn't want to talk about why pain interested him. He was entirely focused on technicalities: what caliber bullet he used, exactly how sharp the knife was and so on.

Although I was doing a lot of performances in the late 70's, I rarely documented them. I hated the art world's fetishistic attitude towards objects and documentation was just another way to frame, define, and then sell art. On the other hand, I loved the idea of making records because it was a way of saving things and also because it involved mass production. Unlike the art world's rules that revolved around quickly changing styles, parties, patrons, critics, and the byzantine twists of art politics, the rules of pop culture were clear: if people buy your records, you can make more records.

But records involve companies and my relationship with corporations has always been difficult. I remember walking into the Museum of Modern Art in 1976 where I was doing a sound check for a performance. I saw a big poster for the performance that said:

*"MOBIL OIL PRESENTS A PERFORMANCE
BY LAURIE ANDERSON."*

I was shocked. I had signed a contract with a museum, not an oil company. This was when I first realized that no matter how hard you tried to avoid it, if you were in the art world, the big money wouldn't be too far away.

Three Songs for Paper and Light

I spent a long time this summer waiting around for ideas to come to me. Writing them down on paper, crumpling them up, waiting some more.

It was very quiet and the softest sounds became almost unbearably loud. The most conspicuous noise was the sound of all that crumpled-up paper slowly, spasmotically unwrinkling.

I began to pick up the loudest pieces, flattening them out. This was a song on one of them:

Talking Papers

I met a painter and he said,

"If you wait, the canvas will call to you"

He said, "If you speak to it,

it will speak to you."

All good things are worth their weight

And he who hesitates . . . is late.

Time to Go (for Diego)

Diego used to be a guard at the Museum of Modern Art. He was on the night shift. And his job was to go around the museum and, as he put it, snap people out of their art trances.

People who'd been standing in front of one thing for hours, he would jump in front of them, and snap his fingers and say,

"Time to go. Time to go. Time to go."

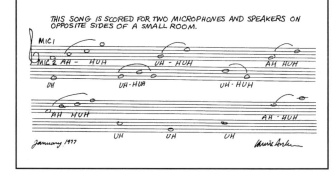

Performing "Steven Weed" live at the Franklin Furnace, New York City, 1977

Several of the songs in "Juke Box" were also performed live. In "The Electric Chair" an office chair was miked to produce the live percussion for "Steven Weed" and other songs about arguments between men and woman. A broken fluorescent tube was miked as the accompaniment for "Photography and Other Good Designs."

Various versions of this set were used in "On dit" (Paris Biennale), "That's Not the Way I Heard It" (Documenta, Kassel, Germany), and "Some Songs" (And/Or Gallery, Seattle, Washington) in 1977 and 1978.

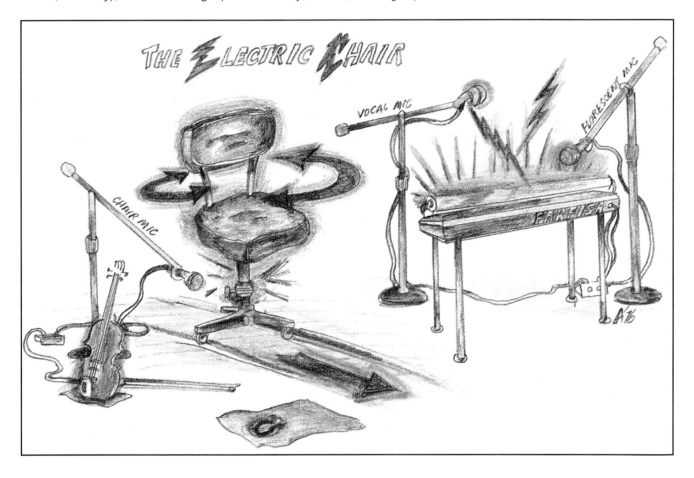

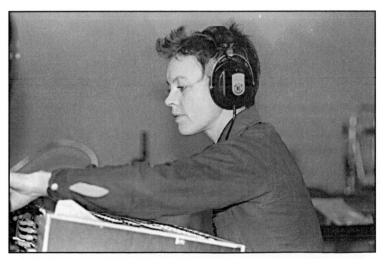

The songs for "Juke Box" were recorded at ZBS Media and also in my four-track home studio. This studio was in the hallway next to the elevator which is faintly audible in the background of almost every song produced there. I came to like this subtle industrial effect and sometimes featured it.

Fast Food Band

"Fast Food Blues" was an interminably long song/complaint about photo documentation. It included a recipe for disposing of your past.

Just wrap it all up
And blow it up to wall size.
Take it to a gallery
And give it to those guys.
You'll never see it again.
Good riddance!
Goodbye.

from "Fast Food Blues" 1976

With Jack Majewski (bass), Scott Johnson (guitar), Arthur Russell (drums), and Peter Gordon (sax)

The Blue Horn File

"The Blue Horn File" with David Van Tieghem and Peter Gordon

"The Blue Horn File" appeared at the Mudd Club. I played violin and sang, David played toys and percussion, and Peter played sax and keyboards. I usually lost my place in Peter's charts almost immediately but played along anyway, mostly random pizzicatto.

60

New Music New York

In the '70s, the Kitchen was the center of Soho, which was the center of the New York art world, which was, of course, the center of the world. "Experimental" work was what we were supposedly doing. I remember hating that term. Where were all the test tubes, and what were we trying to prove? Now much later I realize that most of my life has been an experiment, fortunately without any really conclusive results, and I'm not so snobbish about the term.

I especially remember New Music New York in 1979 which was mostly at the Kitchen. The night I played I remember that all the other performers were wearing all black and we all had our hair slicked back with the same kind of grease and I thought: "This is it! We're the New Music Mafia, and we're going to take over the world. Just as an experiment."

Later I was surprised to learn that this New Music America was noteworthy because of all the press it generated and because it revealed that there were suddenly lots of people who were Composer Performers, people who actually performed their own music. Since we were also our own engineers, copyists, managers, and booking agents, performing our own music didn't seem all that startling. Bob Ashley, Phil Glass, and Meredith Monk had been doing this for years. But now there were lots of us, and we had become a kind of movement.

But the most important thing about that New Music America was that we walked there. (This was when Soho was still an actual neighborhood.)

The Mudd Club show included various visuals. The projected drawing was from a series I was doing of missing things and people. Etan Patz was the first missing child to appear on a milk carton.

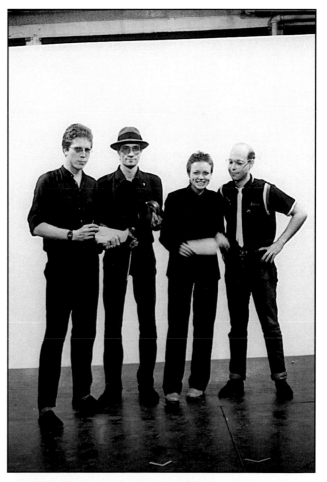

With Rhys Chatham, David Van Tieghem, and Peter Gordon at New Music New York, the first festival in a series that became New Music America

9. HOTLINE

Well you don't know me
but I know you.
And I've got a message to give to you.
Here come the planes.
And I said: OK! Who is this really?

from "O Superman" 1980

And I answered the phone and I heard a
voice and the voice said:
Please do not hang up.
We know who you are.
Please do not hang up.
We know what you have to say.
Please do not hang up.
We know what you want.
Please do not hang up.
We've got your number:
One. Two. Three. Four.
WE ARE TAPPING YOUR LINE

"We Are Tapping Your Line" from "United States 1" 1979

People blame technology for a lot of things. They say for example that technology makes it harder to communicate, harder to have a real conversation. But I think it was probably hard to have a real conversation 100 years ago, it was hard 500 years ago, 5,000 years ago. And by real conversation I mean improvising, really responding to what the other person just said, like jazz, not just repeating things that are already on your mind.

And anyway technology doesn't necessarily alienate people. Sometimes technology makes it possible to be intimate. For example, a lot of people have their first love affairs on the phone. You know, it's very sexy, you can whisper right into his ear and he doesn't have to see your face and if you say something stupid you can hang up right away.

You know that ad, that ad for the phone company, there's a mother and her little daughter and they're sitting around and the phone rings. The mother picks it up and talks for a minute. Then she holds the receiver out to the daughter and says, "Talk to grandma! Here's grandma!" And she's holding a piece of plastic. So, of course, the question is: Is the phone alive? What's alive and what doesn't have life?

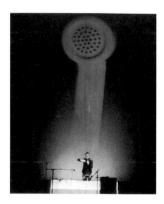

from "United States" 1979

And I said: Hello operator.
Get me Memphis, Tennessee.
And she said: I know who you're tryin' to call darlin'
And he's not home, he's been away.
But you can hear him on the airwaves
He's howlin' at the moon.
Yeah, this is your country station
And honey, this next one's for you.

from "Hiawatha" 1989

62

In "New York Social Life," the performer alternates between telephone and microphone to distinguish voices. This song was performed very rapidly as one long run-on sentence. The tamboura was plucked percussively to produce an extremely irritating nasal tone.

New York Social Life

For telephone, microphone, and tamboura, 1977

Well I was lying in bed
one morning, trying to think
of a good reason to get up,
and the phone rang and it
was Geri and she said:
Hey, hi! How are you?
What's going on?
How's your work?
Oh fine. You know, just
waking up but it's fine,
it's going OK, how's yours?
Oh a lot of work, you know,
I mean, I'm trying to make
some money too. Listen,
I gotta get back to it, I just thought
I'd call to see how you are...
And I said: Yeah, we should
really get together next week.
You know, have lunch,
and talk.
And she says: Yeah,
I'll be in touch. OK?
OK.
Uh, listen, take care. OK.
Take it easy.
Bye bye.
Bye now. And I get up,
and the phone rings and it's
a man from Cleveland and
he says:
Hey, hi! How are you?
Listen, I'm doing a performance
series and I'd like you to do
something in it. You know,
you could make a little money.
I mean, I don't know how I feel
about your work, you know,
it's not really my style,
it's kind of trite
but listen, it's just my opinion,
don't take it personally.
So listen,
I'll be in town next week.
I gotta go now, but I'll give you a call,
and we'll have lunch, and we can
discuss a few things.
And I hang up and it rings
again and I don't answer it
and I go out for a walk and I
drop in at the gallery and they say:
Hey, Hi. How are you?
Oh fine. You know.
How's your work going?
OK. I mean...

You know, it's not like it was
in the sixties. I mean,
those were the days
there's just no money
around now, you know,
Survive! Produce! Stick it out!
It's a jungle out there!
Just gotta keep working.
And the phone rings and she says:
Oh excuse me, will you?
Hey hi! How are you? Uh huh.
How's your work? Good.
Well, listen, stick it out,
I mean, it's not the sixties,
you know, listen, I gotta go now, but, uh,
lunch would be great.
Fine, next week?
Yeah. Very busy now,
but next week would be fine,
OK? Bye bye.
Bye now.

And I go over to Magoo's,
for a bite, and I see Frank
and I go over to his table
and I say: Hey Frank.
Hi, How are you?
How's your work?
Yeah, mine's OK too.
Listen, I'm broke you know,
but, uh, working....
Listen, I gotta go now but
we should really get together,
you know.
Why don't you drop by sometime?
Yeah, that would be great.
OK.
Take care.
Take it easy.
I'll see you.
I'll call you.
Bye now.
Bye bye.
And I go to a party and
everyone's sitting around
wearing these party hats
and it's really awkward
and no one can think of

anything to say.
So we all move around—fast—
and it's:
Hi! How are you?
Where've you been?
Nice to see you.
Listen, I'm sorry
I missed your thing
last week, but we should really
get together, you know,
maybe next week.
I'll call you.
I'll see you.
Bye bye.
And I go home and the
phone rings and it's
Alan and he says:
You know, I'm gonna have a show
on cable TV and it's gonna

be about loneliness, you know,
people in the city who for whatever
sociological, psychological,
philosophical reasons
just can't seem to communicate,
you know,
The Gap! The Gap!
It'll be a talk show
and people'll phone in
but we will say at the beginning
of each program: Listen,
don't call in with your
personal problems
because we don't want to hear them.
And I'm going to sleep
and it rings again and
it's Mary and she says:
Hey, Laurie, how are you?
Listen, I just called to say hi
Yeah, well don't worry.
Listen, just keep working.
I gotta go now. I know it's late
but we should really get together
next week maybe and have lunch
and talk and...listen, Laurie,
if you want to talk before then,
I'll leave my answering machine on
and just give me a ring
anytime.

WHILE YOU WERE OUT		
M_____		
of_____		
Phone_____		
Area Code	Number	Extension
TELEPHONED	PLEASE CALL	
CALLED TO SEE YOU	WILL CALL AGAIN	
WANTS TO SEE YOU	URGENT	
RETURNED YOUR CALL		
Message_____		

10. ON THE ROAD

In the early '70s I went on lots of trips, field trips sort of, just to poke around, to see what was happening outside New York, back out there in America.

I had no money. No tent. No definite plans. Just a sleeping bag, a lighter, some Burroughs books, a few packs of Camels. Out on the highway, it's warm for September and bright. A semi loaded with limestone rolls up and I climb in.

"Sexy Baby-Maker's the handle," says the scrawny slit-eyed driver introducing himself. "Murried, rr'juh?"

"Uh, yeah. Sure, I'm married. My, uh, my husband's waiting in the next town." I'm improvising.

"Well 'juh know nine outta' tin murried wimmen go out? 'Juh know that?"

"Oh. No, gee. In...ter...Interesting." The potholes are hyphenating my words.

"Yup. 'Juh one?" His hand is on my knee now. I try to aim a cigarette into my mouth. We hit another pothole and I miss. The cigarette sticks to my lower lip, bobbing up and down preposterously while I talk. "Hey, gee! I just re...re...remembered that I left a...a....a book...a book back there." I jump out at the next corner, a flying leap.

"No point in hanging around here," I hear myself say. I have begun to talk to myself out loud.

It seems like the middle of the night. I wake up suddenly and peer out from under my rock ledge. The fire has burned down to coals and it's dark in the woods. I hear a rustle and wait for my eyes to adjust to the blackness. From my low vantage point, I can just make out the butt of a musket and a pair of cracked, spatula-shaped shoes. I crawl out of my sleeping bag and the rest of the figure looms into view: male; approximately sixty years old, 140 lbs, black hair, tight sweatshirt. Armed with what appears to be a musket. A minute or so passes. Finally, I hear a voice. "We eat critters."

As a migrant worker in Kentucky, 1977

I don't know what to say, so more time passes.

"We eat critters," he repeats, "Possum. Squirrel. Rabbits. That's what."

Suddenly I understand. He's out hunting: night food.

The man's name is Mr. Taylor and he is twenty-two years old. He invites me back to the house ("next holler") where he lives with Mrs. Taylor, also twenty-two, and their four children: Rhonda, Jim, Jack, and (oddly enough) Jim. There used to be two more Taylors but last summer they fell down one of the holes left by Exxon's systematic strip mining. Now that certain kinds of low grade coal can be converted into oil, companies are re-opening mines that were sealed "forever" seventy-five years ago. Holes were drilled and then left uncovered. Dense brush quickly camouflaged the holes. The holes were deep, vertical, straight down, their sides as slippery as intestines. "I could see the little 'uns out in the field and then I couldn't see them no more," explained Mrs. Taylor, recalling the incident.

Mostly we sit on the porch, Mr. Taylor, Mrs. Taylor, and me, watching it rain and making small talk. Every time the rain stops for a minute, Mr. Taylor jumps up and trots around to the back of the house. We can hear intermittent hacking sounds from the tobacco patch. Then he reappears, his work done for the moment. We talk slowly. Every sentence seems to end the same way, on a kind of upswing.

"Rain's letting up. Don't you think, Rhonda?"

Twenty or thirty seconds go by.

"Yup."

"Think it's time to check the pot. Don't you think, Momma?"

"Yup."

I follow Rhonda into the cabin. Every few seconds she opens a large pot. Steam billows out. Inside there is a large piece of grayish meat, swollen and prickly, bobbing up and down in the water. "Possum," says Rhonda, stirring it. "Looks done." It is the consistency of waterlogged shredded wood. We fish it out, then start to make the biscuits and gravy. "Red eye gravy. Yup. That's the secret," says Rhonda. She adds a pot of yesterday's coffee, stirs in some corn meal. We pour this over the possum and then ("because it's Sunday"), we get out a rusty can of maple syrup and drizzle it over the whole thing.

"That's the secret. Maple syrup. That's the secret ingredient," Rhonda whispers. "Don't tell anyone."

from "After Science, Dinner" 1979

Hotel Hot Dogs à la Laurie Anderson

This recipe is highly recommended if you're dining alone in a hotel room in Germany. It is fast, easy, and the perfect end to a day of back-to-back press interviews.

UTENSILS:
1 lamp
pocket knife
wire strippers

INGREDIENTS:
2 bratwurst (Oscar Meyers will also do)

Unwrap the bratwurst and place on bedside table. Unplug the floor lamp. Using the pocket knife, cut the lamp cord approximately 3 feet from the plug. With wire strippers, peel the insulation from the cord, leaving about 10 inches of exposed wire. Thread the wire through the bratwurst and tie off the wire at the end. Then, just plug it in!

Cook until the bratwurst is crispy on the outside (approximately 2 seconds).*

Make sure the cooking time doesn't exceed 3 seconds since the meat will explode at very high temperatures. Then just relax and enjoy! This dish is excellent accompanied by a glass of cool tap water.

* In the U.S. or other territories where 110 is used, add 2 additional seconds to cooking time.

11. ASK ABOUT ANIMALS

Being made up for "The Human Face," a BBC Documentary, 1991

Facing page: "Born Never Asked"
"United States Part 2," 1980

So I was on this TV show, the David Letterman show. And I sang my song "Walk the Dog" and went over to sit down with "Dave." So he asks, and he's blinking a lot while he's talking, he says, "What was that? What do you call that?," and I said something like, "Country & Western, I guess." All he said was "Oh." And he started to blink some more.

The conversation sort of stalled at that point, so I was sort of just looking around and I saw some notes on his desk. The cue card on top said, "Ask about Animals." "Uh. So. Do you have a dog? Do you like birds?" said Dave, and since I can't remember what we talked about after that I guess it stayed at about this level because they cut to a commercial and never asked me back.

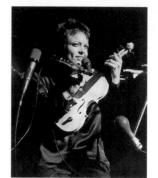

"Walk the Dog" for violin, voice, and electronics, 1979

The David Letterman show, 1984

Walk the Dog

I saw a lot of trees today, and they were all made of wood.
 They were wooden trees, and they were made
 entirely of wood.

I came home today and you were all on fire.
 Your shirt was on fire.
 And your hair was on fire and flames
 were licking all around your feet!!
 And I did not know what to do.

And then, a thousand violins began to play,
 And I *really* did not know what to do then.
 So I just decided to go out, and walk the dog.

I went to the movies and I saw a dog thirty feet high.
 And this dog was made entirely of light.
 And he filled up the whole screen.
 And his eyes were long hallways.
 He had those long, echoing hallway eyes.

I turned on the radio and I heard a song by Dolly Parton.
 And she was singing,
 "Oh! I feel so sad! I feel so bad! I left my mom,

and I left my dad.
 And I just want to go home now.
 I just want to go back to my Tennessee
 mountain home now!"

Well, *you* know she's not gonna go back home.
 And *I* know she's not gonna go back home.
 And *she* knows she's never gonna go back *there*.
 And I just want to know who's gonna go and walk *her* dog.
 Well, I feel so sad. I feel so bad.
 But not as bad as the night I wrote this song.

Close your eyes. (OK)
 Now imagine you're at the most wonderful party. (OK)
 Delicious food (Uh-huh)
 Interesting people (Mm-mh)
 Terrific music (Uh-huh)
 NOW OPEN THEM!!

Oh no. Well, I just want to go home now,
And walk the dog.

You know basically my job is to be a spy. So last year I got a motorcycle, not for the speed, but for the helmet. You put the helmet on and you're immediately anonymous; you can cruise around town in low gear and stare at people all you want. The only problem with wearing a helmet is that it's like wearing a goldfish bowl on your head, acoustically. It's very claustrophobic and you can't hear very well, it's like being under water.

I had a goldfish once and it lived in this glass bowl with a plaster Magic Castle at the bottom, and a plant. All the fish ever did was sort of stare out and occasionally swim into the Magic Castle to see if anything was going on. Nothing ever was. And eventually the fish died from, I think, boredom. Or maybe it just went crazy from the silence.

A few weeks after I got the motorcycle I was stuck in traffic. It took a while for me to realize that a lot of cars were honking at me because I was blocking a lane. "Are you deaf?"

When I got home that day, I took off the helmet and a big piece of foam sprung out. I'd been wearing it with all the packing material still inside.

"Natural History" 1986

And Sharkey says:
All of nature talks to me.
If I could just figure out
what it was trying to tell me.
Listen!
Trees are swinging in the breeze.
They're talking to me.
Insects are rubbing their legs together.
They're all talking.
They're talking to me.
And short animals,
They're bucking up on their hind legs.
Talking! Talking to me!!
HEY! LOOK OUT!
BUGS ARE CRAWLING UP MY LEGS!
You know?
I'd rather see this on TV.
Tones it down.

from "Sharkey's Day" 1983

Both film and computer animation are extremely time-consuming. But when I do these drawings I lose all sense of time. I always find it amazing that fifty hours worth of drawing can whiz by in three seconds.

Film animation from "Like A Stream," 1978

Computer animation from "Empty Places," 1989

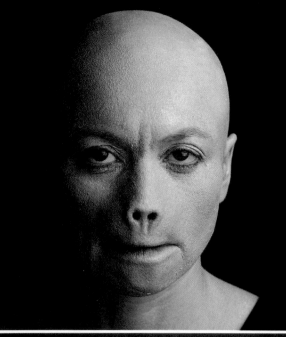

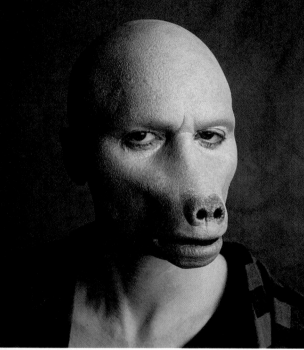

Touring with Animals

You know, there are always lots of animals on my records: birds, wolves, dogs, crickets, mosquitoes; and these songs are really hard to do on tour, all those cages, all that pet food. So I tour with digital animals, sampled barks and howls, which I play on the computer violin and then the only sound I have to worry about is the sound of the computer crashing. Fortunately, that's a pretty interesting sound too.

The only time I really tried to act like an animal was once when Bob Wilson came over and we were going to try to write a play about elephants. Heiner Müller was going to be involved somehow as well. Bob and I got out a photography book about elephants by Peter Beard and we spent the whole night walking and crawling around my loft imitating elephants. The next morning I woke up curled in a ball under the console in my studio. Bob was gone. The front door was wide open. (This piece was never produced.)

Another time I was working with Captain Beefheart (Don Van Vliet) in my studio. This was also a collaboration that never quite worked out. We would work for a while and then take a long walks around the neighborhood. Don was acting kind of jumpy. As we walked along the crumbling sidewalks, we noticed that huge tufts of grass were growing up between the cracks. Every once in a while, Don would jump back with a haunted look on his face and say things like, "WHOA!!! I think I saw Brer Rabbit back there!" From that day on, every time we were in the studio, I kept expecting him to see Brer Rabbit popping up from behind the console and I started to get sort of paranoid myself.

Yes, that's the way it is:
machines are the fall guys. Ani-
mals are the straight men.
(The people are everyone else.)

We are the animals
with the original tanks
We are the vaults.
We are the banks
Oil to oil. Dust to dust.
Got no gold teeth
In God we trust.

from "Songs of the Whales" 1974

It was up in the mountains. We had this ceremony every year. We had it and everyone from miles around came in for it. Cousins, aunts, uncles, and the kids. Grandmothers, grandfathers, everyone. And we set it up around this big natural pool. With pine trees and palm trees. All the trees were there. And we had thousands of those big urns, you know the kind. And everyone would dance and sing, and it lasted for three days. Everyone cooked and looked forward to it all year.

Well one year, we were in the middle of it, and I was just a boy at the time. Anyway, it was evening, and suddenly a whole lot of tigers came in. I don't know where they came from. They rushed in, snarling, and knocked over all the urns, and it was really a mess.

We spent the whole next year rebuilding everything. But in the middle of the ceremony the next time the same thing happened. These tigers rushed in again and broke everything and then went back into the mountains. This must have gone on four or five years, rebuilding and then the tigers would come and break everything. We were getting used to it.

Finally we had a meeting and decided to make these tigers part of the ceremony, you know, to expect them. We began to put food in the urns, so the tigers would have something to eat. Not much at first. Crackers, things like that. Then later we put more food until finally we were saving our food all year for the tigers.

Then one year, the tigers didn't come.

They never came back.

"It Was Up in the Mountains" "United States 3" 1983

I dreamed I was a dog in a dog show.
And my father came to the dog show.
And he said:
That's a really good dog.

I like that dog.
And then all my friends came
and I was thinking:
No one had ever looked at me
like this for so long.

No one had ever stared at me like this
for so long
for such a long time
for so long.

"Dog Show" "United States 4" 1983

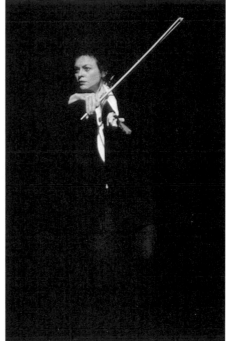

From "Duet with Dogs" "Empty Places," 1989

We built a big platform in my loft to do the "angry dogs" film I needed for a song I was writing. (Usually I like to make short films and watch them over and over while I write music.) Captain Hagerty, their trainer, promised, "They're vicious! Really vicious!" But he could only get them into attack mode for a few seconds at a time before they began to smile those happy dog smiles they've all got. That's what I love about dogs: they're such lousy actors.

Captain Hagerty with his vicious dogs

Some Songs for Snakes

Well I know who you are, baby.
I've seen you go
into that meditative state.
You're the snake charmer, baby.
And you're also the snake.
You're a closed circuit, baby.
You've got the answers
in the palms of your hands.
Who? Do. Who? Do.
Who do you love?

Well I know who you are, baby.
I've watched you
count yourself to sleep.
You're the shepherd, baby.

And you're also one,
two, three hundred sheep.
I've watched you fall asleep.

Well I was up real late last night.
Must have just dropped off to sleep.
'Cause I saw you were crying, baby.
You were crying in your sleep.

You're the snake charmer, baby.
And you're also a very long snake.
You're a closed circuit, baby.
You've got the answers
in the palms of your hands.

from "Closed Circuits" "United States 1" 1979

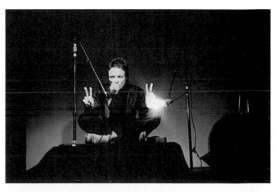

In "Closed Circuits" I used digital processing that produced very sibilant S's and turned the long boom on the microphone stand into a tubular drum which changed in pitch depending on where I hit it.

73

There were two performance versions of "Langue d'amour," one in "United States 4" (1983), which featured a male islander as the narrator, and the other in "Home of the Brave" (1986), in which I impersonate the role of female "anthropologist" narrator. (The role of the snake is played by my gloves.) And why, you might ask, are we all speaking French? Because, mon cher, hermeneutically speaking, "langue" denotes "tongue," not "language" (as in "sa langue longue lui léchait légèrement les lèvres"). We do not say "His long language was lightly licking his lips," unless, of course, this was poetry and not history.

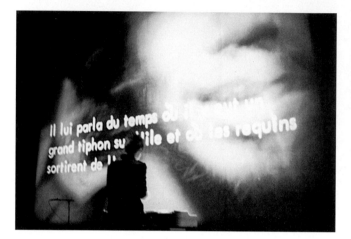

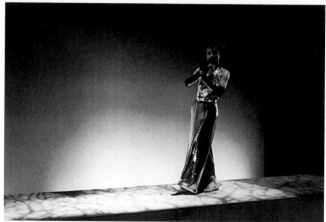

Langue d'Amour

Voyons. Euh. C'était sur une île. Il y avait un serpent et ce serpent avait des jambes. Et il pouvait marcher tout autour de l'île.

Let's see. Uh. It was on an island. There was a snake and this snake had legs. And he could walk all around the island.

Oui, c'est vrai. Un serpent avec des jambes.

Yes, that's true. A snake with legs.

Et l'homme et la femme étaient aussi sur l'île. Et ils n'étaient pas très malins, mais ils étaient heureux comme des poissons dans l'eau. Oui.

And the man and the woman were on the island, too. And they were not very smart, but they were happy as clams. Yes.

Voyons. Euh. Alors un soir le serpent faisait un tour dans le jardin en parlant tout seul et il vit la femme et ils se mirent à parler. Et ils devinrent amis. De très bons amis.

Let's see. Uh. Then one evening the snake was walking about in the garden and he was talking to himself and he saw the woman and they began to talk. And they became friends. Very good friends.

Et la femme aimait beaucoup le serpent parce que quand il parlait il émettait de petits bruits avec sa langue et sa langue longue lui léchait légèrement les lèvres.

And the woman liked the snake very much because when he talked he made little noises with his tongue and his long tongue was lightly licking about his lips.

Comme s'il y avait un petit feu à l'interieur de sa bouche et la flamme sortit en dansant de sa bouche. Et la femme aimait beaucoup cela.

Like there was a little fire inside his mouth and the flame would come dancing out of his mouth. And the woman liked this very much.

Et apres cela elle se mit à trouver l'homme ennuyeux parce que quoiqu'il advint, il était toujours aussi heureux qu'un poisson dans l'eau.

And after that she was bored with the man because no matter what happened, he was always as happy as a clam.

Que dit le serpent? Oui, que disait le serpent?

What did the snake say? Yes, what was he saying?

D'accord. Je vais vous le dire.

OK. I will tell you.

Le serpent lui raconta des choses sur le monde.

The snake told her things about the world.

Il lui parla du temps quand il y eut un grand tiphon sur l'île et tous les requins sortirent de l'eau.

He told her about the time when there was a big typhoon on the island and all the sharks came out of the water.

Oui, ils sortirent de l'eau et ils vinrent droit dans votre maison avec leurs grandes dents blanches. Et la femme entendit ces choses et elle tomba amoureuse.

Yes, they came out of the water and they walked right into your house with their big white teeth. And the woman heard these things and she was in love.

Et l'homme vint et lui dit: "Il faut qu'on s'en aille maintenant," et la femme ne voulait pas s'en aller parce qu'elle était une brulée. Parce qu'elle était une femme amoureuse.

And the man came out and said: "We have to go now," and the woman did not want to go because she was a hothead. Because she was a woman in love.

Toujours est-il qu'ils monterent dans leur bâteau et quitterent l'île.

Anyway, they got into their boat and left the island.

Mais ils ne restaient jamais très longtemps nulle part. Parce que la femme ne pouvait trouver le repos.

But they never stayed anywhere very long. Because the woman was restless.

C'était une tête brulée. C'était une femme amoureuse.

She was a hothead. She was a woman in love.

Ce n'est pas une histoire que raconte mon peuple. C'est quelque chose que je sais par moi-méme.

This is not a story my people tell. It's something I know myself.

Et quand je fais mon travail je pense à tout cela.

And when I do my job I am thinking about these things.

Parce que quand je fais mon travail, c'est ce à quoi je pense.

Because when I do my job, that's what I think about.

The man who read "Langue d'amour" was a Ponapean.

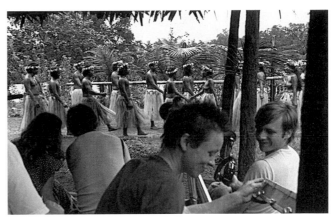

Filming Ponapean dancers

In 1980 as part of a project called "Word of Mouth," I was invited, along with eleven other artists, to go to Ponape, a tiny island in the middle of the Pacific. The idea was that we'd sit around talking for a few days and then the conversations would be made into a talking record. The first night we were all hellishly jetlagged but as soon as we sat down, the organizers set up all the microphones and switched on the 1000 watt lights and we tried our best to be as intelligent as possible.

Television had just come to Ponape a week before we arrived, and there was a strange excitement around the island as people crowded around the few sets. And then the day after we arrived, in a bizarre replay of the plot of the first TV show broadcast to Ponape, prisoners escaped from a jail, broke into the radio station, and murdered the DJ. Then they went off on a rampage through the jungle armed with lawn mower blades. In all, four people were murdered in cold blood. Detectives, flown in from Guam to investigate, swarmed everywhere. At night we stayed around our cottages listening out into the jungle. Finally the chief of the biggest tribe on the island decided to hold a ceremony for the murder victims. The artist Marina Abramovic and I went, as representatives of our group, to film it. The ceremony was held in a large thatched lean-to. Most of the ceremony involved cooking beans in pits and brewing a dark drink from roots. The smell was overwhelming. Dogs careened around barking and everybody seemed to be having a fairly good time, as funerals go.

After a few hours, Marina and I were presented to the chief who was sitting on a raised platform above the pits. We had been told we couldn't turn our backs to the chief or, at any time, be higher than he was. So we scrambled up onto the platform with our film equipment and sort of duck-waddled up to the chief. As a present I'd brought one of those little "Fred Flintstone" cameras, the kind where the film cannister is also the body of the camera, and I presented it to the chief. He seemed delighted and began to click off pictures. He wasn't advancing the film between shots but since we were told we shouldn't speak unless spoken to, I wasn't able to inform him that he wasn't going to get twelve pictures, but only one very, very complicated one.

After a couple more hours, the chief lifted his hand and there was absolute silence. All the dogs had suddenly stopped barking. We looked around and saw the dogs. All their throats had been simultaneously cut and their bodies, still breathing, pierced with rods, were turning on the spits.

The chief insisted we join in the meal but Marina had turned green and I asked if we could just have ours to go. They carefully wrapped the dogs in leaves and we carried their bodies away.

With the Prince of Ubud

In 1984, as part of the press for the tour I was doing in Japan, I was asked to go to Bali and speak about the future with the Prince of Ubud. The idea was that I would represent the western world, the prince the southern world, and the Japanese press representative would represent whatever was left. The conversations would be published in a large book (scheduled for release one year after the concert tour). As press, this didn't seem like a great way to advertise the concerts, but it sounded like fun anyway.

I stayed at the palace in one of the former king's harem houses. Each of the king's wives had had her own house guarded by a pair of live animals, a bear and a fox, for example. By the time I got there years later, the menagerie had dwindled a bit. My house was "guarded" by two fish.

Bali was extremely hot in the afternoons and the conversations with the prince drifted along randomly from topic to topic. The prince was a bon vivant, trained in Paris. He spoke excellent English and when he wasn't in the palace he was out on the bumpy back roads racing cars. So we talked about cars, a subject I know absolutely nothing about, and I felt that, as far as representing the western world went, I was failing dismally.

On the second night, the prince served an elaborate feast of Balinese dishes. At the end of the meal, the conversation slowed to a halt and after a few minutes of silence he asked, "Would you like to see the cremation tapes of my father?"

The tapes were several hours long and were a record of the elaborate three month ceremony shot by the BBC. When the king died the whole country went to work building an enormous funeral pyre for him. Practically everyone in Bali contributed something, a woven mat or intricate chains of braided straw, bits of pottery and cloth. After months of preparation (during which the king's body is stored in the living room), they hoisted him to the top of this rickety, extremely flammable pyre and lit a match. The delicate tower crumpled almost immediately and the king's body fell to the ground with a sickening thud. This didn't seem to disturb anyone but me. The prince considered the ceremony a triumph. His father had been touched by fire and hadn't flown away.

He explained that when a Balinese dies, the soul turns into a bird and sits by the house for a while. The big danger is that it will escape and fly out over the ocean. The Balinese hate water, don't swim, don't trust it. So the idea is to keep the bird within earshot until the body can be burned and the soul can safely ascend, finally, to heaven.

My studio in Los Angeles with palm trees, 1978

In 1978, I spent time in California in the fall looking for a quiet place to live. I finally found what seemed to be the perfect apartment but the night after I moved in I heard a tremendous pounding sound. As it turned out, I had moved in right above a Hawaiian hollow log drum school. Every other night, it was converted into a hula school with a live band of six Hawaiian guitars. I decided to soundproof my place but I didn't hang the door very well and all the sounds kept drifting in.

About this time, like a lot of New Yorkers who find themselves on the West Coast, I got interested in various aspects of California's version of the occult. We would sit around at night while the dust storms howled outside, and ask questions to the ouija board. I found out a lot of information on my past 9,361 human lives on this planet. My first life was as a raccoon.

**AND THEN YOU WERE A COW.
AND THEN YOU WERE A BIRD.
AND THEN YOU WERE A HAT.**
spelled the ouija.

A hat flies in from above "Natural History," 1986

We said: A hat? We couldn't figure it out.

Finally we guessed that the feathers from the bird were made into a hat. Is this true? **YES**. spelled the ouija

HAT COUNTS AS HALF-LIFE.

And then?

HUNDREDS AND HUNDREDS OF RABBIS.

This is apparently my first life as a woman, which should explain quite a few things. Eventually, the ouija's written words seemed to take on a personality, a kind of voice. Finally, we began to ask the board if the ouija would be willing to appear to us in some other form.

F-O-R-G-E-T I-T F-O-R-G-E-T I-T F-O-R-G-E-T I-T F-O-R-G-E-T I-T F-O-R-G-E-T I-T F-O-R-G-E-T I-T

The ouija seemed like it was about to crash. "Please, please what can we do," we nagged, "so you will show yourself to us in some other manifestation?"

**YOU SHOULD LURK.
YOU SHOULD L-U-R-K LURK.**

I never really figured out how to lurk in my own place, even though it was only a rented place. But I did find myself looking over my shoulder a lot. Every sound that drifted in seemed to be a version of this phantom voice whispering in a code I could never crack.

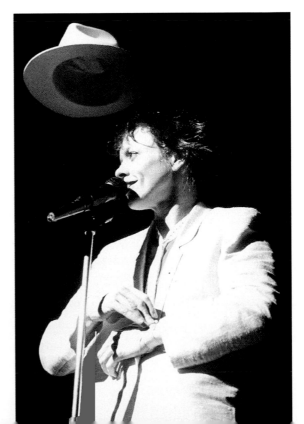

12. MAPS AND PLACES

I was asleep by the road about 100 miles out of Chibougamau. Poplars were rustling. I was dreaming of the Alps.

Suddenly I woke up. My mouth was open. I had the feeling that I had just yelled "MACHINE GUNS!" at the top of my lungs.

from "The Rose and the Stone" 1974

ugly-one-with-the-jewels." Now, ugly, OK. I was awfully tall by the local standards. But what did they mean by the jewels? I didn't find out what this meant until one night when I was taking my contact lenses out and, since I'd lost the case, carefully placing them on the sleeping shelf. Suddenly I noticed that everyone was staring at me. I realized that none of the Tzeltal had ever seen glasses, much less contacts, and that these were the jewels, the transparent, perfectly round jewels that I carefully hid on the shelf at night and then put, for safe-keeping, into my eyes every morning. So I may have been ugly but so what? I had the jewels.

The-Ugly-One-with-the-Jewels

In 1974 I went to Mexico to visit my brother who was working as an anthropologist with the Tzeltal Indians, the last surviving Mayan tribe. The Tzeltal speak a lovely bird-like language and are quite tiny physically. I towered over them.

Mostly I spent my days following the women around since my brother wasn't really allowed to do this. We got up at three a.m. and began to separate the corn into three colors. Then we boiled it, ran to the mill and back and finally started to make the tortillas. All the other womens' tortillas were 360 degrees, perfectly toasted, perfectly round. Even after a lot of practice, mine were still lopsided and charred. When they thought I wasn't looking, they threw them to the dogs.

After breakfast we spent the rest of the day down at the river watching the goats and braiding and unbraiding each others' hair. So usually there wasn't that much to report. One day the women decided to braid my hair Tzeltal style. After they did this, I saw my reflection in a puddle. I looked ridiculous but they said, "Before we did this, you were ugly. But now maybe you will find a husband."

I lived with them in a yurt, a thatched structure shaped like a cupcake. There is a central fireplace ringed by sleeping shelves, sort of like a dry beaver dam. My Tzeltal name was "Loscha" which, loosely translated, means "the-

From "O-Range" a mixed media exhibition at Artists Space, New York City 1973. For the duration of the exhibition, I left my contact lenses on the window sill of the gallery and spent three weeks with 20/800 vision.

Hatchet Head

The summer of 1974 was brutally hot in New York and I kept thinking about how nice and icy it must be at the North Pole and then I thought: wait a second, why not go? You know, like in cartoons where they just hang "Gone to the North Pole" on their doorknobs and just take off.

I spent a couple of weeks preparing for the trip, getting a hatchet, a huge backpack, maps, knives, sleeping bag, lures, and a three month supply of bannock, a versatile high protein paste that can be made into flatbread, biscuits, or cereal. I had decided to hitchhike and one day I just walked out to Houston Street, weighted down with seventy pounds of gear, and stuck out my thumb.

"Going north?" I asked the driver, as I struggled into his station wagon. After I got out of New York, most of the rides were trucks until I reached the Hudson Bay and began to hitch in small mail planes. The pilots were usually guys who had gone to Canada to avoid the draft or else embittered Vietnam vets who never wanted to go home again. Either way, they always wanted to show off a few of their stunts. We'd go swooping low along the rivers, doing loop de loops and "Baby Hughies." They'd drop me off at an air strip, "There'll be another plane by here coupla' weeks. See ya! Good luck!"

I never did make it all the way to the geographic pole. It turned out to be a restricted area and no one was allowed to fly in, or even over, it. I did get close to the magnetic pole though, so it wasn't really disappointing. I entertained myself in the evenings cooking, smoking, or watching the blazing light of the huge Canadian sunsets as they turned the lake into fire. Later I lay on my back looking up at the northern lights and imagining there had been a nuclear holocaust and that I was the only human being left in all of North America and what would I do then? And then when these lights went out, I stretched out on the ground, watching the stars as they turned around on their enormous silent wheels.

I finally decided to turn back because of my hatchet. I had been chopping some wood and the hatchet flew out of my hand on the upswing. I did what you should never do when this happens: I looked up to see where it had gone. It came down WWWWFFFFF!! just missing my head and I thought: My God! I could be walking around here with a hatchet embedded in my skull and I'm ten miles from the airstrip and nobody in the world knows I'm here.

Blood in My Eyelids

It is growing dark now. The fire is going out. The red light of the setting sun sweeps quickly across the lake, lighting up the crests of waves. From across the lake, I hear a motor. The snarling sound grows louder, filling the thin air. It is near the island now. Suddenly, the motor is cut. I hear oars slapping the water, then a crunching through the underbrush. Is it another Cree wandering over from the reservation to investigate the smoke? I run behind a tree. "Laurie? Laurie?" "Pierre!" We stoke up the fire. Pierre plays the guitar, the same almost tuneless songs the Indians play over at the reservation as they eat the potato chips and Fritos they buy with their welfare checks. The stars come out. We talk quietly about the house he will build with a dome for his telescope, about the bison he will keep on his land. "Let's go to my cabin," he says, touching my hair. We motor across the lake. The northern lights are pulsating. Thin veils of green and orange light sweep across the sky. Needle-sharp spindles shoot up and disintegrate in bright yellow clouds. In the cabin, Pierre and I look through the stereoscopic microscope at the nugget crushed 1,700,700 years ago. We build a fire in the old Atlas stove, hold each other close. "You really shouldn't live out in the woods like that," says Pierre. "It's so much more productive to have a little cabin." He is lying on top of me now, our naked bodies pressing. The light from the fire makes his shoulders glow, it touches his hair and turns it red. His lithe body moves over me, inside me. Bright red light shoots in front of my eyes. I open them. It is dark. "I CAN'T SEE!" I call. He places his cool hand on my eyes. I see the blood racing through my eyelids, streaming and pulsating. "You are everything to me," whispers Pierre. His hand grows hot and somehow, sharp. We are rocking, rocking.

from "Individuals" 1979

Remember me is all I ask

and if remembered be a task

Forget me.

valentine, Minerva Miller, ca. 1850

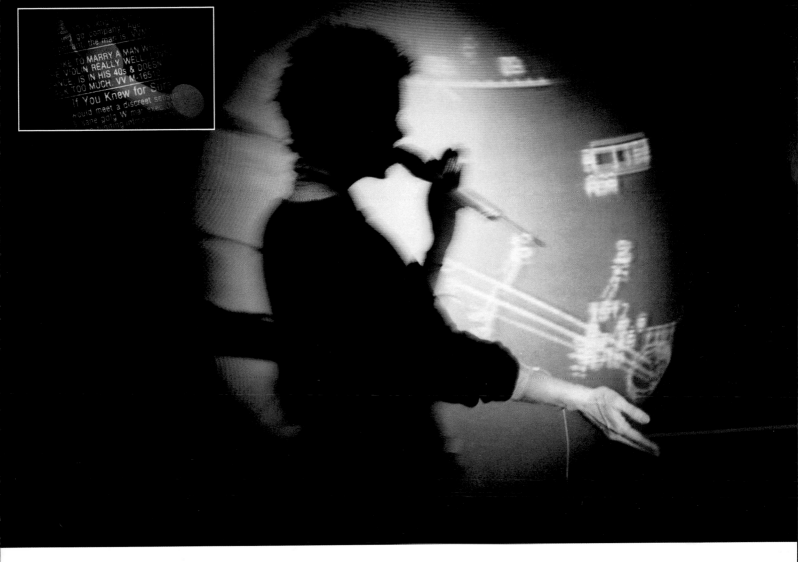

In this dream I'm on a tight rope
and I'm tipping back and forth
trying to keep my balance.
And below me are all my relatives,
and if I fall I'll crush them.

This line, this bloodline,
the only thing that binds me
to the turning world below and
all the people and noise and songs and shouts.

This long thin line, this song line, this shout.
This thin tightrope, this tightrope made of sound.
This tightrope, so thin,
made of my own blood.

"Tightrope" "Stories from the Nerve Bible" 1992

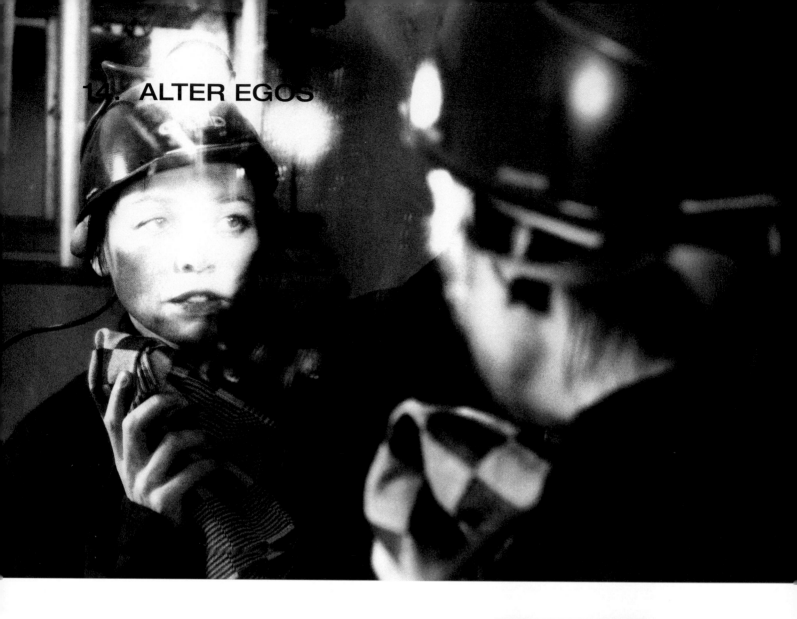

14. ALTER EGOS

The Queen of Punt

An ancient artist's copy
of the Queen of Punt

Self-portrait from a catalog of women artists
compiled by Lucy Lippard, 1973

As a Greek statue from the
video, "The Human Face," 1991

"Vermeer Disappears," photo collage, 1975

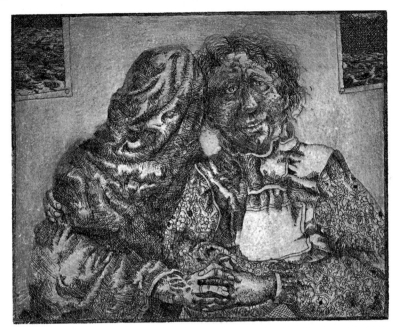

"Two Women," etching, 1972

There was a devout nun in the fifteenth century who decided to make a pilgrimage to Jerusalem. She belonged to an order of nuns who wore bags over their heads and the mother superior told the nun that if she walked through the countryside with the bag on her head she would scare everybody.

But the nun insisted on the trip and finally the mother superior allowed her to walk around and around the cloister every day for three years until she covered the equivalent distance to the Holy City.

At the end of her journey, the nun was so exhausted that she collapsed.

A doctor was called. After examining her, he announced that she was too weak to make the return trip. The nun died shortly after.

—apocryphal story

"Absent in the Present: Looking Into a Mirror Sideways," photographs, 1975

At the Shrink's

"At the Shrink's" is Super 8 film loop projected onto an 8" clay figure, a fake hologram with sound. The figure was installed in the corner of a large room at the Holly Solomon Gallery, New York City.

I used to spend some time seeing a psychiatrist. I would get there around eight in the morning and come into the office, and she sat in a corner and on one side of her was a window and the other a mirror, and she could tell by slight movements of my eyes whether I was looking at her or out the window or at the mirror. I looked at the mirror a lot and one of the things I noticed was that on Mondays it was perfectly clean and clear, but by Fridays it was covered with these lip marks. This was a process that seemed bizarre at first and then predictable and finally more or less inevitable. Then one day, in passing, I said, "Well, it's like the lip marks that appear on your mirror."

And she turned around and said "What lip marks?"

And I realized that because of the way the sun was coming through the window and hitting the mirror at an angle that she couldn't see them. So I said, "Why don't you sit in my chair? You can see them from here." And I'd never seen her get up before but she got up (she could actually walk!) and she came and sat in my chair and she said,

Clay figure for "At the Shrink's" without projection (below). With projection (above), 1975

"Oh! Lip marks."

The next time I saw her was the last time. She said she'd discovered that her twelve-year-old daughter had been coming into the office during the week and kissing the mirror, and that the maid would come in on the weekends and clean off the marks. And I realized that we were seeing things from such different points of view that I wouldn't have to see her again.

Above center: Video Mirror Image: Constructing the Perfect Face from "The Human Face," 1991

"What You Mean We?"

In the video, "What You Mean We?" 1986, I invented a digital clone, whose first appearance was on a talk show hosted by Spalding Gray.

TALK SHOW HOST: So you've been pretty busy for a multimedia performance artist. Let's see, I hear you make records, films, books, and you've been on the road a lot, haven't you?

LAURIE: Yeah. Actually I just got back from a concert tour of Japan, Europe, Australia, and I'll be making another record soon. But lately I've been so busy doing press, you know, interviews and photo sessions, and talk shows like this one, that I don't have the time anymore to do the actual work.

HOST: Well, you can't be in two places at once.

L: Right, I mean, you wish there was another you! So I talked to a design team about it and I mean, cloning is still in very early stages, but I think we did a pretty good job. We were dealing with duplicating speech and a certain musical ability and logic. A few things came out sort of strange but then I think it's always strange to see some kind of reflection of yourself. Anyway, we *do* work together and sometimes he's on his own. But I think it's working out really well. Don't you?

CLONE: Uh, well, I write the music and, uh, it's pretty interesting work really. She does most of the words.

L: Well, you've been writing!

C: Well, some.

L: No, it's been really good!

C: Well, most of the time I'm not really sure what I'm writing about. But I keep busy, you know, writing. I keep writing.

L: And eventually you're going to be doing even more things. Um, actually I didn't realize the time. Look I've got to get to a photo session. I've really got to go. Listen, can you just take over for me? Great, thanks a lot! I'm really sorry.

LAURIE LEAVES THE STUDIO. THE CLONE, ABANDONED, LOOKS AROUND NERVOUSLY. TV THEME SONG BEGINS.

With video clone, 1986

The clone works so well as a stand-in for me that eventually he tries a little songwriting about couples.

Hansel and Gretel are alive and well
> And they're living in Berlin.
> She is a cocktail waitress
> He had a part in a Fassbinder film.
> And they sit around at night now
> Drinking schnapps and gin.

And she says: Hansel,
> you're really bringing me down.

And he says: Gretel,
> you can really be a bitch.

He says:
> I've wasted my life on our stupid legend
> When my one and only love
> Was the wicked witch.

I loved being the clone's partner, and I always wanted to do a sitcom in which the identities get really screwed up. For example, I'd play the clone's psychiatrist and the clone would tell me endless, predictable trains-through-tunnels dreams which I would misinterpret. Then, of course, I would fall in love with my patient and we'd tool around town in a red convertible. Naturally, I'd drive.

The video clone was created by a digital stretching and compressing effect. We experimented with other proportions before finding the ideal male alter ego.

An unprocessed shot of the clone before being re-shaped by the ADO effect. It was strange to direct this video shoot because nobody on the crew wanted to talk to me while I looked like this. It was like being at a cocktail party where people don't look you in the eye, they're always looking over your shoulder to find somebody better to talk to.

Because each scene required three separately shot elements, blue screen, and matched pans and zooms, the scripts had to be carefully story-boarded. Art Director Perry Hoberman designed many of the elaborate schemes for placing the clone within backgrounds and making it possible for him to interact with them.

In the last scene of "What You Mean We?" the clone clones himself and comes up with yet another generation of alter egos, a nine foot woman with hands the size of snow shovels and a pinhead IQ.

"Well, yes I can do a little typing and, um, um, what-not."

From "United States 3," 1983

Well, I was out in L.A. recently on music business, and I was just sitting there in the office filling them in on some of my goals. And I said: "Listen, I've got a vision. I see myself as part of a long tradition of American humor. You know, Bugs Bunny, Daffy Duck, Porky Pig, Elmer Fudd, Roadrunner, Yosemite Sam."

And they said: "Well actually, we had something a little more adult in mind."

And I said: "OK! OK! Listen, I can adapt!"

"Yankee See""United States 3"1983

As a waitress in "Beautiful Red Dress," video, 1989

So Who Is Sharkey, Anyway?

John Howell: Does this Sharkey have anything to do with the Burt Reynolds movie, "Sharkey's Machine"?

Laurie Anderson: No, I didn't know about that movie until later. Then some of my friends who can't stand Burt Reynolds thought I should change the name, but I just decided to dedicate the song to Burt instead. But no, actually Sharkey is the first fictional character I've invented and named. I have no idea who he is.

JH: In your songs, there's often a narrator who's not identified, and who seems omniscient. And in "Langue D'Amour" there's a lyric that sounds like a French-speaking islander talking: "This is not a story my people tell, it is something I know myself."

LA: Yeah, I'm not sure who's talking anymore. It's such a relief not to be myself!

from an interview with John Howell 1984

Trying on a prototype "Sharkey" mask for the "Mister Heartbreak" tour, 1984. All the musicians wore these masks but since we could hardly see or breathe, this section of the show was very short.

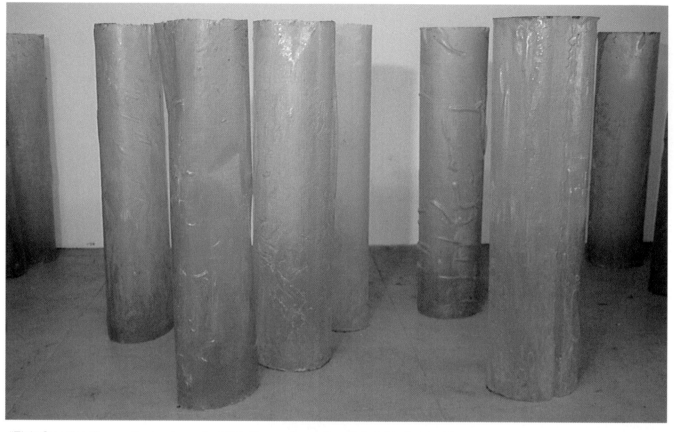

"Eight Standing Figures," polyester resin, 1972. These pieces, heavily indebted to Eva Hesse, were conceived as self-portraits, and were all approximately my height.

I met a writer at a cocktail party. This writer used "I" in all his books. He was famous for the way he used "I" in all the books he wrote. At the party, people kept coming up to him and saying, "Gee! I really like your work!"

And he kept saying, "Thanks, but I'm not very representative of myself."

from "Like a Stream" 1978

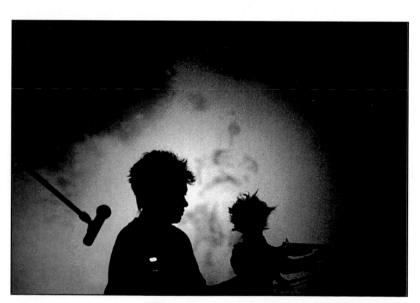

Dummy in "Stories from the Nerve Bible," 1992. Designed by Fred Buchholz. Dummy looked like me and played the violin. On tour in Germany and Israel, Dummy spoke both German and Hebrew.

15. BLACK FIRE ON WHITE FIRE

To Find Myself Lost

My studio in New York City, 1975, with wood stove and camouflage music paper

When I moved into this loft, there was only an old mattress, Richard's wood-burning stove, and a bird that flew in and out of the broken windows. It was so cold! I stayed by the stove and read books I found on the street. I read the books, ripped out the pages, and used them for fuel. "The Book of Legends: Tales from the Talmud and Midrach" was one of the few to escape the flames. It's a beautiful book that begins with a very striking four-color print titled "Noah felled the cedars for the ark." For some reason, the next page is identical. Noah is still swinging that ax with the same firm concentration, the same cedar chips are lying on the grass. It was one of the rejects that the Hebrew Publishing Company periodically dumps onto Hudson Street.

The very first sentence in Volume 1 Chapter 1 ("God Consults the Torah") was "Nine hundred and seventy-four generations before he created heaven and earth, God made the Torah." The next is, "It was written in black fire on white fire."

Each night I sat by the fire and read these sentences again and again. Each time, they became denser, more permanent, the way an incident changes from story to legend through simple repetition. Afterwards, I would sit around in the dark and sing in "Hebrew" or just think about how when John Milton went blind, his daughters read to him in Greek and Latin. They didn't, however, know any Greek or Latin. They read phonetically, flatly. And I think of how it must have sounded to Milton's tuned-in ear to hear all the lilt in Homer ironed out into monotones.

Around this time, which was a couple of months ago, already winter, I was sanding down the columns in my new loft. One day a friend came by and said, "You know, if you just pack some dirt around these things and graft a little bark on the surface, they'll grow like little motherfuckers." I turned off the screaming sander and thought it over. It was true, I had seen telephone poles in the Midwest that were creosoted only down to the ground, then planted. Below ground, the wood rejuvenated, took root, and the poles sent out branches! Would this wood remember its past? Could this wood be resurrected too?

That night I dreamed that hundreds of toothpicks began to pop out of the columns. They grew into 1 x 1's, then branched out into 2 x 4's. When I woke, I started to write about the woods, about last summer when I went up to Canada to see how long I could stay in the woods by myself. But sitting around in all that sawdust, heaps of crumbled columns, it was too graphic, the way things fall apart and just blow away. I couldn't find the words, the road.

One of the songs then, where "lost" and "found" were back to back, was from Dante:

"Midway this life we're bound upon (thrum/thrum)

I woke to find myself lost in the dark wood (thrum de thrum)

Where the right road was wholly lost and gone (thrum de thrum / de thrum / thrum)." Repeat.

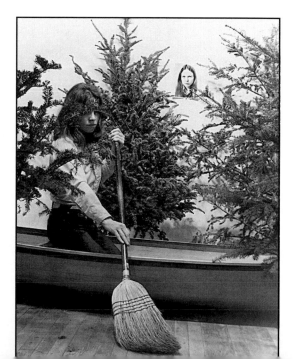

To remember Canada, I needed that smell: pine. But by this time it was February and most of the Christmas trees on the street were brown and sagging, dog-eared with bits of tinsel. Finally I found twenty healthy pines down at the Chambers Street Farm & Garden and lugged them back on my bicycle. I hung them from the pipes in my loft so that the trunks rested lightly on the floor; they almost seemed to spring from that flat pine surface. At last! I lay down in the middle letting that pungent smell fill me, dreaming of Canada, just getting to the part about the ax, when I opened my eyes and saw the difference. This was not the shaggy, scraggly woods, it was a bunch of props! The pipes had determined the placement and the trees were hanging there in perfect rows. It was like the "forest" I saw just outside of Vienna where the Kaiser had planted hundreds of acres of fir on a grid. For miles all you could see was equally spaced trees. (Another example of you-can't-see-the-trees-

for-the-forest.) And now I'm thinking of filters, grids, ways to shape the past, the little tricks memory plays to cut corners, sharpen edges, square off the clumsiness.

One day, as I was whittling down one of the trees for a violin bow, the fire inspectors came tromp-tromping in wearing rubber boots. No one knew how they got in. There was a fire crackling merrily away in the (illegal) stove. Dry pine needles carpeted the floor. The firemen walked in and out of the trees squish-squish, shaking their heads, writing on pads of paper. The chief, a stern beefy guy with bright blue eyes, noticed a T-shirt tacked to the wall. I had made it for myself in case I forgot the fiery part of memory. It was red cotton with a white silk heart stuffed with wads of kleenex. On the heart was written, "What burns never returns."

"Quite a slogan you've got there, sweetheart," said the chief, making some notes, "And by the way, if this forest is here next week when we come back, you'll be out on your ear!"

This was how the forest disappeared and all the "For You I Pine" love songs couldn't resurrect it. The woods were gone, only the words remained and I tried to make them as compact as possible, reducing everything to slogans, mottos, simple tunes.

from "Confessions of a Street Talker" 1975

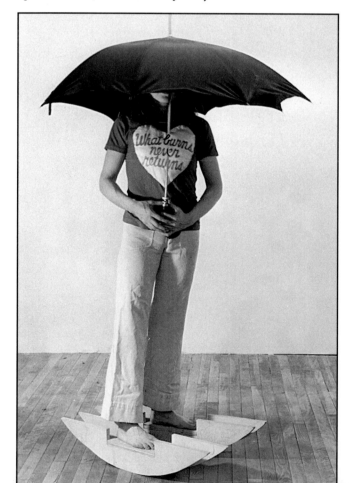

Advertisement on the side of a building in my neighborhood, 1976

REACH FOR THE SKY JOIN OR DIE DOG EAT DOG LOVE IT OR LEAVE IT BEAT THE CLOCK STOP THE PRESS ROCK THE CRADLE RULE THE WORLD LONG TIME NO SEE LISTEN TO THE MOCKING BIRD

CLICK! DON'T LOSE IT NOW! BLESS THIS BRAN IS LIKE THAT CHICKEN FLOAT AS I LIE 1976 YA! OLD FLAMES WAITING FOR YOU IF YOU WERE A SPORT BLACK WATER HOUR OF POWER

"In the Nick of Time" is a duet for live and filmed performer. The performer's image is projected behind her. The film is then frozen and the live performer outlines projected shapes on the screen with red spray paint. At the end of the performance, the wall is covered with red outlines, the "ghosts" of objects. For example, in "Black Water" the live performer outlines a box of Tide with red spray paint. The box of Tide then disappears and the film-performer's hand moves around the now empty area while describing the tide at midnight.

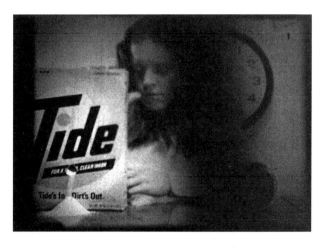

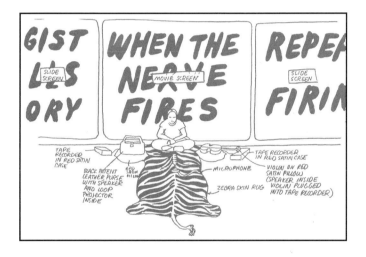

I live over on East Second Street between Avenues B and C, right across from the fire-house. There are a lot of fires in the neighborhood. A wire snaps, a circuit shorts out, and fires start to burn between the walls. Sometimes they burn for days before anyone notices them. It just sort of feels like the landlord has suddenly turned on the heat.

It's incredibly noisy there. The sirens go off about twenty times a day and they really blast into my place. I used to tune my violin to the dial tone, but since I moved to Second Street, I've been tuning my violin to the sirens

I don't know how often the sirens go off at night. I sleep in the back, facing Houston Street, which is more or less a dragstrip at night. Almost every night there's some kind of loud accident.

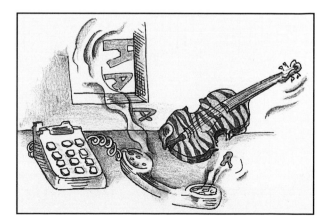

Now, WHEN THE NERVE FIRES the synaptic vessicle comes to the membrane, the synaptic membrane of the pre-synaptic terminal and it releases its contents, neurotransm... into the synaptic cleft. Neurotransmitter traverses the cleft and reacts with the enzyme on the cell surface of the post-synaptic terminal. This enzyme is called ADNIOCYCLA... ou can see here. Adniocyclase catalyzes the conversion of A ... le for the biological activity, the neuronal activity, ... eurotransmitter. Now I'd like to explain how both of thes... onsible for WHAT A PSYCHOLOGIST MIGHT C... MEMORY. And the concept is that REPEATED FIRING alo... sion along that pathway, in response to an action pote... nd in response to synaptic transmission, sending of this neurc... es in conductants of this phosphoralation may be that fu... ynaptic activity at this particular post-synaptic neuron will b... h is generated. This is what we're really referring to...

IT IS DARK. A TAPE OF A MAN EXPLAINING THE CHEMICAL ASPECTS OF MEMORY IS PLAYED. CERTAIN WORDS AND PHRASES APPEAR ON THE WALL — 8 FEET HIGH.

You know, in Amsterdam, if you're responsible for an accident, the cop gives you a piece of white chalk and you have to draw an outline around the victim's body as it's lying on the street. Then later you have to come back and paint it in white.

Performer lies down on zebra skin rug, holding large patent leather purse. From inside the purse, a film is projected onto the ceiling.

Don't Lose It Now!

Just before I left, Aunt Jean gave me something wrapped in brown paper. She pressed it into my hand and said, "Don't lose it now!" I thought it was a sandwich to eat on the train because it was kind of squishy and flexible. But when I got on the train, I opened the package and found a Bible.

It was one of those very flimsy Bibles with tissue paper pages. It seemed pretty well-worn. Most of the pages were wrinkled because when Aunt Jean turned the pages, she would wet her fingers and kind of strafe them across the page. Every page was soggy like it had been marinated in saliva.

PERFORMER OPENS THE BIBLE, SPEAKER INSIDE BLASTS OUT "GIMME THAT OLD TIME RELIGION" BY EDIE GORME; PERFORMER TAKES OUT A "BOOK" MADE OF 2 SLICES OF RYE WITH LETTUCE LEAVES BOUND INTO IT; LEAFS THROUGH IT.

As I Lie

My father's name is Art and when I was a kid I thought that Art was God's name too. You know, because of that prayer "Our father (who) Art in Heaven, hallowed be Thy name…" I never understood why the "who" was there but there were a lot of things I didn't quite understand about English at that point.

Anyway, my father was never critical of me, he sort of idealized me in fact, and it was always a strain to live up to this image. So sometimes I just lied. I pretended things were fine when they were really falling apart.

ON TAPE:
"IMAGE OF A GIRL," WHICH BEGINS WITH BELLS TOLLING THE TIME, "AS I LIE AWAKE, RESTING FROM DAY TO DAY, I CAN HEAR THE CLOCK PASSING TIME AWAY, OH, I HAVEN'T FOUND THAT IMAGE YET, THAT IMAGE OF A GIRL," ETC.

Ya!

Once I was talking to some Swedes and they asked if my family was Swedish. I usually talk pretty softly but for some reason I boomed out in this weird deep voice,

"YA!"

It was a shock, for the first time in my life, I felt my vocal chords vibrating at exactly the right rate.

Actually, I had always thought of myself as some sort of a Viking until I saw a Bergman film and the only word I could pick up was "ingetting" and this word crops up in all kinds of scenes: love scenes, arguments, socialist rallies, over and over "Ingetting" this "Ingetting" that. After some research I found that "ingetting" means "nothing." After that it became part of my fantasy to be really depressed. I would practice in front of the mirror, turning to the side, saying "ingetting" "ingetting" but I was always aware that there were two people in these duets: one who looked very depressed and one who was just pretending to be depressed.

SLOW BARTOK DUET

Old Flames

PERFORMER IS MAKING TOAST.
NAMES OF FORMER BOYFRIENDS ARE WRITTEN IN KETCHUP
ON THE BREAD, THEN TOASTED.

Hour of Power

A HELLFIRE PREACHER SCREAMS ABOUT THE END OF THE WORLD.
ON FILM, A RADIO BEGINS TO SMOKE. FLAMES LEAP OUT.
PERFORMER STARTS TO THROW A GLASS OF WATER ON FLAMES,
THEN DRINKS IT INSTEAD.

ON TAPE: EXTREMELY LOUD
COUNTRY FIDDLING.

BLACKOUT.

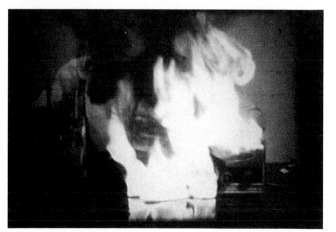

17. ART, THE CRITICS, AND YOU

Esthetics of the Few

When I got out of art school, I took a few jobs to make money. One was teaching art history at various colleges in New York City, mostly at night. I taught Assyrian sculpture and Egyptian architecture but since I wasn't exactly a professional art historian, I wasn't keeping up with the Egyptological journals, so gradually I began to forget the facts. A slide of a ziggurat or pyramid would come up and I'd look at it and I'd draw a complete blank. I couldn't remember a single thing about it. So I'd just make things up, stories about this or that Pharaoh, that kind of thing, and the students would write it down and I would test them on it.

Things went on this way for a while until eventually I began to feel sort of guilty and I quit. (Not before I was fired, but it was very, very close.) Anyway, this is the reason I began to do performances. I discovered that I loved just standing there in the dark, showing pictures and talking.

Another course I taught was an introductory overview officially called "Principles of Art." I couldn't stand the title so I changed it to "Skrooples" (like a breakfast cereal, as in eating scruples), and I focused on the moral principles rather than the formal ones. In other words: Why do people bother to make art? What purpose does it serve?

One of the statements that I was especially interested in at the time was something that Lenin said:

"Ethics is the esthetics of the future,"

which, I thought, could be understood in at least two ways.

First, in the future, we'll all be kind to each other and that will be enough. We won't need to make all these beautiful things. Second, if we look back in history, we see that one of the main purposes of art was to illustrate, to illuminate, certain religious or political ideas and beliefs, to make these ideas and beliefs accessible, desirable. Art-as-propaganda. So, according to Lenin, when we lose these ideas and beliefs, or when we no longer need to convince others in this way, we're left with pure esthetics. We're left with various objects made of artistic lines and waves. We're left with a formalist esthetic, like minimalism in the '60s, or many of its stylistic descendants.

The White Square

And it goes like: Yes, we're making white squares because white squares are so white and so square. Note the squareness, the whiteness, of this white square. This square no longer says, for example, that the world is square or that the room is square. No, now the square is just a shape and we look at it and say "Now that's square!" This approach has the effect of separating the cognoscenti from the rubes who could only say, "But wait a second. That white square looks exactly like the tile in my bathroom. Why am I supposed to be paying attention to it?" I admired Lenin's description of elitism. For me, teaching was also a way of writing songs, and I wrote one for Lenin (for Tape Bow Violin) that went

"Ethics is the esthetics of the few
of the few.
Ethics is the esthetics
of the fu.....................ture."

Unlike Van Gogh

I also worked as an art reporter for various magazines, "ArtNews," "Art Forum," a few others. And mostly my job was to cover minimal sculpture. I liked my job because I got to go to real artists' houses and see what was in their refrigerators, you know, just sort of poke around.

Now, I could sit around in art bars for hours and talk about "the edge" but, frankly, minimal sculpture didn't really move me very much at all.

At the time, my favorite artist was Van Gogh. I loved his intensity. This, to me, was being on the edge. So I mentioned his name in every review I wrote, just, you know, as a kind of foil to all the cool intellectualism that was going on. My reviews began, for example, "This artist, like Van Gogh, uses yellow and blue." Anything to keep his name in print.

Finally, an editor called me in and said, "Look, not every artist can be usefully compared to Van Gogh." Of course I saw the truth to this right off the bat, but I couldn't in good conscience, edit out his name. So the reviews began to read, "This artist, unlike Van Gogh," and so on.

A group of American minimal artists were on a goodwill trip to China. Near the end of their visit, they stopped in a remote province where few Americans had ever gone. One of the Chinese hosts seemed to be very confused about the United States. He kept asking questions like, "Is it true that Americans ride airplanes to work?" "Is it true that all your food is made in factories?"

One of the artists was a conceptualist whose specialty was theories about information and truth. He decided to try out one of his theories on the host.

So when the host asked, "Is it true you have robots in your houses?" he said, "Yes, yeah. We have lots of them. It's true."

The host asked, "Is it true that Americans live on the moon?" The artist said, "Yeah, it's true. A lot of us live there. In fact, we go there all the time."

In this province, however, the word for moon was the same as the word for heaven. The hosts were amazed that Americans traveled to heaven. They were even more amazed that we were able to come back, that we went to heaven all the time.

"The Visitors""United States 4" 1983

What Ornithology Is to the Birds

I used to think the future was art because the avant garde was supposedly the future and I liked the idea of living in a place where things hadn't happened yet. But at the moment I'm having a lot of trouble finding the avant garde. Maybe it's somewhere and I'm completely wrong about this, but I don't think so. And I think the disappearance of the avant garde has something to do with speed. I mean, the lag time between uptown and downtown New York is now a matter of a couple of days. For example, let's say there's a young artist, and let's say he's a he and he might have some fantasies about what the life of an artist is: big loft, green plants, parties, a little work, some minimal suffering followed by his picture in a Gap ad and eventual media stardom. Then he realizes he can't afford the loft right now, times are a little hard, so he takes a job in an ad agency but every Saturday he goes to the galleries to see what's up and by Monday morning these downtown images are comped up in an ad for cars or shoes or cigarettes. I mean it's that fast. The existence of the avant garde depends on its ability to hide, and in New York anyway there's nowhere left to hide.

But back to the question who is art for? Every time I wonder about it, I hear the voice of Walter Annenberg sniffing, "I'm sick of people expressing their artistic attitudes in an unappetizing manner." Everybody knows that art is a question of taste but the way he put it something or someone is definitely eating and something or someone is definitely getting eaten. Taste becomes consumption.

O.K., now for my theory about the recent history of words in art. You see, back in the fifties there were all these abstract expressionist artists and even though they were hanging out at the Cedar Bar every night talking and drinking, they weren't really articulate. I mean it was a macho thing: uh, Paint ... the BIG GESTURE, the uh, paint-like qualities of paint, dripping, how PAINT could look so much like, well, so much like paint.

Of course this left a lot of room for the poets. And remember poetry in the fifties was considered pretty suspicious, a kind of code invented by the intelligentsia so that regular people couldn't figure out what they were talking about, and it was these guys, these poets, who were moonlighting as art critics. And the reviews were basically poems that had some very oblique relationship to the paintings, but they were actually pretty good ways for the poets to get ideas for their next poems.

Then along came a generation of very articulate artists, guys like Barnett Newman, who, even though he said,

"Esthetics to me is what ornithology is to the birds" didn't seem to really believe this, because he wrote very long and also very beautiful essays on his own work. I mean, why wait for the critics to write about what it means when you can do it yourself?

And these came out as huge, slick, wordy catalogues, and you really needed them too. I mean sometimes it's nice to stand in front of a solid blue surface with a brown stripe running down the side and make up your own fantasies about it, but sometimes it's more interesting to find out what led this particular artist to paint this particular stripe. It was as if the artist were standing in front of the painting and talking talking talking about it.

I always thought of my own work as part of this process, that eventually the object itself would disappear or it would become very ordinary and there would just be endless streams of words.

from "Voices from the Beyond," 1991

who said, "The
would be a much
place if everyone just
oll and put it in a
and filled the cradle
raw and just sat there
ked the cradle."
ght, I got a splinter in
t. Bob tried to take it
he couldn't. It hurt a
en he touched it.
got a knife and cut
splinter. It bled a lot
idn't hurt. It's
g how much pain you
e to yourself and how
ain you can take from
ne else. One day, a
afternoon, I took a
ornographic
raphs of myself. After
oped the film, I was
assed of them. I
l the negatives and left
es on the doorstep of
l." "The hardness of
rt, external
stances, the heaviness
e." "It has always
l wonderful to me
n Gogh cut his ear off
s - that bullfighting
And that Picasso put
ry into Guernica and
afrazzi realized it was
nd I wrote a letter to
r John F. Kennedy,
for advice on my
gn for student council
ent. This was in 1960.
ote back and said,
ut what the students
nd promise it." When
he election, he sent
legram. It said,
atulations." One
oon I was talking to an
ler about my work.
, "Anderson,"
ver called me by my
me), "we're
ted in the same two
sex and ego." I
at that said more about
an me but I said,
guess you're right."
ther used to say,
ave such a high
ad - it's a sign of
ence and if you look
then you'll feel smart
he pulled my hair
t back into a pony
e pulled it so tight
oked almost bald. It
tight that pulled my
back into a silly,
nent smile. One
oon I was listening to
ery loud music. I was
l fell asleep. After
n hour the music
d suddenly. It was so
hat it woke me up. My
painter is Vermeer
almost nothing
ns in his paintings.
omes in a window,

window. It always seems to
be 10 a.m. in these
paintings. One day, in
California, I was at a party.
There weren't enough chairs
for everyone so I sat in my
uncle's wheelchair. My
mother into the room and
saw me in the wheelchair,
"You look good in a
wheelchair," she said. My
mother is, by the way, an
excellent horsewoman.
One day I jumped off the
diving board and broke my
back. I had to wear a steel
brace for a year. I was sent
to speech class because I
talked so softly. They
thought the brace was
pressing against my lungs.
Actually, I spoke softly
because I thought I looked
like a cripple, and I wanted
to disappear. One night I
was watching a video show
on television. I fell asleep
and dreamed that my
parents had an arts festival in
the Alps. They invited every
artist I know except me but I
hung around anyway and
pretended I was in the
festival, yodelling with my
violin as an echo. Once I
went to a place called the
Corner Restaurant on a
Cree Indian reservation in
Canada. There was a juke
box in the restaurant and
only one record on the juke
box. It was "Rock You Baby"
by George McCrac. The
Cree Indians were learning
English from the record.
They all spoke with a
southern accent, like George
McCrae. One day, when I
was eighteen, I got drunk for
the first time and I had to
put my arms over my head
to keep from hitting my
head against the ceiling.
Once, for three weeks, I
lived in my lover's loft while
he was in California. There
were many photographs
there of a Swedish woman
that he was also in love with.
I had never met this woman
but after a week of being
surrounded by her
photographs, I fell in love
with her too and dreamed
about her almost every
night. One day, when I got
home from camping in the
woods by myself, I found
that my loft had been broken into
and almost everything I had
was stolen or destroyed. On
the stairs, I found a suitcase
that the thieves had
dropped. Inside it, there was
an old pair of blue jeans,
bongo drums, and an
electric socket.
One day I was complaining

the violin and to sing the
song, the sad song, that
people sing while they
pantomime. No one seems
to know more than one or
two notes of this song.
One day, I was waiting in
line to see a Bergman film.
It was raining. I was crying
but I tried to hide under my
umbrella. When the rain
stopped, a man knocked on
my umbrella, as if it were a
door. He kept saying, "The
rain is over now. You can
take your umbrella down
now. The rain is over.
Once, in December, I was
walking around Rome. I had
a map with little pictures of
all the important buildings,
monuments, and ruins on it.
When I got to the
Colosseum, I realized I
could see more of it from
the drawing than the real
thing. One summer, I went
to Bible camp. We read the
Bible and sang hymns and
prayed. The only sport
there was canoeing.
It was the only non-
religious thing at the camp
but soon I found myself
praying to Christ: "Dear
Christ, please make me a
good canoeist, for your
sake." Once I met a woman
who said she was planning
to kill her lover. She had the
murder all worked out. She
knew where he was every
minute of the day. She
asked me to help her. She
showed me maps of the
daily routes. Later I found
out that she had been
planning this murder
for eleven years. She hadn't
spoken to him in twelve
years. In California, I knew a
deaf librarian. He made up
for his lack of hearing by
using his sense of smell. He
wore so much Jade East
aftershave lotion that it was
easy to tell which part of the
library he had been in
recently. Most of the books
smelled that way too. In
fact, California smells that
way in my memory.
During the Watergate
period, I had a hard time
hating Richard Nixon
because his old photo-
graphs, taken when he was
in the Navy, looked so
much like an uncle of mine.
When I saw Nixon in
Washington D.C. in late
1973, even though I hated
him, I cheered and waved.
In January, I was trying to
write about the woods but I
had forgotten the smell.
I brought fifteen pine trees
into my loft and put my

they were arranged in a
grid because of the pipes.
It wasn't like a forest at all
and neither was my
writing. One day I was
sitting in a mineral bath
pool at the sauna. I was
talking to an old woman.
We were up to our necks in
water. She was telling me
about an operation, but she
wasn't specific. When she
stood up, I saw she had no
breasts. She looked sleek
and simple, like a fish, like
an old child. One summer,
I saw a man on the street
every day for weeks. Every
time I saw him, he said,
"Hi there sweet little
angel." But because of his
Spanish Accent, it sounded
like, "Hi there sweet little
angle" or "Hi there sweet
little anglo." One day,
while I was living in a hut
in Mexico, the women in
the village decided to braid
my hair the Indian way.
After they did this, I saw
my reflection in a puddle.
I looked ridiculous but they
said, "Before we did this,
you were ugly. But now
maybe you will find a
husband."
One day, on my birthday, a
woman came up to me and
said, "You're the star of my
favorite t.v. program!
Could I have your
autograph?" I said I wasn't
an actress but she insisted
that I was. This argument
went on for a while. I tried
to be as convincing as
possible. Finally, I realized
I was an actress after all and
gave her my autograph.
One night I dreamed I was
in Berlin and that my head
was going to be chopped
off. I knew that when your
head is chopped off, you see
a black thump, and hear a
white note. My head was
chopped off but I didn't see
the thump of hear the note
so I thought maybe I wasn't
dead after all. My grand-
parents used to go to
Arizona to paint the
landscape. They set their
easels next to each other
and painted what they saw.
I have two of their
paintings. There is a space
between them, where a
mountain dips down.
Neither of them painted it,
but it is just as real.
I used to wonder how
anyone could believe in the
Immaculate Conception.
When I heard the
explanation, I understood.
"How can a virgin give
birth? How can light come

our high school football
team used to play against a
Catholic School: the High
School of the Immaculate
Conception. It always
sounded strange when the
cheerleaders were yelling
"I-m-m-a-c-u-l-a-t-e! spells
immaculate." When I was
fifteen years old, whenever
I thought of Mozart he was
always about fifteen or
sixteen, practising his violin
in a small studio at around
four in the afternoon. Now
that I'm twenty-eight,
whenever I think of Mozart,
I think of him as a young
composer of around thirty
or so, sitting in the same
small studio. Once when I
was riding my bicycle up
the Gotherd Pass, I felt
myself going up very
quickly. I turned around
and saw that two cyclists
practising for the Tour de
France had grabbed hold of
my bicycle and were
propelling me up the
mountain. One day my
sister, who was ten, took
my twin brothers, who
were three, to the lake.
They were sitting together
in their stroller. She took
them to the end of the pier
and parked the stroller. She
said, "Mom's dead.
Goodbye." and she left. My
brothers say they remember
this day but my sister says it
never happened. One day,
when I was living in
Mexico, I was trying to
learn to make tortillas.
I made them perfectly,
except that they were sort
of square, not round. No
one in the village would eat
these squared-off tortillas.
They said they had tasted
bad, very bad. One day,
I went to the hospital. The
nurse was wearing a white
mini-skirt and three strings
of enormous pearls, which
were peeling. She was also
wearing a huge ring that
looked like a missing part
from a Chevrolet. One
afternoon, Thor and I were
camping by a river in
Canada. I began to rain.
A man rowed by in a boat
and invited us to his house.
We slept in a big bed with
six other people. In the
morning, we had banana
sandwiches for breakfast.
In Chicago, my home town,
there are handles on the
corners of the buildings
because of the wind. I have
been to many cities but I've
never seen these handles.
Maybe Chicago is the only
city with handles. It's very

She said, "You know, back
in African times…" and
then she covered her mouth
and laughed. One day,
I was walking on First
Avenue in New York.
I saw a red stream on the
sidewalk. As I walked the
stream became thicker and
redder. In the middle of
the block, two men with
a hose were washing away
the blood. There had been
a murder there a few
minutes ago. It was strange
how everyone knew,
without asking, that this
was human blood. One
summer, it was impossible
for me to get up in the
morning unless I pretended
I was in a Swedish town,
that it was snowing outside,
that I would ski down to
the river, work on a novel
in the afternoon, then bake
some large spice cookies.
I was living in New York
then, and it was very hot.
One day, I read an article in
the New York Times about
people who have been deaf
most of their lives.
Suddenly, they begin to
"hear" things. They aren't
going crazy, it's a physical
phenomenon. One old
woman, who hadn't heard
anything for 25 years,
suddenly heard a contin-
uous medley of Christmas
carols, day in, day out. She
could never shut it out.
One day, at Kennedy
Airport in New York, I was
walking off a plane when a
man jumped out from
behind a pillar and put a
creme pie in my face. I was
pretending to be
sophisticated at the time
but the pie made it
impossible. The man was an
ex-lover of mine who was
mad because I had gone to
Rome without him. One
day in spring, I decided to
try to steal my roommate's
boyfriend. They were
making love in her
bedroom. I went into the
living room, which was
next to the bedroom, and
began to play Tschaikovsky
violin concerto on my
violin. Soon, they both
came out and asked me to
stop. One day in autumn,
Jeff and I were driving fast
on a deserted highway in

from "Windbook" 1975

explosion, next to the car
window. I thought it was a
stray bullet from a duck
hunter. When I looked out,
I saw that a duck had

mirror. One
afternoon, B
out to a hillsi
were growin
melting. We
pile of wet oa
sat on it. We
other's photo
was a very fra
Bob said "Rer
we went cam
One mornin
bicycle in Ho
scenery was
was reading a
book was Wi
"History of Ph
paperback. I
chapter, my b
down
halfway into
One day I fou
Houston Stre
words were u
of the underl
was this: "An
even need to
It was a pape
Mark Twain.
Once, I wen
Graham Cru
Bible and gav
address. Eve
for years afte
literature. I s
how they fou
addresses.
I used to be h
people who t
themselves in
Now that I d
much less frig
found, too, t
certain under
street-talker
each other, b
anything, exc
ourselves. O
my six-year o
by herself. Sh
and in this ga
galloping aro
She held her
holding the re
half was hors
was human.
received a le
little sister. S
learning to w
She wrote, "
write in long
have very mu
When I told
Darboven, sh
Many things
on the day I d
that gravity is
something ve
One day, I di
is part of my
depressed an
continue to f
depression u
thinking Berg
beautiful. On
lying on the h
Virginia. It w
felt a pressur

18. SOME BOOKS

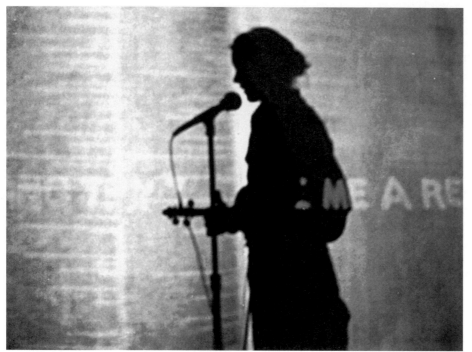

From "The Dictionary"
"For Instants Part 1," 1975

Windbook

"Windbook" is a two-hundred-page diary of handwritten stories and photographs printed on onion skin paper. The book is in a glass case. Fans are concealed on both ends of the case. The fans alternate, blowing the pages back and forth. The photographs were shot so that the corner of the room is the spine of the book and the walls are the pages. People move slowly through the room, light changes, stories appear and disappear.

One day during the Cuban missile crisis in 1961, I thought everyone would be killed soon; but it is 14 years later and although many people have been killed, I am not one of them.

One afternoon I was talking to an art dealer about my work and he said, "Anderson," (he never called me by my first name) "Anderson, we're interested in the same two things: sex and ego." I thought that said more about him than me but I said, "Gee, maybe you're right."

"Windbook," book under glass with built-in fans, 1975

The Package

A mystery story in pictures, Bobbs-Merrill 1971

In 1971, I decided it was time to support myself. The money I had saved quickly ran out so I decided to try to publish a book. I made a series of drawings, a mystery story in pictures. One morning, I woke up with absolutely no money at all, so I looked in the phone book and found the closest publishing house, Bobbs-Merrill.

I walked there with my drawings and asked the receptionist if I could see someone about publishing a book. She said the next available appointment was in six months. "Do you mind if I just sit and wait?" I asked. She obviously did mind. I sat down in the office anyway and made a point of doing absolutely nothing for hours. No magazines. Nothing. Just staring straight ahead.

Finally an editor came out of her office and said, "OK OK! You're driving me crazy! So what do you want?"

I showed her my book and she said, "Well, listen, we absolutely can't do anything right now but, hm... well, actually, these do look interesting."

As she leafed through the drawings, I began to talk about contracts and she said something noncommittal about things taking time, and then I said I believed that contracts should be simple and that I was glad she was interested in my work, and would it be at all possible to get an advance on the contract and, if so, that it would really be great if the advance could be cash since I was dead broke and it was Friday afternoon and the weekend was coming right up.

The meeting ended when she reached into her purse and gave me $70.00 of her own money, which I will never forget.

A couple of months later, I was paid for the book and as I was walking home I passed a "See Jamaica" poster in a travel agency. I walked in, bought a ticket to Kingston and left from there for the airport. In Kingston, I stayed in a beautiful bougainvillea-covered cottage on the side of a hill. I told the manager that I was an author working on my second book and no matter what, I was not to be disturbed.

Above: from "The Package"
Above left: portrait etching from back jacket

"Transportation Transportation'," 1973

A series of booklets that consisted of twenty-six pairs of stories built around the alphabet. I meant "Transportation Transportation'" to be a kind of proof that motion and time don't exist. (Seriously!)

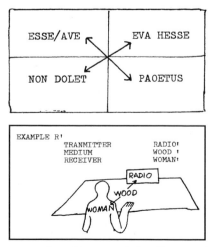

Following pages: two pages from "Transportation Transportation'," 1973

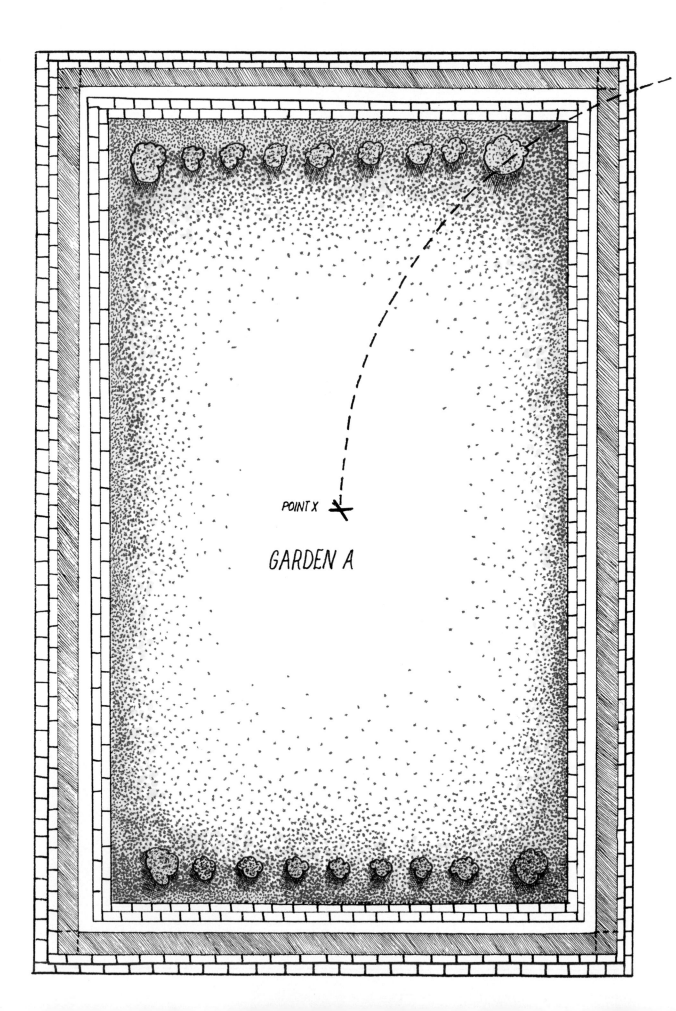

POINT X

GARDEN A

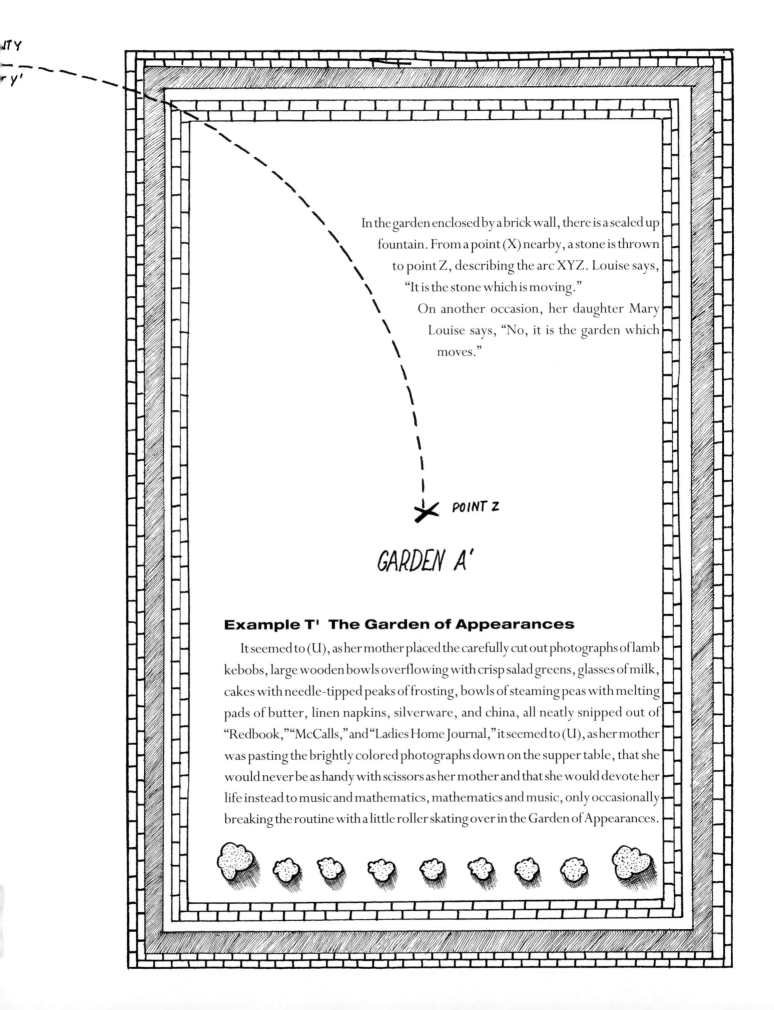

In the garden enclosed by a brick wall, there is a sealed up fountain. From a point (X) nearby, a stone is thrown to point Z, describing the arc XYZ. Louise says, "It is the stone which is moving."

On another occasion, her daughter Mary Louise says, "No, it is the garden which moves."

✗ POINT Z

GARDEN A'

Example T' The Garden of Appearances

It seemed to (U), as her mother placed the carefully cut out photographs of lamb kebobs, large wooden bowls overflowing with crisp salad greens, glasses of milk, cakes with needle-tipped peaks of frosting, bowls of steaming peas with melting pads of butter, linen napkins, silverware, and china, all neatly snipped out of "Redbook," "McCalls," and "Ladies Home Journal," it seemed to (U), as her mother was pasting the brightly colored photographs down on the supper table, that she would never be as handy with scissors as her mother and that she would devote her life instead to music and mathematics, mathematics and music, only occasionally breaking the routine with a little roller skating over in the Garden of Appearances.

Baloney Moccasins

"Baloney Moccasins: A Magazine for the Medieval Mind" 1970,
written by George DiCaprio, illustrations by Laurie Anderson

Handbook

*"Handbook," 1974, is a handwritten, seventy-five-page book.
There is one phrase on each page.*

*"Handbook" is about the physical activity of page turning: the
weight of the pages, the texture and origin of the paper, the slight
breeze created when each page is folded back. It's a kind of
manual.*

some pages from "Handbook" 1974

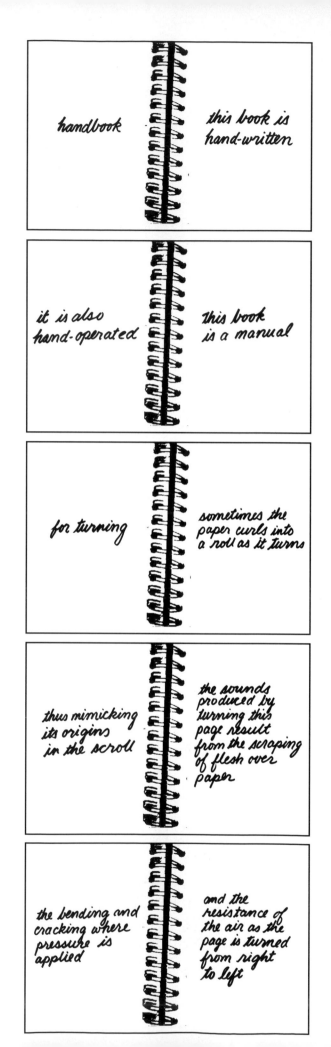

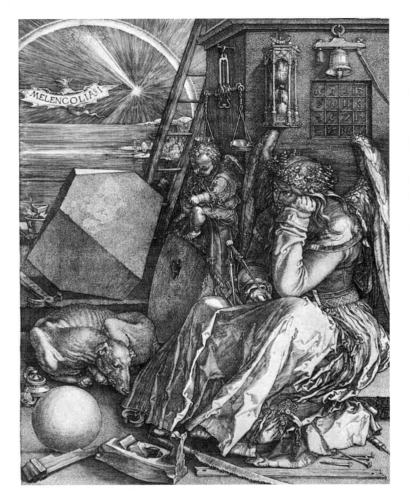

Light in August

On July 26, 1974, someone cut a hole in the concrete wall of my loft and stole or destroyed almost everything I owned. "Light in August," 1974, is a thirty-six-page book, a visual list of some of the things I lost. On each page there is an image of Dürer's "Melancholia," the angel of depression. A single object in the print is highlighted in red to correspond to one of my lost possessions.

"I never understood the density of an electric socket until it became one of my last possessions."

Radio

Violin

Music Books

Box of Love Letters from 1968

Tools

Tape Recorder

19. SONGS AND STORIES FOR THE INSOMNIAC

Excerpts from a performance of twelve film/songs. Performed at Artist's Space in New York, The Museum of Contemporary Art in Chicago and Oberlin College, 1975.

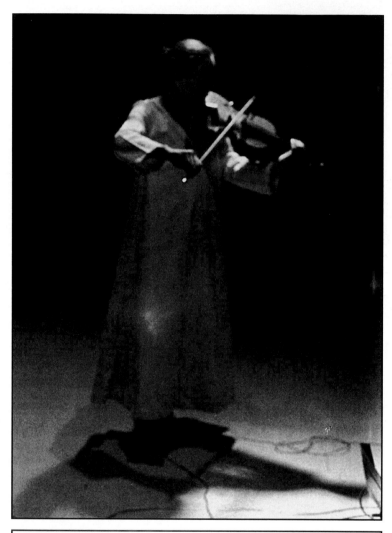

"Songs and Stories for the Insomniac," invitation, 1975. The invitation disk could be spun around to reveal words through a cut-out window, such as "An arch never sleeps."

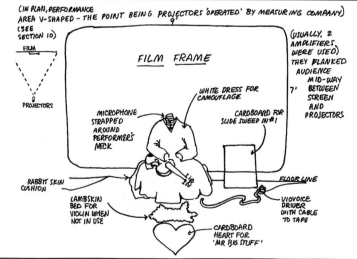

The Bridge

*PERFORMER ENTERS WEARING LONG WHITE DRESS
MADE OF FILM SCREEN MATERIAL*

Ever since I moved into my new loft, over on Canal Street, I've been having a lot of trouble getting to sleep. The building is right next to the Hudson and the wind blows off the river and rattles the windows in their frames and it sounds like someone is constantly trying to break in.

*HOLDS PIECE OF CARDBOARD IN FRONT OF THE SLIDE.
THE PROJECTED IMAGE APPEARS ON THE CARDBOARD.*

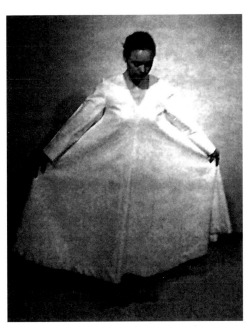

Wearing the film screen dress, designed by Patrice George, 1975

It's noisy at night. It's a trucking district and the trucks roll in from New Jersey at three or four in the morning. The street is rocky and as I rock I can hear the rocks ricocheting off the bottoms of the trucks. There's an enormous bridge right outside my windows. There's something about that arch, its bulk, its tension, that gets into every song I sing to myself at night. It dominates the space. When Geraldine saw how close it was, how it seemed to be as much inside as outside, she said, "Well, I guess you won't need any furniture."

So I've kept my place pretty bare, a hammock, a rocking chair, a couple of other things and it's at night, when I'm alone, that I realize just how bare it really is.

*PERFORMER HOLDS OUT DRESS.
AN IMAGE OF A ROCKING CHAIR IS PROJECTED ONTO THE DRESS.
SINGS IN UNISON WITH PRE-RECORDED VOICE.*

Well I ain't got no use for no red rockin' chair
Ain't got no honey baby now. Lord Lord!
Ain't got no honey baby now.
Well, who'll rock the cradle?
Who'll rock that cradle when I'm gone?

SINGS HARMONY WITH PRE-RECORDED VOICE.

Oh yes you can rock the cradle.
 Oh yes and I'll rock the cradle
You can sing the songs. You can
 I will sing the songs. I'll rock the
rock the cradle when I'm gone
 cradle when you're gone. Lord! Lord!
Lord Lord! You can rock the
 I'll rock the cradle when
cradle when I'm gone.
 you're gone.

Art and Illusion

It was like this paper I got from a student. The assignment was to "Go to the museum, look at some art, and write about it." She gave me an incredibly vague paper, "Well, I went to the museum but I can't remember which museum it was, or where it was."

It turned out that she had gone to the Museum of Natural History and written about a stuffed seal in its painted panorama of icebergs and snow floats. I think about that seal a lot at night when I'm sitting around trying to figure out what my life is slowly becoming.

Art and illusion, illusion and art
This is the song that I'm singing in my heart
Art and illusion, illusion and art

Was it a real seal, or was it only art?
Was it a former seal, or was it really art?
Art and illusion, illusion and art.

FILM OF UMBRELLA BEGINS TO LIGHT UP FROM INSIDE, THE PULSE KEEPS TIME WITH THE SONG, WATER BEGINS TO POUR OUT FROM UNDER THE UMBRELLA.

Look Smart

One of the songs I find myself singing quite a lot is something called "Look Smart." It's a song about pressure right about here on my forehead where my mother used to pull my hair back into a pony tail.

She would say, "You know, you have such a high forehead, it's a sign of intelligence and if you look smart, then you'll feel smart too." And she would pull my hair back so tightly that it kind of stretched my mouth into a grotesque permanent smile. I remember standing in front of a mirror singing a song that went like:

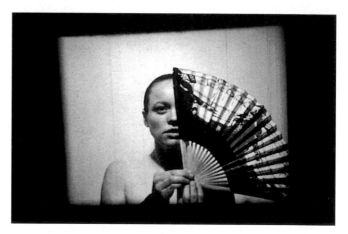

Well, if you look smart, then you'll feel smart too.
And if you feel smart, then you'll look smart too.
And if you look and feel smart,
then you'll actually *be* smart
Oh it's important to look smart!

Video Rock

I can't stand video but when Alan left he gave me all his video equipment and said, "This'll put you right to sleep." I like to watch it at night, especially the snow. One night, I went to sleep and dreamed that my parents had an arts festival in the Alps, where they owned a couple of peaks. They invited almost every artist I know, except for me, but I hung around anyway and pretended I was in the festival, working on a piece about yodeling with my violin as an echo.

I guess the thing I really can't stand about video is that it's furniture and when you're rocking in a rocker and watching

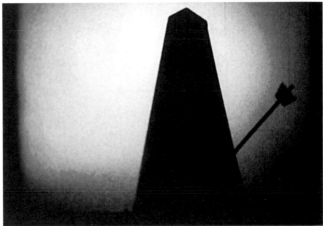

learning English from it and they were duplicating his southern accent pretty well, but it still sounded like gibberish. In Cree, McCrae's "Woman! Take me in your arms!" sounded like "Wuhmun! Taak mean Yrraaams!"

TV, the image keeps going in and out of whack. So I discovered that if you put the monitor on another rocker, you can get into synch with the image and it will get you into a good rhythm for yodeling or whatever it is you do while you watch TV.

*PERFORMER SINGS
"AH VID-DEO-DEE-OH-A VIDEO-DO-A VIDEODEODEODEO ETC."
IN AND OUT OF SYNCH WITH YODELING VOICE ON TAPE.*

*PERFORMER HUMS TUNE TO "ART AND ILLUSION" AND
WALKS FORWARD TOWARDS AUDIENCE.
OBJECTS AND WORDS ON FILM ARE PROJECTED ONTO DRESS.
AS PERFORMER FANS DRESS OUT TO THE SIDE, THE WORD
"ART" EXPANDS TO "HEAR" AND THEN TO "HEART."*

Taak Mean Yrraams

When I was up in Canada last summer, I went to an Indian reservation near Chibougamau. It was a Cree reservation. Actually, it was a random scattering of tar and leather buildings, but there was a shack there with a sign saying "The Corner Restaurant" even though there wasn't a single corner on the whole reservation. Inside the restaurant, there was a juke box and on the juke box there was only one record: "Rock Your Baby" by George McCrae. The Indians were

**EAR
ART

HEAR

HEART**

*FAN AND UMBRELLA, CLOSE AND OPEN
IN RHYTHM WITH FOLDING
AND SPREADING OF DRESS.*

Night Song

*PERFORMER PLAYS "NIGHT SONG" ON VIOLIN.
THE VIOLIN BOW IS SYNCHED WITH THE WIPERS,
WHICH MOVE LIKE TWO METRONOMES.*

Hey ah Hey

One day last summer when I was in Canada on a Cree Indian reservation, some anthropologists showed up out of nowhere. They came in a little plane with maple leaves painted on the wings. They said they were there to shoot a documentary on the Cree Indians. They set up their video equipment in a tin quonset hut next to the Hudson Bay Company. Then they asked the oldest man on the reservation to come and sing some songs for their documentary.

On the day of the taping, the old man arrived. He was blind and wearing a red plaid shirt. They turned on some lights and he started to sing. But he kept starting over and sweating. Pretty soon it was clear that he didn't really know any of the songs. He just kept starting over and sweating and rocking back and forth. The only words he really seemed sure of were:

"Hey ah. Hey ah hey. Hey hey hey ah hey. Hey."

PERFORMER LEAVES; ON FILM, WORDS APPEAR, FILLING SCREEN.

Hey ah hey hey hey ah hey
I am singing the songs,
the old songs, but I can't remember the words
of the songs,
the old hunting songs.

Hey ah hey hey hey ah hey
I am singing the songs of my fathers
and of the animals they hunted down.
Hey hey hey ah hey
I never knew the words of the old songs.
I never went hunting.
Hey hey ah ah hey ah hey
I never sang the songs
of my fathers
Hey hey ah hey

I am singing for this movie
Hey ah hey ah hey
I am doing this for money.
Hey hey ah hey

I remember Grandfather
he lay on his back
while he was dying.
Hey ah hey hey ah hey
I think
I am
no one.
Hey hey ah hey hey hey ah hey

In the late '70s, my work was described as "photo-narrative," "autobiographical," "body art," and finally, "performance art." Of these, "body art" seemed the strangest. In 1975 I performed "Songs and Stories for the Insomniac" at the Museum of Contemporary Art in Chicago as part of a show called "Bodyworks."

I like the inertia of instruments, like a turned-off television taking up space but no time, like a museum where all the art dies a sudden death at closing time, reverting to hunks of stone, steel, dabs of paint in various stages of flaking away, bits of cloth. A few nights ago I was in a museum in Chicago, "The Museum of Contemporary Art." Downstairs, there was a show called "Bodyworks." Basically, it was pieces of paper on a wall, photographs, notes, tapes. Artists putting their bodies on the line, on the shelf, dressing in drag, assuming alter egos, putting themselves through various exercises, contortions, exorcisms, all in an effort to exit the body, the brain, trying everything short of jumping out the window. But in fact, no bodies were there. Only paper.

I did the performance in a big room that was part of a Gaston Lachaise exhibition. The room was filled with pedestals and on each pedestal there was a body part made of

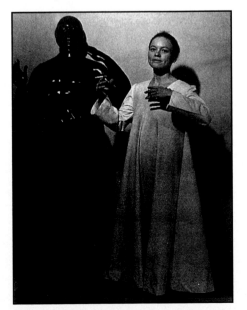

Posing with Gaston Lachaise sculpture in Chicago, 1975

stone, mostly heads, by Gaston Lachaise. I love Lachaise. His women have a bulk and poignancy, so delicately, precariously balanced on tiptoe. Most of the heads had been moved over to the walls to make room for the performance. But two of the large black nudes were too heavy to move so they flanked the performance area, like bookends, like bodyguards. I was very nervous but their dark, bulky presence made me feel better. I was especially nervous because my parents were there. They've been wondering exactly what it is that I do and I've never really been able to pin it down very well.

Afterwards, at the party, my father said, "You know, talk about talent! You're really up there with the greats, I mean, Frank Sinatra, for instance."

Another man said, "I'm sorry but your work just frustrates me. I don't stand in front of Cezanne and applaud. I know that that painting isn't going anywhere."

from "Confessions of a Street Talker" 1975

A Note On Documentation: The Orange Dog

There was only one snapshot of the performance "Songs and Stories for the Insomniac." The only documents left are the elements: slides, films, and tapes. At the time, I was very adamant that performances couldn't and shouldn't be documented. I thought that since my performances were about memory, the best way to record them was in other people's memories. Then I realized that other people didn't remember them very well at all.

They'd say, "Remember that performance you did with that orange dog four years ago?"

And I'd say, "There was no orange dog. I never did anything with an orange dog."

Much later (1985) I decided it was time to document a performance on film so that I could run the projector and say, "OK! Now do you see an orange dog?"

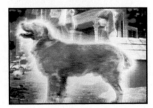

20. MADE OF LIGHT: SILENT MOVIES

I went to the movies and I saw a dog thirty feet high
and this dog was made entirely of light
and he filled up the whole screen.

from "Walk the Dog" 1979

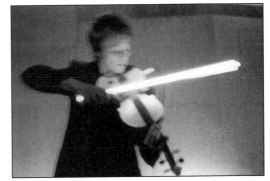

The neon bow also occasionally picked up CB in the area.

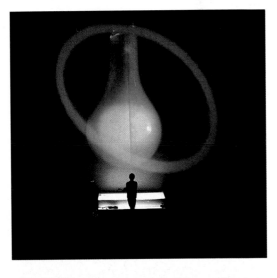

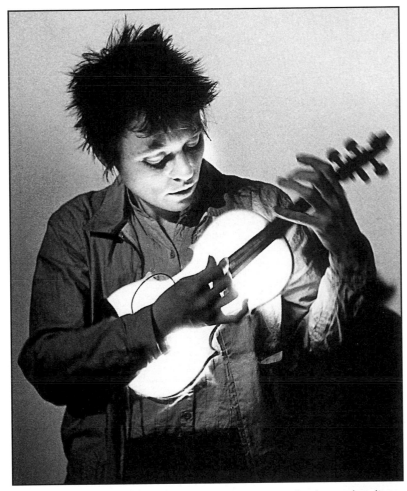

Neon light inside the violin created a dangerous sounding buzz when it was played.

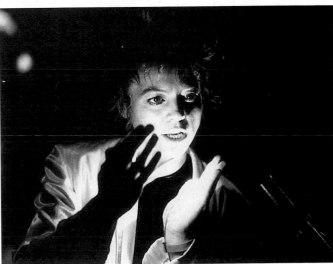

With battery-powered handlights

For Instants Part 3
(Refried Beans)

Performed at Whitney Museum and Museum of Modern Art,
New York City 1976

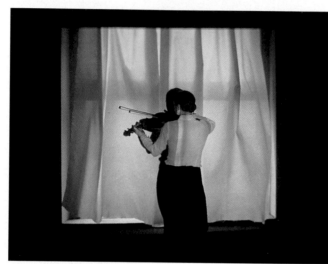

From "For Instants Part 3," 1976

I started doing performances with film because I was in a series of film festivals in the early '70s. And by film festival I mean eight people in a loft. And I was always late; I'd barely finish editing the film so I never got to the soundtrack. At the last minute, I'd grab my violin and run to the festival and stand in front of the film and play the violin and do all the dialog live.

And after a while I thought: Well this is an interesting relationship of film and sound. Like in Japanese silent movies, instead of the live piano player, there were six guys who would sit in front of the film. And they'd have these wood blocks and other simple instruments and they'd sit there with their heads turned so they could see both the film and the audience and they did all the music and sound effects, so it was a film, and a concert all at once.

In "For Instants" the performance space was a corridor between the screen and the projector. The audience sat on both sides of this corridor more or less looking at each other and turning their heads back and forth to watch the performance, like a tennis match. Three images (film and slides) were projected simultaneously onto the screen. By standing in front of one of the beams, the performer's body blocked the light from that projector, making a shadow on the screen that revealed the other two images hidden underneath.

White on White

William Faulkner used to sit on his porch at night. And people from town would come up to see him. Most of them knew that they were Faulkner's raw material and that sooner or later they'd be transformed into characters in one of his books. So they would stand around on the dark lawn, chatting, being careful to show only their best sides.

And Faulkner had this way of talking to them. Whenever someone said something he considered "out of character," he would shade his eyes, lean out into the dark and say,

"Uh, could you move away? You're blocking the light."

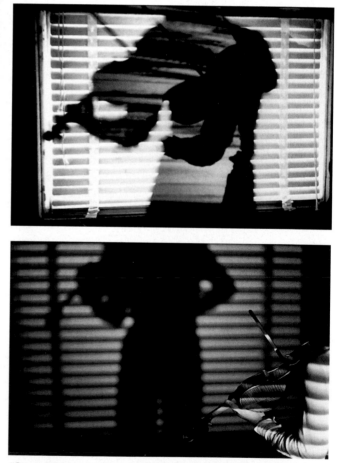

"Song-Writing for Three Light Sources" from "For Instants Part 3," 1976

Write on White

The second half of "White on White" is played directly in front of the projector after the film has run out. The shadow of the bow hand moves like a pencil back and forth along the bottom of the frame. The violin is rasping, abrasive.

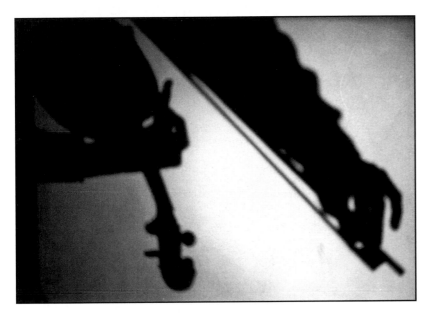

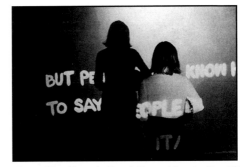

From "But People Don't Know How to Say It" from "For Instants Part 3," 1976

FLASHBACK

In "Flashback," words flashed rapidly, creating afterimages, so that eventually the audience was reading the negative afterimage, reading their own recent memories, reading their own minds.

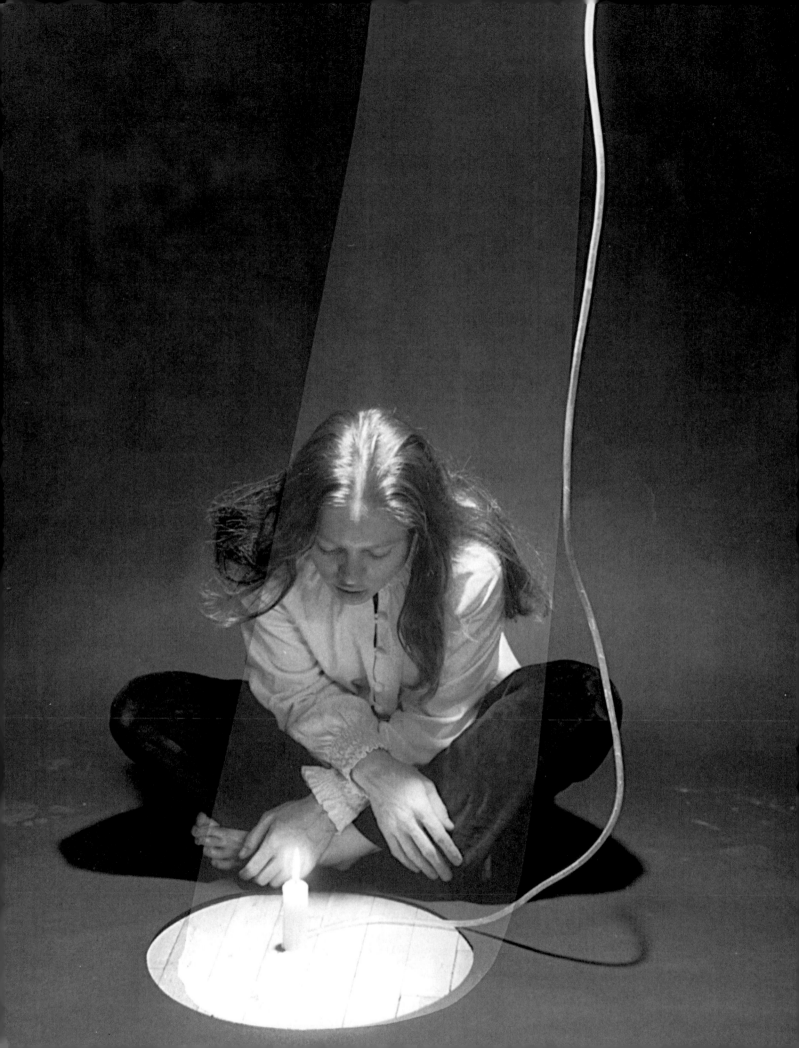

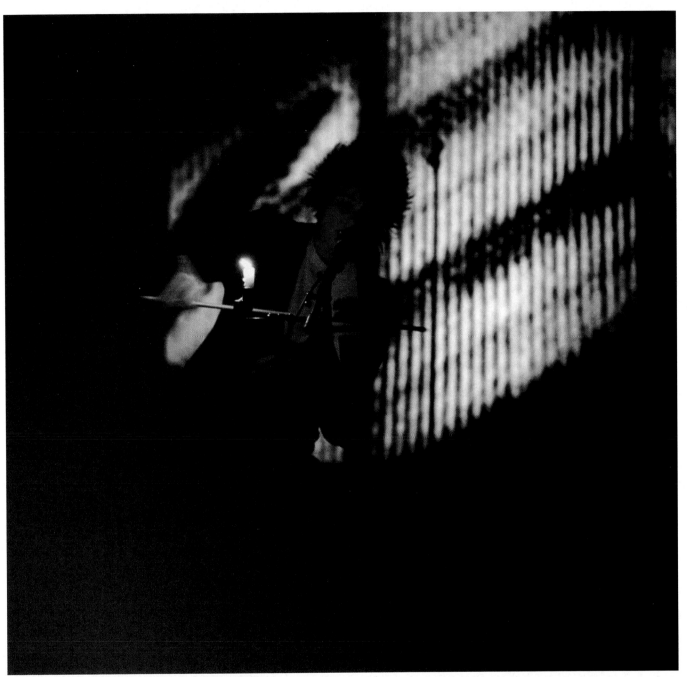

A single candle replaces the follow spot in "Empty Places," 1989

LEFT: From "For Instants," 1975

A sensor was aimed at the flame. When I spoke, the flame moved in and out of the sensor's range causing the spotlight to flicker

They say that heaven is like TV
A perfect little world
That doesn't really need you.

And everything there is made of light.
And the days keep going by.
Here they come.

from "Strange Angels" 1989

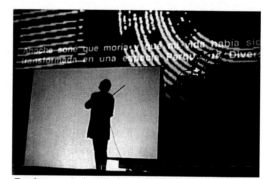

Filmed shadows are rear-projected on screen. From "Home of the Brave," 1986.

Nightdriver

"Nightdriver" was an installation consisting of audiotape, headphones, slides. Wadsworth Atheneum, New Haven, Connecticut 1978.

The "viewer/listener" sits in a chair casting a shadow onto the screen. Cars slowly pass towards and "through" the body.

"You never felt out of place
because you never stopped.
You were rarely
where you thought
you were."

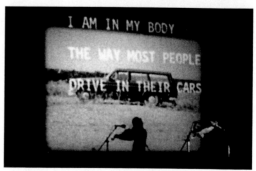

Performer is behind one of several screens in Spanish performance of "Empty Places," 1989.

"I am in my body
the way most
people drive
in their cars."

From "On Dit" Paris Biennale, 1977

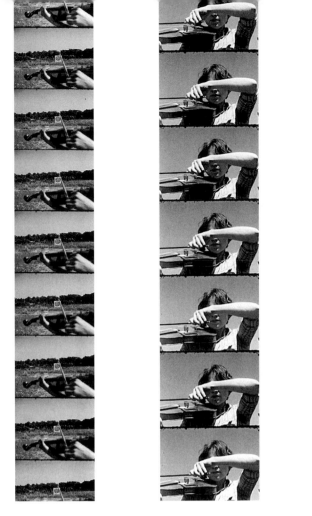

From 1975 to 1979, I ran through ideas very fast, writing and rewriting songs and stories, experimenting with new instruments, working with various groups of readers and musicians, and trying to rethink the whole idea of performance. I wanted the pieces to be fresh and awkward so I booked myself on fast-paced, grueling tours of colleges and alternative spaces all around the United States and tried things out. My goal was never to do the same thing twice. I hated the polish of theater, I thought it seemed canned, and my main goal was to be raw.

Sometimes these pieces were just music or just words. Sometimes I used film or animation. Sometimes I would project the film into corners or do a piece in which every time I said a sentence I would throw a violin bow at a designated target in the room. There were around thirty of these ad hoc pieces and they were all different. I didn't bother to document them. I barely finished them. "Out of the Blue" (University of Massachusetts, Amherst) was typical of this way of working except that only three people came. It was extremely quiet and one man spent the whole time interrupting, "I don't really believe what you're saying," or "What makes you think this is interesting to me?," things like that. It was my first experience with heckling and I didn't really know what to do so I just tried to build it into the piece.

From "United States 2," 1980

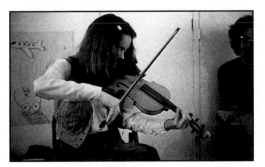

From "Out of the Blue," 1975

21. SONGS FOR LINES SONGS FOR WAVES

Excerpts from a film-video performance.
Performed at The Kitchen, New York City, 1977.

*"Songs for Lines Songs for Waves" was a performance using the Tape Bow Violin, slow scan video, film projection, slides and the
Tape Bow Trio. It consisted of twelve songs.*

frame line **ocean** **name**
frail aisle canoe mean

AS THE PERFORMER SINGS, THE RHYTHM TRACK IS MADE UP OF BITS OF WORDS PLAYED ON THE TAPE
BOW VIOLIN. SOME ARE WORDS IN REVERSE. "SAY WHAT YOU MEAN AND MEAN WHAT YOU SAY"
IS RECORDED ON THE BOW. "SAY" IS "YES" BACKWARDS. "MEAN" IS "NAME" BACKWARDS.
THE ENTIRE PHRASE IS PLAYED IN BITS AT VARIOUS SPEEDS TO PRODUCE A LANGUAGE
THAT GRADUALLY BECOMES PURE RHYTHM.

Ezilaer dna pu ekaw uoy yad eno.

Dias uoy tahw naem t'ndid uoy ho.

Kcab ti ekat ot tnaw yam uoY.

. Yats ot ereht era sdrow eht tub

!Kcart esol t'noD !naem uoy tahw yas!

Enog er'yeht ecno dna gnorts era sdrow.

Kcab meht ekat t'nac uoy

: Yas ro od uoy tahw rettam on os.

Naem uoy tahw yas.

!Yas uoy tahw naem dna.

Naem eb ot tnaem evah yam uoy

Ecin eb ot tnaem evah yam uoy

Thgir ti yas t'ndid uoy fi tub

Emoh og tsuj dluohs uoy neht!

Yas ro od uoy tahw rettam on

Naem uoy tahw yas

Yas uoy tahw naem dna!

AN OCEAN WITH NO SHORE LINE. WAVES ROLL IN.
THE LAST WAVE DISSOLVES INTO A FRAME LINE. THE FILM IS FRAMED SO THAT THE FRAME LINE IS
LOCATED IN THE CENTER. THE VIOLINIST STANDS IN FRONT OF THE PROJECTOR, CASTING A SHADOW
OF THE BOW AS IT MOVES BACK AND FORTH ACROSS THE FILM FRAME.
ANAGRAMS APPEAR ABOVE AND BELOW THE LINE.

| **united** | **phase** | **ocean steamship** | **the carotid artery's** |
| in duet | shape | compass in the sea | to carry heart's tide |

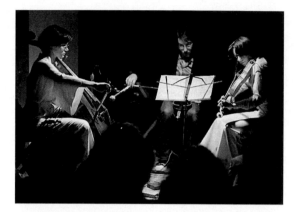

The Tape Bow Trio: Patrice Anderson, Joe Kos, Laurie Anderson

Another Bad Accident

All three instruments were equipped with both strings and audio tape heads mounted on the bodies of the instruments.

The trio began very classically, all syrupy strings.

In the second movement, the musicians played the tape bow instruments. Loud arguments are recorded on tape. Performers played wildly.

In the third movement, the musicians played tape bows of car crashes: skid, impact, shattering metal and glass. The crashes could be played forwards and backwards. Accidents happened and then un-happened.

A Man, a Woman, a House, a Tree
Song for Slow Scan Video

Slow scan is a video system which uses no videotape. The camera records the visual information and translates the picture into sound. This visual information is then stored as sound.

In "A Man, a Woman, a House, a Tree" four pictures, stored as audio information, are reconstructed by playing The Tape Bow. The performer attempts to "draw" the images on a video screen. This turned out to be extremely difficult to do and often produced visual gibberish.

Jane!

For slides of words and two trap drummers. Performer shouts a song about innuendo.

"Ava Eva" etching, 1972

A Song for Juanita

Last summer I spent a couple of weeks in a Buddhist monastery. No one was allowed to speak or to read or to write. It was very quiet there.

The first night, I heard an unearthly sound coming from somewhere on the other end of the building. Sometimes the sound was a low moaning, other times a piercing shriek, sometimes a soft sing-song. It went on for hours, the same word over and over. It sounded like, "Juanita! Juanita? JUANITA!!"

I couldn't imagine who Juanita might be, or why someone wanted her so badly, or why she never answered such an obviously desperate call.

Later, I found out that the word wasn't "Juanita" at all, but "Anata," the word for ego, the word for self.

22. TALKING ORCHESTRAS

I AM LOOKING FOR 30 PEOPLE TO PARTICIPATE IN A PERFORMANCE-
SPONSORED BY THE ART DEPARTMENT- WHICH WILL BE PRESENTED AT
YALE IN EARLY MARCH.
 THE FIVE SONGS IN THE PERFORMANCE ARE SCORED FOR VOICE- TALKING,
BREATHING, SOUND EFFECTS (VOCAL BOAT HORNS, CAMERAS, PARROTS),
VOCAL AND HAND PERCUSSION. ALTHOUGH IT WILL BE LARGELY ACOUSTIC,
SECTIONS OF THE SONGS ARE MIKED AND OCCASIONALLY FILTERS SUCH AS
PHASE SHIFTERS ARE USED. ONE SONG IS FOR TAPE/VIOLIN (AUDIO HEADS
MOUNTED ON THE VIOLIN AND AUDIO TAPE SUBSTITUTING FOR HORSEHAIR)
AND CHORUS.
 MOST OF THE SONGS ARE BASED ON LOOP-LIKE REPETITIONS, WITH SOLOS
AND ENSEMBLE WORK MIKED TO PREDOMINATE. OTHERS ARE NARRATIVE...
SOUND EFFECTS ACCUMULATING AS A STORY IS TOLD. SOME OF MY FAVORITE
MUSIC IS BALINESE MONKEY CHANTS AND AFRICAN PERCUSSION.

 MOST OF THE PERFORMANCES I DO INVOLVE TAPE- EIGHT TRACK OVER-
DUBBING AND I AM INTERESTED IN THE POSSIBILITIES OF "MULTI-TRACK"
LIVE SOUND. IN THE PAST YEAR, THESE PERFORMANCES HAVE BEEN PRE-
SENTED AT THE WHITNEY MUSEUM, THE MUSEUM OF MODERN ART, AKADEMIE
DER KUNST (BERLIN), LOUISIANA MUSEUM (COPENHAGEN), LA JOLLA MUSEUM,
AND SEVERAL GALLERIES AND UNIVERSITIES IN NEW YORK AND CALIFORNIA.

 I AM CURRENTLY COMPLETING WORK ON AN LP WHICH WILL BE CUT IN
LATE MARCH AND, DEPENDANT ON THE RESULTS OF THE PERFORMANCE,
HOPE TO INCLUDE ONE OF THE SONGS FROM THE YALE CONCERT.
 I AM UNABLE, AT THIS POINT, TO OFFER PAYMENT FOR THE PERFORMANCE,
WHICH IS ON A STRICTLY VOLUNTEER BASIS. THERE WILL BE APPROXIMATELY
EIGHT REHEARSELS, HELD AFTER THE REGULAR GLEE CLUB REHEARSELS,
FROM 9:15- 10 pm . THE PLACE WILL BE ANNOUNCED NEXT WEEK.

 IF YOU THINK YOU MIGHT BE INTERESTED IN PARTICIPATING- THERE
WILL BE A PRELIMINARY REHEARSEL ON WEDNESDAY, FEBRUARY 2 AT
9:15. I WILL PLAY TAPES, TALK ABOUT THE PIECES AND MAYBE TRY A RUN-
THROUGH OF A SECTION. FOR FURTHER DETAILS, CONTACT NAN BECKER,
DIRECTOR, ART SCHOOL GALLERY.
 Laurie Anderson

1977. Unfortunately no one showed up for this rehearsal.

In 1978 and 1979, I wrote several pieces for Talking Orchestras, that is, orchestra and chorus. I had become tired of my own voice but I loved the way spoken language could turn into music. The stories were extremely short, usually two or three sentences. The instruments would play for a while and then the stories would sort of float out over the music, like thought balloons.

Performers were asked to both play and speak. This wasn't easy for professional musicans who associated talking with acting. They tended to overact, to ham it up. I had to remind them to talk as normally as possible. The string players had tape heads attached to their instruments and several Tape Bows each, with voices and sound effects recorded on them. At first the professional musicians didn't really want to use the electronics. Eventually, they came around when they realized that the Tape Bow instruments were quite difficult to play and that their right-hand bowing skills were crucial.

The Talking Orchestras pieces included "Born Never Asked" (performed by the Oakland Youth Symphony, directed by Robert Hughes, 1980), "It's Cold Outside" (performed by the American Composers Orchestra and West Deutscher Rundfunk Orchestra in Cologne, directed by Dennis Russell Davies, 1981), and "Like a Stream," 1978, which was put together by many presenting organizations around the United States (including Hallwalls in Buffalo and D.C. Space in Washington D.C.). I conducted the chamber pieces myself and it was exhilarating to try to shape the sound of breathing on twenty Tape Bows, which could sound like a family of sleeping giants (slow) or a wild sex orgy (fast).

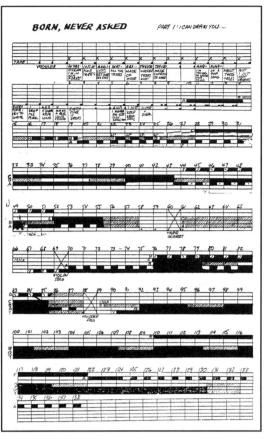

Scores from "Born Never Asked," 1978

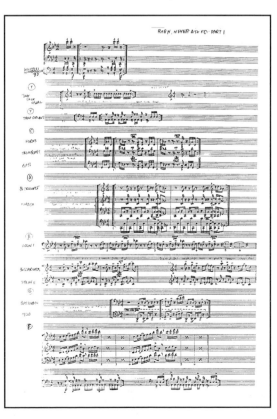

Excerpts from "Like a Stream"

TAPE BOW:
BREATHING (SLOW)

SPEAKER #1:

I can draw you so that
you have no ears.
I can draw you so that
you have no ears at all.
So that where your ears
would be there is only
blank paper.

SPEAKER #2

I met a man in Canada and
every day he had
the same thing
for lunch.
He had a carrot and
he had a bowl
of chocolate pudding.
First he ate the carrot
into the shape of a spoon.
Then he ate the pudding
with the carrot-shaped spoon.
And then he ate the carrot.

SPEAKER #3

I read about a rabbit in a laboratory.
They held the rabbit's head,
eyes open,
pointed towards an open window.
For twenty minutes.
Staring at the bright window.
Then they took a knife
and cut the rabbit's head off,
peeled the tissue off its eyes,
dyed it, and under the microscope,
like film, the tissue developed.
There were two windows
imprinted on the rabbit's eyes.
And they said, "Look!
This rabbit has windows on its eyes!"

SPEAKER #4

The reason you think there are always
fires at riots is because that's the only place,
at the scene of a riot, where there's
enough light for the video camera.
Actually, maybe this fire is only something
happening near the riot,
incidental to the riot.
Someone's trash can is on fire
or someone is having a barbeque
near the riot but not as part of the riot.
But that's why you think there are always fires
at riots when sometimes
there aren't any fires at riots,
or in any case, not at every riot.

SPEAKER #5:

Oh. Oh. I like the way you look.
Oh. Oh. Oh. I like the way you talk.
Oh. I like the way you walk.
But most of all I like the way you look,
the way you look
at me.

SPEAKER #6:

If you…if you can't talk…just…
if you…if can't…
if you can't talk about it…
you should…just…point to it…
if you…if you can't talk about it…
point to it.

TAPE BOW SOLO:
WALKING (ON GRAVEL;
IN A REVERBERANT HALLWAY;
IN HIGH HEELS)

SPEAKER #1:

When Bobby got back
from his first trip to Las Vegas,
he said he noticed he was pausing
just a little bit longer than usual
after putting his money
into parking meters
and Xerox machines.

SPEAKER #2:

I don't know, I've got a feeling
that this isn't what I, you know,
what I paid my money for.
I mean, I've got a funny feeling
that this just isn't, it's not,
you know, what I paid my money for.
No one's ever looked at me
like this before.

SPEAKER #3:

It was that way for him.
Some days he was flying.
Flying easily.
Everything seemed so easy.
White light. Great ideas.

He could do no wrong.
And then one day
it would all leave him.
For no reason, it left him
and suddenly nothing worked.
Everything was different.
He burned the toast. Dented the car.
He was clumsy, depressed.
And then it would change again.
It would be easy again.
It changed fast, and for no reason
it changed.
And he went to the doctor
and the doctor said, "Chemical imbalance"
and gave him some chemicals
and cured him.
Cured him until it was all evened out,
every day, same thing.
And he was so relieved
to find that "he" wasn't crazy.
"It's not me, it's my biochemistry."

SPEAKER #4:
Did he fall? Or was he pushed?

SPEAKER #5:
Last night I dreamed
I was lying in bed sleeping.
Last night I dreamed all night
that I was just lying in bed dreaming
I was sleeping. Last night
I dreamed I was sleeping.

from "Like a Stream" 1978

Film/Song in 24/24 Time

In this piece, sound and picture were composed simultaneously from a mathematical score. Frames are blacked out and whited out. When the image flickers, for example, it is sometimes expressed as vibrato. Drop-outs of both sound and picture are alternately positive (ON) or negative (OFF).

"Film/Song" is approximately 52 seconds. It was composed for four violins and voice.

"Self Portrait with Two Windows," 1978

Quartet for Sol Lewitt

A guitar chord expressed graphically by the Synclavier from "Sharkey's Day" "Mister Heartbreak," 1984

I composed "Quartet for Sol Lewitt," 1977, by assigning note values to numbers according to their placement in his drawings. The quartet is scored for four violins.

In 1978 I collected several scores and published them in a book called "Notebook." I worked on the layout for "Notebook" in Berlin over a period of five days in which I didn't sleep. I was used to staying up for at least two nights in a row preparing for performances but five nights was a record. On the morning of the sixth day with no sleep, I was staggering down the street when I heard what sounded like the most beautiful music I'd ever heard coming out of an enormous metal door. I stopped to listen. Twenty-four hours later, I woke up still slumped in the doorway of a tool and dye factory where the machines were producing complicated polyrhythms. I often used machine sounds as basic tracks for my music and had spent a lot of time recording them in factories, but this particular one was the best by far.

Since 1984, most of the record mixes have been automated and stored digitally, and much of the music I've composed has been on computers. Usually I try to replace the computer parts with real instruments unless the parts are unplayable.

Technical score for "Natural History" performance, 1986

Computer mix of "Smoke Rings" SSL Mix 60: instrumental transferred from PCM-1610 Safety Mix, 1986

The first time I performed in Europe was in 1965 when I was seventeen. There were fifty of us in the "Talented Teen USA" troupe and we wore matching red blazers and did "up-with-America" type shows in town halls, fairs, and U.S. Army bases. I had never heard of "performance art." My act was a "Chalk Talk" and I talked about life in the United States (what Americans like to eat, wear, and drive; cowboys and Indians; high school, etc.) while I drew cartoons on a huge pad of newsprint. Since we did the shows in several different countries, the tour supervisors said "Remember, you will be in foreign countries, so try to use a few 'foreign' words." I'd had four years of Latin (which my teachers had always said would come in handy someday), but when I tried it out, I found out what "dead language" really means.

My dressing room table on the "Empty Places" European tour. I spent most of my backstage time learning to sing my songs in various languages, most of which I don't speak. I could never decide whether it was better to sing and speak in English, or to use subtitles. Both had the effect of distancing me from the audience. On the other hand, I enjoyed being vulnerable and clumsy.

The "Empty Places" European tour, 1990, was performed in twelve different languages.

English:

I see by your outfit that you are a cowboy.

I see by your outfit that you're a cowboy too.

Let's all get outfits and we can all be cowboys.

'Cause that's how the west was won.

Slovonian:

Po tvoji opremi vidim, da si kavboj.

Po tvoji opremi vidim, da si tudi ti kavboj

Po tvoji opremi vidim, da si tudi ti kavboj

Kupimo si opremo in vsi smo lahko kavboji!

Kajti tako smo zavojavali zahud.

Hungarian:

Látom a felszereléseden,

hogy cowboy vagy.

Látom a felszereleeseden,

hogy te is cowboy vagy.

Mert így nyerték meg a nyugatot.

Szerezzünk mi is olyat, és mi is cowboyot lehetünk!

Hát így nyerték meg a Nyugatot.

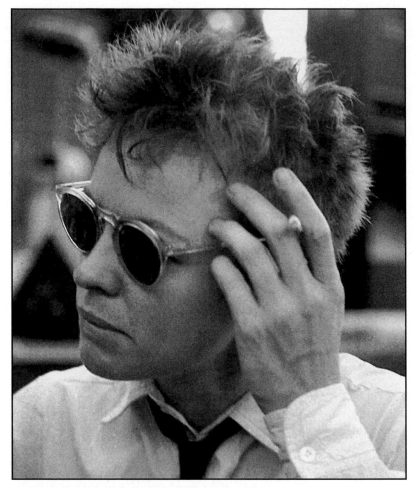

As expatriate, 1978, unidentified European café

Around 1976, I began to do a lot of performances and projects in Europe. At the time it was much easier to work in Europe than in the United States and I liked the romantic expatriate feeling I got every time I left. I traveled alone dragging two black cases of instruments and electronics. The performances were in all kinds of theaters, art galleries, festivals, museums, and improvised venues (a marketplace in Middleburg, Holland, a church in Venice, shipyard in Hamburg). I'd meet the tech crew and we'd go over the score. I'd have to really spell everything out because often the crews had never done anything even remotely like this.

Arriving in Milan 1980 with Jacqueline Burckhardt, Martin Diesler, Jean-Christophe Ammann, Laurie Anderson, and Judith Ammann

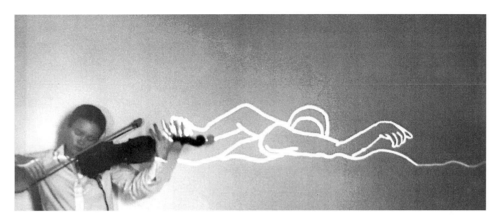

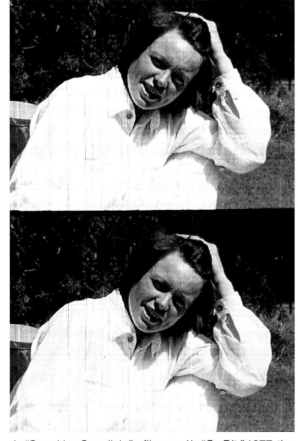

In "Speaking Swedish," a film used in "On Dit," 1977, the soundtrack was played backwards to sound like Swedish. The French subtitles, however, told another story.

The performances always had lots of fairly complicated cues and we'd have a few rehearsals. I'd instruct the crew, "So when you see the film of the swimmers come up, take channel two out slowly, switch microphone three off and hit the slide," and they'd shrug that confident continental shrug as if they understood perfectly and I was just boring them with these details. But on the night of the performance, things would always go wrong in one way or another. Swimmers would appear more or less at random, flashing on, then off, then on again. The microphone would go dead and then come back on with an endless shriek of blood curdling feedback. This is how I learned to improvise.

These performances were often in conjunction with an exhibition of my visual work or some collaborative workshop or media event. For example, when I did a performance in Amsterdam, I also worked with a group of ten-year-old kids. They wrote a series of two-minute ads that I produced for Dutch radio. The ads were for emotions: fear, jealousy, joy, and so on and they just cropped up on Dutch radio with no explanation.

Usually the performances were in the language of the country or they were subtitled. The language barrier occasionally became the subject of the piece.

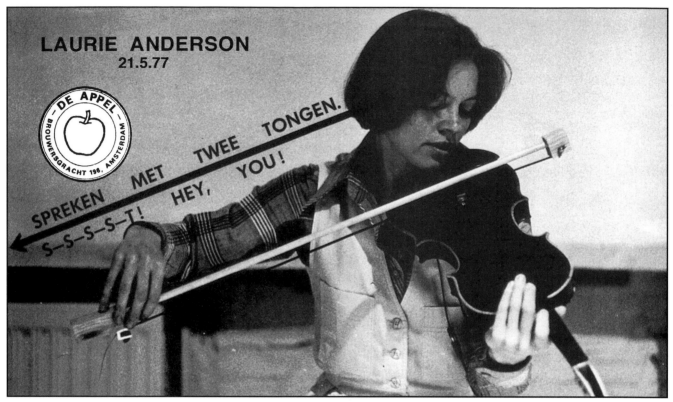

I used the Tape Bow occasionally as a kind of "translation tool." My method was to record a number of colloquial sayings and proverbs in other languages. Then I would cut these up into strips and listen to them backwards to see if I could hear anything in English. One time out of twenty, this would happen. And one time out of twenty out of that, there would be some relationship between the two meanings.

FORWARDS

Italian

Carta canta e villan dorme.

(Paper sings and the peasant sleeps.)

Flemish

Leder vogel singt sodls hij gebekt is.

(Each bird sings according to his own beak.)

Dutch

Spreken met twee tongen.

(To speak with a forked tongue.)

BACKWARDS

English

I can't wake up.

Say, say, you can whistle.

Psssst! Hey you!

Dublin, 1977. Since only a single phrase or sound was recorded on each bow, a long song often required many bows.

In Berlin, the Wall became a visual metaphor for the language barrier. In "That's Not the Way I Heard It" (Akadamie der Kunst, Berlin), I told stories in English as German subtitles appeared on the screen. At the beginning of the performance, the translation was more or less accurate. Then gradually the translation drifted until it had very little or nothing to do with the story being told out loud. Obviously this was a piece for a bilingual audience, but also a comment on the fact that language is already a code.

> EngliSH…SH SH SH EngliSH…
>
> FrenSH…SpaniSH…DeutSH…DutSH…YiddiSH…
>
> RusSHian…SHinese…PoliSH…SwediSH…
>
> FinniSH…FinniSH…FinniSH…

from "Song for Whispering Voice and Broken Record" 1979

Whenever I began to set up my equipment in Germany, I noticed there was a lot of resentment on the part of the crew. Gradually I realized that the all-male tech crew disliked the combination of women and electricity. Power was clearly a man's job. I discovered this when I didn't know how to make a connection and the Berlin crew proudly solved the problem. After that, they were nicer to me.

With Tina Girouard and Michael Schneider, Documenta 6, Kassel, Germany, 1977. My first attempt to sing in German. In the press, my German accent was described as "John Wayne selling used cars."

In performances, I loved to use the lowest setting on the Harmonizer, a digital processor that lowered my voice, to sound like a man. This was especially effective in Germany. When I spoke as a woman, they listened indulgently; but when I spoke as a man, and especially a bossy man, they listened with interest and respect.

Sorting slides with subtitles in Swiss-German, 1977

In this film animation "How to Write," from "Home of the Brave," drawings gradually turn into their Japanese ideograms. David Van Tieghem and Adrian Belew perform in front of the screen.

I've always been interested in the many dialects of American English, from '40s gangster lingo to mediaspeak. I often use electronic filters to emphasize these talking styles.

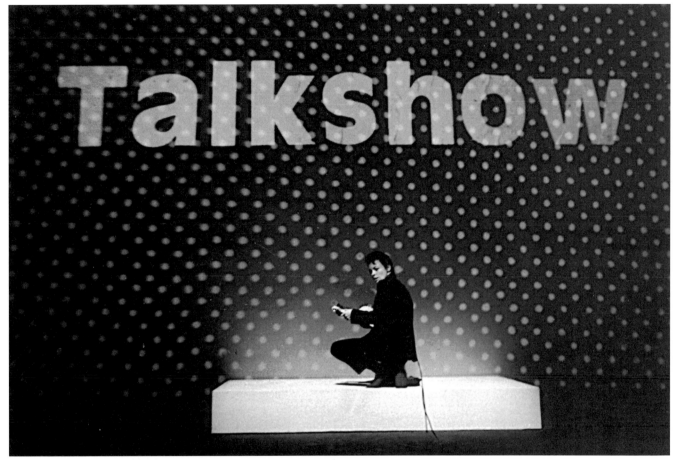

"Talkshow" from "United States 2," 1980

During the newspaper strike, the networks asked the writers to read their columns on TV. The writers weren't actors; they did all the wrong things. They squinted into the lights, wore rumpled clothes, and used BIG WORDS.

The signs for the deaf were getting more and more obscure with qualifying phrases and…uh…awkward…pauses.
So the producers kept saying:
OK! Buzz words only! Two syllables: tops!

In performances, projected words, like notes on a scratch pad or silent choruses, create a background or subplot for the spoken stories.

**UPDATE DOWNTIME DROPOUT HEADSET HEATWAVE FLASHBACK WETBACK
JETLAG EARSHOT GRIDLOCK BACKBEAT CROSSFIRE FEEDBACK DOMEHEAD HOTSHOT
NOSECONE UPSHOT MELTDOWN HOTLINE PHASELOCK UPLINK RERUN**

In 1980, I wrote a song for William Burroughs called "Language Is a Virus from Outer Space." This was a quote from one of Burroughs's books and it's a strange thing for a writer to say, that language is a disease communicable by mouth. It's also a very Buddhist thing to say. I mean, in Buddhist thought, there's the thing and there's the name for the thing and that's one thing too many. Because sometimes when you say a word, you think you actually understand it. In fact, all you're doing is saying it, you don't necessarily understand it at all. So language, well, it's a kind of trick.

"Three Blind Boys" from "Language Is a Virus from Outer Space," 1986

I saw this guy on the train, and he seemed to have gotten

stuck in one of those abstract trances, and he was going

"Uuuuugh…ugh…uuuuuuuugh!!"

And Geraldine said: You know, I think he's

in some kind of pain.

I think it's a pain cry. And I said:

If that's a pain cry, then language…is a virus…

from "Language Is a Virus from Outer Space" 1986

A FRAME B FLICK C NOTE D DAY E COLI F STOP G MEN H BOMB
I BEAM J WALK K RATIONS L SHAPE MC² NYC O TYPE P COAT
Q TIP RSVP S CURVE T SHIRT U BOAT V SIGN WWII X RAY Y ME? ZZZ

Good evening. Now, I'm no mathematician but I'd like to talk about just a couple of numbers that have really been bothering me lately, and they are zero and one. Now first, let's take a look at zero. Now nobody wants to be a zero. To be a zero means to be a nothing, a nobody, a has-been, a ziltch.

On the other hand, just about everybody wants to be number one. To be number one means to be a winner, top of the heap, the acme. And there seems to be a strange kind of national obsession with this particular number.

Now, in my opinion, the problem with these numbers is that they are just too close—leaves very little room for everybody else. Just not enough range.

So first, I think we should get rid of the value judgments attached to these two numbers and recognize that to be a zero is no better, no worse, than to be number one.

Because what we are actually looking at here are the building blocks of the Modern Computer Age.

from "Lower Mathematics" 1986

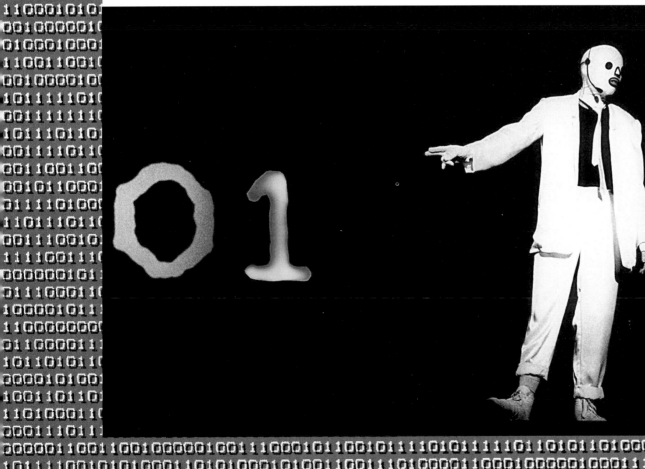

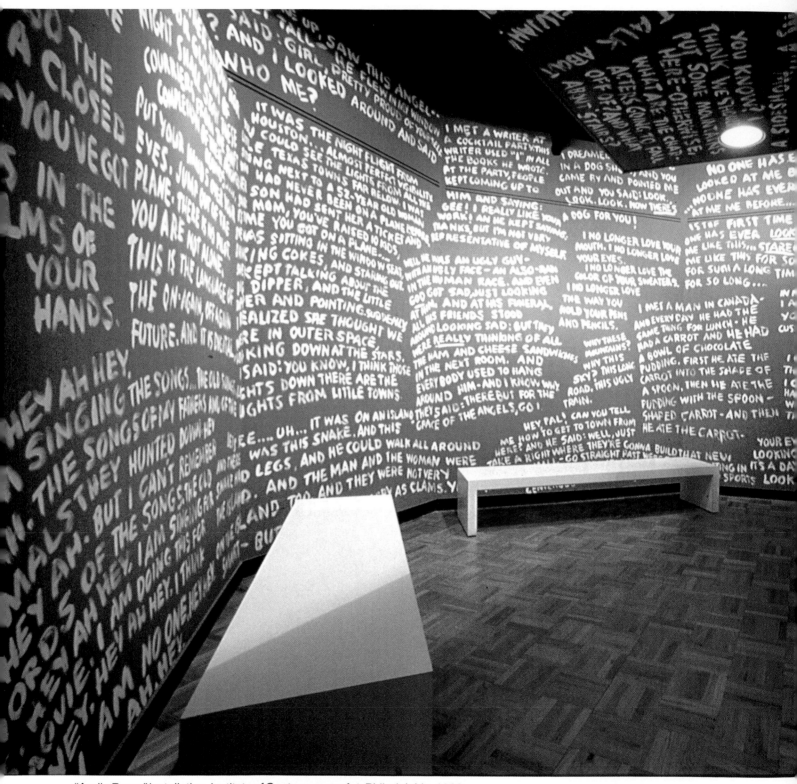

"Audio Room" installation, Institute of Contemporary Art, Philadelphia, 1983

Nicholas Zurbrugg: Can you remember your first performance as a storyteller?

Laurie: I can remember my first performance as a liar.

NZ: What was that? Was that as a child?

LA: Yeah. I'd just make things up for the other kids. And these sort of had to do with the Bible, but not too much. Based on the Bible, put it that way. I grew up in the Bible Belt and spent a lot of my childhood listening to these stories, at Bible school, Bible camp, Sunday school and so on. And these stories were completely amazing. Outrageous stories! About parting oceans and talking snakes. And people really seemed to believe these stories. And I'm talking about adults. Adults who mainly just did the most mundane things imaginable (mowing their lawns, throwing potluck parties). They all believed in these wild stories. And they would sit around and discuss them in the most matter of fact way.

NZ: So that was a kind of local surrealism.

LA: No, no, that was the local truth. Surrealism is an art term. We weren't artists.

NZ: How did you move from Bible Belt storytelling? When did you go through the art barrier, as it were?

LA: I haven't. I try to tell the truth as I see it. I'm just telling the same mixture of midwestern Bible stories that I always have. They're a mixture of the most mundane things with a fabulous twist on them. It's only what I learned in Bible school. How Bible school related to public schools is what I'm interested in. Always have been.

from an interview with Nicholas Zurbrugg 1991

25. FRAMES FOR THE PICTURES

Some things are just pictures
They're scenes before your eyes.
Don't look now, I'm right behind you.

from "Coolsville" "Empty Places" 1989

You know, people often ask me whether I'm a filmmaker or a musician and it always reminds me of that question: So if you could have the choice between having no eyes and no ears which would it be? I could never really decide.

I mean, first of all the eyes can be very stupid. They can slip out of focus and miss really important things. "Yeah, we were here all right, and open, but we're just blobs of jelly after all. We didn't see a thing."

Also, the eyes are really kind of primitive. They're like pre–World War II field cameras. I mean the lenses are very crude, you can't do any zooms. And the pans look really terrible and the dolly shots are a mess with your feet moving up and down like that all the time. It's just not too smooth.

For example, let's say you walk into a restaurant and here's what your eye is really seeing: the door swings open and there's an awkward jerk backwards and the flash of somebody's arm. Then a rickety scan of the restaurant as you look for a table. Suddenly the floor lurches into view as someone bumps into you.

If at the end of the day you looked at the rushes of this shoot, you'd immediately fire the cameraperson.

But the point is when you think back on the same scene in the restaurant or when you dream about it, suddenly the camera work has really improved. You see the establishing shot, a bird's-eye view of the restaurant followed by a two-shot of you and your dinner partner. Things are really well lit and fairly well cut.

YOUR MIND HAS FIXED IT ALL UP FOR YOU.

And it's this doctored-up fake that passes for vision, not the actual chaos we see through our eyes. And the same thing happens when you try to picture the past or the future. Things get filtered through your memories and your expectations and they smooth it all out.

from "Voices from the Beyond" 1991

"Mailman," a photograph from "Dark Dogs, American Dreams,"
1980

The Mailman's Nightmare

I have this recurring nightmare, and that is that everyone in the world, except myself, has the proportions of babies. I mean they're normal height and everything, five feet, six feet tall, but they have these giant heads, like babies, you know? And enormous eyes, and tiny arms and legs, and they can hardly walk. And I'm going down the street and when I see them coming, I give them some room and step aside. Also, they don't read or write, so I don't have that much to do. Jobwise, it's pretty easy.

from "Dark Dogs, American Dreams," an installation, Holly Solomon Gallery, 1980

Dark Dogs, American Dreams

An audio-visual installation, Holly Solomon Gallery, New York City 1980.

There were twelve very large soft-focus portraits. On a central console, the viewer could select one of the portraits and listen to an audiotape of that person reading a dream. These were my own dreams, but I liked the sounds of all these different voices. Each dream was like a short song.

Girl-on-the-Beach

I had this dream, and in it I wake up in this small house somewhere in the tropics. And it's very hot and humid and all these names and faces are somehow endlessly moving through me. It's not that I see them exactly. I'm not a person in this dream, I'm a place. Yeah, a kind of a … just a place. And I have no eyes, no hands. And all these names and faces just keep passing through. And there's no scale, just a lot of details. And I'm thinking of a detective movie, you know,

when the hero is dead at the very beginning, so there's no whole person, just a slow accumulation of details. Or, you know, like films in the '20s where you're sitting there and you're hardly ever aware of the fact that twenty-seven out of every sixty minutes you're sitting in total darkness.

Cheerleader

In this dream, I'm coming out of a Jane Fonda movie and I see that all the other women coming out of the theater are walking like Jane Fonda. Even the ones with short legs are walking like they have really long, leggy legs. And everyone's talking like her too. They keep repeating lines from the movie like "That's really not fair!" But the main thing is that in the movie Jane Fonda's head is really big and in technicolor. And all these women are really small and there are lots of them and their heads just aren't as big. Their heads are really small and not well-lit, like shrunken heads, really. They all seem to have these real horrible shrunken heads and they just keep coming out of the movie theater.

Artist with Sailfish and Lamp

"Frames for the Pictures" from "United States 2," 1980. The rear screen projectionist, wearing headset, leans in front of the projector, casting a large shadow on the screen.

Frames for the Pictures

I had this dream, and in it my mother is sitting there cutting out pictures of hamsters from magazines. In some of the pictures, the hamsters are pets, and in some of them, hamsters are just somewhere in the background. And she's got a whole pile of these cedar chips, you know the kind, the kind from the bottoms of hamster cages, and she's gluing them together into frames for the pictures. She glues them together, and frames the pictures, and hangs them up over the fireplace. That's more or less her method. And suddenly I realize that this is just her way of telling me that I should become a structuralist filmmaker, which I had, you know, planned to do anyway.

from "United States 2" 1980

The Happy Ending

You know, I really appreciate that the United States is the only government in the world to put something about happiness in a government doctrine. I mean, this is really incredible. Happiness, the word happiness! in a government doctrine. Not justice or fairness, but the pursuit of happiness!

But of course it's extremely hard to be happy, as everybody knows. Especially for my Swedish relatives who get every-thing backwards. I mean, they're a pretty gloomy bunch and when they go to a funeral they're supposed to be sad which is easy for them so they get very happy. But when they go to a party where they're supposed to be happy they find it very difficult and this makes them very depressed and sad.

But maybe it was films that really tricked people into thinking it was possible to sustain a high level of happiness. Fellini wrote that when he saw American films as a boy in Italy he was astounded by all these images of almost insanely happy people dancing around in sophisticated evening clothes on the roofs of Manhattan. Everybody was happy. It was amazing, it was obnoxious. It was maybe the reason his own films were about a lot of big parties that never ended or else went horribly, tragically wrong.

You know, there are a few Americans who are really convinced that the happy ending was a plot devised by film directors in the '30s and '40s to drive Americans crazy and personally I think, as a conspiracy theory, this one could have some weight.

from "Voices from the Beyond" 1991

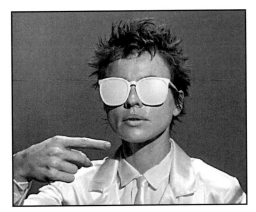

Signing lyrics in "O Superman" video, 1981

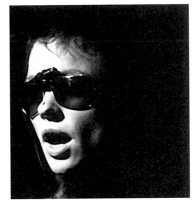

"The Audio Glasses," 1979; amplified sounds

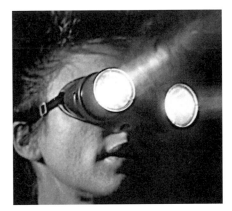

"The Headlight Glasses," 1983

I read about some sea lions in California who were being trained as Directors of Photography so that they could carry both cameras and lights down to the bottom of the ocean where whales spend ninety percent of their time. Humans can't swim at these depths, so the sea lions were being trained to document the secret life of the whales.

When I read this I thought, "I bet dogs would make good DPs." So I got a tiny video camera and attached it to several different dogs (getting mostly endless arty crotch shots). I also attached it to the trunk of a mechanical stuffed elephant who trundled around a stage during a concert raising his trunk and taking very low crane shots of the audience. I had wanted to attach the cameras to squirrels for a treetop view of suburbia, but I was afraid the squirrels would run off for good.

Dutch Astronaut

Last fall I was on a German TV variety show. The guests were Gidon Kremer (the Russian violinist), Tina Turner, four Dutch astronauts, and myself. After the show, I had a long talk with one of the astronauts about technology. But I found it very hard to talk to this guy because he was wearing contact lenses with x's marked on them. Scientists were studying his peripheral vision and they kept losing track of the iris, so they marked the center of his eyes with x's. So he had these little x's sort of orbiting around in his eyeballs and I said, "Listen, you've gotta get glasses."

from "Natural History" 1986

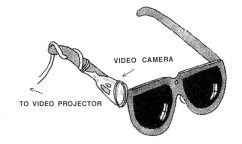

"The Video Glasses," 1992

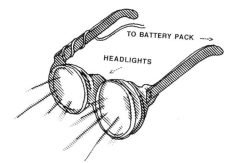

"The Headlight Glasses," 1983

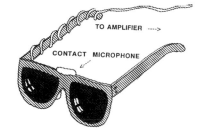

"Audio Glasses," 1979

143

THE ROOM-AS-A-CAMERA (FINE ARTS BUILDING, MAY, 1976)

EXTERIOR VIEW OUTLINED WITH PIN PRICKS IN WINDOW SHADE

Sketch from an installation of "The Room as Camera," 1976

It was the night flight from Houston, almost perfect visibility. You could see the lights from all the little Texas towns far below. I was sitting next to a fifty-two-year-old woman who had never been on a plane before. Her son had sent her a ticket and said, "Mom, you've raised ten kids, it's time you got on a plane."

She was sitting in the window seat staring out. She kept talking about the Big Dipper and pointing. Suddenly I realized she thought we were in Outer Space, looking down at the stars. I said, "I think those lights down there are the lights from little towns."

from "Like a Stream" 1978

The Camera Never Lies
"Alive From Off Center," TV show, 1987

CLONE IS SITTING AT HIS DESK. IT'S COVERED WITH BOOKS ABOUT EISENSTEIN. A FRAMED PICTURE IS PROPPED UP AMONG THE MESS. THE CLONE IS WEARING A HAWAIIAN SHIRT AND DARK GLASSES.

CLONE: *(PICKING UP FRAMED PHOTO)* You know, ever since I had this picture taken of myself with this cardboard cutout of Ronald Reagan, I feel like I know the guy. Look at us here!

(TAKES OFF GLASSES. CLOSE UP OF PHOTO.)

We're obviously pals!

Now, they say the camera never lies. But of course, the camera is actually a great liar!

But hey, let's face it. Reality is pretty boring, right? For example, remember that vacation you took last summer? It was pretty boring, right? But take out that scrapbook and leaf through it and it looks like you're happy tourists having a wonderful time. Right?

It's more interesting, more compact, more coherent. More real.

(STROLLS AROUND)

Now, one of the most famous moments in film history is the Odessa Steps sequence in Eisenstein's "Battleship Potemkin." Now, in fact, there never was a massacre on the Odessa Steps. So what was Eisenstein doing? He was making it more interesting, more compact, more coherent. More real.

So, to sum it up: Tourists take pictures to prove they were there. Filmmakers make movies because they were never there.

Photography and Good Design

1977

This is a song for all the current flowing through the room. Various lights, flickering fluorescent tubes, and electrical equipment on stage are miked and sent through a phase shifter to accentuate the electrical hum. This pitch is then played as the root of a dissonant chord on a Farfisa electric organ.

Darling, I stayed at your place when you went to California,
and I saw all those photographs of her smiling face.
There's a big one in the kitchen, she's smiling on the beach.
There's a small one in the bathroom,
She's looking out and smiling.
Well I thought you were just friends 'til I found a letter
It said, "Darling I love you,
But you love me better."
It read, "Darling, I really love you, but you love me better."
Well I may have been blind, but now I can see.
Darling, my darling, you were two-timing me.

I looked at those photographs day after day,
Night after night.
Her eyes were a dazzling blue, even in black and white.
I tried to picture the way she talked, the way she moved,
What she thought about driving on the road alone.
She was so strange and beautiful, so cool, so warm.
And she did smile a lot.
After a while I knew I was in love with her.
I couldn't help falling in love with her.

I had a dream that she and I were lovers.
We made love all day underneath your covers.
We used all your tools to drill holes in your sculpture.

Then we lay on it all night.
She was a great cook too: cold cuts.
Well, I loved her so much. And I will never forget her,
The day she smiled and said to me,
"Darling, I love you,
But you love me better"
The day she whispered,
"Darling, I love you,
But you
Love me better."

This computer portrait was made from a verbal description of the "suspect" (myself) from "The Human Face," 1991

Fully Automated Nikon (Object/Objection/Objectivity)
Photo-narrative installation, 1973

I was eating shrimp in a little seafood restaurant in Chincoteague, Virginia. A woman who appeared to be in her mid-fifties, wearing white toreador pants, came over to my table. She stared at me for a few seconds. Then she said,

"You're her! You're really her!"

I didn't know what she meant, so I said, "What do you mean?"

"You're the one on 'The Secret Storm' who's in love with the doctor but she can't marry him because his mother suspects that you caused the accident that time when—"

"No, I'm not her," I said. "I guess I just look like her."

This seemed to delight and excite her.

"Of course you deny it!" she said. "You don't want to be recognized! I've seen a few other celebrities here and they all deny it!" I smiled. "See! You smile just like her!"

I denied it again but the more I denied it, the more convinced she was of my identity. The conversation was turning into an argument and partly to assert myself, I asked if I could take her picture. As I shot the photograph, I realized that photography is a kind of mugging, a kind of assault. I was shooting her, then stealing something.

Man with a Box

When I got back to my neighborhood, the Lower East Side in New York, I decided to shoot pictures of men who made comments to me on the street. I had always hated this invasion of my privacy and now I had the means of my revenge. As I walked along Houston Street with my fully automated Nikon, I felt armed, ready. I passed a man who muttered "Wanna fuck?" This was standard technique: the female passes and the male strikes at the last possible moment forcing the woman to backtrack if she should dare to object. I wheeled around, furious. "Did you say that?" He looked around surprised, then defiant. "Yeah, so what the fuck if I did?" I raised my Nikon, took aim, began

Two Men in a Car

to focus. His eyes darted back and forth, an undercover cop? CLICK.

As it turned out, most of the men I shot that day had the opposite reaction. When I confronted them, they acted innocent, then offended, like some nasty invisible ventriloquist had tricked them into saying dirty words against their will. By the time I took their pictures they were posing, like taking their picture was the least I could do.

From a slide show featuring frozen chickens posed in scale models of Baroque rooms, 1970

Two Tiny Pictures

"You know, I can see two tiny pictures and there's one in each of your eyes. And they're doin' everything I do! Every time I light a cigarette they light up theirs. I take a drink and they're drinking too. It's driving me crazy! It's driving me nuts!"

William S. Burroughs, "Home of the Brave" 1986

147

26. THE NOVA CONVENTION

I first met William S. Burroughs in 1978 at the Nova Convention, which was a three-day celebration of his work in New York City. During the day there were seminars about his work with Timothy Leary, Susan Sontag, and many other writers and intellectuals. At night there were concerts by musicians and poets who'd been influenced by his work. Frank Zappa read the talking asshole section from "Naked Lunch," Patti Smith played the clarinet, Phil Glass played the piano. There were lots of other people too. It was a real scene.

Keith Richards was also supposed to appear, and even though the promoters of this event knew a week ahead of time that he wasn't going to show up, they didn't announce it. They just tacked up a note and posted it on the inside of the door to the theater.

"Keith Richards will not be appearing tonight" it said in very light pencil. So a couple thousand kids poured through the door and a lot of them were looking for Keith. Phil would be playing a solo piano work and they'd be yelling "KEITH! KEITH!!!!"

Nothing would shut them up and since I was one of the emcees, I'd have to keep going out to introduce someone else they didn't want to hear. "You know, just keep the ball rolling," the promoters kept saying.

Finally Burroughs shuffled out wearing a porkpie hat and carrying a briefcase and he sat down at a big wooden desk.

"Good evening."

Gravel crunching under a ten ton truck. Plastic ripping in slow motion. That voice! And he started talking about sex and drugs and alienation, things these kids thought they'd invented themselves and they couldn't believe it. But it was that voice that really got to people. And you could never read his books again without hearing that voice saying every word.

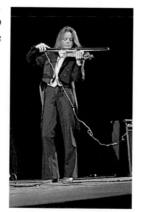

The Nova Convention was the first time I used the Harmonizer to alter my voice. This is a digital filter that I tuned to drop the pitch of my voice so that I sounded like a man. The machismo surrounding Burroughs was thick and this filter was my weapon, my defense. It was the first time I used an audio mask and being in drag was thrilling.

This Is the Language of the Future

Last year, I was on a twin-engine plane coming from Milwaukee to New York City. Just over La Guardia, one of the engines conked out and we started to drop straight down, flipping over and over. Then the other engine died and we went completely out of control. New York City started getting taller and taller.

A voice came over the intercom and said:

Our pilot had informed us that we are about to
attempt a crash landing.
Please extinguish all cigarettes.
Place your tray tables in their upright, locked position.
Your Captain says: Please do not panic.
Your Captain says: Place your head in your hands.
Captain says: Place your head on your knees.
Captain says: Put your hands on your head.
Put your hands on your knees!
(heh-heh)
This is your Captain.
Have you lost your dog?
We are going down. We are all going down
Together.

As it turned out, we were caught in a downdraft and rammed into a bank. It was, in short, a miracle. But afterwards I was terrified of getting onto planes. The moment I started walking down that aisle, my eyes would clamp shut and I would fall into a deep, impenetrable sleep

YOU DON'T WANT TO SEE THIS.
YOU DON'T WANT TO BE HERE.
HAVE YOU LOST YOUR DOG?

Finally, I was able to remain conscious, but I always had to go up to the forward cabin and ask the stewardesses if I could sit next to them: "Hi! Uh, mind if I join you?"

They were always rather irritated, "Oh, all right (what a

baby)" and I watched their uniforms crack as we made nervous chitchat. Sometimes even this didn't work and I'd have to find one of the other passengers to talk to. You can spot these people immediately. There's one on every flight. Someone who's really on your wavelength.

I was on a flight from L.A. when I spotted one of them, sitting across the aisle. A girl, about fifteen. And she had this stuffed rabbit set up on her tray table and she kept arranging and rearranging the rabbit and kind of waving to it:

"Hi. Hi there!" And I decided: This is the one I want to sit next to. So I sat down and we started to talk and suddenly I realized she was speaking an entirely different language. Computerese. A kind of high-tech lingo. Everything was circuitry, electronics, switching. If she didn't understand something, it just "didn't scan."

We talked mostly about her boyfriend. This guy was never in a bad mood. He was in a bad mode. Modey kind of guy. The romance was apparently kind of rocky and she kept saying: "Oh man you know like it's so digital!"
She just meant the relationship was on again, off again.

Always two things switching. Current runs through bodies, and then it doesn't. It was a language of sounds, of noise, of switching, of signals. It was the language of the rabbit, the caribou, the penguin, the beaver.

A language of the past.

Current runs through bodies and then it doesn't. On again. Off again.

Always two things switching. One thing instantly replaces another. It was the language of the future.

PUT YOUR KNEES UP TO YOUR CHIN.
HAVE YOU LOST YOUR DOG?
PUT YOUR HANDS OVER YOUR EYES.

JUMP OUT OF THE PLANE.
THERE IS NO
PILOT.
YOU ARE NOT ALONE.

THIS IS THE LANGUAGE
OF THE ON-AGAIN
OFF-AGAIN
FUTURE.
AND
IT IS DIGITAL.

Backstage with William Burroughs and John Giorno, San Francisco, 1980

In 1980, I went on a short club tour with Burroughs and John Giorno. The main thing I remember was that Bill kept disappearing. No matter where we were, he would find a place to go shoot targets. Even though his writing is full of paranoia and danger, I still found it frightening that he was actually using a gun.

The Nova Convention was the first time I really used the word "you" meaning specifically "you-in-the-audience." As a performer I had used "I" until I ran out of stories. Then I tried having other people read my words. But this was different! Finally, I wasn't just remembering things out loud! I was actually talking directly to people and it felt completely different.

27. THE VOICE OF AUTHORITY

Basically my work is storytelling, the world's most ancient art form. And as a narrator I have used a lot of different voices in order to escape my own perspective. They are audio masks and I find that if I sound…

(VOICE DROPS ELECTRONICALLY ONE OCTAVE IN PITCH)

like this I find I have different things to say.

I think of this as a kind of Voice of Authority, but it's also the voice of a shoe salesman or of a guy who's trying to sell you an insurance policy you don't want or need. He's a bit insecure but cheerful, not very bright but quite pompous anyway. It's only recently that I realized that this guy is based on my first ideas of who men were.

When I was a kid my father would come into my room when I was sick or sad and he would try to cheer me up by telling stories, doing little dances, and singing songs and I thought: How charming! Men are such a carefree species. So lighthearted! So free! The women, on the other hand, were

the authority figures always saying things like, "Read this book! Eat this dinner!" and the men didn't seem to have a care in the world. Now, it took me a long time to realize that this wasn't necessarily the way things were in the real world.

from "Talk Normal" 1986

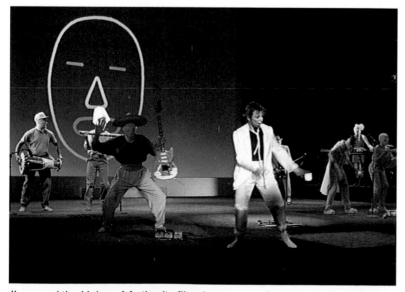

I've used the Voice of Authority filter in many performances. In addition to being male, it is also technological. It passes through systems: radio, TV, the phone, a loud p.a. Or it comes from the cockpit, the lectern, or from behind a large desk.

Well I drove down to Big D.C.
And I walked into Room 1003
And there they were
The Big Boys.
And they were talking
Big **B** Little **O** Little **M** Silent **B**
They were saying:
Let's teach those robots how to play hardball.
Let's teach those little fellas a little gratitude.

from "Sharkey's Night" 1985

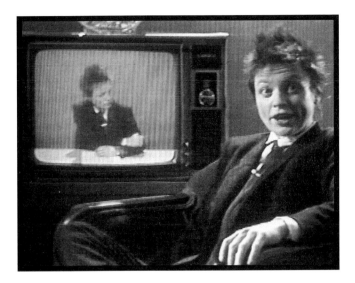

Difficult Listening Hour
For voice and two harmonizers

Good evening. Welcome to Difficult Listening Hour.
The spot on your dial for that relentless and impenetrable
sound of Difficult Music.

(THE REPEAT MODE IS HIT ON THE HARMONIZER
AND THE WORD "MUSIC" IS CAUGHT IN ITS MEMORY
AND REPEATED.)

So sit bolt upright in that straight-backed chair,
button that top button
and get set for some
difficult music.

(THE WORD "MUSIC" IS CANCELLED.)

Ooola. Oooooola. *OOOO LA!*

(THE THIRD "OOOO-LA" IS CAUGHT AND REPEATED
BACKWARDS AND THEN FORWARDS
FORMING A KIND OF RANDOM AUDIO MOEBIUS STRIP.
IT BECOMES THE BACKGROUND RHYTHM TRACK
FOR THE REST OF THE TALK.)

I came home today, and
I opened the door with my bare hands,
And I said, "Hey!
Who tore up all my wallpaper samples?
Who ate all the grapes? The ones I was saving?"
And this guy was sitting there,

And I said:
"Hey, Pal!
What's going on here?"
And he had this smile, and
When he smiled
He had these big white teeth,
Like luxury hotels
On the Florida coastline.
And when he closed his mouth, it looked
Like a big scar. And I said to myself,
"Holy Smokes!
Looks like some kind of a guest/host relationship to me."
And I said, "Hey, pal!
What's going on here anyway?
Who are you?"

And he said,
"Now, I'm the Soul Doctor,
And you know, language is a virus from Outer Space.
And hearing your name is better
Than seeing your face."

"United States" 1980

The Pirate, the Parrot, and the Skull

You know a while ago I went to the National Museum of Ventriloquism and it's in Covington, Kentucky, just across the river from Cincinnati. And they have a huge collection of figgers there, also known as dummies, but they get very upset if you refer to them as dummies, so figgers.

Apparently, pirates actually invented ventriloquism. They would get the skulls of their enemies and attach them to these sticks and they wired the jaws so that they could move them and make them talk and then they'd sit up there on deck pounding the sticks and making their enemies say whatever they wanted. And of course on their shoulder there was a parrot. So you have the pirate and the parrot and the skull and it was sort of a very elegant trio.

Of course the thing about parrots is that you can teach them to talk, but you'll never see a parrot try to teach another parrot how to talk (they just don't have access to crackers) and you can talk to a skull forever and it will never learn a thing, so it's sort of a closed circuit, but in spite of that, this pirate-parrot-skull trio has been a real inspiration to my own work. You know, you've got the mic stand "stick" and the "dummy head" mics and you stand around on stages banging the mic stands and making the mics talk.

Anyway, I've invented a few different kinds of voices for these mics and one is a group of girls that sounds like this:

SINGS INTO MIC PRODUCING HARMONIZED GIRL GROUP

Oooo!

and I use them as a kind of Greek chorus to comment on the action. I mean a lot of tragic things have happened in the United States, but there is no Greek chorus to set up a really bone-chilling wail or to comment on the action as a group.

The American version of the Greek chorus is the laugh track. It's the only way the audience is allowed to participate in the action, just raise the faders and there they all are laughing their heads off. It's why Reagan was such a successful president. He was a TV president. He understood the importance of the close-up, the conspiratorial wink; and one-on-one he could hypnotize just about anyone in the audience. I mean, you sat there in front of the TV, drooling and nodding your head. You didn't have a chance! Just like any other advertisement.

from "Voices from the Beyond" 1991

28. THE AUDIENCE

The audience in Budapest, Hungary; "Empty Places" tour, 1990

The first time I realized I could work outside of the avant garde circuit was 1978. I was scheduled to do a performance in a museum in Houston and since the museum wasn't really set up for this sort of thing, no stage, no chairs, no sound system, the performance was booked into a local country-and-western bar. The advertisements in the local papers made the performance seem like it might be some kind of country fiddling event, so a lot of the regulars came. They arrived early and sat along the bar, so when the art crowd showed up, dressed in black and fashionably late, there was nowhere to sit and they were forced to mingle.

From my point of view, it was a pretty strange looking crowd. About halfway through the concert, I realized that the regulars were really getting it. What I was doing, telling stories and playing the violin, didn't seem bizarre to them. The stories were a little weird, but then, so are Texan stories. I remember that I felt so relieved. I could talk to people who were outside the rarefied New York art world and they actually liked it. It was a whole new world.

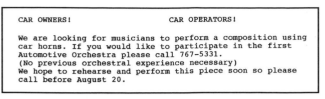

CAR OWNERS! CAR OPERATORS!

We are looking for musicians to perform a composition using
car horns. If you would like to participate in the first
Automotive Orchestra please call 767-5331.
(No previous orchestral experience necessary)
We hope to rehearse and perform this piece soon so please
call before August 20.

Is the pitch of the horn on your car, truck or motorcycle
horn either an A flat or C sharp? If so, please audition for
the Automotive Orchestra (parking lot of the Grand Union) on
Saturday.

The Audience as Performers

The first performance I did involving the audience as performers was a car concert in Rochester, Vermont, in 1972. Every Sunday evening, there was a town get-together on the green. The high school brass band played in the gazebo and everyone from the surrounding area came. The audience parked their cars on the green, circling the gazebo. The strange thing was that they never got out of their cars. After each number, they honked their horns as applause. After the somewhat tinny sound of the high school brass, the car horns sounded rich, resonant, loud, exciting. Basically, the applause sounded better than the concert.

I decided to write a piece for car horns and I handed out flyers to people as they drove up to the supermarket. Most of the drivers were somewhat suspicious of the project and politely said no thanks. So finally, I decided to make it more of a competition.

Dozens of cars and trucks showed up for the "audition." Since most of the thirty driver/musicians didn't read music, the scores were designed as color bars, one color for each type of vehicle. The bars were printed on large cards that were propped on the musicians' windshields. I conducted the piece

Explaining the scores to driver/musicians

by holding my hand over the color bars on the cards to indicate the duration of each note.

The concert was performed on the town green but this time the relationship was reversed: the audience sat in the gazebo and the orchestra surrounded it. One of the pieces sounded more or less like barking seals but another had the magnificence of an enormous traffic jam. Rochester is in a small valley and the sound pounded and reverberated for several miles like aural fireworks.

RUTLAND DAILY HERALD, MONDAY MORNING, AUGUST 28, 1972.

Rochester Concert's a Gasser

By TOM SLAYTON

ROCHESTER — (Special) — The unregulated whisper of late summer rain provided the background here Sunday afternoon as the sounds of the automotive age were harnessed in the name of art.

A dozen automobiles gathered on the Rochester town green for, of all things, a concert. Most of the audience, quiet appropriately, sat in automobiles of their own. Almost everyone came to the site of the event, one of the state's prettiest town commons, in their cars.

At Sunday's concert there were varieties of car-door slamming, revs, frantic arm waving direction and horn blasts. In fact, there was a composition entitled "The Well Tempered Beep".

There was also "Hornpipe for

Horn and Pipe," "Concerto for Landrover with Six Cylinder Backup", and (of course) an "Auto Da-Fe", which was described as "six-part fugue for the well fueled heretic".

Perhaps it was an unwitting commentary on the extent to which the external combustion engine has come to dominate life in even rural America. Perhaps it was a headache to local people who had to put up with half-an-hour of beeping, car-door slamming and laughter.

It was certainly a half-hour of good fun in the rain.

New art forms are never accepted when they first make their appearance. Sunday's gasoline concert may have been the beginning of a trend. Or maybe even the end of one.

If people can learn to laugh at themselves, they must be healthy. Now with automobiles in the saddle and driving mankind, we become blessed with an age that would love to be linked to the atom or even the stars — but has so far shown much stronger ties to the gas pump. If we could but learn to

laugh at the automobile — that undercover mainstay of our society — we might regain the health we've lost while sitting down and rolling from place to place.

The organizers of the concert are members of a group called the Rochester Horn & Engine Society. Headed by one Ms. Laurie Anderson, they declare that "car horns have dimensions other than noise pollutants and nerve irritants."

The new-forms society notes the automobile has now invaded the farthest-flung reaches of human endeavor. But they add:

"We do not aim to bring urban sounds to the country, but simply to bring some order to this ever increasing stream of sounds."

And who could be upset at that?

Trumpet on, o Horn & Engine Society. There's a wry smile in your manner that's worth all your noise and bother. Perhaps Auto Triumphant can be conquered. Humanity may yet win the battle of the highway.

(Herald photo—Slayton)

Performers Are Ready at Rochester Concert.

The Electronic Audience

In 1980 I released "O Superman" on a small New York label, Bob George's 110 Records. The idea was that we would sell it mail order, and the initial pressing was 1,000 copies financed by a $500 grant from the National Endowment for the Arts. Then one day I got a call from London, an order for 20,000 copies of the "single" immediately followed by another 20,000 by the end of the week. I looked around at the cardboard box of records and said, "Listen, can I just call you back?"

By some fluke, the record had struck a chord in London and was climbing the charts. I was equally flattered and horrified. I decided I needed some more help.

A & R people from Warner Brothers Records had been coming to my concerts for a few months and asking whether I wanted to make a record. I hadn't really been too interested; I thought that pop music was usually designed for the average twelve year old and I didn't want anything to do with it. On the other hand, I was really happy that so many people suddenly wanted to hear my music in England. So I called someone at Warners and asked if they could just press and ship some records for me. They said they didn't usually do this sort of thing ad hoc, that it would be better to sign an agreement. And that's how I got around to signing an eight record deal granting Warner Brothers Records the right to own and distribute my music "in perpetuity throughout the universe." I quickly found out that in my world (the New York avant-garde) this was considered "selling out." It took me a while to understand, but finally I realized this judgment was totally consistent. The avant garde in the late '70s was extremely protective of its own ideas, territory, and privilege. I myself had benefited from this attitude. I had been supported and protected by this network. It had always been a safe place to work, until I signed a

contract with a "commercial" company. A couple of years later, this process was known as "crossing over" and was looked on more favorably by the avant garde. By the time it was considered a "smart commercial move" in the mid '80s, there was no longer much of an avant garde left to comment on it anyway. The result of all this for me was that I had a whole new audience, an electronic audience. And I had no idea what they expected or wanted.

"O Superman" was used as a sound track for several films and as the score for many dance pieces. About eight years after I'd written this song, it began to be used in television commercials, for cotton, cars, and other products. I discovered this once by chance when the TV was on and I heard this very familiar sound, hadn't heard it in years but there it was "-ha-ha-ha-ha-ha-ha-" coming out of the television, but it might just as well have been coming from the bedsprings for all the reality it had. And I thought, I've heard that somewhere before! It turned out to be an ad for the electronic security system for the prevention of theft in luxury cars.

"NEARLY NINE OUT OF TEN OF THESE COSTLY CARS DO NOT EVEN PROVIDE A SECURITY SYSTEM TO HELP PREVENT THEFT. BEFORE YOU BUY ANOTHER CAR, BE SURE YOU SEE THE"

So I called the car company and said, "You know I wrote a song once that sounds a lot like your ad," and they said, "Small world." There was really nothing I could do without bankrupting myself in their pursuit so I gave it up but there was a certain elegance about it, considering that the theme of their ad campaign was the prevention of theft which was also how they'd obtained the sound track. On the other hand, I've taken a lot of things from pop culture so in the long run, it seems like a pretty even deal.

Talk Normal

"Talk Normal" (1988) was a series of talks. Since much of it was about my own work process, I decided to give the audience some work to do too; so at the beginning of the talk, I made this announcement:

Drawing by member of the audience

"I've been asked by the management to tell you to please refrain from any use of flash photography during the evening. If, however, anyone wants to make any charcoal sketches of the proceedings, the ushers will be coming by with newsprint pads and sticks of charcoal. Just let them know what you'll need."

In 1979, Peter Gordon and I did a performance at the Customs House in New York. Members of the audience were given questionnaires as they arrived. They were asked to answer questions about their income, education, and employment. After a period of "review" by an unseen "committee" they were assigned seats. The performance area was divided in half. On one side there were comfortable seats, color video monitors, printed programs, a waiter taking drink orders, and a long table with brie and tarts; on the other side, a couple of folding chairs, two jumbo bags of Cheez Doodles, baloney, and a black and white monitor on the fritz.

Peter and I directed our talking and playing (clarinet and violin duets) mostly towards the side with the color monitors. The audience was not told what the basis for selection had been.

Around 1978, I met the comedian Andy Kaufman. He was performing his Elvis act in a club in Queens. The performance started with Andy playing the bongos and sobbing. We became friends and I acted as Andy's straight man in clubs and field trips. At the Improv in New York, Andy would begin by insulting women and saying "I won't respect them until one of them wrestles me down!" This was my cue to jump up and fight. I sat in the front drinking whiskies, trying to get up the nerve. Meanwhile, I was supposed to be heckling him. After three whiskies, I managed to get pretty abusive. Wrestling him down, however, was pretty hard. Andy really fought.

On our "field trips" we would go to Coney Island and stand around the "test your strength" games, the ones with the big sledgehammers and bells. Andy would make fun of all the guys who were swinging away and I was supposed to beg him for one of the huge stuffed bunnies. "Oh Andy honey! Please get me a bunny! Please please!!" Finally Andy would step up to the big thermometer and swing. The indicator would wobble up to "Try again, weakling." At this point, Andy would start yelling that the game was rigged and demanding to see the manager.

We also went on the Rotowhirl, the ride that plasters everyone against the walls of a spinning cylinder and stretches their bodies into dopplered blobs. Before the ride actually starts, there are a couple of awkward minutes while the attendant checks the motor and the riders, bound head and foot, stare at each other. This was the moment that Andy seized. He would start by looking around in a panic and then he would start to cry "I don't want to be on this ride! I've changed my mind! We're all gonna die!!!" The other riders would look around self-consciously. Should they help? He would then begin to sob uncontrollably.

I loved Andy. He would come over to my house and read from a novel he was writing. He would read all night. I don't know if any of this book was ever published. I've never been one to hope that Elvis is still hanging around somewhere hiding, but I will probably always expect to see Andy reappear some day.

I never understood the concept of Mass. Who are they? And where are they? I've always thought of mass media as a kind of giant slime mold. Nobody knows what Mass refers to, and the Mass itself is incapable of expressing itself. So the method is to keep probing it, poking it, pulling it, to provoke some kind of reaction. But it just lies there in its petrie dish, completely inert.

The only people who decided that they are equipped to speak for the Mass is one lone publication, the Happy News newspaper "USA Today" whose banner headlines announce... "IT'S PROM TIME AGAIN!" or "WE'RE EATING MORE MEAT THIS WEEK." I mean: Prom time for who? and What you mean we? are just some of my questions.

So, anyway, you have this medium, television, that is both extremely public and extremely private. How do these spheres relate? Money is the answer. The programs are the lures to draw the viewer in to the ads, so s/he can participate in the true goal of broadcast TV, which is sales. This is the only way TV is truly interactive.

You know, there's a very interesting lawsuit in the courts now. The plaintiff is a man who says that whatever he tapes off television belongs to him. He says, "Look, the minute that signal comes into my house, on my private property, it is one of two things, it is a) trespassing, or it is b) an unsolicited gift."

If it is a), it is the obligation of the sender to prove it is not harmful to the receiver's health. This is difficult to do since television is radiation. Granted, radio frequency is an extremely low level of radiation but it is there. And if it's b), then it belongs to the receiver, who may use it for any purpose.

from "Talk Normal" 1986

Bribing the audience is one way to relate. I handed out keys and used batteries to the "Saturday Night Live" audience, 1986.

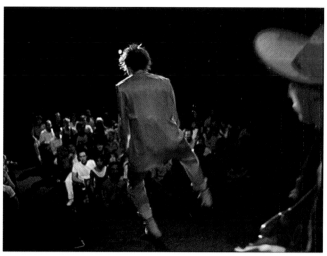

"Sharkey's Night" "Home of the Brave," 1986

The Double Audience

"Home of the Brave" was a concert film. One of the most difficult things about making this movie was the audience because there were actually two audiences: the people who came to the concert and the people who came to the movie of the concert. And this was one audience too many.

Relating to the audience as fans always made me somewhat queasy. I usually kept a camera with me and when fans shot, so would I.

Fans in London, 1990

People in audiences usually think they're invisible. But I often light the shows so that I can see the audience; watching the audience has become a way of editing my shows. If, during a piece, too many people have that "HUH?" expression on their faces, I'll cut that section out of the show. It's not that I'm trying to be simplistic or democratic. (For example, I don't think the bigger the audience, the better the music. If I thought that, then I'd think heavy metal music was by far the most brilliant music of our time.) But one of my jobs as an artist is to make contact with the audience and it has to be immediate. They don't come back later to look at the details in the background.

When "United States" was on tour we worked with a different soprano in every city. She would arrive at the theater at the last minute for instructions. Her part was to stand at the end of the diving board, sing a high "A" as long as she could and then jump into the pit. Setting up the show was usually pretty hectic, especially in Italy, and often while I was crawling around on the floor gaffing cables right before the show, I would look up to see the local soprano, dressed-to-kill in an evening gown and gloves, conducting animated interviews with the local TV crew, gesturing to the screens and instruments and explaining the show she had never seen.

On several tours ("Mister Heartbreak" and "Natural History," for example) I worked with groups of musicians. I was never a good band leader. For one thing, I didn't like being on the phone all the time trying to schedule rehearsals. And even though I recorded complicated studio versions of songs, most of the musicians who played on these records had never been in the studio at the same time. When I tried to translate the records into live performances, I found that I had to spend a lot of time building rapport with the musicians. Eventually I was spending so much time trying to do this that I no longer had much rapport with the audience, so I began to do more solo shows.

My goal has always been to make some kind of intimate contact with the audience. Sometimes I've been able to build this relationship with very large crowds and sometimes I haven't been able to make contact with very small groups. So it's not a question of size, but scale. The ideal performance space allows the audience to see the images well and hear the words clearly.

The largest audience I've ever had was Madison Square Garden when I followed Bruce Springsteen in a benefit that Paul Simon had organized. Springsteen's music is ideal stadium tempo, by the time it slaps off the rafters, the chord rings out and makes way for the next one. In this show, I performed "Let x=x," a very wordy song with not much of melody really and all the words just sort of welded together and stayed on the stage.

Once I did a concert that was really connected to its surroundings. It was in 1978, and I was part of an Italian theater festival near the town of Rimini. The festival stage was set up on a hillside about a mile from town. Power lines had been run out from Rimini to the festival. Every time there was a big light cue on stage, the whole town got dark.

From "United States 4," 1983

In most performances, there is some device to bridge the boundary between the stage and the audience. In "United States" there was a diving board that projected over the pit and a ramp with landing lights on either side. The diving board was also used in the "Home of the Brave" version of "Blue Lagoon."

Setting up the diving board for "Home of the Brave," 1986

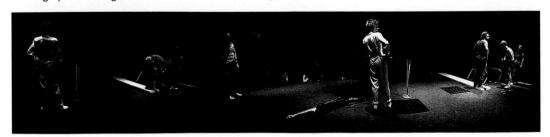

29. SOME SCENES FROM *UNITED STATES*

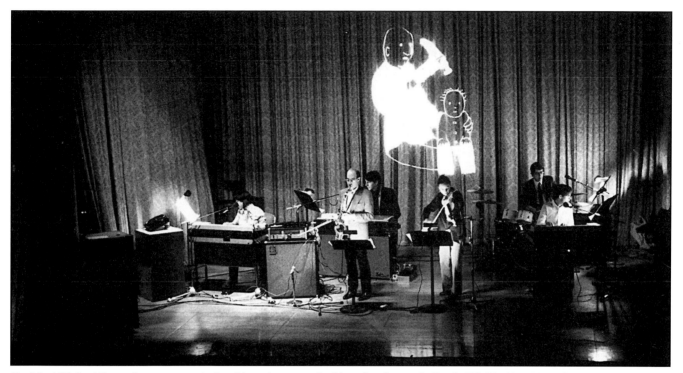

Part 1 of "United States" was presented as "Americans on the Move" at Carnegie Recital Hall in New York City, 1979.

Around 1979, I began to write "United States." I had been spending a lot of time in Europe and I'd be sitting around the dinner table with my European friends and they would ask, "So how could you live in a place like that?" always implying a high-tech cultural wasteland. The answer, the performance "United States," ended up being eight hours long. Another reason it was so long was because I thought of "United States" as an opera, a talking opera, and this fit well in the current mode. At the time, all my friends in the downtown music world seemed to be writing operas. You'd be walking down the street, see a friend and say, "So how's your opera going? Yeah, well mine's coming along too..."

"United States" was in four parts: Transportation, Politics, Money, and Love. It was designed to be a portrait of a country but the more I worked on the portrait, the more elusive it became. The idea of portraying a subject that is constantly moving became an integral part of the piece.

In 1979 I met Perry Hoberman who first worked with me as a projectionist. Later he invented a number of visual systems and helped me design the look of performances.

This slide system, "The Duck's Foot Dissolve" (named because the shutters sounded like ducks walking on wet concrete), allowed the projectionist to do real time vertical and horizontal wipes, giving the projected images a post-production look.

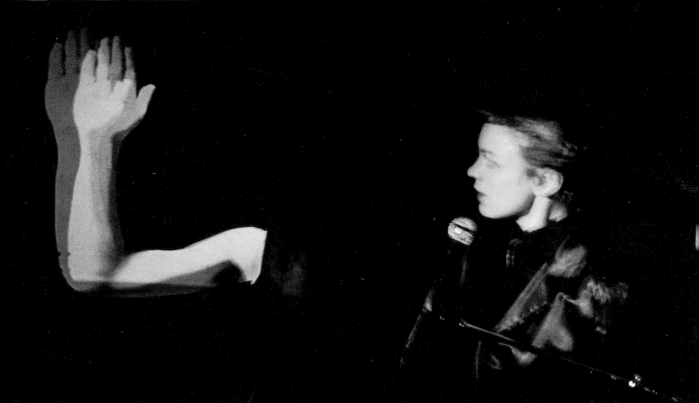

United States

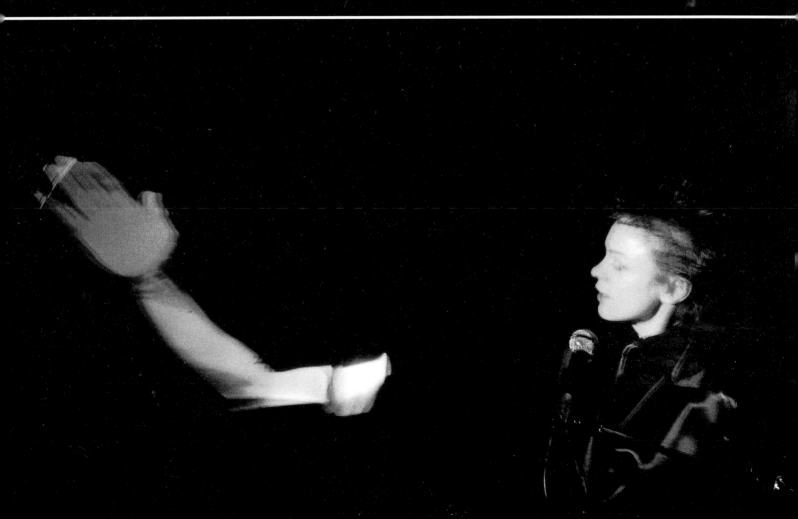

United States Part 1

SAY HELLO WALK THE DOG VIOLIN SOLO CLOSED CIRCUITS FOR A LARGE AND CHANGING ROOM PICTURES OF IT THE LANGUAGE OF THE FUTURE SMALL VOICE THREE WALKING SONGS THE HEALING HORN NEW JERSEY TURNPIKE SO HAPPY BIRTHDAY ENGLISH DANCE OF ELECTRICITY THREE SONGS FOR PAPER, FILM, AND VIDEO SAX SOLO BORN, NEVER ASKED SAX TRIO

Opposite page: Waving a white violin bow which acts as a screen. An arm appears midair.

"United States" premiered at the Brooklyn Academy of Music in 1983. The complete two-evening cycle was also presented in London and Zurich. It began with the motion problem that had appeared in "Transportation Transportation'," 1972.

A certain American religious sect has been looking at conditions of the world during the Flood. According to their calculations, during the Flood the winds, tides, and currents were in an overall southeasterly direction.

This would mean that in order for Noah's Ark to have ended up on Mount Ararat, it would have to have started out several thousands miles to the west.

This would then locate pre-Flood civilization somewhere in the area of upstate New York, and the Garden of Eden roughly in New York City.

Now, in order to get from one place to another, something must move.

No one in New York remembers moving, and there are no traces of biblical history in the upstate New York area. So we are led to the only available conclusion in this time warp, and that is that the Ark has simply not left yet.

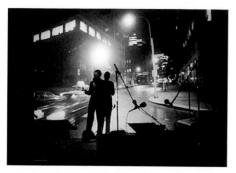

One of my work methods is to turn on all the equipment in my loft and just move around and see what happens. This is how I discovered cheap holography. I was playing the violin in front of a projector one night and noticed that if I waved the bow in front of the projector, the image would be caught on the moving bow. It hovered there like a ghost. This was a projection technique I used in "United States," creating phantom rooms and disembodied waving hands.

Images of a room are projected. White violin bow cuts into plane of focus creating a "screen." Projection of room floats midair.

Say Hello
For Two Microphones and fake Hologram

You're driving alone at night.
And it's dark and it's raining.
And you took a turn back there
and you're not sure now that it was the right turn,
but you took the turn anyway
and you just keep going in this direction.
Eventually, it starts to get light and you look out
and you realize
you have absolutely no idea where you are.
So you get out at the next gas station and you say:

Hello. Excuse me. Can you tell me where I am?

You can read the signs. You've been on this road before. Do you want to go home? Do you want to go home now?

Hello. Excuse me. Can you tell me where I am?

You can read this sign language. In our country, this is the way we say "hello." Say hello.

Hello. Excuse me. Can you tell me where I am?

In our country, this is the way we say "hello." It is a diagram of movement between two points. It is a sweep on the dial. In our country, this is also the way we say "goodbye."

Hello. Excuse me. Can you tell me where I am?

In our country, we send pictures of people speaking our sign language into Outer Space.

We are speaking our sign language in these pictures. Do you think that They will think his arm is permanently attached in this position? Or, do you think They will read our signs? In our country, "goodbye" looks just like "hello."

SAY HELLO. SAY HELLO. SAY HELLO.

162

Playing keyboards reminds me of driving a car. You sit there with this big dashboard and with your feet on the pedals, and there's a very head-on relationship with the audience. On the other hand, I love listening to long stories in a car and this piece was originally written to be listened to while driving.

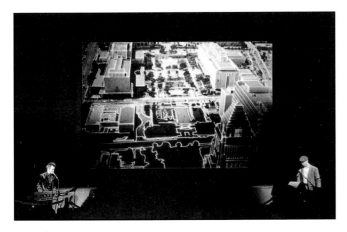

A Sideshow, a Smokescreen, a Passing Landscape (excerpts)

Duet for keyboards and a man and a woman in a car
(with Peter Gordon)

Peter: There was an old couple
who decided to drive cross country in their car.
Both of them where almost legally deaf.
About ten miles away from home,
the burglar alarm for their car door went off
and got stuck in the "on" position.
They drove all the way to San Francisco like this.
You could hear them coming from three miles away.
The alarms didn't seem to bother the old woman at all.
She thought it was sort of pleasant. Near Chicago,
she said to her husband, "It sounds like faraway bees
on a summer day." Her husband said.
"What?"

Laurie: You can read the signs.
You've been on this road before.
Do you want to go home?
Do you want to go home now?

P: One of the major airlines used to run
a kind of lottery, mostly to give passengers something
to do while the plane was waiting in line on the runway.
The stewardess would hand out lottery tickets
and you peeled the sticker away.
If you had the right combination of numbers,
you won a free trip to Hawaii. If you didn't,
you didn't win a free trip. The airline discontinued
the game when there were too many complaints
about the timing of the lottery. They said,
"Our surveys tell us that our customers
felt that waiting on the runway was the wrong
time to play a game of chance."

L: In my dream, I am your customer,
and the customer is always right.

P: He said, "You know, to be really safe you should always carry a bomb on an airplane. Because the chances of there being one bomb on a plane are pretty small. But the chances of two bombs are almost minuscule. So by carrying a bomb on a plane, the odds of your becoming a hostage or of getting blown up are astronomically reduced."

L: You're driving and you're talking to yourself and you say to yourself: Why these mountains? Why this sky? Why this road? This big town. This ugly train.

P: In our eyes. And in our wives' eyes. In our arms and (I might add) in our wives' arms.

L: How come people from the North are so well organized, industrious, pragmatic and, let's face it, preppy? And people from the South are so devil-may-care? Every man for himself.

P: I know this English guy who was driving around in the South. And he stopped for breakfast in southeast Georgia. He saw "grits" on the menu. He'd never heard of grits so he asked the waitress, "What are grits, anyway?" She said, "Grits are fifty." He said, "Yes, but what are they?" She said, "They're extra." He said, "Yes, I'll have grits, please."

L: Over the river, and through the woods. Let me see that map.

P: A sideshow. A smokescreen. A passing landscape.

P: I remember when we were going
to go into outer space. I remember when
the President said we were going to look
for things in outer space. And I remember the
way astronauts talked and the way everybody
was watching because there was a chance
that they would burn up on the launching pad
or that the rocket would take off
from Cape Canaveral and land in Fort Lauderdale
five minutes later by mistake.
And now we're not even trying to get that far.
Now it's more like the bus. Now it's more like
they go up just high enough to get a good view.
They aim the camera back down.
They don't aim the camera up.
And they take pictures and come right back
and develop them.
That's what it's like now. Now that's what it's like.

L: Every time I hear a fire engine it seems
like the trucks are running away from the fire.
Not towards it. Not right into it.
They seem like monsters in a panic,
running away from the fire.
Stampeding away from the fire.
Not towards it. Not right into it.

P: In Seattle, the bus drivers were out on strike.
One of the issues was their refusal to provide
a shuttle service for citizens to designated
host areas in the event of a nuclear attack on Seattle.
The drivers said, "Look, Seattle will be a ghost town."
They said, "It's a one-way trip to the host town,
we're not driving back to that ghost town."

L: A city that repeats itself endlessly.
Hoping that something will stick in its mind.

We were in a large room. Full of people. All
kinds. And they had arrived at the same time.
And they were all free and they were all asking
themselves the same question: What is behind
that curtain? They were all free. And they were
all wondering what would happen next.

*from "So Happy Birthday," a duet for a man and woman
performed by Geraldine Pontius and Joe Kos, 1979*

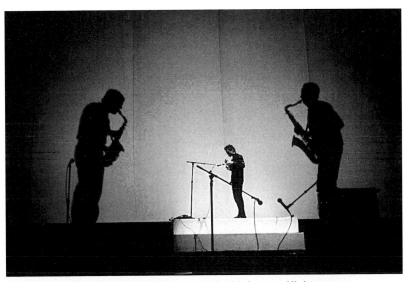

Sax players play live behind the screen lit with focused light source.

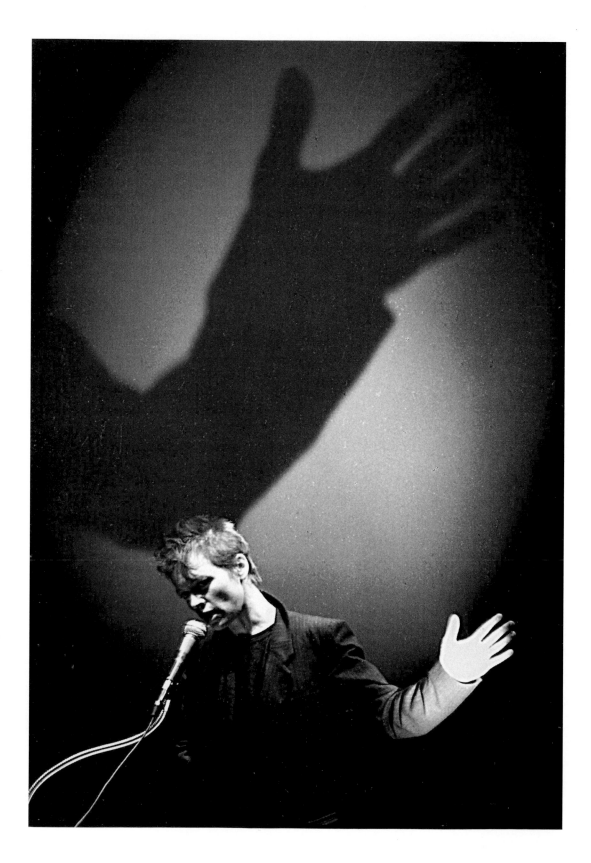

United States Part 2

FROM THE AIR BEGINNING FRENCH O SUPERMAN TALKSHOW FRAMES FOR THE PICTURES
DEMOCRATIC WAY LOOKING FOR YOU WALKING AND FALLING RED HOT PRIVATE PROPERTY
NEON DUET LET X=X THE MAILMAN'S NIGHTMARE DIFFICULT LISTENING HOUR LANGUAGE IS A VIRUS
FROM OUTER SPACE (FOR WILLIAM S. BURROUGHS) REVERB IF YOU CAN'T TALK ABOUT IT,
POINT TO IT (FOR LUDWIG WITTGENSTEIN AND REVEREND IKE) CITY SONG FINNISH FARMERS

"United States Part 2" was first performed in 1980 at the Orpheum Theater in New York City, co-sponsored by the Kitchen. Ronald Reagan had just been elected president and the humiliation of the aborted hostage rescue in the Iranian desert was still fresh.

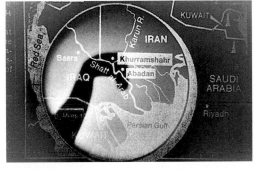

Spinning, holding two tape bows which were miked to sound like a helicopter

167

"O Souverain" by Massenet

In 1978 I went to a remarkable concert in Berkeley, California. The program of songs was presented by Charles Holland accompanied by Dennis Russell Davies.

At the beginning of the concert, Charles was really nervous. He kept dropping the music paper, dropping his glasses. Finally he began to sing "O Souverain" by Massenet from "Le Cid." "O Souverain" is basically a prayer for help. So, as Charles said later, he was in an ideal emotional state: singing about what he was actually feeling at the moment. In other words: Lord help me now!

Ah, all is over, finished!
My beautiful dreams of glory,
My dreams of happiness
Have flown away forever!
Thou hast taken my love,
Thou hast taken the victory!
Almighty, I submit to thee.

O Sovereign, O Judge, O Father!
Always veiled, present always.
I adored thee in prosperous times.
And blessed thee in somber days.
I go where thy will calls me
Free of all human regrets.

O Sovereign, O Judge, O Father!
Thine image alone is my soul
I give myself to thine hands.

O heavens, azure, luminary
Spirits from on high bending over
It is the soldier who falls in
despair, but with God all faith
is there. Thy may come, Thy may
appear with the Dawn of Eternal Day.

O Sovereign, O Judge, O Father!
This servant to a Just Master answers Thy
call without fear!
O Sovereign. O Judge. O Father!

Ah! tout est bien fini!
Mon beau rêve de gloire,
Mes rêves de bonheur
S'envolent a jamais!
Tu m'as pris mon amour
Tu me prends la victoire,
Seigneur, je me soumets!

O souverain, ô juge, ô père
Toujours voilé, présent toujours,
Je t'adorais au temps prospère
Et te bénis aux sombres jours!
Je vais òu ta loi me réclame
Libre de tous regrets humains!

O souverain, ô juge, ô père,
Ta seule image est dans mon âme
Que je remets entre tes mains!

O firmament, azur, lumière,
Esprits d'en haut penchés sur moi,
C'est le soldat qui désespère,
Mais le chrétien garde sa foi.
Tu peux venir, tu peux paraître
Aurore du jour éternel!

O souverain, ô juge, ô pere!
Le serviteur d'un juste maître
Répon sans crainte à ton appel.
O souverain, ô juge, ô père!

I was so impressed with the emotional intensity of this song and with Charles's interpretation of it, that I decided to write a kind of cover version. The song I wrote was, in turn, covered many times in English, German, Italian, and finally back into French. French cover version of "O Superman."

The writer Robert Coe, 1979

I met Robert Coe in 1979 and it was the beginning of a long series of collaborations. Robert worked as a dramaturg on many projects ("United States," "Mister Heartbreak," "Empty Places," "Stories from the Nerve Bible"). He helped me with the broadest concepts as well as with the tiniest details, shifting words in songs, suggesting lines, Shakespeare quotes, statistics, and helping me edit whole notebooks into their final song forms. He would sit and listen to endless takes of songs and suggest changes that always seemed to sharpen the meaning. In "Let x=x" for example, he changed "Several moons are out tonight" to "Satellites are out tonight."

O Superman...O Judge...O Mom and Dad...
O Superman ..O Judge...O Mom and Dad...
- - - - - -
Hi Mom...I'm not home right now but if you'd like to leave a message- please
wait - - - - - - for the sound of the beep *WHERE ARE YOU? I HATE DIRT-*
here HI! This is your mother. You know - - ---honey...I fixed your favorite dinner *I SWEEP*
Are you coming home? You can come come as you are_ - - - - (nothing fancy) *ALL DAY*
But don't forget to pay - - - -To pay as you go. *just remember*
MOVE IT OUT!
And Mom said: - - - - - You know when love is gone- there's always justice- *singin*
And when justice is gone- there's always force
And when force is gone - there's always mom. Hi Mom.
- - - - - -
O Superman...O Judge...O Mom and Dad......
- - - - - - *(strings out)*
And Mom said: You know the government today- and they said: *called*
Is anybody home? You home? - - - -
They said: Well we got the know how- we got the can do- we got the go ahead-
and we're taking you know who...Well you can come as you are ...Are you ready?
But you know you got to pay as you go.
- - - -
And I said: WOK...Who is this really?...And they said: *the voice said -*
Neither snow nor rain nor gloom of night - - - -Can stay these couriers from
the swift completion..of their appointed rounds *(MASSEN ET BIRDS?)*
MOVE IT OUT!
And Mom said: Have Here come the planes - - - -Strange planes - - - -
They're made in America--they're American planes...
- - - -
She said: When love is gone- there's always justice...And when justice is gone-
there's always force- and when force is gone...there's always *Mom, Hi Mom*
MASS She said: Here come the planes- Strange planes- They're made in America- they're American planes-
Smoking or non smoking?
You know when love is gone- there's always justice- and when justice is gone there's always force & when force is gone
there's always *So hold me mom - your arms- they're electronic*

Working notes for "O Superman"

O Superman

O Superman. O Judge. O Mom and Dad.
O Superman. O Judge. O Mom and Dad.

Hi. I'm not home right now.
But if you want to leave a message,
just start talking at the sound of the tone.

Hello? This is your mother. Are you there?
Are you coming home? Hello? Is anybody home?

Well you don't know me but I know you.
And I've got a message to give to you.
Here come the planes.
So you better get ready, ready to go.
You can come as you are, but pay as you go.
Pay as you go.

And I said: OK! Who is this really?
And the voice said:
This is the hand, the hand that takes.
This is the hand. The hand that takes.
Here come the planes.
They're American planes, made in America.
Smoking or nonsmoking?

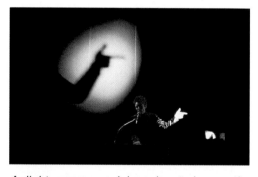

A light source and lens located near the performer projects a shadow onto the screen.

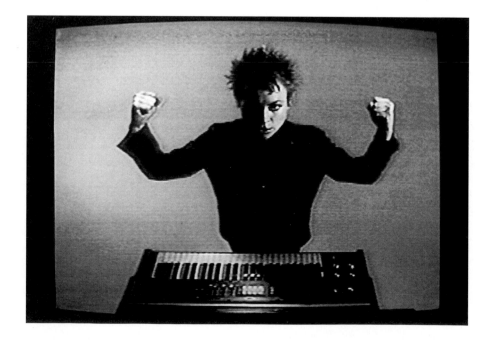

From the video "O Superman"

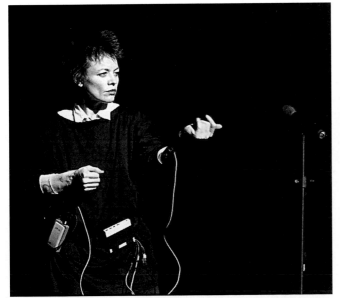

And the voice said: Neither snow nor rain
nor gloom of night
shall stay these couriers from the swift completion
of their appointed rounds.

'Cause when love is gone, there's always justice,
and when justice is gone,
there's always force,
and when force is gone, there's always Mom. Hi Mom!

So hold me Mom in your long arms.
So hold me Mom, in your long arms
in your automatic arms
your electronic arms, in your arms.

So hold me Mom, in your long arms,
your petrochemical arms
your military arms
in your electronic arms.

Using the Bodysynth, a midi device triggered by hand motions,
in "Stories from the Nerve Bible," 1992

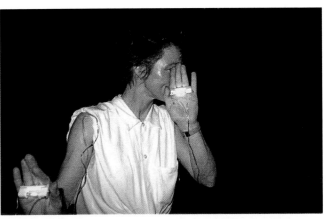

Testing the handheld lights in "Home of the Brave," 1986

From *"Plate Cancellations"* lithograph, 1972. At the end of a limited edition printing run, the plate is crossed out (to prevent further prints being pulled from that plate). In *"Plate Cancellations"* the cross itself was the motif.

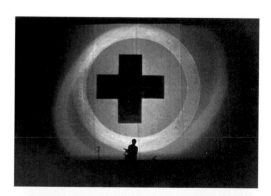

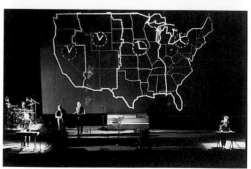

A video game rocket is projected over a map, a postcard, and various objects.

Let x=x

For Vocoder, marimba, claps, and metronome

I met this guy, and he looked like he might have been a hat check clerk at an ice rink, which, in fact, he turned out to be, And I said:
Oh boy! Right again!

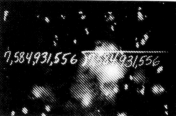

Let $x=x$. You know, it could be you.
It's a sky-blue sky. Satellites are out tonight.
Let $x=x$.

You know, I could write a book.
And this book would be thick enough to stun an ox.
'Cause I can see the future, and it's a place.
About seventy miles east of here, where it's lighter.

Linger on over here. Got the time?
Let $x=x$.

I got this postcard and it read, it said: Dear Amigo, Dear Pardner,
Listen, I just want to say thanks. So…thanks.
Thanks for all the presents.
Thanks for introducing me to the chief.
Thanks for puttin' on the feedbag.
Thanks for going all out.
Thanks for showing me your Swiss Army knife.
Oh and uh…thanks for letting me autograph your cast.
Hug and kisses,
XXX OOOO

Oh yeah. P.S.
I…..I feel….feel like….I am…..in a burning building
And I gotta go.

Your eyes. It's a day's work looking into them.
Your eyes. It's a day's work just looking into them.

Finnish Farmers

For voice, violin, and drums

During World War Two, the Russians were testing their parachutes. Sometimes they didn't open at all and a lot of troops were lost this way. During the invasion of Finland, hundreds of troops were dropped during the middle of winter. As usual, some of the chutes didn't open and the troops fell straight down into the deep snow, drilling holes fifteen feet deep.

The Finnish farmers would then get out their shotguns, walk out into their fields, find the holes, and fire down them.

During the 1979 drought in the Midwest, the American farmers began to rent their property to the United States government as sites for missile silos. They were told: Some of the silos contain Minutemen, and some do not. Some are designed to look like ordinary corn and grain silos. The military called these the Decoy Silos, but the farmers called them the Scarecrows. The government also hinted that some of these silos might be connected by hundreds of miles of railroad in an underground shuttle system.

This is the breadbasket. These are the crops.
The shot heard round the world.

The farmers, the Minutemen.
The farmers,
the ones who were there.

Breadbasket. Melting Pot.
Meltdown.
Shutdown.

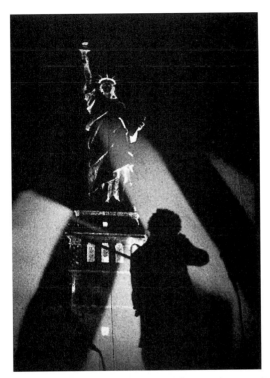

An image of the Statue of Liberty is superimposed over a film of an American flag spinning around in a dryer. The violin is played to sound like a siren.

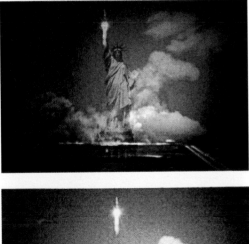

30. THE ELECTRIC BODY

One day, Geraldine said to me, "You know, everytime I come to your house, I think I'm going to be electrocuted."

from "Windbook" 1975

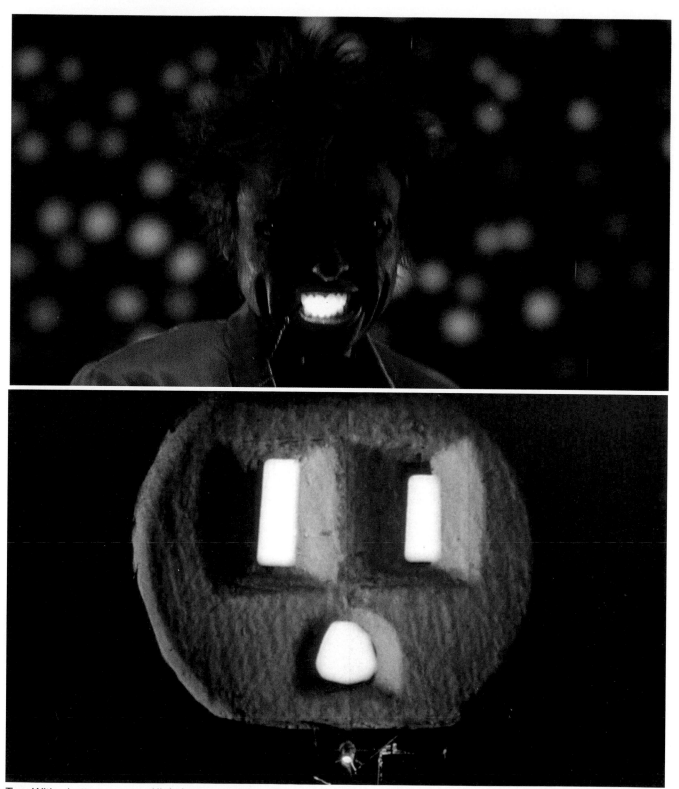

Top: With a battery-powered light in my mouth from "Home of the Brave," 1986. Bottom: from "United States 3," 1983

I saw a photograph of Tesla, who invented the Tesla Coil. He also invented a pair of shoes with soles four inches thick to ground him while he worked in his laboratory. In this picture, Tesla was sitting in a chair, wearing the shoes, and reading a book by the light of the long streamer-like sparks shooting out of his transformers.

A while ago, I got a call from the Tesla Institute in Belgrade, long distance. The voice was very faint and it said, "Understand, do we, that much of your work has been dedicated to Nikola Tesla and do we know the blackout of information about this man in the U.S. of A. And so we would like to invite you to the Institute as a free citizen of the world as a free speaker on American Imperialist Blackout of Information, Capitalist resistance to Technological Progress, the Western World's obstruction of Innovation. So think about it." He hung up. I thought: "Gee, really a chance to speak my mind" and I started doing some research on Tesla, whose life story is actually really sad.

Basically, he was the inventor of AC current, lots of kinds of generators, and the Tesla coil. His dream was wireless energy. And he was working on a system in which you could plug appliances directly into the ground, a system which he never really perfected.

Tesla came over from Graz and went to work for Thomas Edison. Edison couldn't stand Tesla for several reasons. One was that Tesla showed up for work every day in formal dress: morning coat, spats, top hat and gloves, and this just wasn't the American Way at the time. Edison also hated Tesla because Tesla invented so many things while wearing these clothes.

Edison did his best to prevent conversion to AC and did everything he could to discredit it. In his later years, Edison was something of a showman, and he went around on the Chautauqua circuit in upstate New York giving demonstrations of the evil effects of AC. He always brought a dog with him and he'd get up on stage and say: "Ladies and gentlemen! I will now demonstrate the effects of AC current on this dog!" And he took two bare wires and attached them to the dog's head and the dog was dead in under thirty seconds.

At any rate, I decided to open the series of talks in Belgrade with a song called "The Dance of Electricity" and its beat is derived from the actual dance, an involuntary dance, and it's the dance you do when one of your fingers gets wedged in a live socket and your arms start pumping up and down and your mouth is slowly opening and closing and you feel the power but no words come out.

from "United States 1" 1979

For me, electronics have always been connected to storytelling. Maybe because storytelling began when people used to sit around fires and because fire is magic, compelling and dangerous. We are transfixed by its light and by its destructive power. Electronics are modern fires.

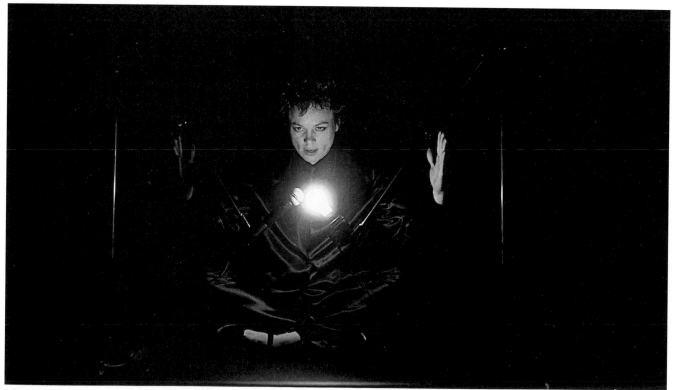

Neon mic stand, "Home of the Brave,"
1985

And don't think I haven't seen all those
Blind Arabs around! I've seen 'em around.
And I've watched then charm that oil
Right out of the ground.
Long black streams of that dark, electric light.
And they said, "One day, the sun went down
And it went way down, into the ground.
Three thousand years go by…
And we pump it right back up again."
'Cause it's a closed circuit, baby.
We can change the dark into the light.
And vice versa."

from "Closed Circuits" 1979

"Closed Circuits" "United States 1," 1979

Console from "Home of the Brave," 1986

Well I had a dream and in it
I was teaching cave people how to use
Blenders and toasters.
I drive up to the cave in my car.
Hey hey hey hey! In my car.
And there they are banging their heads
Against the walls of the cave.
And I say: Hey folks! Listen!
You're doing it the hard way.
Lemme show you a thing or two.

from "Yankee See" 1983

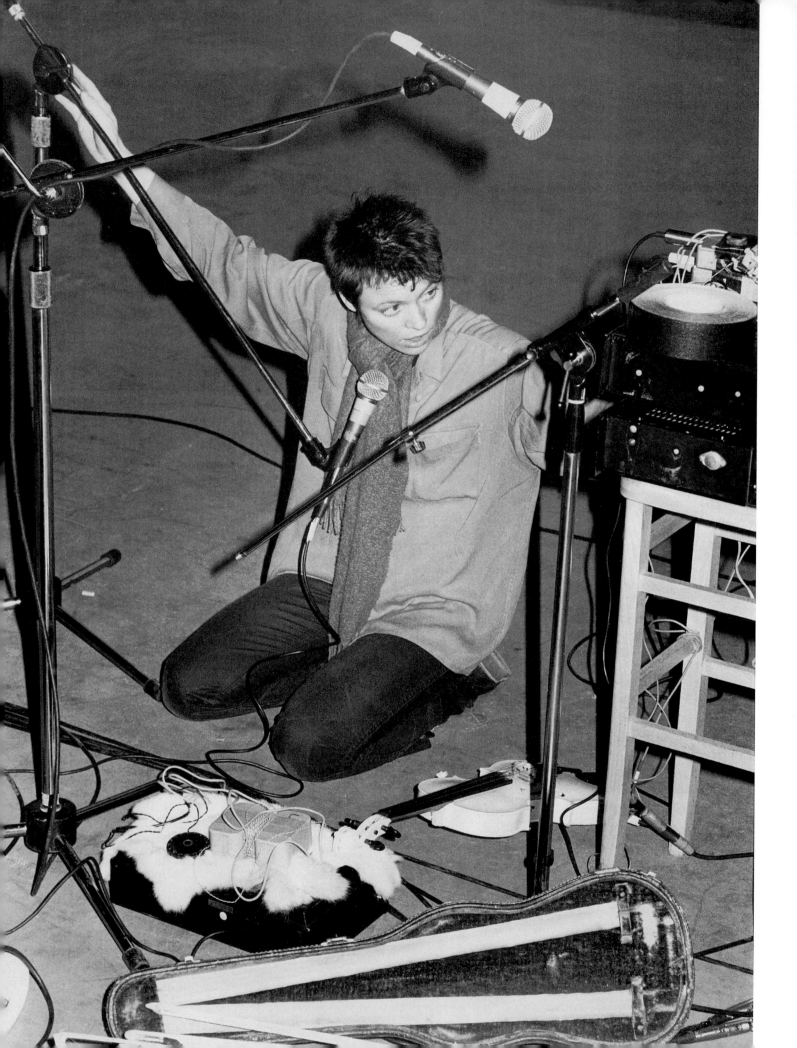

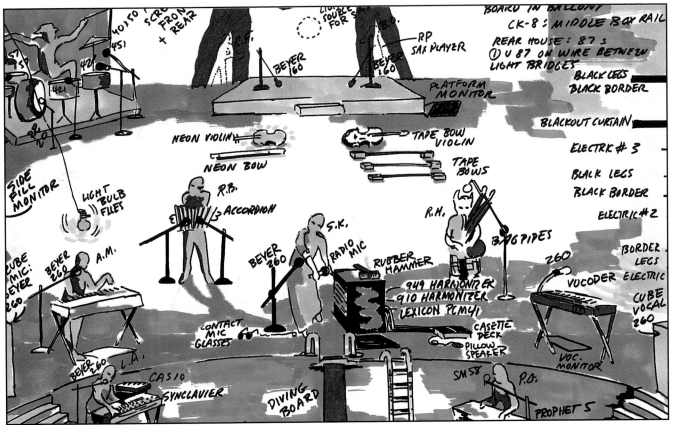

Tech diagram for "United States 1-4," 1983

Well I walked uptown and I saw a sign that said:

TODAY'S LECTURE:

BIG SCIENCE AND LITTLE MEN.

So I walked in and there were all these salesmen and a big

Pile of electronics.

And they were singing: "PHASE LOCK LOOP.

NEUROLOGICAL BONDING. VIDEO DISC."

They were singing:

"WE'RE GONNA LINK YOU UP."

They were saying "WE'RE GONNA PHASE YOU IN."

They said, "Let's look at it this way:

Picture a Christmas tree with lots of little sparkly lights,

And each light is totally separate but they're all sort of

Hanging off the same wire. Get the picture?"

And I said: "Count me out!" And they said:

"We've got your number."

And I said: "Count me out. You gotta count me out!"

from "Language Is a Virus" 1979

Opposite page: Setting up equipment in London, 1981

Stage diagram for "Natural History," 1986

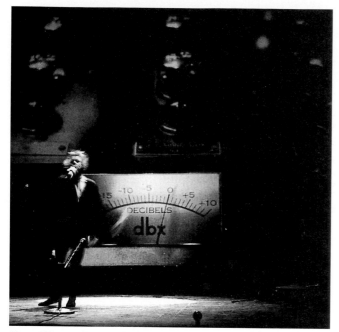

From "Empty Places," 1990

You know, I can't believe all this stuff is still actually working.

There are literally thousands of things that could go wrong with it. It really makes me wonder how the military could be so confident in their systems which have thousands of times more potential for error. Recently though, some of the military research has concentrated on the study of nature rather than machines or systems.

When the army was trying to build a six-legged robot that could walk on the moon they were having a lot of design problems. So they decided:

"Hey! Let's look at insects. They've got six legs. Let's see how they do it!"

So they spent an enormous amount of money on this research and what they discovered was that six-legged insects can barely walk. They're constantly tipping over and tripping over their legs and breaking them off. But like all military research that goes billions over budget, they keep reminding you:

"Yeah sure this went a few billion over. But think of the spin-off technologies!
Tin Foil! The spray-on foods! Like spray-on cheese!

You'd never discover this stuff without spending some extra cash!"

One of the most ambitious spin-offs is a company in Florida that has been advertising near the obituary columns. For a rather large fee you can rent space in a capsule and they take your ashes and launch them up into low orbit.

Yeah, you can spin around forever up there with the rest of those loose wrenches. That is until the day some astronaut drives by and your capsule smashes right into his windshield like a bug on a hot summer highway.

from "Empty Places" 1989

180

Mixing playback tapes, 1983

When I first started to work with electronics, I remember thinking, "I should take a year or two off, and just learn about some of these things." I didn't, because I was afraid that at the end of that time I wouldn't remember why I wanted to learn it in the first place. So I just try to learn what I need to know as I go along. During performances in the '70s, I would always carry a screwdriver onstage to tweak the equipment or to give it a sharp rap to loosen up the circuit boards.

A lot of my work comes from just playing around with equipment, seeing what it will do. And whenever I get stuck and think I'll never have another idea again in my life, I just try, first of all, to relax and then just play around with the equipment. Because your tools teach you things.

That's why working with technology in school is so hard sometimes. The art departments never seem to have enough equipment so you have to plan everything way ahead of time and then you actually get to use the equipment only for a day or two and you just have to work so fast!

It's like if you were a painter, you'd have to think of the painting you wanted to do for months and then one day you get to run out and rent a brush and do the painting real fast and then return the brush (clean) the next day to the rental company. You know, it's probably not going to turn out all that fresh. So, in the end, your tools teach you things, and you can't always force them to do everything you happen to think up.

But then I guess everybody who works with material knows this, whether it's wood or stone or words or notes. You have to understand the nature of the stone you're cutting, otherwise you touch it wrong and it's in a million pieces on the floor. Fortunately for me, I live on Canal Street, the Used Electronics Junk Capital of the World, and I've learned about material by buying cheap junk and taking it apart and then trying to put it back together so that it will do something it didn't do before.

Also, I try to have a very hands-on approach to things. I try to know as much as possible about the systems I use, electronics, lighting, digital processing, because you can often build the tech into the piece in an interesting way.

from a lecture to art school students, San Francisco, 1979

Sorting slides, 1983

31. MORE SCENES FROM *UNITED STATES*

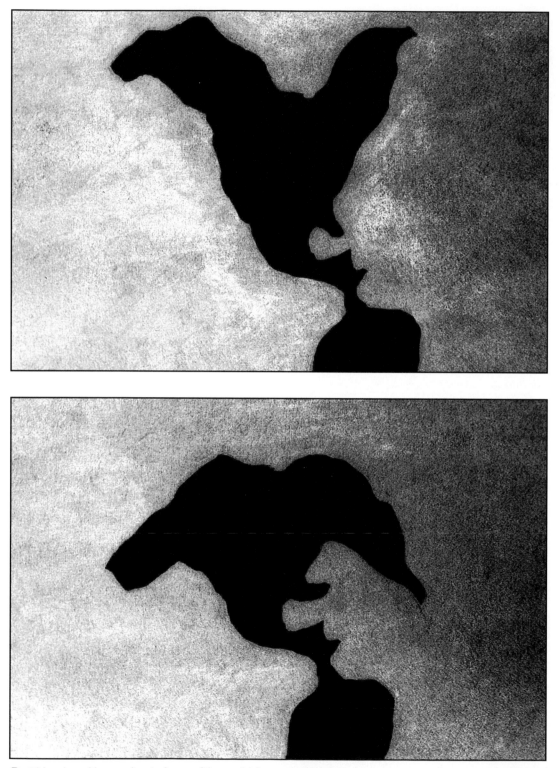

Part 3 begins with an animated map of the world devouring itself. Rampant consumerism, money, the hard sell, and the American salesman were some of the subjects of this section.

UNITED STATES PART 3

BIG MAP HEY AH BAGPIPE SOLO STEVEN WEED TIME AND A HALF VOICES ON TAPE EXAMPLE #22
STRIKE FALSE DOCUMENTS NEW YORK SOCIAL LIFE A CURIOUS PHENOMENON
YANKEE SEE I DREAMED I HAD TO TAKE A TEST RUNNING DOGS FOUR, THREE, TWO, ONE
THE BIG TOP IT WAS UP IN THE MOUNTAINS ODD OBJECTS DR. MILLER BIG SCIENCE

Several objects were made in connection to the performance.

"Three-D Map." Installation at the Holly Solomon Gallery, New York City, 1981. The flat world becomes a globe as it's viewed through the 3-D glasses.

"$10 Bill." Installation at the Holly Solomon Gallery, New York City, 1981. When the piece is viewed through glasses, the building disappears.

Looking into his eyes was like walking into a large municipal building. He had perfected an arrangement of his features that suggested International Style architecture: a subtle yet daring blend of American industry's most durable yet flexible materials. His expression seemed to suggest he had just finished saying, "That's the way things will be in the year 2,000."

from "Words in Reverse" 1979

Odd Objects

Our plan is to drop a lot of odd objects onto your country from the air. And some of these objects will be useful. And some of them will just be odd.

Proving that these oddities were produced by a people free enough to think of making them in the first place.

THE U.S. HELPS, NOT HARMS,
DEVELOPING NATIONS
BY USING THEIR NATURAL RESOURCES
AND RAW MATERIALS

One of the reasons that Chrysler has run into such financial trouble is that there have been some problems with the relay devices between the computers and the robot welders. When a problem develops farther up the line, it takes a long time for the computers to tell the robot welders to stop. So the robot welders continue to make these welding motions, dropping molten steel directly onto the conveyor belt, even though there are no cars on the line, building up a series of equidistant blobs. It takes several hours for the computers to tell the robot welders to stop. At the rate of eighty cars per hour, a typical plant is capable of manufacturing approximately one hundred of these molten blobs before the plant can be totally shut down.

You know,
I think we should
put some mountains here.
Otherwise, what are the characters
going to fall off of?
And what about stairs?
Yodellayheehoo.
Hey professor! Could you turn out the lights?
Let's roll the film!

Big Science.
Hallelujah.
Big Science.
Yodellayheehoo.

from "Big Science" 1983

During "Yankee See" there is a section that looks like a multimedia trade fair demo when films, slides, lights, and sound run through their splashiest effects.

Well, I was trying to think of something to tell you about myself, and I came across this brochure they're handing out in the lobby.

And it says everything I wanted to say, only better.

It says: Laurie Anderson, in her epic performance of United States Parts 1 through 4, has been baffling audiences for years with her special blend of music…slides…films…tapes…films…. (did I say films?) …hand gestures…. And more!

Hey hey hey hey hey hey hey!

(Much more.)

from "Yankee See" 1983

I met the producer Roma Baran around 1978. She played bass and accordion in a performance of "United States Part 2." She produced "O Superman," "Big Science," "Mister Heartbreak," "Home of the Brave" (record and film), "United States Live," "What You Mean We?," "Strange Angels," and "Carmen" as well as various other projects. Roma and I have spent thousands of hours in recording studios and video and film sets. When we were recording "Big Science," my first album for Warner Brothers, she encouraged me to combine talking and singing in ways I hadn't thought of. She also liked authenticity so, for example, when we needed a wolf howl she planned to record live wolves (we ended up using off-the-rack sound effects for this). Roma is often a minimalist and forced me to use only the most essential musical elements. In the song "The Dream Before" I recorded forty-eight tracks of music and elaborate sound effects. In the mix, Roma kept taking things out: drums ("Don't need 'em"), keys ("too decorative"), sax ("lose it"), wind ("sounds like tape hiss"). I was horrified. Almost nothing was left! Just vocals and a tiny guide keyboard (used for pitch). It took me a while to realize that, as usual, Roma was right. Simple is best.

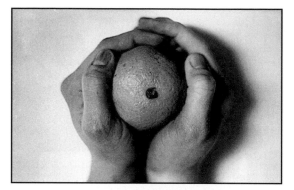

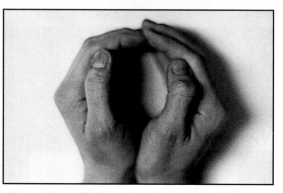

(Above) From "O-Range" performance, 1972, "Proving that the world is round"

(Below) From "United States 3," 1983. The extra set of arms was used in a section about bowling for dollars.

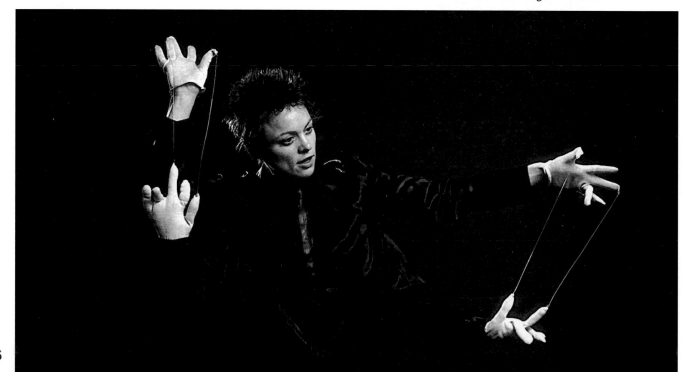

False Documents

I went to a palm reader and the odd thing about the reading was that everything she told me was totally wrong. She said I loved airplanes, that I had been born in Seattle, that my mother's name was Hilary. But she seemed so sure of the information that I began to feel like I'd been walking around with these false documents tattooed to my hands. It was very noisy in the parlor and members of her family kept running in and out. They were speaking a high, clicking kind of language that sounded a lot like Arabic. Books and magazines in Arabic were strewn all over the floor. It suddenly occurred to me that maybe there was a translation problem, that maybe she was reading my hand from right to left instead of from left to right.

Thinking of mirrors, I gave her my other hand. Then she put her other hand out and we sat there for several minutes in what I assumed was some kind of participatory ritual. Finally I realized that her hand was out because she was waiting for money.

"Ooo coo coo. It's cold outside.
Don't forget your mittens."

UNITED STATES PART 4

IT TANGO BLUE LAGOON HOTHEAD (LANGUE D'AMOUR) STIFF NECK TELEPHONE SONG
SWEATERS WE'VE GOT FOUR BIG CLOCKS (AND THEY'RE ALL TICKING) SONG FOR TWO JIMS
OVER THE RIVER MACH 20 RISING SUN THE VISITORS THE STRANGER CLASSIFIED
GOING SOMEWHERE? FIREWORKS DOG SHOW LIGHTING OUT FOR THE TERRITORIES

I wanted you. And I was looking for you.
But I couldn't find you.
I wanted you and I was looking for you all day.
But I couldn't find you.
I couldn't find you.

A lot of the songs are based on the rhythms and repetitions of arguments and conversations.

She said, It looks
Don't you think it looks a lot like rain?

He said, It goes. That's the way it goes.
It goes that way.

He said, Isn't it, isn't it just
Isn't it just like a woman?

She said, It's hard. It's just hard.
It's just kind of hard to say.

He said, Isn't it just
Isn't it just like a woman?

She said, It takes. It takes one.
It takes one to. It takes one to know one.

He said, Isn't it, isn't it just like a woman?

She said, she said it,
She said it to know,
She said it to no one.

Isn't it, isn't it just,
Isn't it just like a woman?

"It Song" 1979

189

And down by the ocean
under the boardwalk
You were so handsome
We didn't talk.
You're my ideal.
I'm gonna find you.
I'm goin' to Coolsville.
So perfect. So ideal.
This train. This city. This
train.

from "Coolsville" 1989

Turning into a cartoon man, "The Human Face," 1991

Writing love songs has always seemed sort of strange to me. When I learned to use the word "you" it meant "you" in the audience not the abstract "you" who's in all the "I love you" love songs. This is probably why most of the love songs I've written are about looking for someone who is hidden either in the past or the future.

Get the blanket from the bedroom.
We can go walking once again.
Down in the boondocks
Where our sweet love first began.
Ooo I'm gonna follow you
Out in the swamps and into town
Down under the boardwalk
Track you down.

from "Smoke Rings" 1986

Sweaters (for Jean Luc Godard)

I no longer love your mouth.
I no longer love your eyes.

I no longer love your eyes.
I no longer love the color of your sweaters.

I no longer love the color of your sweaters.
I no longer love the way you hold
your pens and pencils.
I no longer love it.
Your mouth
Your eyes
The way
you hold
your pens and pen-
cils.
I no longer love
it.

Like a hole, like a black hole in space
You disappeared and there's nothin' to take your place.
Now I'm sweatin' and freezin' in this Jamaican sea breeze
I remember you in my knees.
They're weak, feel like fallin'.

from "It's Not the Bullet That Kills You (It's the Hole)" 1977

You get a good idea.
And BAM!
You're in love again.
And then you're not in love
anymore.
And then you are again.
And nobody can tell you
what to do about that.

from "Break It" 1975

Turning into a cartoon woman, "The Human Face," 1991

I got your letter. Thanks a lot.
I've been getting lots of sun
and lots of rest.
It's really hot.
Days, I dive by the wreck.
Nights, I swim
in the blue lagoon.

I always used to wonder
who I'd bring to a desert island.
Days, I remember cities.
Nights, I dream about a perfect place.
Days, I dive by the wreck.
Nights, I swim in the blue lagoon.

I saw a plane today flying low over the island.
But my mind was somewhere else.

And if you ever get this letter: Thinking of you.
Love and kisses. Blue Pacific.
Signing Off.

from "Blue Lagoon" 1983

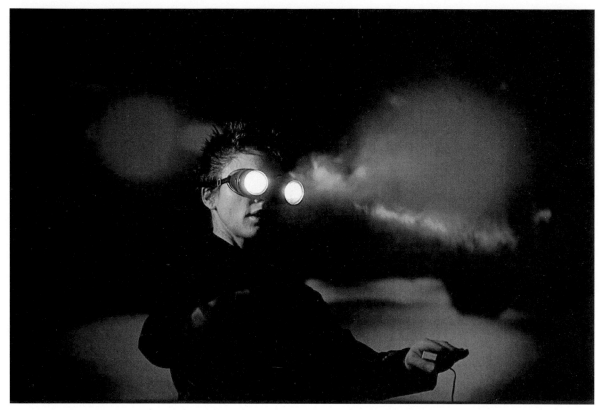

*I couldn't see a thing wearing the Headlight Glasses and during
this song I felt my way along a diving board which extended over
the orchestra pit.*

You're driving and it's dark
and it's raining.
And you're on the edge of the city
and you've been driving all night.
And you took a turn back there
but now you're not sure it was the
right turn.
But somehow it looks familiar so you
just keep driving.

Hello. Excuse me.
Can you tell me where I am?

You've been on this road before.
You can read the signs.
You can feel your way.
You can do this
in your sleep.

from "Lighting Out for the Territories" 1983

32. SETS

In a way, all the sets I've designed have been about places I've lived. Many of the performances start with stories about a place : a room, a loft, a city, a country.

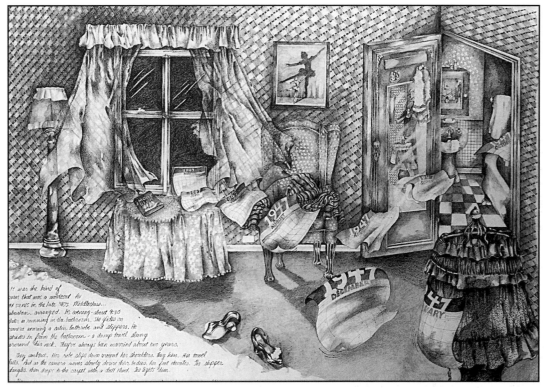

Sketch for set of "Dearreader," 1975

Projection towers being erected for "Empty Places" 1990 tour. Images were rear-projected onto the tower screens. Thirty slide projectors and five film projectors were controlled by a central computer.

■ There are Eskimos who live above the timber line. There's no wood there for the runners on their sleds. So instead, they use long frozen fish which they attach to the bottoms of their sleds to slip across the snow.

I saw a man on the Bowery. He was wearing ancient, greasy clothes and no shoes but brand new bright white socks. He was standing on two small pieces of plywood and as he moved along the block, he bent down, moved one of the pieces slightly ahead and stepped on it. Then he bent down again, moved the other piece slightly ahead and stepped on it.

from "Songs for a Foreshortened Hallway" 1979

In "Songs for a Foreshortened Hallway" (above) footsteps are recorded on the Tape Bow and played forwards and backwards as the performer walks along a corridor of light. On the screen, a woman walks slowly forward.

In "United States 1," projections were used to extend the stage space. A platform with a single step allowed the performer to enter "film space" and become part of the image. This platform was a kind of bridge between the second and third dimensions.

"United States 4" began with an illusion. Images of an empty stage were projected onto a large screen. When we were on tour, I shot slides of the empty stage at each theater before we loaded in. Usually the slides were processed in time to project in that evening's performance.

Laser tunnel designed by Norman Ballard, "Stories from the Nerve Bible," 1993

194

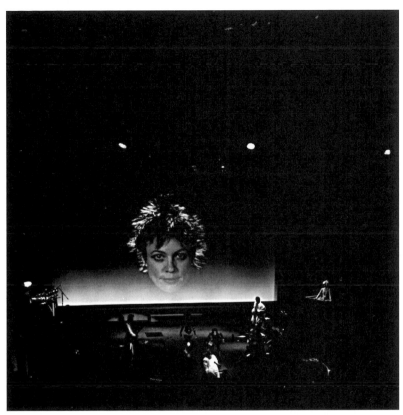

In "Talk Normal" performer enters from trap door. "Home of the Brave" 1986

In the '70s, sets often had to be improvised. Instruments were simply placed near the edge of the stage. A log was an early version of the platform or beam.

The Floating Theater

In 1988 I designed a totally electronic midi-controlled set. All the units, mechanical clouds, air suspended scrims, sound, lights etc. could be controlled from a central console. It was never built, for obvious financial reasons.

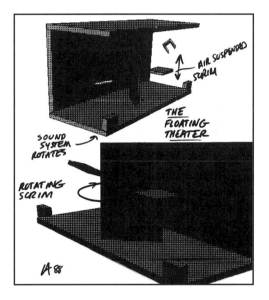

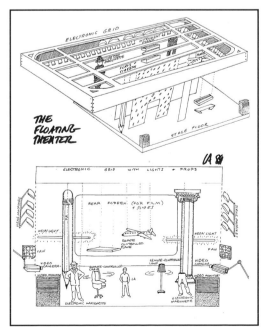

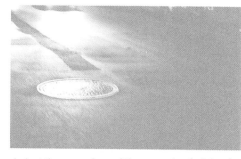

I shot thousands and thousands of slides for "Empty Places." I shot a lot of them in my neighborhood so when I looked behind me during the performance in Budapest, it was like I'd never left Tribeca.

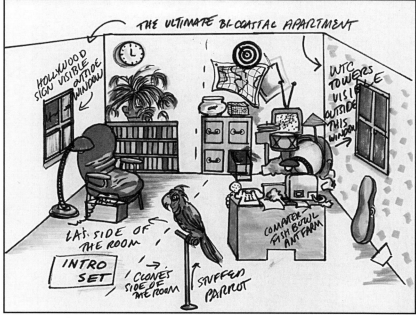

Sketch for KTCA video intros, 1987

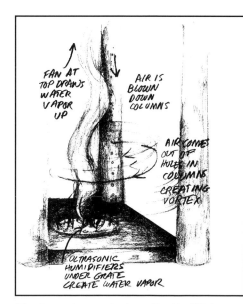

The tornado was designed by Ned Kahn.

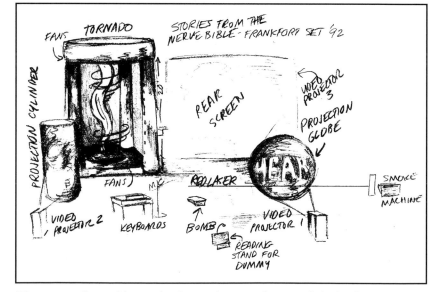

There were three video projection surfaces and a tornado in the first version of "Stories from the Nerve Bible."

196

33. IS ANYBODY HOME?

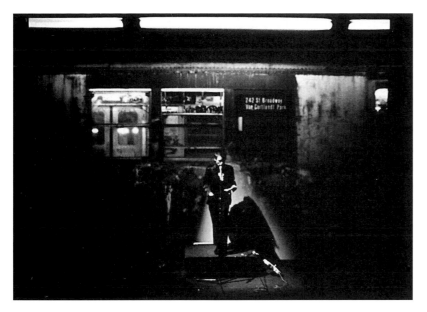

Private Property

William F. Buckley, Jr., Mr. Private Property, planned to give a little talk, a political speech, in a small town in Illinois. His advance men discovered that the center of town had disappeared, and that all the commercial action was out at the mall. When Buckley arrived at the mall, he set up his microphone near a little fountain and began to hand out leaflets and autograph copies of his latest book. Just as a small crowd of shoppers gathered, the owners of the mall ran out and said, "Excuse us. This is private property, we're afraid you'll have to leave."

You know, when I got back from a trip this summer, I noticed that all of the old factories here on the outskirts of town had suddenly been transformed into luxurious condos and that thousands of people had moved into them almost overnight. Most of the new residents appeared to be professional barbecuers. Every night, they were out on their fire escapes barbecuing something. And the smoke rising from their little fires made the whole neighborhood look like a giant battlefield. And I would look out my window and say, "Hm...."

You know, last night I came up out of the subway and I said to myself, "Hm. Do you want to go home?"

And I thought, "You are home."

from "United States 2" 1980

Dear Laurie Anderson,

I am for myself a long time walking around where the growing idea to come to the new world and more specially to New York. So, to have to look to see the inner side of the American Art World and go to see what means it. For the bigger part, the European artist looks with a great deal of surprise in his eyes to this town of New York and all of the people of this town so coming together and please to informate me. So where are the questions. Namely:

1. How is it to leave your own town and so to go to New York?

And what means it? And how feels it?

2. How did you become a good house to live in?

3. What means New York in the social way? Their colleagues?

4. What do you do to be living?

5. What means New York? What means it and how feels it?

And finally, what needs it?

I hope it is not so much for answering this questions? It should help me to be more complicated.

With friendly thanks, I am for you now.

letter from an anonymous woman in Holland 1976

Just the other day I won the lottery, I mean,
lots of money.
I got so excited I ran into my place and I said:
HEY! IS ANYBODY HOME?
Nobody answered
but I guess that's not too weird
since I live alone.

from "Beautiful Red Dress" 1988

"Over the River and Through the Woods," "United States 4," 1983

It's the one with the pool.

It's the one with the fir tree in the front yard.

Leave the lights on.

from "United States 4" 1983

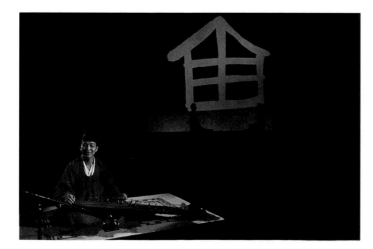

So, it was late at night. And it was, you know, in the fall. And in the fall there are a lot of bugs, right? Flying around the house. And they are making a lot of sound. And you are trying to write.

But you can't concentrate to write because of the sound of all these bugs.

from "How to Write" 1986

The word "house" in Japanese

A house burns backwards from "Stories from the Nerve Bible," 1992

From "Natural History," 1986

The Wrong House

Lyrics for songs are culled from huge notebooks that I keep adding to. In a way, I've only written one long song. Occasionally, the lyrics are reused.

I came home today

And you had rearranged all the furniture.

And you had changed your name.

And I'd never seen you wear that

Pin-striped shirt before.

And then I realized,

I was in the wrong house.

from "Classified" 1983

I came home today

And both our cars were gone

And there were all these pink flamingos

Arranged in star patterns all over the lawn.

And then I went into the kitchen

And it looked like a tornado had hit

And then I realized

I was in the wrong house.

from "Talk Normal" 1985

All of life comes from some strange lagoon.

It rises up, it bucks up to its full height

From a boggy swamp on a foggy night

It creeps into your house.

It's life! It's life!

from "Sharkey's Day" 1984

My studio in L.A. with Piñata and phone, 1978

34. ANGELS AND ALIENS

Well I was out in my four door with the top down
And I looked up and there they were:
Millions of tiny teardrops, just sort of hanging there

And I didn't know whether to laugh or cry.
And I said to myself: What next, big sky?

from "Strange Angels" 1989

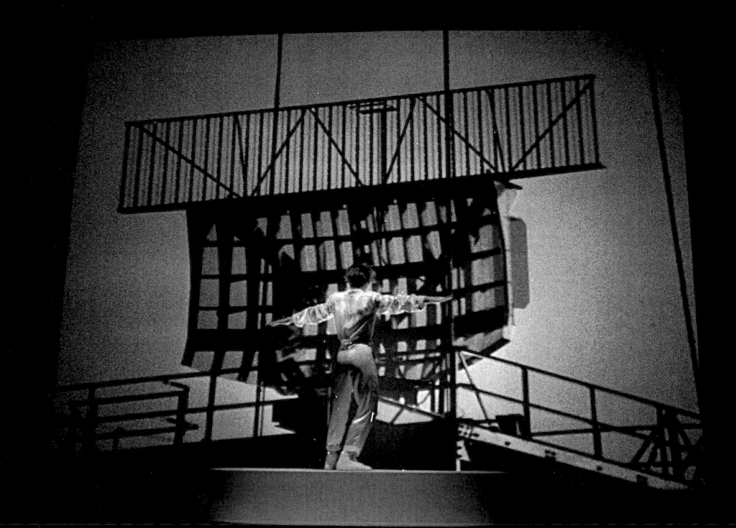

I've always been fascinated with the sky, with staring at the sky. Growing up in the Midwest left a lot to the imagination. Since there's nothing there but sky. And nowhere to go but up. I remember as a child I'd go out to my fort in the woods and light up oak leaf cigarettes and try to imagine who or what might be up there and I invented these otherworldly creatures as a kind of control group, as a way to evaluate regular adults.

I also liked to try to think of things that were so unusual and improbable that they could definitely never have happened, I remember one of them was:

A father is about to kill his son by clonking him over the head with a piece of wood. But just before he does this, a bluebird flies down and lands on the son's head, distracting him and preventing the murder.

I was quite proud of this one because I was reasonably sure that it had never happened in all of time. Anyway, it seemed like I was always waiting for something or someone unusual to arrive, to come down with more information, a sign, something, anything. Just for contrast.

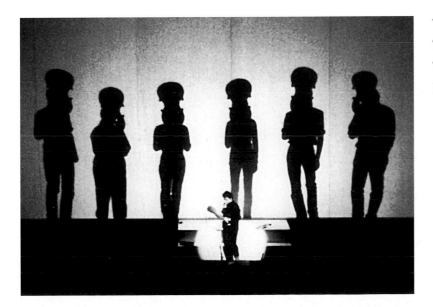

They look like us.
They act like us.
They are not us.
Remember us.

from "United States 4" 1983

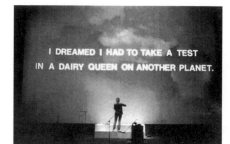

Song for Tape Bow Violin "United States 3," 1983

The day the Devil comes to getcha
He has a smile like a scar.
He knows the way to your house.
He's got the keys to your car.
And when he sells you his sportcoat
You say: Funny! That's my size!
ATTENTION SHOPPERS!
Everybody please rise.

Give me back my innocence.
Get me a brand new suit.
Give me back my innocence.
Oh Lord! Cut me down to size!

from "The Day the Devil," 1986

A Curious Phenomenon

Recently there has been a discovery of a curious phenomenon deep in the deciduous woods of Southern Illinois. In the midst of the underbrush there is a clearing revealing a circle of short wooden tree-stump-like structures. In the middle of that circle there is a post-and-lintel structure. The entire circular configuration is oriented toward the exact point at which the sun rises on the day of the summer solstice.

Who built this structure? And for what purpose? To what end? A primitive calendar? A center of worship? A lost tribe? Woodhenge: A mystery that continues to cloud the American brain.

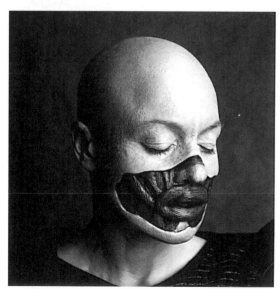

From "The Human Face" 1991

They stun the guys and they grab the girls
for experimental purposes
in other worlds.
Greasy tentacles wrap around you.
Yeah, alien sex, alien sex.

from "Alien Sex" 1992

from "United States 3" 1983

Last night I woke up. Saw this angel.
He flew in my window.
And he said: Girl, pretty proud of yourself, huh?
And I looked around and said:
Who me?
And he said: The higher you fly
The faster you fall. He said:

Send it up! Watch it rise! See it fall.
Gravity's rainbow.
Send it up! Watch it rise. And fall.
Gravity's angel.

Why these mountains? Why this sky?
This long road. This ugly train?

Well he was an ugly guy, with an ugly face.
An also-ran in the human race.
And even God got sad, just looking at him.
And at his funeral all his friends
Stood around looking sad.

But they were really thinking
Of all the ham and cheese sandwiches
In the next room.

And everybody used to hang around him
And I know why. They said:
There but for the grace of the angels
Go I.
Why these mountains? Why this sky?

from "Gravity's Angel," 1986

A while ago, I was in an airport on my way to Paris and a guy came up to me and said, "I really like your music." And I said, "Thanks a lot," and we had one of those conversations that took a lot of hairpin turns. We talked about everything, jump cutting around, analyzing lines from Raoul Ruiz movies like: What if every heartbeat you ever had had a name? Things like that. And finally I said, "Listen, it's been really great talking to you and what's your name?" and he said, "Wim Wenders." And I said, "Oh, I really like your films!" and we became friends and talked about a lot of things. He was working on his script for "Wings of Desire" at the time and so a lot of the conversations were along the lines of Do angels wear black raincoats and follow you to the library, or not?

Anyway he's just finished another film called "Until the End of the World" and he asked me, "Can you write a song from the year 2,000 for the movie?" Now that's a tough one. The year 2,000 doesn't seem that far. But if it's a pop song it's pretty much in a kind of time warp anyway. For example there's that Beatles song with the line "She was just seventeen if you know what I mean." I always wondered what "if you know what I mean" meant. It was written in 1963 which would make her about forty-five years old now (if you know what I mean).

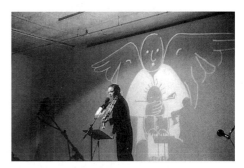

*"Speak Softly" The Kitchen,
New York City, 1979*

from "Voices from the Beyond" 1991

Strange angels. Singin' just for me
Their spare change falls on top of me
Rain falling, falling all over me.
All over me.

from "Strange Angels" 1989

Last night I saw a host of angels
and they were all singing different songs.
And it sounded like a lot of lawnmowers
Mowing down my lawn.

And up above kerjillions of stars
spangled all over the sky
And they were spirals turning
Turning in the deep blue night.

And suddenly for no reason
the way that angels leave the ground
They left in a kind of vortex
Traveling at the speed of sound.

from "Ramon" 1989

Song for Paper, Film, and Video

The detective novel is the
only novel truly invented in
the twentieth century.
In the detective novel, the
hero is dead at the very
beginning. So you don't have
to deal with human nature at
all. Only the slow accumulation
of facts....of data....

The detective novel is the
only novel truly invented in
the twentieth century.
In the detective novel, the
hero is dead at the very
beginning. So you don't have
to deal with human nature at
all. Only the slow accumulation
of facts....of data....

When TV signals are sent out, they don't stop. They keep going. They pick up speed as they leave the solar system. By now, the first TV programs ever made have been traveling for thirty years. They are well beyond our solar system now. All those characters from cowboy serials, variety hours and quiz shows are sailing out. They are the first true voyagers into deep space. And they sail farther and farther out, intact, still talking.

And as we listen with our instruments, as we learn to listen farther and farther into space, we can hear them. We listen farther and that is all we hear. They are jamming our lines. We listen and we hear them talking, traveling, going faster and faster…getting fainter and fainter. And as our instruments become more sophisticated, we can hear them better, speeding away, the sound of speeding away, like a phone continuously ringing.

In science fiction films, the hero flies in at the very beginning. He can bend steel with his bare hands. He can walk in zero gravity. He can see right through lead doors. But no one asks how he is able to do these things. They just say, "Look! He's walking in zero gravity." So you don't have to deal with human nature at all.

United States 1979

The Dutch Astronaut just published a book, "The Home Planet," a collection of the writings of various astronauts with lots of pictures taken from outer space captioned with their descriptions of what it was like up there. They wrote things like, "I never knew what round was until I saw the round round earth turning in space. And why call it earth when it's mostly water with just little bits of land where the animals and people are?" The two things they seemed to agree on were:

1) Nobody is up there watching us. Nobody at all and 2) We're not the last survivors of life in the universe but very likely we are the very first examples of life. And these things have convinced them that the most important thing for humans to learn is how to be excellent ancestors.

from "Voices from the Beyond" 1992

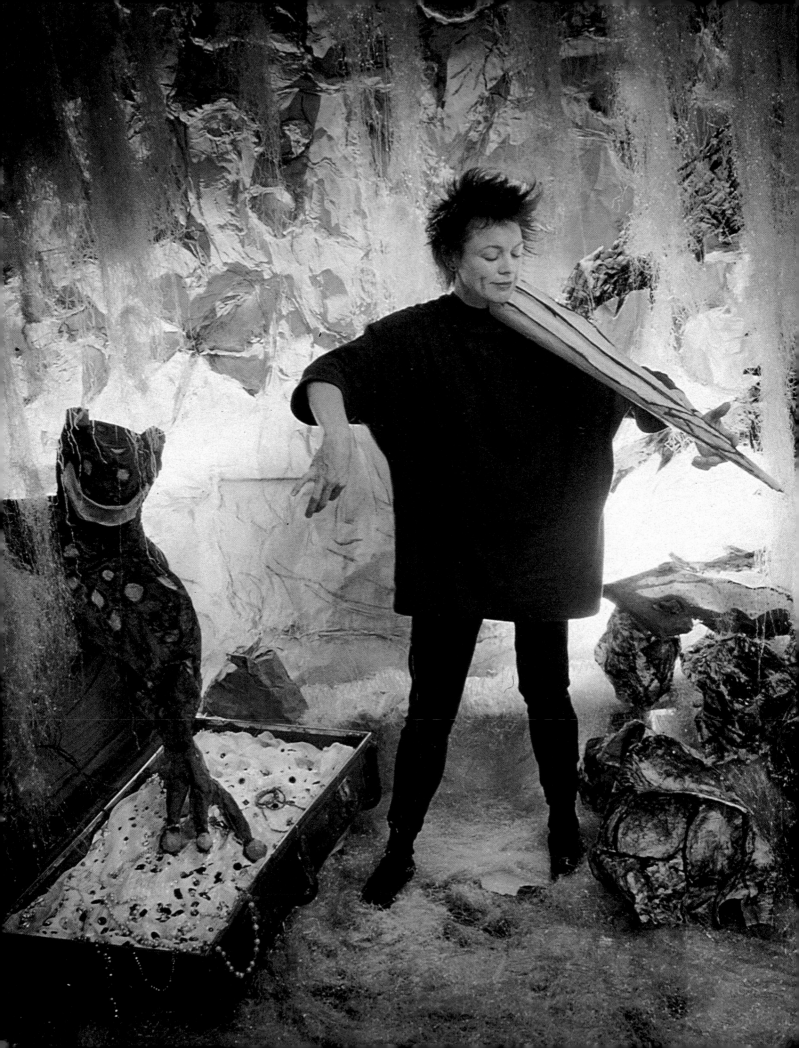

The Healing Horn

When I was in L.A. I went to several services run by an organization called Universalist World Church. The services were held in a huge auditorium, formerly a used-car showroom. The head of this operation was a man named Dr. J., an Egyptologist, preacher and recording artist. At the back of the church he sold cassettes he had produced in his home studio. The cassettes had titles like: "UFOs and the Creatures Who Drive Them." His assistant was a tiny woman named Miss Velma, a soprano who also administered the Oil of Youth at the Healing Horn. The Healing Horn was an actual horn of unidentifiable origins all set in jewels. When you touch the horn you feel a rejuvenating surge of energy, about fifty volts, as long as you happen to be standing on the metal plate embedded in the altar.

The most spectacular event of the year at the World Church was a Christmas service. There was a giant screen painted with a Nativity scene. There were lots of animals painted on the screen, with holes cut out where their heads would be and there was a microphone behind each hole. During the service, Miss Velma would stand behind the screen and stick her head through the holes, using a different voice for each animal. "Hi, I'm the cow and I saw it all." "Hello. I'm the dove. The lovely dove. And I was there, too. I saw everything, too."

The service would then abruptly cut to Dr. J., who would announce, "First, Miss Velma will shoot an arrow through a balloon. Then she will perform an Indian dance. And finally, she will perform a song for you on the mellophone." With no further explanation, Miss Velma comes out from behind the screen. First she shoots an arrow through a balloon. Then she does an Indian dance. And last, she performs a song on the mellophone.

And somehow it was amazing. First he tells you what will happen and then it actually happens, just the way he said it would. Like a prophecy being fulfilled.

from "United States 1" 1979

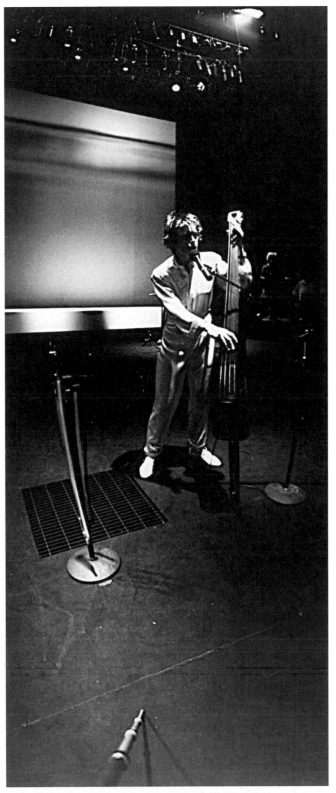

From "Gravity's Angel" "Home of the Brave," 1986

35. GOLDEN CITIES GOLDEN TOWNS

**Paradise is exactly like
where you are right now
only much much better.**

from "Kokoku" 1986

Coolsville. Cooooolsville
So perfect. So nice.
Hey little darlin'.
I'm comin your way little darlin'
And I'll be there, just as soon as I'm
all straightened out.
Yeah, just as soon as I'm
perfect.

from "Coolsville" 1989

LA: I shot a film of commuters in the subway in Tokyo and then I digitized and looped it. I watched it over and over as I wrote "Coolsville," a song about trying to get to a perfect place. But perfection is probably some sort of horrible death wish, I always forget that imperfect things are the most perfect expression of what it's really like to be here.

SK: "Coolsville" sounds like the ultimate nightmare. Do utopian dreams always turn out to be nightmares if and when you get there?

LA: Well, Ronald Reagan's did. That's one of the things that "Empty Places" is about. He promised people a lot of things that were completely unrealistic, he promised them a movie, and watching this rickety dream fall apart was pretty unbearable for me, because it created a lot of disillusionment and suffering.

from "Guardian" interview with Sarah Kent 1990

Hey! Pal! How do I get to town from here?
And he said: Well, just take a right
where they're gonna build that new
shopping mall,
go straight past where they're gonna put in the freeway,
take a left at what's gonna be the new sports center,
and keep going until you hit the place
where they're thinking of
building that drive-in bank.
You can't miss it.
And I said: This must be the place.
Coo coo coo. Golden cities. Golden towns.
Golden cities. Golden towns.

from "Big Science" 1983

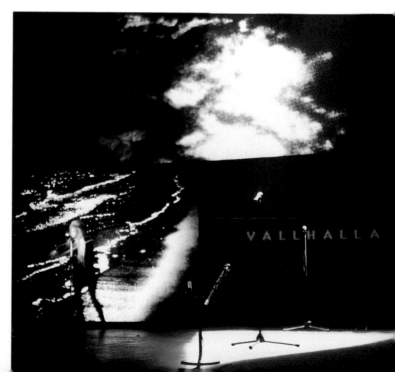

"Empty Places," 1989

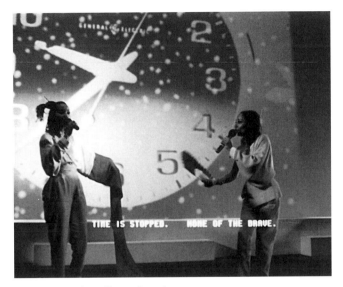

I come very briefly to this place
I watch it move. I watch it shake
from "Kokoku" 1986

CA: What does "Kokoku" mean?

LA: "Hometown of the brave men," or, loosely translated, "home of the brave."

I wrote "Kokoku" because I went to a Zuni Festival in the Southwest last year. The Zunis have been worried about the increasing wobble in the earth's orbit and they have been reporting signals from "somewhere out there" that claim the wobble is a warning to earthlings about the future. The basic message was simple: "You have such a beautiful planet, please be very very careful." This Saturday I'm going to another all-night Zuni drum festival out in the desert run by some characters called "The Mudheads" who have been rehearsing for a year, learning the creation myth backwards. Now, I don't really know if they start at the end of the story and go back to the beginning or if they talk backwards or what. I hope I find out.

interview with Charles Amirkhanian. "The Guests Go in to Supper" 1986

For a lot of people the '60s are still a kind of lost but ideal era, a time of intellectual rigor, sexual freedom, great music, a kind of lost utopia. For me personally all I remember was a lot of

Fake record ad from "Stories from the Nerve Bible," 1992

guys doing these endless guitar feedback solos which just made the decade that much longer than it would have been anyway, not to mention all the macrame that got produced, you know macrame plant hangers, macrame place mats, tote bags. I had a nice macrame hairshirt myself, you can still find some of this stuff in the really good flea markets.

But back to the subject, the myth about the glamorous '60s. I think it can actually be traced to one particular evening, the night when Jacqueline Kennedy happened to see a Broadway musical entitled "Camelot" and it changed the face of this country from that moment on. So…maestro?

("CAMELOT" MEDLEY ON VIDEO)

Let's go back to that moment at the top of the decade, when Lerner and Lowe came up with their unforgettable chart-topping tale of *Camelot*. Yes back to the days of power and privilege along the Potomac, the days when Harvard intellectuals were commuting from Cambridge to D.C., when the young President himself was out writing poetry on his sailboat. And those nights! The glittering openings as the great art patrons arrived for cultural events, sponsored by the brand-new National Endowment for the Arts.

So let's listen in to some of the greatest hits, such as: "I Wonder What the King Is Doing Tonight?" or the timeless love song "How to Handle a Woman" or one of my personal favorites, the touching "Where Are the Simple Joys of Maidenhood?" All summed up in that naive but searching question: "What Do the Simple Folk Do?"

So let's sit back and enjoy the music.

from "Stories from the Nerve Bible" 1992

36. HOME OF THE BRAVE

A concert film shot in 35 mm Panavision at the Park Theater in Union City, New Jersey, 1985. Released through Cinecom International Films, "Home of the Brave" was based on a performance of the 1984 "Mister Heartbreak" tour.

GOOD EVENING ZERO AND ONE EXCELLENT BIRDS OLD HAT DRUM DANCE SMOKE RINGS LATE SHOW WHITE LILY SHARKEY'S DAY HOW TO WRITE KOKOKU RADAR GRAVITY'S ANGEL LANGUE D'AMOUR TALK NORMAL DIFFICULT LISTENING HOUR LANGUAGE IS A VIRUS SHARKEY'S NIGHT

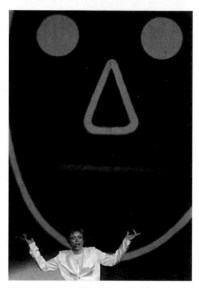

The "Mister Heartbreak" tour, 1984

In "Home of the Brave," what you see are seven musicians on a bare stage playing strange instruments and wearing costumes that occasionally mutate into other strange instruments. Behind them is a thirty-by-forty-foot screen onto which slides and films are projected. There are eleven other people who come and go over the course of ninety minutes: a horn section, stagehands, Latin percussionists and a game show hostess. A telephone drops in from nowhere. Scribbled diary fragments and grocery lists flash on the screen. William Burroughs tangos by. Subtitles mistranslate a song in French. This is a "kind of a concert film" the way my performances are "kind of concerts."

The film was shot over a period of ten days in the Park Theater in Union City, New Jersey, in July 1985. The theater was built in the late nineteenth century to present passion plays. Half the shooting time, there was an audience who arrived every day by bus from Manhattan; the rest of the shoot was reserved to get difficult shots, especially of the screen.

When I decided to make this movie, I began looking for a director. I asked a lot of people for suggestions and talked to directors whose concert films I admire, Marty Scorsese ("The Last Waltz") and Jonathan Demme ("Stop Making Sense"). Both said, "Do it yourself. Get a good director of photography, video playback and a loud assistant director."

I'm not sure I would advise anyone else to star in their own movie. The special blend of schizophrenia and narcissism that you need to split roles can result in a power struggle. Eventually, of course, the director wins. Editing was like watching myself in a dream. I was never convinced by Jung's three-story model of the self until one night, waking up from a particularly humiliating dream, I looked down and saw myself at a desk. I was writing the dream, casting myself as dupe. And I was laughing. Laughing my head off.

Directing "Home of the Brave," 1985

(l to r) Dolette McDonald, Janice Pendarvis, Isidro Bobadillo, David Van Tieghem, and Dickie Landry

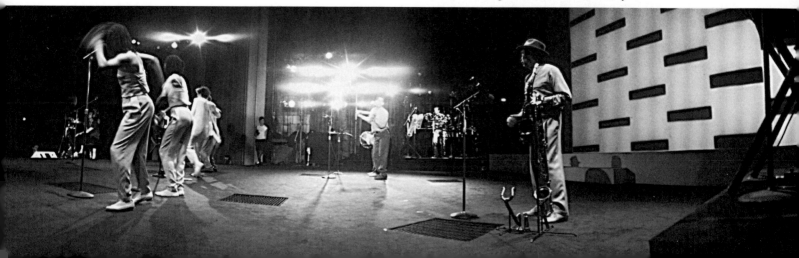

"Home of the Brave" begins with a projected animation of products falling from the sky. The performers ambulate on as anonymous clones. Flintstone Kabuki crossbred with the Bauhaus. A drum machine bangs out an odd time signature. The central character lurches forward playing wolf howl double stops on an industrial remnant of a violin.

"Home of the Brave" took a year and a half to make and cost $1.65 million. Getting the money was the hardest part. As feature films go, it's not much. But for me it meant months of emoting in front of storyboards as potential backers shuffled in and out. Eventually I got so good at it, it seemed like I was describing a film I'd seen a thousand times. It hardly seemed necessary to make it.

Finally we got the go-ahead, but right before we started to shoot, we lost most of the money. The producer Paula Mazur and I decided to look for a million dollars. We had a week. We stuffed our briefcases with paper and called on every midtown Manhattan office that had anything even vaguely to do with films. "Hi. Yeah, well we need a million dollars. That's right. By Friday. Well I guess Monday would be O.K. . . ."

Eventually, Warner Records found the money, no thanks to me. But at least now I know midtown really well. I can look up at those buildings and I know who's sitting there.

My main commitment has been to live performances. I love the potential of real-time disaster. I like the contact, the feedback. I resisted the pressure to shoot on video because it's too flat and too lonely. Movie theaters are social: the gossipy ticket line; communal high-velocity eating in the dark. And movie houses preserve the trappings of theaters: the parting curtains, the vestigial stages, too skinny for anyone to walk on but wide enough to suggest their heritage.

Costume sketches

For the film, I wanted the stage to be bare, to strip it of cables and monitors. We built a raised stage three feet above the existing stage. Under this lid was a hotbed of electronics. The film was totally digital from initial recording to final mix. Computers, cables, and processors took digital information from the stage above and fed it to the 24-track recording equipment located in the house. Monitors were flush-mounted in the floor so that the musicians were hearing the music mix floating out of what looked like subway grates. Playing on this stage was like being on a subway platform with trains of sounds roaring underneath.

Sharkey's Night

In "Sharkey's Night," I tried to make the perform-
ers and the screen animation blend, by making
the performers more abstract, almost like car-
toons. Although of course in a film, the camera
is the ultimate animator. Zoom in and the head
is the size of a car.

Hey what's that big noise from the sky?
Sounds like thunder. Nope.
Sounds like the Fourth of July. Nope!
Wrong again.
You know, it's just those angels walking.
They're clomping around again.
They're wearing those big clumsy shoes
We got for them.

And Sharkey says:
Deep in the heart of darkest America.
Home of the brave.
He says: Listen to my heart beat.
Paging Mr. Sharkey.
White courtesy telephone please.

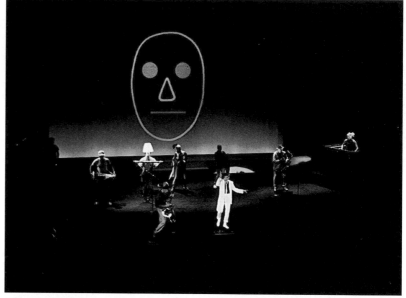

"Sharkey's Night"

Joy Askew playing the sax

Daniel Ponce and Isidro Bobadillo wear-
ing a battery-powered lampshade

With Adrian Belew, David Van Tieghem, Daniel Ponce, Isidro Bobadillo, Janice
Pendarvis, Dolette McDonald, Dickie Landry, and Joy Askew

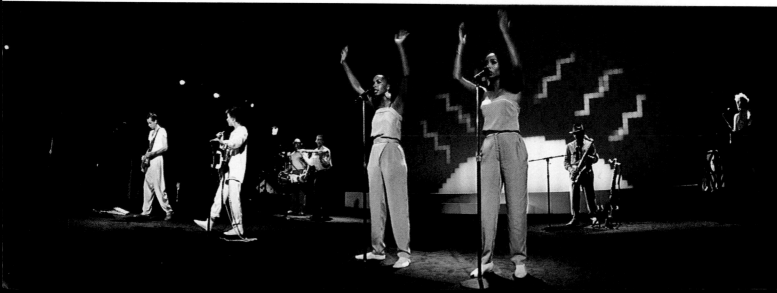

Talk Normal

Adrian Belew with rubber guitar

Dickie Landry working out

In "Talk Normal" suddenly everything is chaos. Stagehands barge through carrying a cardboard swan, apparently a prop being delivered to some other concert. This was one of my favorite parts of the concert because the audience thought the concert had somehow ground to an abrupt halt. Performers just walked off, chatting. Stagehands start to clean up. I call Joy Askew, the keyboard player, on the phone and we chat. It doesn't seem to be a concert anymore, but what is it?

Even though I design the performances to be split-second collaborations between sound, image and action, it's the presence and inventiveness of performers that bring the work to life. As film director I did nothing except remind the performers that the cameras weren't really there. Although most of the performers had been on the sixty-city concert tour, I never thought of them as my band but as guest artists.

Gravity's Angel

"Gravity's Angel" was originally composed for the dancer Trisha Brown, who told me there was a lot of falling in her dance, so I wrote the music as a series of falling lines. I told the cameramen: "As soon as you find your subject, lose him. Fall away to black unpredictably up, down, and sideways. Forget gravity. It's a ghost song."

Sharkey's Day

In "Sharkey's Day" animation on the screen was synched with singers' choreography.

And Sharkey says: I turn around, it's fear.
I turn around again and it's love, oh yeah.
Strange dreams.

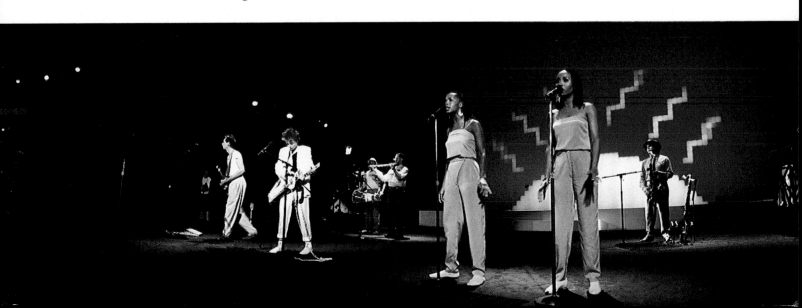

Kokoku

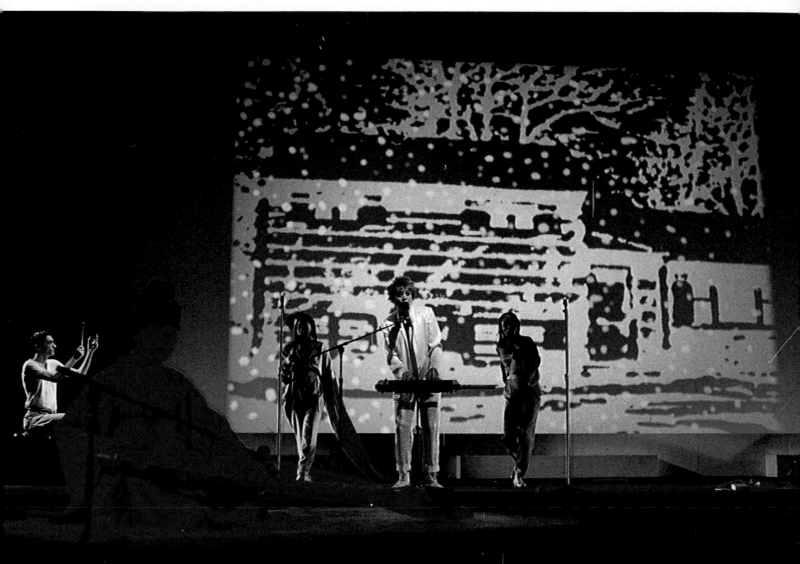

With David Van Tieghem, Sang Won Park, Dolette McDonald,
and Janice Pendarvis

I wanted the Japanese song "Kokoku" to look like Kabuki: bright, flat, no shadows. I told the cameramen: "Stay parallel to the screen. When you move, glide. When you dolly in, come in at a right angle to the screen. No curves. Think of Bunraku puppetry. Your camera is the puppet. Sneak behind it, you know, like the G.I. behind the gliding shrubbery." The operators put up with a lot of talk like that. I think they chalked it up *to the overwrought nerves of a first-time director. But the result is a strict formal frontality that also has the slippery rhythms of the song itself. Like most of the songs in the movie, "Kokoku" was composed of many projected images. I thought of the screen as a very tall, skinny, extremely demanding actor whose contract demanded that he be in virtually every shot.*

I come very briefly to this place.
I watch it move. I watch it shake.

Kumowaku yamano. Watashino sakebi. Watashino koewo.
Ushano kokoku. Watashiwa sokoni. Watashiwa asobu.
Mountains with clouds. A cry. My voice.
Home of the brave. I'm here now. And lost.

Jikanwa tomaru. Ushano kokoku.
Time is stopped. Home of the brave.

And on a very distant star
Slimy creatures scan the skies.
They've got plates for hands
And telescopes for eyes.
And they say: Look! Down there!
A haunted planet spinning 'round.
They say: Watch it move.
Watch it shake. Watch it turn.
And shake.

And we say: Watch us move.
Watch us shake.
We're so pretty.
We're so pretty.

We say: Watch us move now.
Watch us snake.
We're so pretty.
Shake our hands. Shake our heads.
We shake our feet. We're so fine.
The way we move. The way we shake.
We're so nice.

from "Kokoku"

"Kokoku" was inspired by the work of James Joyce, particularly "Ulysses," which I think of more as a movie than as a book. It seems like a screenplay with camera motions built in. I'm thinking of one scene: there's a girl on the beach, and she's sitting there, and she's looking at her dress and thinking, "Boy, this is a really nice dress." And then she's looking down at her shoes and thinking, "These are pretty nice shoes, too, and the socks aren't bad either."

And then the camera moves to a man who's walking down the beach and he sees her and thinks, "I wonder who that ugly cripple is?" And this isn't so much a situation of the omniscient author looking down at his puppet-like characters, as much as a huge crane shot that shows you her, and then shows you him.

In the song "Kokoku," there's motion on several levels. It begins with a percussion track, the word "shake," put into the repeat mode of the Harmonizer and then turned into a moebius strip. So that's the basic motion, a very small shaking. On the next layer are various kinds of vocal vibratos which I slowed down using a Synclavier. Then there's the kayageum, a Korean zither, which has a very very wide, slow vibrato. And then the lyrics themselves are about a wider, broader motion: people looking up and people looking back down. The words in Japanese are fake haikus that I made up which are more or less grammatically correct in Japanese. They are place words, still images.

With digital violin. Although I composed most of this music in the studio on keyboards, I rewrote some of it for the violin. My violin was souped up to interface with the Synclavier, a digital music computer. So I could play anything: birdcalls, buzzers, voices, howls.

Smoke Rings

Standby. You're on the air.

Buenas noches Señores y Señoras.

Bienvenidos.

La primera pregunta es:

Que es mas macho,

pinapple o knife?

Well, let's see.

My guess is that a pineapple

is more macho than a knife.

Si! Correcto!

Pinapple es mas macho que knife.

La segunda pregunta:

Que es mas macho?

Light bulb o schoolbus?

Uh, light bulb?

No! Lo siento. Schoolbus es mas macho que light bulb.

Gracias. And we'll be back in un momento.

Well I had a dream and in it

I went to a little town

And all the girls in town were named

Betty.

And they were singing:

Doo doo doo doo doo.

Doo doo doo doo doo.

Ah desire! It's cold as ice

And then it's hot as fire.

Ah desire! First it's red

And then it's blue.

And everytime I see an iceberg

It reminds me of you.

Doo doo doo doo doo.

Doo doo doo doo doo.

Que es mas macho iceberg o volcano?

from "Smoke Rings"

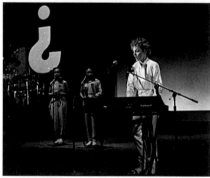

Producer Paula Mazur as Game Show Hostess in "Smoke Rings" with Dolette McDonald and Janice Pendarvis as contestants

Some of the dances are extensions of conducting. The time signature for "Smoke Rings" was difficult so I invented a dance to show musicians where the downbeat was.

Listen to My Heart Beat

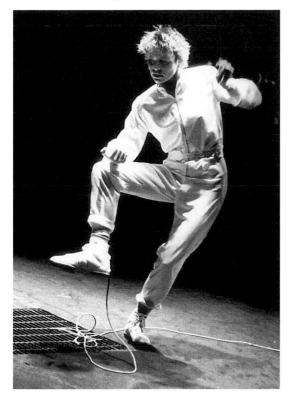

For "Drum Dance," I designed a suit with electronic drum sensors built in, the ultimate portable instrument. I had taken a cheap drum machine apart to try to fix it. I realized all the sensors still worked even when the cables ran many feet away from the circuit board. Because the sound was so loud, so out of proportion, I had to make the movements bigger, wilder. I had to dance.

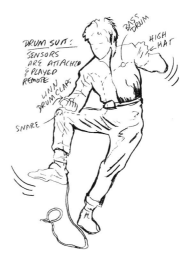

"Home of the Brave" opened in New York at the 57th Street Playhouse. The reviews were lukewarm and it played for about a week. It had a similar short life in most other cities. I was devastated. I had spent two years on the movie, poured all my energy into it, and it had basically bombed.

Eventually it did show up in various film festivals, and was even selected for "Directors' Fortnight" at Cannes where it received favorable reviews; but my baptism in big-time movies had been a shock.

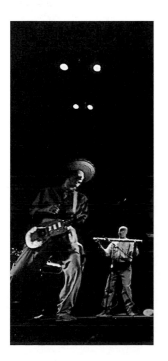

37. THE BODY SHOP

From the Bauhaus: Dancing About Architecture

A few years ago there was a reconstruction of some Oskar Schlemmer dances at the Guggenheim Museum, presented by Deborah McCall.

People keep thinking that "performance art" is something that was invented sometime in the '80s, but of course it's actually been around a long time, even before it had quotes around it, but unlike ballet or opera there are no companies that re-present this work so it tends to disappear.

The Schlemmer dance was really fresh and beautiful. It was a collection of dances about architecture; three softly rounded robots (dressed as a pyramid, a sphere, and a cone) moved themselves around the stage in the way an architect might rearrange a model. Schlemmer had a very childlike sense of animation, like in a kid's drawing where there's the house at normal scale and regular-size windows and then there's this giant doorknob because kids know that the most important thing about a house is how do you get in and how do you get out.

And the evening's performance was introduced by Andreas Weininger who used to play trumpet in the Bauhaus band. Weininger was about ninety-five years old and he began by saying: "Good evening. I'm from the nineteenth century." And everybody went "Oooooooooo." And it was a Saturday night and he said, "You know in the nineteenth century we also had Saturday night and let me tell you what we did…" And he began to tell these strange stories about what went on at the Bauhaus and it seemed like it happened last week and then the performance began and it also looked like it had just been choreographed a few days ago and for people in New York (who think that the only important things that have ever happened took place within the last five minutes) this was a real revelation. And it was a shock to suddenly feel this kind of continuity and to realize that artists have ideas and then they're used by other artists and it's not progress, but a long, long conversation stretching backwards and also forwards into time.

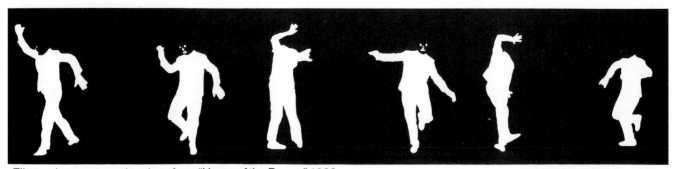

Film and computer animations from "Home of the Brave," 1986

The Geography of Dance

As hosts for "Alive from Off Center" the clone and I introduce a dance piece called "Geography."

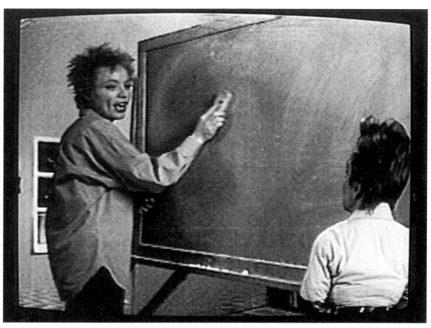

With clone at blackboard

LA: *(TALKING VERY FAST)* It's like this. Choreography is the geography of dance. **C = G**

Choreography is the landscape of dance. It's the map. Here look.

It's how you get from A to B.

CLONE: That looks very confusing. Where is the dancer in this?

LA: But that's the point! Don't you see? It's like they say: You can't tell the dancer from the dance.

It's speed! Velocity! MOTION! It's like Steve Martin said: "Talking about music is like dancing about architecture."

Now you can't dance about architecture can you?

C: Well, what about the square dance?

LA: What about the square dance?

C: A square dance is a dance about a barn.

LA: A barn is a building. It's hardly architecture.

C: Well how about if I do something like this?

LA: See, that's what I'm trying to say And if I do this it's got scale.

And if I do this it's what?

C: Geography.

from "KTCA Intros" 1987

Who's That Bald Guy?

From "United States 1," 1979

In most performances there have been images of bald people streaking through the backgrounds. Mostly because it's hard to draw hair and clothes and also because I love the motion of running. Often this guy is used as a segue, a running gag.

I drew this guy because I had broken my knee and I was forced to stay off my feet for a while. I missed running so much that I decided to draw someone running. So I tried to imagine it. But I'm no Muybridge. When I got the film back from the lab I was shocked at what a poor imitation of movement it was. And also there was a lump on his head where my pen had slipped. But as I watched the sequence loop over and over again, I began to love his awkwardness.

In "White Lily," the performer, casting a shadow, walks across the stage following the running man. When the performer walks offstage, a slide of her shadow appears.

220

Diagram for "Sharkey's Day" video, 1984, by Perry Hoberman

Rising up from the smoke in "Sharkey's Day" video, 1984

Computer animation from "Natural History," 1986

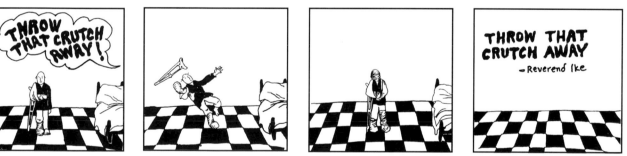

"Throw That Crutch Away (for Reverend Ike)" a slide animation from "United States 2," 1980

Film animation from
"United States 1," 1979

Slide animation from
"Walk Don't Walk," 1978

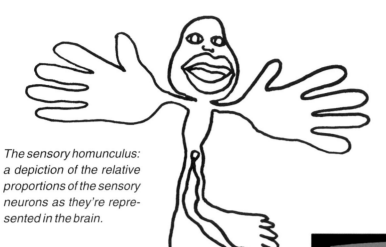

The sensory homunculus: a depiction of the relative proportions of the sensory neurons as they're represented in the brain.

Well I stopped in at the body shop
I said to the guy, I want stereo FM
installed into my teeth.
And take this mole off my back
and put it on my cheek.
And while I'm here,
why don't you give me
some of those
high-heeled feet?

from "Monkey's Paw" 1989

There was this man
And there was this road
And if only I could remember these dreams
I know they're trying to tell me something.
Ooooeee. Strange dreams.

from "Sharkey's Day" 1984

Sun's coming up.
Like a big bald head.
Poking up
over the grocery store.

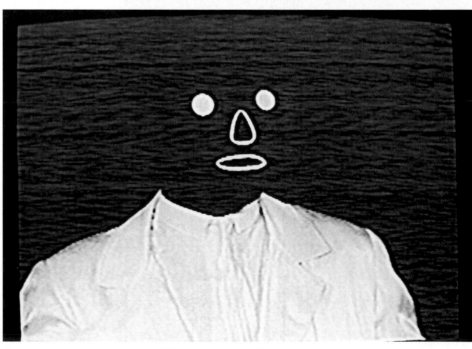

Images above from the video "Sharkey's Day," 1984

The Audio Glasses

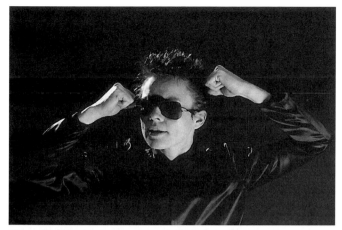

A contact mic is mounted on the bridge of dark glasses. I made these glasses when I pulled the contact mic off my violin and, being an oral person, tried putting the mic in my mouth. This didn't work so I attached it tightly to my skull, braced by the glasses. When I knocked on my head, it sounded like a huge reverberant space. When I clicked my teeth together, it sounded like an enormous door being slammed shut. They're dark glasses to represent a kind of mental darkness.

Wearing the Audio Glasses "United States 2," 1980

The Lens Head

Using the Lens Head in "Home of the Brave," 1986

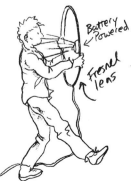

In "Talk Normal," I used a two-foot Fresnel lens as a mask. Many of the instruments and gadgets I've invented have been based on things I've seen in "Edmund Scientific" a kind of catalog for amateur scientists and tinkerers.

After a few months of sitting in the editing room working on "Home of the Brave" looking at pictures of myself day after day, we paused on a close-up of my face, and I thought, "If I ever see this face again I'm going to shoot myself!" The simple truth is that you should never take that many pictures of yourself; and if you do, you should not sit around for months staring at them.

Eventually, editing began to seep into my daily life. I'd be sitting in a restaurant talking with someone and suddenly I'd look around and think, "Wait a second! This isn't very well lit! I wonder if we have any other coverage of this?" Or worse, "Who wrote this anyway?"

It was my own fault, really. I decided to put my photograph on record covers, posters, in films. These pictures were duplicated and distributed. I could have chosen not to do this. I could have said no.

One night after a performance, a man talked his way backstage and introduced himself as a fan and also a doctor. He said he wondered if by chance I had a lot of headaches or felt a lot of pressure in my head. He said that he was struck with the number of images of large heads in the performance and thought it might be a symptom of something.

Still with time code from "This Is the Picture" video, 1984

Posters on a Spanish street, 1989

I turned the corner in Soho today
and somebody looked right at me and said,
"Oh no! Another Laurie Anderson clone!"

from "Talk Normal" 1986

38. LIKE A PAPER DOLL

Backstage at a TV studio, 1984

Sometimes I wish I hadn't gotten
That tattoo.
Sometimes I wish I'd married you.
One hundred fires.
One hundred days.

Sometimes I feel like a stranger.
Sometimes I tell lies.
Sometimes I act like a monkey.
Here comes the night.

from "Kerjillions of Stars" 1989

270809 115460034

From *"The Human Face,"* 1991

Mom said: Honey, money will feed you

Money will dress you

Money will take you away.

Pop said: And when you're at a loss for words

Money will know what to say

'Cause money talks and nobody walks.

Mom said: Honey, talk may be cheap

Silence may be golden,

Maybe speech is free. Pop said:

But honey, when money talks nobody says:

Hey! Are you talking to me?

from "Money" 1975

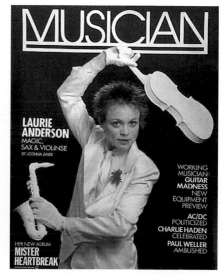

Publicity shots

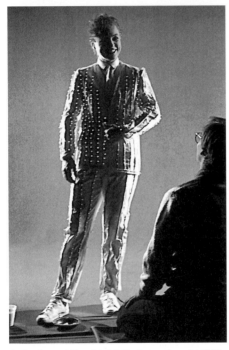

I designed the Light Suit made of LED's (fabricated by Fred Buchholz) for a video but never used it, mostly because it was so stiff I couldn't walk in it.

 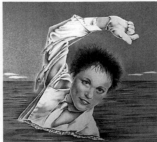

Collage by M. Dara *Painting by anonymous fan*

1981. In the mid-'70's and early '80's, I believed the purpose of costumes was to enable me to disappear. Finally lighting designers said they couldn't ever find me on stage and asked me to please wear something a little brighter than a funeral director's suit.

1985. During the mid-'80s, what I think of as my minstrel era, I wore a white suit and felt like some kind of glad-handing salesman.

From a comic book by Popetti, an Argentine artist, 1990

Natural History

HANSEL & GRETEL SMOKE RINGS OLD HAT DRUM DANCE FILM CLIP LOOP THE DAY THE DEVIL PARK/LOCK BIG SCIENCE HOLOGRAMS WHITE LILY WALKING & FALLING TV SIGNALS TIE & SHOES WHOSE SHOES? THE DUTCH ASTRONAUT LET X=X RADAR GRAVITY'S ANGEL KITCHEN CLOSED CIRCUITS DRUM BREAK GOLDFISH BOWL BABYDOLL MACH 20 KOKOKU I NO LONGER LOVE IT TURNING CLOCK O SUPERMAN

The "Natural History" tour in 1986 was for the most part a collection of songs from "Home of the Brave" and "United States" as well as several new songs. It was a kind of retrospective but I discovered the difference between "concerts" and "performances." I missed the "through line," the loose plot of performance. "Natural History" while it was fun to do, felt sort of random. The tour included the United States, Europe, Japan, and Australia.

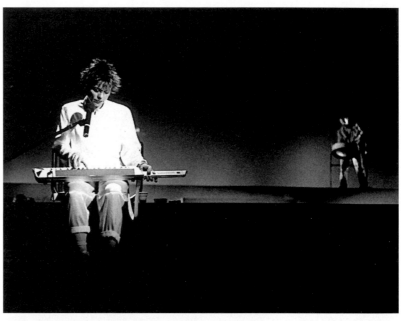

"Hansel and Gretel" from "Natural History," 1986

Take me out to the ballgame.
Take me out to the park.
Take me to the movies.
'Cause I love to sit in the dark.
Take me to your leader.
And they said, "Do you mean Ron?"
And I said, "I just want to meet him."
And they said, "C'mon, we don't even know Ron!"

from "Babydoll" 1986

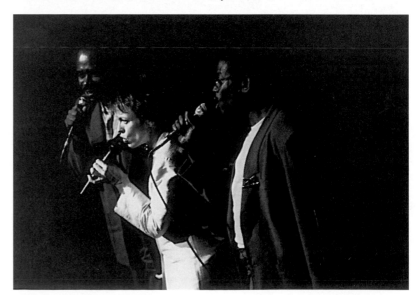

With Bennie Diggs and Phil Ballou

Explaining my instruments on Japanese TV, 1986

The Japanese were especially interested in the digital instruments and the way the computer-controlled images were made. One company made a very professional version of the audio glasses and presented it to me in a velvet-lined eyeglass case. The representatives talked vaguely about marketing this as a special product or toy but either I didn't understand what they wanted or they were just being polite.

Being a media star in Japan was both flattering and oppressive. I knew that the Japanese media, like the English press, was voracious, always looking for something brand new and then tiring of it quickly. I tried not to get drawn into the "media star" mentality. On the other hand, it gave me lots of opportunities to meet strange people I wouldn't otherwise have run into.

As kids, we had a big floor-to-ceiling map of the world in our playroom, the kind with the United States dead-center and Russia and China chopped up and shoved over to the sides and we'd roller skate around the room to Chubby Checker records and the world would keep zooming by, and the things that really stuck out were these two little islands at the top shaped like boots and just sort of hanging there: Japan and England.

We asked who lived there and they said, "Oh, the people who live on these islands drink tea and they love gardens and they have big navies and they're very reserved." So I never really got it very clear which was which. Even later when I went to those places I could never really keep them straight.

LAURIE ANDERSON

As musical guest on "Saturday Night Live," hosted by Tony Danza, 1986

And slowly my heart is burning
It's burning my hands
It's burning my eyes
I can feel the heat.
Slowly my head is turning
It's teaching my heart
It's showing my heart
It's telling it how to beat.

'Cause slowly slowly I'm learning
That nobody knows how I feel
Better than me.
And slowly slowly I'm burning
My head is hot
My feet are on fire
I can feel the heat.

from "Babydoll" 1986

39. MY THAT IS SLIM

Excerpt from an interview with Andy Warhol and book editor Craig Nelson, 1984

CN: Was that when you cut the twelve singles for "Juke Box," your 1977 piece at Holly Solomon?

LA: Yeah, the "Talking Book," glad you mentioned it! It's something I did in '75, on a grant from ZBS Media, a studio for experimental music and audio in upstate New York. I'd never worked in a studio, and I needed the sound of sand behind a contact lens, sort of grinding around. And I walked in and Bob Bielecki had six really huge microphones aimed at this piece of glass and he was dropping pieces of sand on this glass. And I thought, "This is my kind of guy!" And it was the first time I had used headphones, and we could hear every little sound that the other person made, every breath, like having a conversation inside each other. So we did a lot of things together.

One of Bob's specialties is string vibrations, but he's also worked with a lot of artists on many psycho-acoustic projects and experiments. One artist, R.I.P. Hayman, had this theory: just like in REM sleep, when your eye's moving to follow a dream, perhaps your ears beat on their drums when you dream of sounds. So Bob dropped these tiny microphones down R.I.P.'s ears, and for several days he was monitored while sleeping. The results were, let's say, inconclusive. You'd hear these sudden sounds on the tapes, really loud, and then you'd realize that they were coming from a cat twenty feet away, snoring his head off. But not too many what you might call drum beats were picked up.

CN: Maybe it was the wrong dreamer; maybe he was having only visual dreams. They should have used you after doing a record when you'd have lots of audio dreams and nightmares.

LA: Oh, yeah! Mixing nightmares are the worst!

CN: Great gods, there's nothing there!

LA: Last night I had a mixing nightmare, and it was really awful. I'd been very sick all through the holidays, and had all these antibiotics. I was completely groggy from it, and I was working with these two 24-track machines. It wasn't a nightmare but it was like one. They were going crazy. It was like being retarded. I couldn't control them.

(MR. WARHOL COMES IN.)

Andy Warhol: Oh, are you talking about your sex life?

LA: No, my drug life. I was on all these antibiotics.

AW: So both of you are sick?

CN: I'm well!

LA: And mine was over Christmas.

(MR. WARHOL LOOKS WORRIEDLY AT THE TAPE RECORDER.)

CN: It's on.

AW: How do you know?

CN: This little red dot is flashing.

AW: Oh, really? How's your new diet coming?

CN: Good, very good.

LA: What new diet?

CN: You only eat when you're really hungry.

AW: But that's all the time, right? I want to be anorexic, but if you go past the line, it's scary. Have you ever been that way?

LA: Once.

AW: It's just like drinking, where you cross the line and from then on, you can't drink and ever be sober again. From then on, one drink can make you drunk. I don't understand that at all; it's like anorexia, where you go past the limit and you can't eat any more.

LA: Even one little cracker.

AW: It's so hard! The doctor told me I was going to get pneumonia if I didn't get a shot or something two years ago when I was 115 pounds.

LA: That is slim.

AW: Well, I really liked it and I want to go back. But then I happened to drop by the doctor and get a check-up, he took my temperature, put me in the x-ray machine, and found pneumonia.

CN: How strange.

AW: Is it "pneumonia" like "ammonia"?

LA: I know it's not "p-neumonia."

CN: It's "new-monia" like "old-monia."

AW: And the doctor said if I didn't go right home and right to bed he was going to put me in the hospital just like that.

LA: Sorry you stopped in?

AW: On, no, I told him I'd go and do everything he said. And it went away in two days, it really did.

CN: Were they feeding you in a tube?

AW: No, I just took the pills and it seemed to work. They took another x-ray and it was gone; I must have caught it right in time. You look more anorexic in your pictures than you do in real life.

LA: Yeah, it's the black and white.

AW: But you look real healthy.

CN: Are you still swimming?

LA: No.

CN: But what are you doing to get in shape for your tour?

LA: I've gotta start with something soon.

AW: But performing is such hard work, that must be the best exercise all by itself.

LA: You've got to do other things to get ready for it though, or else you'll go on stage and just peter out.

CN: She's doing a thirty-city North American tour, followed by Japan, and then by Europe.

AW: Is this your first big tour?

LA: Oh no, I've done a lot of them, last summer's was the worst.

CN: Worse than this one?

LA: Yeah, it was much longer.

CN: And everything goes along with you?

LA: Oh yes.

CN: That's always something that's intrigued me. Here you are working with the state-of-the-art in technology, and I feel like a lot of your work is about a person being confronted with the most aggressive, vicious, dehumanizing technology, science on the attack. Is it a love-hate kind of thing?

LA: Well, I do always want to be in control; that's part of the joke: you use technology to criticize it. But it's always got to be under control. Once, when I was performing in Zurich, the technicians were messing up completely. I was having to speak Swiss German and they couldn't understand what I was saying. I'd have to come back between songs and scream "YOU'RE MESSING THIS UP!" And then I'd go back onstage and talk really quietly, you know, "A while ago…" It was really awful. But it does bother me very much when things break. But then again, I also like it because you have to do something to fix it and you have to do it right that second.

CN: Your first record was called "Big Science," which is a term that doesn't sound pleasant to me at all.

LA: Well, I've always thought of that as a '40s film, rather than the '80s. All the language is '40s— "Hey Sport!" "Hey Pal!!"

AW: Do you shoot in film or video?

LA: Well, I make videos, but in performance I only use film.

AW: That's good. Film is the best.

LA: Film is beautiful.

AW: So do you want someone in the office to type up this tape?

CN: No, I'll do it; I can type 90 so it's easy enough.

LA: 90?

CN: It's certainly not any big thing, just after lots of practice you get to a point where your brain listens to the tape and your fingers do the typing, like the way people talk most of the time, with the lips and not with the head.

LA: I know very few people who can talk and think. In fact, I can't think of any right now. Maybe because I'm talking. Conversation, letter writing, the lost arts.

CN: Maybe if the phones get too expensive now people will go back to letters.

LA: They won't remember how.

CN: We'll all have to practice by writing love letters.

LA: I guess people still do that.

CN: At least, little notes that you leave under the sheets.

LA: "Where were you?" You know my phone is broken and it's taking a long time to get it fixed.

CN: Is that your ultimate dream: phone death? I think the two most prominent things in "United States," at least after looking over the book once again, are phones and planes.

LA: And dogs.

CN: But you like dogs. You had one?

LA: Not to call my own. I had some hermit crabs. They're great pets.

CN: Do they like people? Are they affectionate?

LA: Not really. Why did I like having those? 'Cause I got them somewhere else and they never, oh, they had such a sad end; they just kind of froze and starved. They couldn't really eat what I gave them to eat: little shrimp, lettuce, stuff like that. I got them in the South Pacific and smuggled them back in several pockets.

CN: And you kept them in a turtle bowl? A bathtub?

LA: No, I brought a lot of sand back, too, lots of shells. They were very nice.

CN: And you couldn't figure out what they eat?

LA: No, they were just really picky. And then they sort of seemed to panic.

CN: So why is it that you're not a big plane fan?

AW: You don't like planes? Oh I'm such a fan of planes.

LA: You really like them?

AW: Oh I just want them to crash. I really do. I look forward to it. I used to be so afraid of them, but then I realized that if it happens, you just go like that.

LA: No you don't!

AW: Oh yes, it's just like that. But the things I'm afraid of are things like the State Theater, with all those seats and such few aisles, and you get a seat right in the middle and you can't leave until the intermissions. But after a few experiences of being late to a plane and rushing to get there, you love getting on one. Soon, you'll be getting your own plane anyways. Why don't you go on a helicopter ride?

It's fun, it really is, you can go around the Statue of Liberty, ride through the World Trade towers, right between them but with all this touring you're doing, you have to be used to planes by now. Are you booking your own tour?

LA: No, I have someone else doing it. The best part is Italy, where after the concerts they say, "Oh, the money! We forgot the money! We'll wire it to you at your next place, OK?"

CN: Also what you told me about the promoters that fudge a bit on the seats. They say, "Oh Laurie, you're so great, you sold out the theater and we've got 800 seats." Then you find out it was sold out, but it was a 1,200-seat theater.

AW: Did you see Roy Lichtenstein's new mural yet? It's so beautiful.

LA: No, I never get around the galleries much any more.

AW: How come? You live right down there and you never get around and see the shows?

LA: I'm kind of a recluse.

CN: She's overdone with work, you can't believe it. I don't know how you get anything new out with all this grinding pressure.

LA: I work at night.

CN: And then you sleep from 4 to 5:30 a.m. and then get up and start another huge day all over again. Both of you have the same love of vacations.

AW: Well, I think every day's a vacation for me. When you really, really like what you're working on, it's like always being on vacation.

CN: But I can't believe how little sleep you get by on, how many different, very complex things you'll do all at the same time. When Laurie was pulling her book together, she was recording the new album and working with Trisha Brown, scoring "Set and Reset," all at the same time, and it was just crazy, you must have been sleeping about 45 minutes a day.

LA: I was a real zombie.

CN: And the book ended up being no easy tooth to pull. So much of it had to be reshot; we had to think very carefully on how to get some of it across in translation. The best part I remember was you holding up a piece of 8mm film, where the picture is about 1/52nd of an inch by 1/23rd of an inch, and saying, "We'll use the negative of this and print it a whole page with the words superimposed in white," and I'd say, "That should do it," but neither of us, really, had a strong idea of what, exactly, the whole thing was going to look like. We were both working on this like maniacs, and it was all completely in the abstract.

AW: Well, I started reading the book. It has a story; it has a real plot. I was surprised.

CN: So with all this maniac work I'd ask Laurie, "When are you taking a vacation?"

LA: I never know what to do on vacation.

CN: Lie on the beach.

LA: I hate the beach.

CN: Lie on the mountain.

LA: Right.

Street of Crocodiles

*CLONE IS FEEDING THE FISH, HUMMING TO HIMSELF.
LA RUNS INTO ROOM.*

LA: Hey! Have you ever heard of Bruno Schultz?

CLONE: Bruno…Schultz…uh…let's see…Bruno Schultz…

LA: Well, he was this writer in Poland in the '30s. He wrote this great book called "Street of Crocodiles." He lived his whole life in the same little town. The book is sort of about his childhood but it's really weird, like he didn't know the difference between what was alive and what wasn't.

CLONE: *(APPROACHING HIS DESK)* Sounds interesting.

LA: Like when he talks about chairs. It's like they're still alive. See, the trees get chopped up and they're suffering because they've been forced into these arbitrary chair shapes.

*(CLONE BEGINS TO SIT DOWN. LOOKS AT CHAIR.
IT MOVES EVER SO SLIGHTLY. HE CHANGES HIS MIND,
LEANS AWKWARDLY ON THE DESK INSTEAD.)*

LA: Anyway, Schultz's father worked in a dry goods store and in the book the dummies keep coming to life.

CLONE: The dummies?

LA: Yeah. The imitation people, the artificial people, the models.

CLONE: Oh.

LA: I mean his whole world is so corroded and fermenting. Everything's broken and crummy and skimpy. Like when he describes snow, it's not a fluffy blanket, it's a threadbare tablecloth full of holes. Even the sheets and pillows were alive. Listen to this!

"He slept thus until late morning, while the pillows arranged themselves into a large flat plain on which his now quieter sleep would wander. On these white roads, he slowly returned to his senses, to daylight, to reality. And at last he opened his eyes as does a sleeping passenger when the train stops at the station."

from "Introductions" "Alive from Off Center" 1987

237

LA: Yeah, well, so like I was saying, people see me on the street and they say "Wow! Laurie Anderson!" And I don't take it personally anymore because it's this way: they've seen my picture, they've seen me on television, and it's just surprising to them that people from the second dimension are walking around in the third dimensional world, mailing letters, buying groceries, and so on. So I have to congratulate them. "Congratulations! You have made the connection between the second and third dimensional worlds. Good job!"

Interviewer: Do you think the fact that they find out that you are real is inspiring to them?

LA: Not particularly. It's just interesting to see that people don't quite believe in television.

Interviewer: Is that good?

LA: That's great.

Interviewer: Television's dangerous isn't it?

LA: Dangerous? A lot of things are dangerous. Information is dangerous. Boredom is dangerous. It's so silly to say something like that. Television is many things.

from an interview on the TV show "The Eleventh Hour" 1989

I dreamed there was an island that rose up from the sea.
And everybody on the island was somebody from TV
And there was a beautiful view
But nobody could see
Cause everybody on the island was screaming Look at me!
Look at me! Look at me! LOOK AT ME!! LOOK AT ME!!!

from "Language Is a Virus (from Outer Space)" 1986

I think the most amazing thing that's happened in the last few years has been the attempt to create life, to create intelligence. Even objects that didn't use to think are starting to think. And they're getting names, "Mister Coffee," for example. Now there's a household item that seems to have the potential to do other things than just make coffee, and it's not far away to imagine it having other human attributes, hopes, fears, desires.

One of the goals of people working on artificial intelligence at MIT is to create a machine so intelligent, so sensitive, that a soul will be attracted to it.

Now one thing they haven't counted on is that souls are shy. And even if one does manage to get inside, there's no reliable test to prove it's actually in there.

It was like the Dutch Astronaut I met who had a theory about technology. His take was that technology is actually a new kind of parasite that began to develop consciousness about 100 years ago and which, like all parasites, is gradually taking over its host, strangling the life out of it.

from "Natural History" 1986

I saw a strange article in "The New York Times" about the effect of TV on kids. The question was: Do kids who see violence on television find it easier to pick up a gun and shoot someone? Or are they able to separate the fake world of television from the real world? The answer in the paper was: Yes, kids can separate TV from real life except in families where everyone already acts like they are on TV. This was bizarre, but you know what it means. Lots of people learn how to run their lives from watching television. They learn how to walk into a meeting with confidence. They learn how to have a love affair, how to eat, how to stand and so on. They just copy the people they see on TV. But, as a statistic, it seems pretty odd.

Then again maybe it's not. People have been learning from machines for a while now. And sometimes there's a real confusion about what's alive and what isn't. It seems like about half the movies being made now are really about this. In these movies, robots, zombies, and androids are the stars, and the plots are usually about how to distinguish between the real people and the electronic ones.

Sometimes I think television is just a very clumsy ancestor of this new intelligence. Right now, TV is a box full of pictures, an electronic puppet show. But the future of television is bound to the future of the computer, and I guess I'm really curious about what it will say and do when it finally starts to think on its own.

I suppose the thing that bothers me most about television is the narcotic effect it has on the viewer, that blank theta-wave expression. It has to do, I think, with machines. A lot of people who work with machines get that way.

For example, you go into the bank and say to the teller, "So how much money is in my account?" and the teller says, "I-CAN-NOT-TELL-YOU-WHAT-IS-IN-YOUR-ACCOUNT."

And you say, "Where did you learn to speak English?"

"From a machine" is one of the answers.

from "Talk Normal" 1986

You know? I don't believe there's such a thing as TV.
I mean they just keep showing you the same pictures
over and over
And when they talk they just make sounds
that more or less
synch up with their lips.
That's what I think!

from "Language Is a Virus (from Outer Space)" 1986

With Peter Gabriel. Still with time code from "This Is the Picture" video, 1984

41 . LIP SYNCH

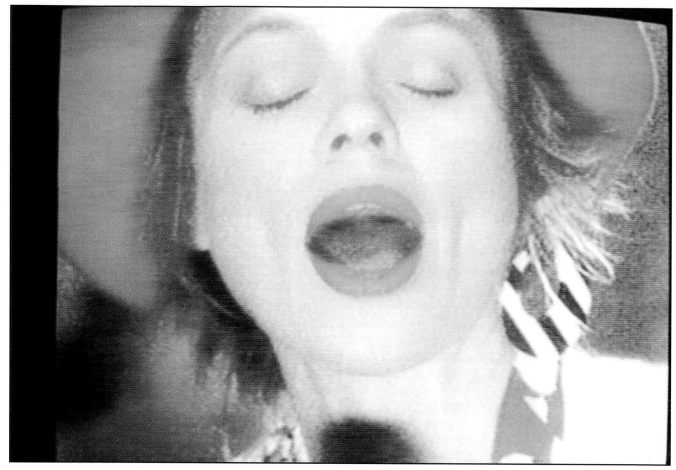

"Beautiful Red Dress" video, 1990

In 1984, Nam June Paik asked Peter Gabriel and me to do a song for his live "Good Morning Mr. Orwell" TV event. "A video would be nice too," he added. "The shoot will be this Sunday." It was Friday morning.

We began with a Linn drum pattern. By midnight we'd added bass and guitar. By Saturday morning we were on to keyboards and flute and by late afternoon we'd begun to write the words. Around 3 a.m. we were pretty fried but now the deadline was only hours away so we started recording harmony parts. Around 5, the engineer and I were watching the meter as Peter sang.

Publicity shot. Trying to look alert with Peter Gabriel on the set of "This Is the Picture," 1984

I see pictures of people rising up.
I see pictures of people falling down
I see pictures of people they're standing
on their heads

The levels were dropping rapidly and we began to search for the problem, yanking cables and checking connections. Finally we looked around at Peter to see if he had any technical solutions. Now I've heard people talking in their sleep but never singing in their sleep. It was amazing. His head had fallen back from the mic and he was still singing (on pitch!). At 2 p.m. the next day we were still frantically drawing the storyboards and it wasn't until 4:30 that we staggered into the studio where the crew had been waiting for six hours. "Gee 4:30 already?" We tried to be casual. During the shoot we were so tired we couldn't remember any of the words, so the prop department wrote huge cue cards with stress marks:

Sit-ting by the win-dow´.
Watching the sno-o-o-w fall. I'm looking out´.
And I'm mooooving.
Turning in time. Jump UP´!
And I can land on my feet. Look OUT!
This´ is the picture.
This´ is the picture.

Even though there are always lots of images in my performances, I've always found it difficult to make music video. Lousy lip synching is just so creepy and besides the whole thing is so overtly a commercial, so I try to mess around with the form as much as possible. In 1986, I made a backwards music video entitled "What You Mean We?" There was no lip synch to playback during the shoot, the performers just sang the song at the top of their lungs, any tempo, any key, and the final mix of the song "Smoke Rings" was layered in during post-production with no attempt to synch it to anything.

The video is set in a diner, cutting between the counter and the kitchen. In the kitchen, the song is blaring from a radio and the cook is dancing around preparing a revolting concoction. It keeps cutting back to the counter (and total silence) where the customer is waiting for his order.

Bennie Diggs as the cook sings along to the radio. "Ooo I'm gonna follow you—Out in the swamps and into town. Down under the boardwalk. Track you down."

"Smoke Rings"
From "What You Mean We?"

"Hey look! Over there! It's Frank Sinatra
Sitting in a chair,
And he's blowing perfect smoke rings
up into the air."

The opening shot is a closeup of a radio. "Smoke Rings" is on the air.

Phil Ballou as the customer. "Uh, miss. Do you think you could check on my order?"

"Carmen"

"Carmen," a commission from "Expo '92," was a fifteen-minute version of the opera. It was a day and a night in the life of a contemporary Carmen. There is no dialog in the video. The sound track is a collage of music from the opera.

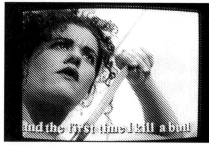

Carmen's co-workers in the tobacco factory

Carmen dreams of killing a bull with a kitchen knife.

In this version Carmen marries Don José, but her new life is interrupted when the debonair Escamillo comes to visit.

It's Our Pleasure to Serve You

Instead of doing a music video for the album "Strange Angels," I did a series of short "Personal Service Announcements" on various topics: military spending, the national debt, the national anthem, women's salaries, technology, and television.

At the time, I thought of myself as a spokesperson. I believed I should speak out on "the issues," and I was doing a lot of lectures and participating in panels dealing with things like the relationship of art to politics.

National Debt

You know recently I've started to get pretty worried about the national debt. Now I don't know how many of you are personally in debt, but it's probably pretty puny compared to the numbers on that big electronic sign that's up on Sixth Avenue in New York right now, you know the one that runs 'round the clock tabulating the national debt which is rising at the hair-raising rate of $8,000 per second.

Now as most of you probably know at this moment all the taxes west of the Mississippi go exclusively towards paying the interest on the national debt.

Now if the numbers continue to escalate at this rate, and given the inflation on current interest rates, by the year 2020 all the taxpayers west of the Amtrak corridor will be paying off the interest on the national debt.

This of course means that everybody east of this corridor is then responsible for basically everything else, things like, oh, defense, social services, foreign aid, the space program, the drug war, and last but not least paying off the principal on the debt.

So let's take a look at who's over here, at who will actually be footing this bill. We've got a fair amount of Maine, there's Atlantic City, quite a lot of Florida beachfront, half of Boston, and of course New York also falls into this category.

And if my calculations are correct, taking population and inflation into account, by the year 2020, each citizen in New York would have to be earning an annual gross income of approximately 32 million dollars in order to contribute his, or her, fair share.

from "Personal Service Announcement #2" 1990

I Hate TV

You know, I hate television. I did see a great TV show out in Ohio recently and it was on at 6 a.m. and it was just lot of lunch menus, what they were serving for lunch in the high schools and junior high schools around town that day. So you'd hear this great music, real happy music, and these words would scroll by:

<div align="center">

**TURKEY TETTRAZINI
ON A ROLL**

JELLO

LIMA BEANS

MILK

</div>

Now I don't know who was up at 6 watching this show. But it did give you a chance to check whether or not you like the menu. And if not, you could make sure you brought your own lunch.

Now in my opinion, this is television at its best.

from "Personal Service Announcement #6" 1990

42. LARGE BLACK DICK

Let's talk about one of our hidden minorities: American men. White American men. I mean those get-out-of-town kind of guys, like Jesse Helms.

Washington D.C.? It was a town that wasn't big enough for the Senator and the artist Robert Mapplethorpe. Yeah, Jesse liked pictures of snowy landscapes, art that made you feel good. And Mapplethorpe? He was after the big taboos, things like: What do sex and religion have in common?

So the Senator looked at the artist's photographs and they were pictures of men with no clothes. And there were lots of chains and black leather and crosses. But the picture that bothered the Senator the most was a very large black dick sticking out of a business suit. So he made a law that said:

WE'RE NOT GOING TO LOOK AT THIS AND YOU'RE NOT GOING TO LOOK AT IT EITHER.

You know, I remember when I was a kid sitting in church and the preacher would point to pictures of Jesus Christ, who was wearing no clothes and bleeding profusely. And the preacher was saying:

LOVE THIS MAN! LOVE HIS BODY!! HE LOVES YOU!!!

And all the men and boys in church were squirming around, they couldn't look. They couldn't wait to get out of there. And this of course was the reason for the invention of Sunday afternoon football.

 It's been two years now since the Corcoran Gallery cancelled Robert Mapplethorpe's show and Jesse Helms asked all the women and pages to leave the Senate so they wouldn't have to look at all the dirty pictures he was handing around. At the time, I thought this would blow over, that people would recognize Helms as just another hysterical crank desperate for a campaign theme. Instead he got re-elected. And the issue of control, who controls what, has

started to blend in with a whole new brand of puritanism.

But it's not hard to see that control is a major theme in America. Every episode of "Star Trek" is based on it. Losing control is the worst thing that could happen. The captain loses control of the ship for one reason or another and he starts yelling from the bridge,

"I'VE LOST CONTROL!
I'VE LOST CONTROL OF THE SHIP!!"

And the plot of every show is how he manages to regain it. It's no coincidence that the whole drama is played out on the set of the Control Room.

So who's really in control here? What's this morality play really about? Since all this began, one of the things that happened is that everybody's gotten really preachy and puritanical, politicians, pop singers, cab drivers, artists. And it's actually really hard to avoid. I mean it's impossible to talk about puritanism without becoming one. I know this because my puritan ancestors came to this country from England for religious reasons. The King of England wouldn't let them punish people for playing games on Sunday. So they came to America to exercise this precious right to punish people who didn't agree with them. Welcome to America.

from "Voices from the Beyond" 1991

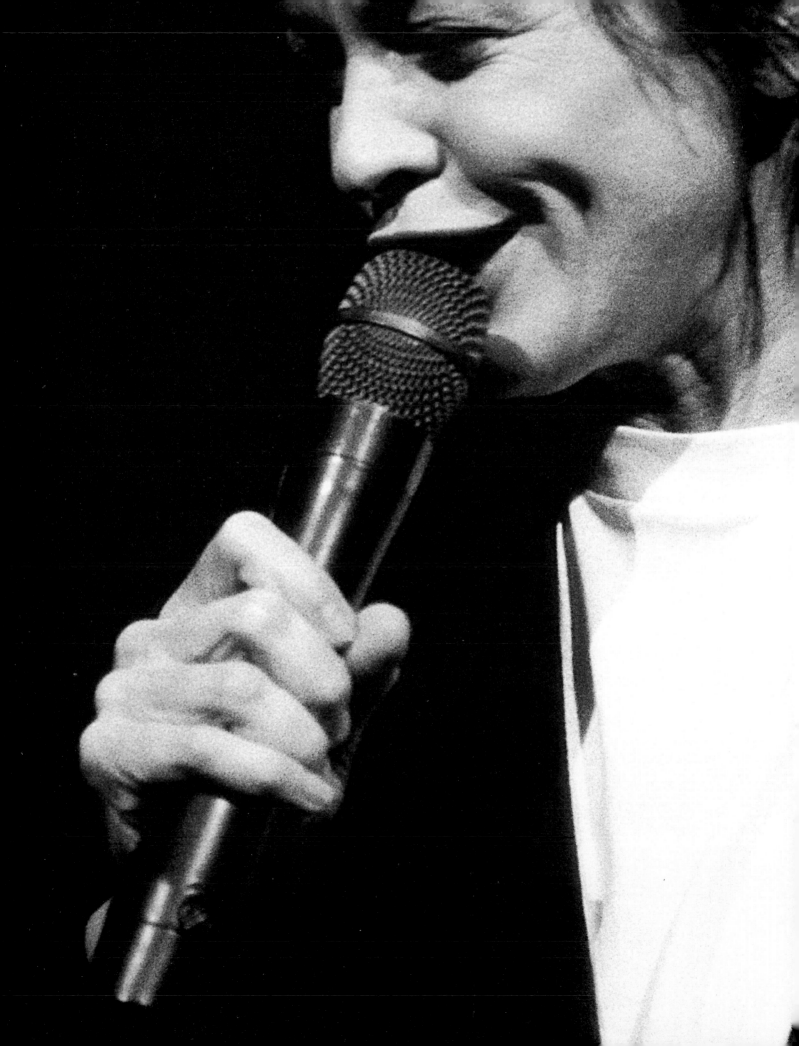

Hanoi 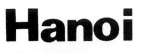 Haiphong

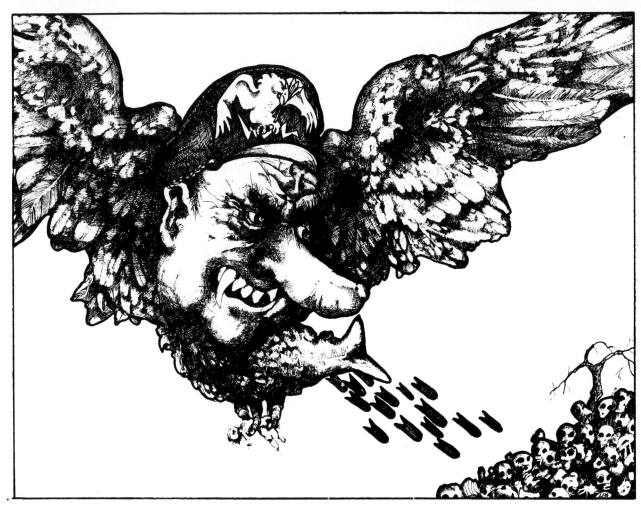

Hanoi and Haiphong cities have been bombed. Waves of B-52's. Thousands of tons of bombs. Mass murder from the skies.

Why? Nixon's attempt to hide the war from the American people has been upset by the recent North Vietnamese offensive. His "Vietnamization" program has utterly failed. Out of desperation he has given in to his military advisors. Desperation because the Vietnamese people have chosen not to follow Nixon's 1972 election script.

Nor will the American people follow that script any longer.

★ In three years of promising peace, Nixon has dropped more than 3 million tons of bombs on Indochina. That's 4000 pounds per minute, or the equivalent of three Hiroshimas.

★ Since December he has doubled the number of air strikes.

★ American ground troops have been replaced by electronic sensors and remote-controlled anti-personnel weapons.

It is time to break the silence. Time to show we are not good Germans. Time to strike back at the American war machine—at Nixon and Kissinger, at ITT and Honeywell. Time to demand an end to the bombing. An immediate withdrawal of all troops from Indochina. A cessation of all support for the Thieu regime.

Already people are on the move. Strikes have been called at dozens of campuses across the nation. Protest rallies and actions have been scheduled in every major city. Join us to end the war.

For more information:
Peoples Coalition for Peace and Justice (924-2469)
New York Switchboard (533-3186)
April 22 (741-2018)
Campaign End the Air War (777-5560)
Clergy and Laymen Concerned (749-8518)
National Student Association (202-265-9890)
Womens Strike for Peace (741-1751)
Anti-War Union (202-785-4733)
Ad Hoc Military Build-up Committee (617-492-5570)
Peace Parade Committee (255-1075)

STRIKE BACK

Poster, 1972

University Review

Like many artists, I became involved in the censorship battle. But the more I thought about it, the more complex the argument seemed. Obviously, the idea that government could make rules for artists was intolerable. At the same time, the art world's reaction made me kind of queasy. Artists were taking the moral high ground, making politically correct statements seemed suddenly to qualify as art, as if the purpose of art was to teach people tolerance or goodness, to set them free from their "prejudices," and it began to sound suspiciously like some 19th-century vision of art as self-improvement.

The argument centered around "bad images," "bad words," and, most of all, federal funding. Words got twisted. The big questions, however, were left unanswered:

> Can art hurt you?
>
> Should art help you?
>
> What is real power?
>
> And what, really, is a lie?

As an artist I'm interested in fear and I like to try to see where it comes from, my own and other people's. Tonight time is sort of limited, so I won't be going into my fears, except maybe one or two. Like a couple of years ago when the syringes started to wash up on the beaches around New York and a lot of people I knew were dying of AIDS and every night I had dreams where lots of things kept washing ashore, old crutches and casts and nurses' uniforms, and then far away, way out near the horizon, you could see what looked like hundreds of hospital beds and they were floating towards shore and there were people in the beds and back on the beach there were crowds of people yelling at them not to come in. And they were yelling

"AHOY! WHAT DO YOU WANT?"

And it was like what happened to the boat people but these were the bed people, harder to steer, and they kept getting closer and closer and nobody wanted to look at them much less help them and by now the Navy has shipped back the 10,000 beds that didn't get used in the Gulf War and everybody's poised, waiting for the future to happen.

from "Voices from the Beyond" 1991

Interviewing a Bill Clinton fan for National Public Radio at a Bush rally in New Jersey, 1992. Every time George Bush mentioned a campaign pledge, Clinton fans put on their plastic Pinnochio noses and yelled "Bush lies!"

OK, now I wanted to say too that it's a special pleasure to be here on tax day and to just take this opportunity to think back to George Bush's last campaign promise concerning taxes.

You know there were a lot of things he could have said other than "read my lips," things like "take my word for it," or "believe me." But he picked "read my lips" which then meant you had to actually look at his lips, you know, have a personal relationship with him which was a sort of deeply disturbing experience, Bush being a somewhat inorganic individual.

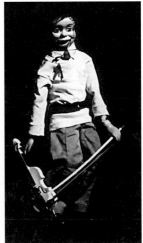

The Dummy at a benefit performance for the Kitchen, Town Hall, New York City, 1992

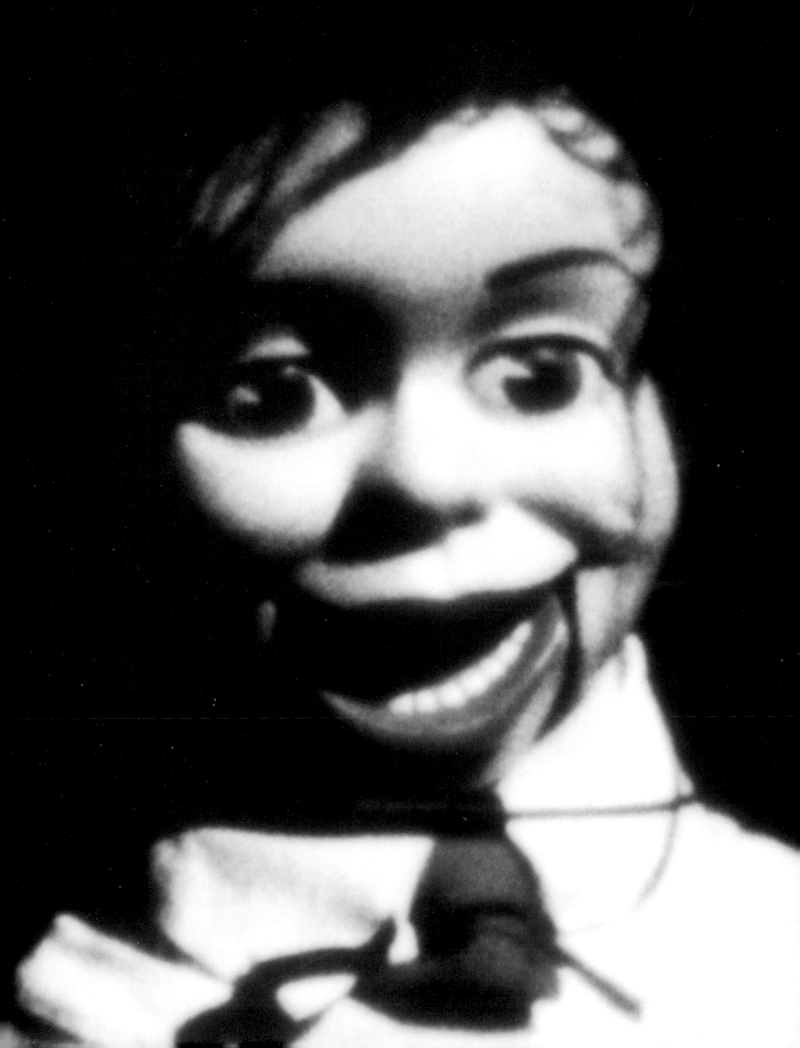

43. IN LOVE WITH THE PRESIDENT

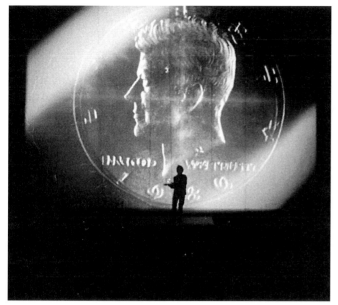

"United States 2," 1981

Jack

I always liked Jack Kennedy. I wrote to him once in 1961 when he was campaigning in the Wisconsin primaries. It was a fairly long letter ("I really admire the way you're running your campaign and I'm running for president of my student council and I wonder if you could just give me some advice.") And he wrote back, a long letter with lots of tips like: Put up posters and flyers, make sure everybody in school knows your name. Also, very important: find out what the students want and promise it. I mean his approach was really practical: be a real representative, not just an idealist.

So a little later I wrote back. "Thanks for your excellent advice! I won the election and best wishes in your own campaign." And then he actually sent me a telegram that said, "Congratulations! Good job!" and one dozen red roses. So of course this was front page in the local paper: "Junior High Girl Receives Roses from Jack Kennedy" and it just confirmed a lot of things for all the women in town who were in love with him, and of course it was the women who were the swing vote in the election.

from "Talk Normal" 1986

Jimmy

I dreamed that I was Jimmy Carter's lover, and I was somewhere, I guess, in the White House and there were lots of other women there too and they were supposed to be his lovers too. But I never even saw Jimmy Carter and none of the other women ever saw him either.

And there was this big discussion going on because Jimmy had decided to open up the presidential elections to the dead. That is, that anyone who had ever lived would have the opportunity to become President. He said he thought it would be more democratic that way. The more choice you had, the more democratic it would be.

from "Democratic Way" 1980

"Democratic Way" was performed at the anti-inaugural ball at the Pension House in Washington, D.C., as a kind of farewell to Jimmy Carter. I shared the bill with a group called "Tiny Desk Unit." I remember that there were an awful lot of guys in narrow ties hanging around the sidelines, undercover agents as it turned out.

Ron

Good evening. Tonight's topics are politics and music. Now there are those who say that politics and art just don't mix. But before we begin, I just want to say a word about Sonny Bono. I mean the guy bothers me. Ever since he was elected mayor of Palm Springs it seems like singing politicians are everywhere.

I do have to say however I was happy to learn that the singer Alice Cooper is running for office somewhere out west, I forget exactly where and he's got a really great slogan. His slogan is:

"A TROUBLED MAN FOR TROUBLED TIMES."

Now he's got my vote on that slogan alone. But of course now that so many singers are doing politics a lot of politicians are starting to sing, so it's sort of evening the whole thing out. And lately what with all the elections and amendment pro-

posals it's been a really great time to study the political art-song format. I mean just how do people convince each other of things that are basically quite preposterous? It's an art form! I mean listen carefully and you discover these aren't speeches at all, but quite sophisticated musical compositions.

Now take a guy like Hitler. You listen to his speeches. They're all rhythm, no pitch. I mean Hitler was a drummer. A really good drummer. And he'd always start things off with a really simple kick-snare idea. You know,

> boom chick boom chick
>
> boom chick boom boom chick

He'd lay down this really solid groove and people would start getting into it, you know, moving to it. And then he'd add a few variations:

> ba BOOM chick
>
> bababa BOOM chick

and then he'd take a really wild solo and they'd all be yelling and dancing. YEAH!

Now don't forget these were the people who invented the Christmas tree, so in their minds, see, there's this fir tree out in the forest and they say, "YA! This tree must be inside the house. Inside! Inside!" They've got this thing about nature and it's the same with music. They've got to do something with it. They've got to bring it on home. So they're stompin' and movin' and groovin' and their feet are all synched up to those drums and they're moving like one giant thing. And pretty soon they've got to go somewhere, they've got to get out, they've got to go someplace, like Poland.

Or take Mussolini. You listen to his speeches. And he's singing grand opera. Doing all the parts. And he's hitting all those hard to reach high notes.

FRONTIERE! FRONTIERE!

He was always singing about the frontier. And anyway he'd get on a roll and all those fans with their ham sandwiches up in the third mezzanine are going nuts and it goes on for

hours and hours. Yeah they go wild, those opera fans.

But of course the all-time American master of this art form was Ron Reagan. And when Reagan wanted to make a point he would lean right into the mic and get softer and softer until he was talking like this.

And the more important it was the softer and the more intimate it would get. With lots..........and......lots.............of........pauses.

Like he was trying to remember something that happened a long time ago, but he could never really quite put his finger on it. And when he talked he was singing to you. And what he was singing was: "When You Wish Upon a Star."

So good night ladies.
And good night gentlemen.
Drive safely now, and please
don't call again.
And when you wake up
you little sleepy heads
Get up! Get up! GET OUT

OF BED! Take a look around. Walk out your door.
Breathe in that new morning.
That's right. Things are pretty different now.
Now that people finally realize it's OK to have it all.

Sure there are a few stragglers. There's some yelling going on. Things like: "YOU JERK" or "GET OUT OF MY FUCKING NEIGHBORHOOD!" But hey, it's a free country. And in conclusion, I'd like to sing a short song, one of my favorites. Goes something like this. Girls?
Ooo oo oo oo oo oo oo ooo oo oo oo
I see by your outfit that you are a cowboy
I see by your outfit that you're a cowboy too.
Let's all get outfits and we can all be cowboys
'Cause that's how the West was won.

from "Empty Places" 1989

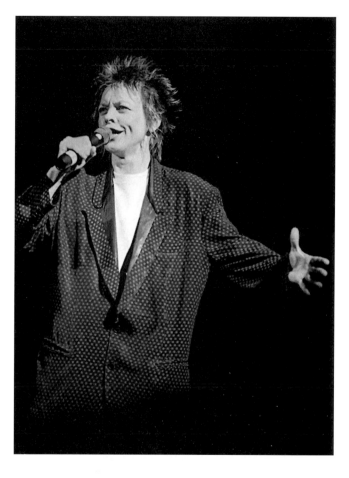

If I were the president
If I were queen for a day
I'd give the ugly people all the money.
I'd re-write the book of love
I'd make it funny.
Wheel of fortune. Wheel of fame
Two hundred forty million voices
Two hundred forty million names.

from "Kerjillions of Stars" 1989

44. B SIDE OF THE NATIONAL ANTHEM:
EMPTY PLACES

This evening's performance is dedicated to Abbie Hoffman,
the man who yelled "Theater!" in a crowded fire.

**VIOLIN SOLO MY EYES POLITICS AND MUSIC SO GOOD NIGHT LADIES I SEE BY YOUR OUTFIT SPEAKING JAPANESE
NATIONAL ANTHEM A AND B COOLSVILLE THESE RULES DUET WITH DOGS LOLITA THE NATIONAL DEBT
POBRE MEXICO HIAWATHA THE WALL LARGE BLACK DICK PARADE LISTEN HONEY GRILS BEAUTIFUL RED DRESS
SHADOW BOX LAST NIGHT STRANGE ANGELS MORE STRANGE ANGELS BRILLIANT PEBBLES RAMON FALLING**

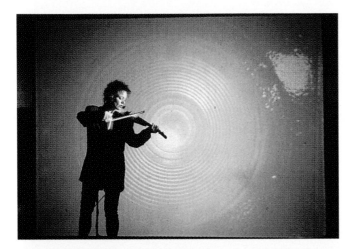

There were ten projection surfaces in "Empty Places," and forty film and slide projectors. The images were mostly of New York. But there were also many animated sequences. Suddenly all the screens would come alive with bluebirds, picket fence and roses blooming, only to be immediately transformed into a hellish city street piled with garbage.

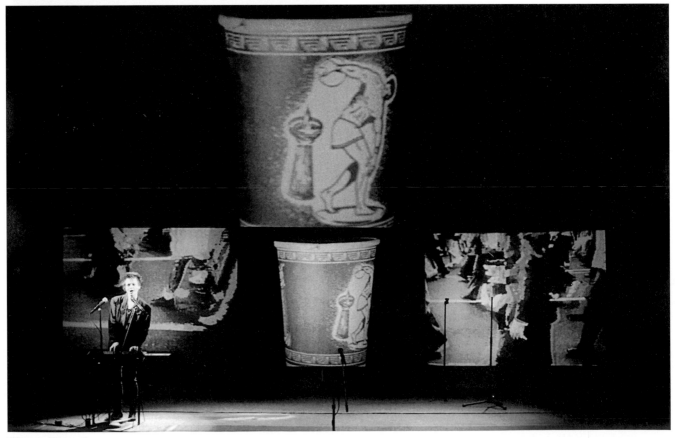

"Empty Places"

B Side of the National Anthem

You know, now that there's some talk about changing the national anthem to "America the Beautiful," I think it's a good time to look at the one we've got.

Now I have to say I really like "The Star Spangled Banner." It is hard to sing though, with all those arpeggios. I mean you're out at the ballpark and the fans are singing away and it's sort of pathetic really watching everyone try to hold on to the melody.

The words are great though. Just a lot of questions written during a fire. Things like:

Hey! Do you see anything over there?
I dunno, there's a lot of smoke.

Say, isn't that a flag?
Hmmm. Couldn't say really, it's pretty early in the morning.
Hey! Do you smell something burning?

I mean, that's the whole song! It's a big improvement over most national anthems though, which are 4/4 time. (We're number one! This is the best place!)

I also like the B side of the national anthem, "Yankee Doodle." Truly a surrealist masterpiece.

Yankee Doodle came to town
riding on a pony.
Stuck a feather in his hat
and called it macaroni.

Now if you can understand the words to this song you can understand anything that's happening in the art world today.

from "Empty Places" 1989

I shot the images for "Empty Places" mostly at night, wandering around alone with my cameras. Taking these photographs and then passing the places later and recognizing them made me feel strangely affectionate towards the city. My targets were empty warehouses, bombed-out buildings, abandoned cars gleaming in eerie dim street lights. Shark light. I didn't shoot people even when I found them huddled under their blankets on the loading docks. I shot "Empty Places" largely to show the way the Reagan Era looked at the end of the decade out on the street.

"Empty Places" is an inverted pyramid. It begins with a lot of ideas about politics and music, moves through some cinematic songs about the United States and then narrows down to a very, very simple, nonclever end. Usually I pride myself on things having three or four meanings. And so a single meaning was really scary to me. The end of the performance was a simple story, a kind of message, about personal responsibility. This really seemed risky because I'd always been proud that I never told anybody what to do. I'd always bragged, "Well, I'm drawing the picture, I'm making the observation, but it's up to the audience to draw their own conclusions. I wouldn't tell them what to do even if I knew." And here I was dispensing advice. On the other hand, being cool and collected seemed very mannered to me given ruins I was showing on the screens.

In addition, I was feeling extremely vulnerable. I was just starting to recover from a nerve disease that I'd picked up in Rio. I had lost most of my night vision and was subject to long bouts of dizziness. When my eyes were hit with a follow spot, I lost my way on stage and had a tendency to head for the pit.

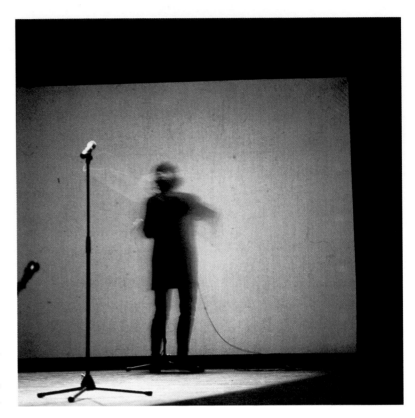

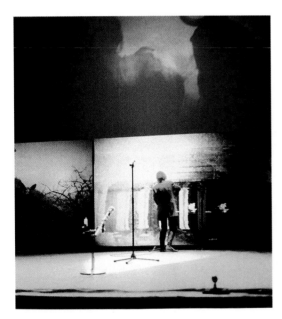

Last time I was in Mexico I crossed the Rio Grande. Now that's a crazy river. It just keeps flooding and changing course and messing up all the maps. And there's a sign posted by the border that says:

WILD RIVER REASONABLE MEN.

Just to remind people to be philosophical about how often the river moves and property changes hands and Mexico becomes America and America Mexico. But the sign that should really be posted at the border is that old Mexican proverb, the one that goes:

Pobre Mexico Tan lejos de Dios
Tan cerca de los Estados Unidos

Poor Mexico So far from God
so close to the United States.

from "Pobre Mexico" 1989

254

Hiawatha

I used Longfellow's "Indian" cadences as basic rhythmic patterns for "Hiawatha"

By the shores of Gitchee Gumme.
By the shining Big Sea Water.
Downward through the evening twilight.
In the days that are forgotten.
From the land of sky blue waters.

And I said: Hello operator.
Get me Memphis Tennessee.
And she said: I know who
You're tryin' to call, darlin'
And he's not home, he's been away.
But you can hear him on the airwaves
He's howlin' at the moon.
Yeah this is your country station
And honey, this next one's for you.

And all along the highways
And under the big western sky
They're singin': Oooo! They're singin' wild blue.
And way out on the prairies
And up in the high chaparral

They hear a voice it says: Good evening.
This is Captain Midnight speaking
And I've got a song for you.
Goes somethin' like this.

Starlight. Starbright. We're gonna' hang
Some new stars in the heavens tonight.
They're gonna' circle by day.

They're gonna' fly by night
We're goin' sky high. Yoo hoo.
Yeah yoo hoo hooo.

So good night ladies and good night gentlemen.
Keep those cards and letters coming.
And please don't call again.

Geronimo and little Nancy.
Marilyn and John F. dancing.
Uncle took the message and it's written on the wall.
These are pictures of the houses
Shining in the midnight moonlight.
While the King sings Love Me Tender.

And all along the watchtowers
And under the big western sky
They're singin' Yoo hoo. Yoo hooo.

And way way up there, bursting in air
Red rockets, bright red glare
From the land of sky blue waters
Sent by freedom's sons and daughters.
We're singin' Yoo Hoo. Yoo hooo.

And dark behind it rose the forest
Rose the black and gloomy pine trees
Rose the firs with cones upon them.
And bright before it beat the water
Beat the clear and sunny water
Beat the shining big sea water.

The emotional center of most of the performances always revolves around stories about "you" and they are addressed directly to the audience in the simplest way possible.

John Lilly, the guy who says he can talk to dolphins, said he was in an aquarium and he was talking to a big whale who was swimming around and around in his tank. And the whale was asking him questions, telepathically. And one of the questions the whale kept asking was: Do all oceans have walls?

It's like that door you find one day, way at the back of your closet. And you go into the closet and turn the knob and open it. And outside there it is: the immense Caribbean. And you can't believe it. You've lived here for so long, and you never knew that all this was right here the whole time.

from "Shadow Box" 1989

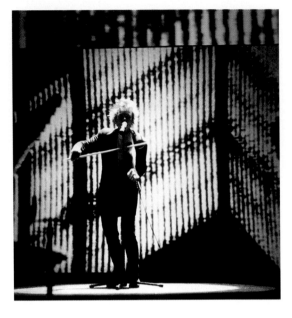

A couple of months ago I was getting out of a cab and I turned around and fell right down into an open manhole, yeah, right into the New York City sewer system. And when I was down there I looked around and said to myself: This is exactly like one of my songs. And then I thought: No it's not. So the ambulance took me to the hospital and parked my wheelchair in the emergency room. And I sat there watching this long line of misery passing by. Gunshot wounds, stabbing victims, and as the night wore on, the old people started to come in.

And there was this old woman sitting next to me. She was a bum and her feet were bleeding and swollen up like grapefruits. And she kept saying, "Look at my feet. Look at my feet." And I couldn't. And there was an old man sitting on the other side of her and she kept saying: "My feet. Look at my feet."

And he did. And he said: "That must really hurt."

from "Falling" 1989

You're walking.
And you don't always realize it,
but you're always falling.
With each step, you fall forward slightly.
And then catch yourself from falling.

Over and over, you're falling.
And then catching yourself from falling.
And this is how you can be walking
and falling at the same time.

from "United States 2" 1980

Some people walk on water.
Some people walk on broken glass.
Some just walk round and round
in their dreams
Some just keep falling down.

from "Ramon" 1989

45. WE DON'T KNOW WHAT WE ARE

Here come the little ones Here come all the bookworms Here come all the ex-wives
Here come the crazy ones Here come the wireheads Here come the ex-marines
Here come the ones Here come all the people Here come a lot of guys
They call the new Arabians. In their pajamas. Driving in their sex machines

"Parade," 1989

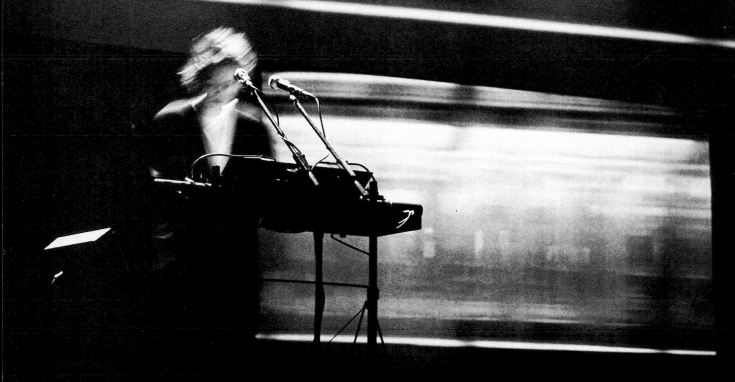

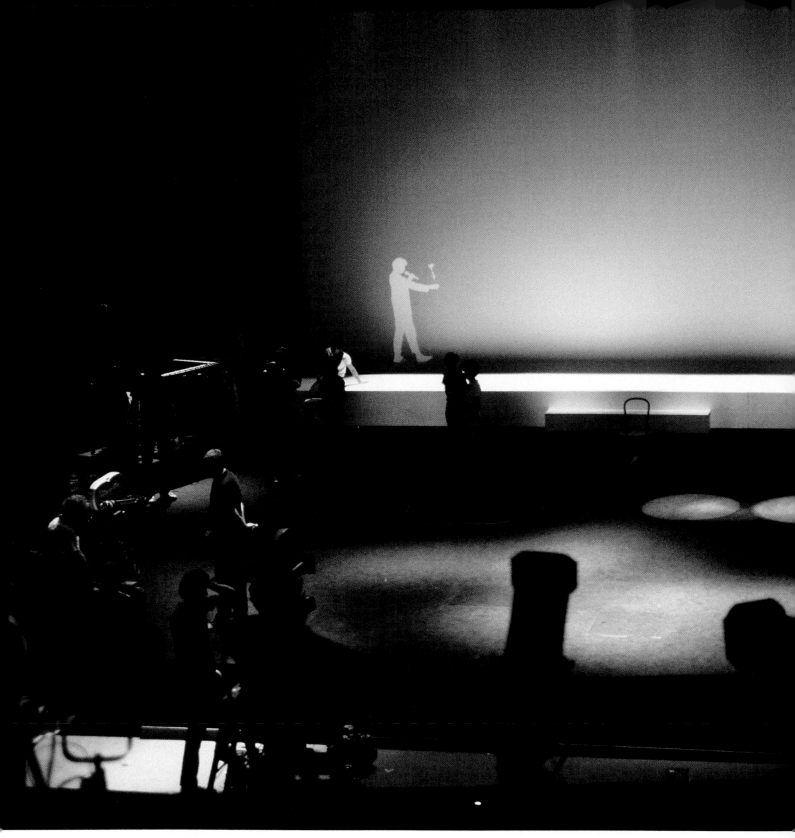

Preparing to shoot "White Lily," 1985

I've written a lot of stories for nobodies: Juanita (aka Anata), a Cree Indian who has forgotten his fathers' songs, a boy who sees himself as a dog in a dog show, as well as a lot of song lyrics about being nobody. In "Ramon" I finally tried to express an opinion about helplessness.

What Fassbinder film is it?
The one-armed man
Comes into the flower shop and says,
"What flower expresses:
Days go by
And they just keep going by
Endlessly
Pulling you
Into the future?

Days go by
Endlessly, endlessly
Pulling you
Into the future?"
And the florist says,
"White Lily"

"White Lily" 1986

In this dream, I'm not a person, I'm a place.

So when you see a man who's broken
Pick him up and carry him.
And when you see a woman who's broken
Put her all into your arms
'Cause we don't know where we come from.
We don't know what we are.

from "Ramon" 1989

46. THIS IS NOT A STORY MY PEOPLE TELL

Vocal chords opened and closed

Single white female.
Loves J. S. Bach. Long walks.
Guys named Steve.
Please don't send a photo.
Oil paintings only please.

Ah Lolita! Light of my life!
Ah Lolita! Like a little butterfly.
Oooo I love those tiny little feet!
Here she comes.

from "Lolita" 1989

Using a megaphone in "O-Range," 1972

When I began to take singing lessons, I suddenly discovered that after years of being an alto, I was actually a soprano. I had this new voice and so, like with any new electronic gadget, I began to write things for it. They turned out to be songs about women and they had a whole new sound. More vulnerable. Because you know, it's hard to be ironic when you sing. It's hard to lie.

I also stopped using the electronic male "Voice of Authority" so often. I began to use my own voice for pieces that contained pointed social criticism. I've always thought that women make excellent social critics. We can look at situations, especially those involving power, and size them up fairly well; since we don't have much authority ourselves, we don't have that much to lose.

Like a ventriloquist, I've been throwing my voice
Long distance is the story of my life
And in the words of the artist Joseph Beuys
"If you get cut you better bandage the knife."

from "It's Not the Bullet That Kills You (It's the Hole)," 1975

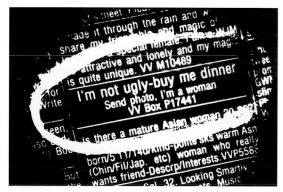

From "United States 4," 1983

Well, they say women shouldn't be the presidents
'Cause they go crazy from time to time.
Well, push my button baby, here I come!
Yeah, look out baby, I'm at high tide.
I've got a beautiful red dress
And you'd look really good
Standing beside it.

from "Beautiful Red Dress" 1989

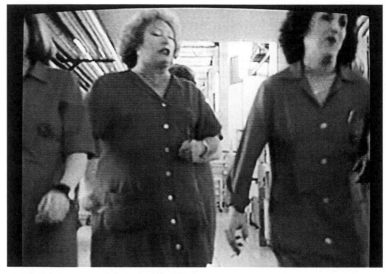

Factory workers from the video "Carmen," 1991

I was living out in West Hollywood when the Hollywood Strangler was strangling women. He was strangling them in West Hollywood. Every night there was a panel discussion on TV about the strangler, speculations about his habits, his motives, his methods. One thing was clear about him: He only strangled women when they were alone, or with other women. The panel members would always end the show by saying,

"NOW, FOR ALL YOU WOMEN, LISTEN, DON'T GO OUTSIDE WITHOUT A MAN.

DON'T WALK OUT TO YOUR CAR, DON'T EVEN TAKE THE GARBAGE OUT BY YOURSELF. ALWAYS GO WITH A MAN."

Then one of the eyewitnesses identified a policeman as one of the suspects. The next night, the chief of police was on the panel. He said, "Now, girls, whatever happens, do not stop for a police officer. Stay in your car. If a police officer tries to stop you, do not stop. Keep driving and under no circumstances should you get out of your car."

For a few weeks, half the traffic in L.A. was doing twice the speed limit.

from "United States 1" 1979

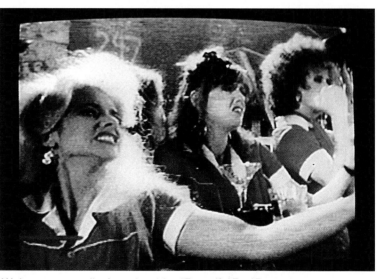

Waitresses on strike from the video "Beautiful Red Dress," 1990

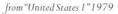

From "Songs and Stories for the Insomniac," 1975

By now, I've gone through two waves of women's art action groups. The first was in the early '70s, a spin-off of the Women's Liberation Movement. We'd get together and complain, "The gallery system is so corrupt! It's run entirely by men," followed rapidly by "So how do we get a piece of the action?" There was a lot of talk at the time about female imagery. I tried to distance myself from this because I wasn't sure there was really such a thing. In one review, a piece of mine ("The Acoustic Lens") was singled out as especially feminine work because it was soft and round. The writer of this review, a woman casting around for female iconography, didn't seem to care that impermeable, square lenses don't work very well.

I'm still not sure that art is either quintessentially male or female. But while art may not have gender, artists do. It's tough to be a woman in the United States and it's tough to be an artist. The thing that impresses me about female artists' groups like Women's Action Coalition is that whatever the esthetic, mutual support is the common goal. In 1992, I got very involved in the formation of Women's Action Coalition. I suggested using the blue dot, the video element that was used to hide the faces of alleged victims in rape trials, as a placard for the first Women's Action Coalition demonstration at a rape trial.

In addition, I will always be grateful to the people who helped me get a start, almost all of them women: Allana Heiss, Holly Solomon, Marcia Tucker, Lucy Lippard, Karin Berg, Jo Bergman, Jacqueline Burckhardt, Bice Curiger, Jane Crawford, Edit DeAk, Elizabeth Jappe, Dany Keller, Janet Kardon, Susan Martin, Robin Kirk, Nancy Drew, Barbara London, Roselee Goldberg, Roma Baran, Linda Goldstein, Rande Brown, and many others.

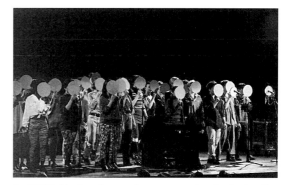

In 1992, I helped organize an evening featuring the blue dot at Town Hall in a benefit for the Kitchen.

Us and Them

Well, I was down at the courtroom
Hanging around the restrooms
over there by the phones,
And I was reading from
the *Great Book of the Species*
Also known as *Flesh and Bones*
And in this book there's a chapter
Called "Us and Them"
And it talks about the difference
Between women and men
Ladies and gentlemen of the jury,
Please come on in.
Love is in the courtroom
Wearing no pants.
It's moving around
Doing the mystery dance.
So let the scales of justice
Fall from your eyes.
Ladies and Gentlemen of the jury
Please rise.

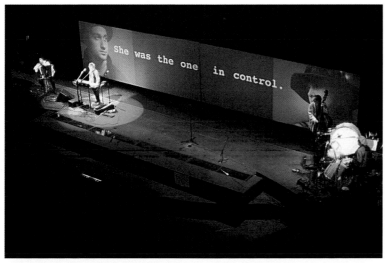

With Guy Klusevcek, Greg Cohen, and Cyro Baptista performing "Us and Them," 1993

from "Us and Them" 1993

The last strictly political thing I ever did was in the women's movement back in 1973. I was marshal at a demonstration at the Playboy Club. This was a big media event, lots of TV cameras, and my job was to explain to the press what we were doing there. So we're marching around with these big signs and once in a while we'd halt and I'd explain to the reporters that we were marching to protest the way women were being exploited economically like animals and I had drawn up some pamphlets to illustrate this, pictures of chicks and bunnies and foxes and pussy cats and other animals that had come to symbolize women and I was handing them out.

So, we're marching around the club and this woman, one of the bunnies, was just getting to work and she saw us blocking the entrance and she said, "So hey, what's going on?"

And I said, "Well, we're here to protest economic exploitation and the treatment of women as animals," and I gave her one of the free pamphlets.

And she said, "Listen, honey, I make eight hundred dollars a week at this job. I've got three kids to support. This is the best job I've ever had. So if you want to talk about women and money, why don't you go down to the garment district where women make ten cents an hour and why don't you march around down there?"

And I said: "Hmmmmmmm."

from "Empty Places" 1989

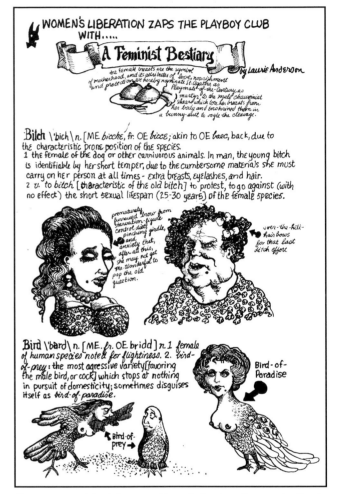

From a pamphlet I drew and handed out at demonstration in front of the Playboy Club, New York City, 1973

Last spring I spent a week in a convent in the Midwest. I had been invited to do a series of seminars on language. They had gotten my name from a list in Washington, from a brochure that described my work as "dealing with the spiritual issues of our time," undoubtedly a blurb I had written myself. Because of this and also because men were not allowed to enter the convent, they asked me to come out.

I stayed in a very spartan room. A wooden cross hung over the head of the single bed. It was quiet there at night but every morning at 5 a.m. precisely, there was a tiny tapping at the door. I'd jump out of bed and run to the door but I was never in time to see who was there. One of the sisters always left orange juice in a plastic cup, the kind they use for methadone, perfectly placed so that the door would just miss knocking it over when it opened.

The night I arrived they had a party for me in a nearby town in the downstairs lounge of the Crystal Lanes Bowling Alley. The alley was reserved for the nuns for their Tuesday night tournaments. It was a pizza party. The lounge was decorated to look like a cave. Every surface was covered with that spray-on rock that's usually used for sound proofing. In this case, it had the opposite effect. It amplified every sound. The tournament playoffs were going on and we could hear all the bowling balls rolling very slowly down the aisles, making the stalactites tremble and resonate.

Finally the pizza arrived and the Mother Superior began to bless the food. This woman normally had a gruff low-pitched speaking voice but as soon as she began to pray, her voice rose, became pure, bell-like, like a child's. The prayer went on and on, increasing in volume every time a sister got a strike, rising in pitch.

"Dear Father in Heaven."

The next day, I was scheduled to begin the seminar on language. I had been very struck by this prayer and I wanted to talk about how women's voices rise in pitch when they are asking for things, especially from men. But it was odd. Every time I set a time for the seminar, there was some reason to postpone it. The potatoes had to be dug out, or a busload of old people would appear out of nowhere and have to be shown around. So I never actually did the seminar.

I spent a lot of time there walking around the grounds and looking at all the crops, which were all labeled. There was also a very neatly laid out cemetery, hundreds of identical white crosses in rows. They were labeled:

MARIA THERESA MARIA-THERESA THERESA-MARIA

The only sadder cemetery I saw was last summer in Switzerland. I was dragged there by a Herman Hesse fanatic, a very sincere Swede who had never recovered from reading "Siddhartha." And one hot August morning, when the sky was white, we made a pilgrimage to the cemetery. We brought a lot of flowers and we finally found his grave. It was marked with a huge fir tree and a mammoth stone that said "HESSE" in huge Helvetica Bold letters. It looked more like a marquee than a tombstone.

And around the corner was this tiny stone for his wife, Nina, and on it was one word, "AUSLÄNDER" ("FOREIGNER").

This made me so sad and so mad that I was sorry I'd brought the flowers. Anyway, I decided to leave the flowers along with a mean note. It read:

> Even though you're not
> my favorite writer
> (by a long shot!)
> I leave these flowers
> on your resting spot.

from "Talk Normal" 1985

Prehistoric Female Cave Composers

Over the last few months I've been getting a lot of faxes and messages in very spidery typewriting from a man in Prague. At first the messages were sort of cryptic. They were descriptions of some prehistoric cave people in Czechoslovakia and of the caves themselves that were covered with a kind of scribbling that the writer of the fax assumed was some form of musical notation created by blind prehistoric cavewomen.

The messages were signed "V. Snopko, Minister of Culture of Czechoslovakia."

Gradually the faxes got more specific. It turned out that I was being invited to see some caves and somehow interpret and transcribe the notation on the walls of the caves and then play this music in a cave concert. It was also apparently crucial that these concerts be performed in the dark because these cave people were supposedly blind. I thought, "Perfect! This is really my kind of project!"

I was on tour in December and each week the messages became progressively more urgent. Could I meet? Could I come to see the caves as soon as possible? What did I think about the idea?

When I finally arrived in Prague I met Snopko (or at least I think it was Snopko). Like everybody else in the lobby, he was wearing jeans and a down jacket and he came up and introduced himself as the Minister of Culture and I thought, "Well, I might as well go along with this because maybe he actually *is* the Minister of Culture."

He seemed to be in a great rush, which is always kind of fishy. Either he was trying to look busy or else he was afraid someone might come up to him and call him by a totally different name. As it turned out Snopko had been an anthropologist before '68 working on prehistoric Czech cave pottery, and then when the Russians came he'd been assigned to a number of rather demeaning (but relaxing) jobs, so he'd had over twenty years to think about what those cave scrib-

blings might represent and then suddenly the future happened in Prague and he was made the Minister of Culture and apparently felt obliged to do something about his speculations.

Snopko spent a long time showing me pictures of pottery and insisting that if I could understand the stars and lucky sevens and other engravings that it would be a real clue to the minds of prehistoric Czechs. The question "Why me?" did pass through my mind a few times and I tried somewhat pathetically to steer the conversation but it kept swirling in one of those vicious circles that only death or collapse will end.

He went on that the pots were of course made by blind prehistoric women who, in the process of decorating the pots and singing while they worked, had somehow managed to invent a type of musical notation and that singing was useful and everything but that writing was a much higher form of art and writing was invented by men. It was abstract. It was, how shall we say, on a higher plane.

Now I had to sort of agree because it seems likely that men invented writing and wrote (what?) 90 percent of everything that's ever been written. Oh, there is the recent theory that a woman, the mysterious "J," wrote much of the Old Testament, but only because God was portrayed in these books as unfathomable, patriarchal, tyrannical, and inconsistent, the way presumably only a woman would write about a man.

But I feel like I can picture this "J" scribbling away and laughing, although the first time I saw the Bible reenacted was sometime in the '70s there was a cable TV show in the Midwest, and Bible study groups would act out parts of the Bible, but these were pretty low budget productions, shot in the church basement or someone's rec room, and all the prophets had towels wrapped around their heads for turbans but you could see the tags (the ones with washing

instructions) sort of sticking out. There were very few women in these tapes, they tended to get the odd Shepherdess or Dancing Girl bit part. Recently though, women seem to have assigned themselves bigger roles.

A few weeks ago, I saw a videotape about a kind of goddess cult that is based in Sedona, Arizona, and it's not exactly a religion really, it's sort of vague. There are no rules or anything, just a general sort of good will towards all the energy radiating out of the earth and you can go on one of their pink jeep tours and drive around to different spots in the desert and just feel the energy venting up out of the landscape.

And then the camera moves to the goddesses and they look like perfectly normal American women and they're saying things like, "Well, I've never been a goddess before, so I'm not sure exactly what to do or anything…" I mean there is no book to refer to, no Bible to bang, which is probably a pretty positive thing in some ways. I spent a lot of time in the past watching people bang on The Good Book and later that book started getting mixed up with other books, like when they throw the book at you, you never exactly know which book it is, I mean it would be good to know what they're throwing, whether it was Dostoyevsky or just, you know, *Ivanhoe*.

Right around this time, I saw Glenda Jackson in a Eugene O'Neill play where she goes into this long tirade about what if God were a woman and she goes on and on about this male God who was full of pride and judgment. Yes, only seven days! That was all it took and and it was pretty wonderful, a great achievement, so fast! And then you're born and you have to measure up to all these achievements and when you die you have to be judged all over again on how well you did. And she goes on: What if, instead of being born out of this pride, what if God were a woman and what if when you were born, you were born not out of pride but out of her agony and that when you died you were accepted no matter what you had done?

Instead, not only are women never God, you can hardly find any representations of them. They're finally getting into the movies but it's taken a while. Until last year almost every movie around was about two guys: Young Pool Shark /Old Pool Shark, Retarded Brother/Normal Brother, Good Cop/Bad Cop. I mean: The Buddy Films. And this is because all the Hollywood screenwriting teams are two guys and they sit around and think, "Hmmm, what should we make a movie about? Say! How about two guys?" The women are way in the background if they're there at all or else they're either in bed, in a coma, or dying of cancer (so the male Doctor/Hero can learn a lesson in humility) or they're dead, like Laura Palmer. In the last few months, there have been a few innovations, the girls get cars and guns and get to go on wild guy-like rampages (although of course they are still required to die in the end).

Real women, however, aren't really much in the news either except maybe as the trophy wives that get traded in by various tycoons, or rape victims, or Anita Hill or the odd exception like Maggie Thatcher reruns.

Where are they all?

I suppose this is one of the reasons I don't much believe in the concept of progress. But if I do have one modest hope for the future it's that sometime in my life I get to see a female newscaster, a really old woman, who just sits there and gives her opinions on what's been happening in the world, her analysis. And I don't mean the bimbo sidekicks in those fake family news teams where the woman is the old sage's bright but perky mistress. I mean some funky old woman who just sits there and looks right into the camera, without being beautiful, and just talks.

from "Voices from the Beyond" 1991

47. VOICES FROM THE BEYOND

In 1991, I was asked to talk at the Museum of Modern Art as part of a series connected with an exhibition entitled "High Art Low Art." The Gulf War had been heating up for months and I believed that compared to a lot of the art being produced, the Gulf War had a lot going for it: a gripping story, super high-tech equipment, a vivid, villainous enemy. After presenting the talk "Voices from the Beyond," I realized I had a lot more to say on the topic. Over the next few months, the talk expanded to a three-hour, free-form ramble on censorship, power, art, women, Communism, AIDS, Anita Hill, etc. As national and world events unfolded, I incorporated them into the talk which I presented at many colleges and theaters.

I loved being on tour with this talk because I got to go so many places alone, without the trucks of equipment and crews that tours usually entail. I met lots of people this way and it was also much easier to eavesdrop. For example, I could hang around the banks of phones in airports, one of my favorite listening posts, and tap into various conversations. I was on the same beat as the traveling salesmen, and after lunch these guys would call in to the main office and I could stand there at the phones, taking notes for my portrait of the American Salesman.

"Frank? Listen Frank, I hate to say this about Brad, we both know he's got a heck of a job, yeah...yeah...you're so right.....but we both know Brad just isn't pulling his weight, know what I mean? And I'm not saying this just because we're both up for the Safeway account."

I wasn't sure whether "Voices from the Beyond" was actually art, and neither were the audiences. However under the circumstances I felt that thinking these things through out loud was the most interesting option. Also, I found that with no visuals I was able to make a lot of logical and verbal jump cuts. "Voices from the Beyond" was a kind of mental movie.

Defining the Enemy

I've been thinking about the future because of all the things that have been happening in the last year or so, things that have made my own work more political and have opened my eyes to things in American culture that have been hidden away for a while and everybody's frantically looking around for someone to blame. I guess the standard explanation is the simplest. After decades of being told

"THE RUSSIANS ARE COMING! THE RUSSIANS ARE COMING!"

we have to face the fact that, after all this time, not a single Russian ever showed up.

I mean thirty years of practically bankrupting ourselves preparing for this, not to mention producing all those doomsday movies about missiles ripping out of silos, special evacuation roads, and dazed hordes of Americans staggering around in rags in the radioactive ruins of this country. And then all of a sudden the Russians are just over there ("Hey, hello!") and they're drinking Coke and watching videotapes, shopping at the Gap. And suddenly they look so much like we do.

It's like during the American revolution when Paul Revere was riding through the colonies screaming

"THE BRITISH ARE COMING! THE BRITISH ARE COMING!"

And you're hunched in your smoky little Colonial Style cottage and you hear this guy come yelling along the road and you think: Wait a second, I'm British. Everybody here is British. We're all British! So who, exactly, is coming?

Two hundred years later, it's still crucial to define an enemy in order to create the maximum amount of national solidarity. This idea seemed to work pretty well in the Gulf War but now in this time of national gloating, I have to say that losing the Gulf War would have been a disaster, but winning it seems almost as dangerous.

One of the most important effects of the war has been the supposed renewal of national pride, erasing the Vietnam syndrome. And I was thinking about this as I watched the Gulf War victory parade in New York. Suddenly tanks were driving through my neighborhood and all these people dressed up like sports fans were running around screaming hysterically about being Numero Uno.

But it was the guys bringing up the rear of that parade that were the most ghostly: the Vietnam vets still dressed in their fatigues and occasionally raising their fists in some some kind of long-forgotten Huey Newton–type power salute.

Then just a few days ago I read a really eerie statistic. And that is that twice as many Vietnam vets have committed suicide since the war as died during it.

But it wasn't until later after the victory parades were over that I had the time to wonder, wait a second! Why was the Gulf War presented by only one TV network? One that trumpeted the event with super graphics and a thunderous patriotic soundtrack? What happened to all the other reporters?

And I started to remember some of the things Pentagon officials said after Vietnam: that they would never try to wage a war again without the unqualified support of the press, that it was the constant media meddling and public demonstrations (not inept military strategy), that lost the war. And they vowed that this would never happen again.

The Gulf War was an unqualified success because no one was allowed to question it seriously. It was of course presented as a show, an ad, a drama. And nobody complained for the same reason that moviegoers don't jump up during a movie and shout things like "Crummy plot!!" If you complained you had to disguise it as yet another form of entertainment, like the musicians who got together to sing "Give Peace a Chance" and

then announced that maybe they were for the war, maybe not, but they just felt like singing this song anyway.

Actually I spent most of the war flying back and forth to Europe. It was really an ideal time to fly because a lot of the airlines were laying off crews and all the planes were nearly empty. In an airport in Spain I was handed an interesting list of tips devised by the U.S. Embassy for Americans who found themselves in wartime airports. The idea was not to call ourselves to the attention of the numerous foreign terrorists who were presumably lurking all over the terminal. So the embassy tips were a list of mostly "don'ts," things like:

DON'T WEAR A BASEBALL CAP.

DON'T WEAR A SWEATSHIRT WITH THE
NAME OF AN AMERICAN UNIVERSITY ON IT.

DON'T WEAR TIMBERLANDS WITH NO SOCKS.

DON'T CHEW GUM.

DON'T YELL ("ETHYL!!! OUR PLANE IS LEAVING!!!!!")

And so on. I mean, it's weird when your entire culture can be summed up in eight giveaway characteristics.

from "Voices from the Beyond" 1991

In "Voices from the Beyond" there was a single slide, a road.

Ethereal Worms

Last year I was in Rio on tour and I went to a restaurant and had some fish and suddenly I got violently ill. It turned out that it was one of those new poison ocean diseases with no name and I got a version of it that made me too dizzy to stand up for months. So I went to an acupuncturist, a kind of a nerve doctor, and I said, "Listen, I ate this fish a few months ago and ever since then I've been too dizzy to stand up."

He looked at me for a minute and he said, "Do you work with electronics?"

This was strange because there are things you think you can more or less hide, but then it turns out that everybody but you can see them and he began an elaborate series of tests.

He had this very futuristic device for devining diseases; it looked like pieces of a Walkman that had been taken apart and hot-glued back together without a schematic and it had nine-pin din connectors going nowhere and a pen connected by a cable. And I put my hand on one side of this thing and he put his hand on the other and he held this pen in his other hand and let it hover over the pages of a book of diseases, sort of like dousing, and he would run the electric pen down the list and when he got a little jolt, a little sign, he would circle the name of the disease. Actually I was sort of sympathetic to this way of working because some of my own work methods are about this abstract but he finally came up with the answer.

"Worms," he said. "You've got worms. Ethereal worms."

I said, "What do you mean?! Do they have mouths and hearts? Are they alive?" But he was being a little cagey about answering these questions. The more I asked the more it sounded like the key questions vegetarians ask when they have to eat something, and they have to determine if something is, or ever was, truly alive or not. Fortunately the vegetarians finally boiled it down to a few simple rules:

1. **DON'T EAT ANYTHING WITH A FACE.**
2. **DON'T EAT ANYTHING WITH SEXUAL URGES.**
3. **DON'T EAT ANYTHING WITH A MOTHER AND FATHER.**
4. **DON'T EAT ANYTHING THAT CAN RUN AWAY FROM YOU.**

But to backtrack for a second, I arrived in Rio and I was on the twenty-second floor of a hotel just unpacking my suitcase when I looked out the window and saw somebody fly right past. Now there's the song about flying down to Rio but nothing about flying around *in* Rio, so it was sort of surprising even given the jetlag.

Then I looked out and several people were flying around out there, just sort of swooping around the high-rises with their arms outstretched like in some Peter Pan nightmare. In fact Rio looks a lot like Never Never Land or Fantasia with these craggy cartoon mountains and that Christ up there on the mountain top looking like he's doing the samba. Actually it doesn't look at all like it took hundreds of people a long time to haul him up there. It looks like he'd just landed and could fly away again any minute.

I always thought it was a great idea for gods to go away for a while. It always bothered me that the Christian God is always there watching you, *has* always been there, *will* always be there, world without end, watching you.

Now Greek gods at least were always going away for the winter for example so that when spring arrived and they came back everyone was really glad to see them.

Anyway, back in Rio, when I looked closer I realized that the people flying past my window were actually hang gliding so I went over to try it and now, hang gliding feels like the closest thing to suicide you could ever imagine.

You just hook yourself up to some flimsy nylon wings and take a running start down a ramp and then jump off a cliff and suddenly everything's very, very quiet and very small and Rio is far, far below and so is the Christ and I flew around the cliffs and saw the sewage treatment plant and then I flew out over the ocean and saw the pipe that pumped the raw sewage into the ocean and several feet of brown foam were billowing up at the end of pipe and right beyond little fishing boats were bobbing up and down pulling in these poison fish we were all going to eat later that day. But it didn't matter. Finally I was flying.

from "Voices from the Beyond" 1991

"Rio Panorama," 1989

48. STORIES FROM THE NERVE BIBLE

EAST: O Little Town of Bethlehem: rock-throwing capital of the world.
WEST: those who came before me.
UP: the true meaning of the word "ARISE"

HEY LITTLE GIRL THE GULF MY GRANDMOTHER'S HATS WAR IS THE HIGHEST FORM OF MODERN ART NIGHT IN BAGHDAD THE CARDINAL POINTS TILT ALIEN SEX THE RIGHT TO BEAR ARMS SPEAK MY LANGUAGE WHERE I COME FROM ETHEREAL WORMS TIGHTROPE THE MIND IS A (WILD WHITE HORSE) LA VIDA THAT LITTLE CLOCK

You know the reason why some nights
you don't have a dream?
When there's just blackness?
And total silence?

Well, this is the reason:
It's because on that night
you are in somebody else's dream.
And this is the reason you can't
be in your own dream because
you're already busy
in somebody else's dream.

In 1992, I was invited to perform in Israel. As an official guest of the government, I met many artists and politicians and did a lot of press conferences. The journalists always began by asking about the avant garde.

One journalist asked, "So what's so good about new?"

"Well," I said, "...uh...um...new is interesting."

"And what," she said, "is so good about 'interesting'?"

"Well, interesting is, you know, interesting...it's uh...like being awake." I was treading water.

"And what's so good about being awake?" she asked. By now I was getting the hang of this: Never actually answer a question in Israel. Always just ask another question.

The Israelis were also very curious about the Gulf War and what Americans had thought about it and I tried to think of a good question to ask in answer to this but what was really on my mind was that the week before I had been testing explosives in a parking lot in Tel Aviv. This happened because I had brought some small bombs to Israel as props for the performance and the Israeli promoter was very interested in them. It turned out that he did weekend duty on one of the bomb squads and bombs were also something of a hobby during the week. He was eager to talk pyrotechnics.

So I said, "Look, these bombs are no big deal, just a little smoke," and he said, "Well, we can get much better stuff for you," and I said, "No, really, these are fine," and he said, "But they should be big, theatrical! I mean you need just the right bombs."

And so one morning he arranged to have about fifty small bombs delivered to a parking lot, and since he looked on it as sort of a special surprise favor, I couldn't really refuse, so we're out in this parking lot, testing the bombs and after the first few I found that I was really getting pretty interested.

They all had very different characteristics. Some erupted in fiery orange sparks and made a low popping sound; others exploded in midair and left long smoky trails. He had several of each kind in case I needed to review them all at the end, and I'm thinking, "Here I am, a citizen of the world's largest arms supplier, setting bombs off with the world's second largest arms customer, and I'm having a great time."

So even though the diplomatic part of the trip wasn't going so well, at least I was getting some instruction in terrorism. And it reminded me of something in a book by Don DeLillo about how terrorists are the only true avant garde artists because they're the only ones who are still capable of really surprising people.

And Jerusalem? It looked just the way my grandmother had described it, pristine, white, majestic. Except that it was full of guns. Guns and bones. I'd come to Jerusalem hoping to find out something about time and timelessness, something about how an Ark could turn into a whale or into a book. But "Stories from the Nerve Bible" is about the future, and it didn't have any answers, only questions.

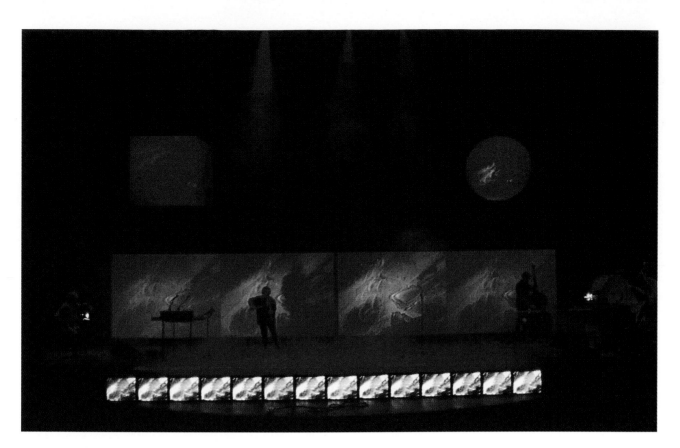

"Come here little girl, get into the car.
It's a brand new Cadillac. Bright red.
Come here little girl."

You know that little clock, the one on your VCR,
the one that's always blinking twelve
because you never figured out how to get in there
And change it.
So it's always the same time
Just the way it came from the factory.
Good morning. Good night.
Same time tomorrow. We're in record.

So here are the questions. Is time long or is it wide?
And the answers?
Sometimes the answers just come in the mail
and you get a letter that says all the things
you were waiting to hear, the things you
suspected, the things you knew were true.
And then in the last line it says:
Burn this.

I think that history has nothing to do
With parades or line or trains
Or roads. Maybe it's a light
And in that little book called "Einstein's Dreams"
He plays the violin and time stops.
World without end. Remember me.

from "That Little Clock"

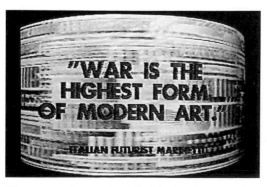

The news spins on the cylindrical screen.

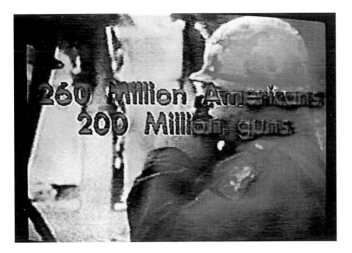

The Right to Bear Arms

You know, in the last year there have been a lot of arguments in my country about the Bill of Rights. Of course, the Bill of Rights is amazing. It guarantees freedom of speech, freedom of the press, religion, the right to trial by jury and so on but at the moment a lot of Americans are fighting about what the thing really means.

For example, let's take a look at the second amendment, the right to bear arms. This amendment was written two hundred years ago back when people were bagging possum.

So it's pretty hopelessly outdated now as a concept.

The founding fathers also probably hadn't imagined that eighth graders would be showing up at school armed with semi-automatic assault weapons.

And they probably didn't predict that at the end of the twentieth century the privately owned arsenals in this country would dwarf almost every other countries' national stockpiles. Because, ladies and gentlemen, the current figures are these: two hundred and sixty million Americans—two hundred million guns.

Sometimes when you hear someone screaming,
It goes in one ear and out the other.
Sometimes when you hear someone screaming,
It goes right into the middle of your head
And stays there forever.
I hear these voices, at the back of my head.
I'm holding my ears, then my ears turn red.
My hands are clean. My hands are clean.

from "Where I Come From"

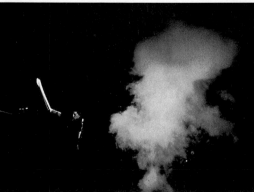

War Is The Highest Form Of Modern Art

During the Gulf War I was traveling around Europe with a lot of equipment and all the airports were full of security guards who would suddenly point to a suitcase and start yelling, "WHOSE BAG IS THIS?"

(EXPLOSION)

"I want to know right now who owns this bag!" and huge groups of passengers would start fanning out from the bag just running around in circles like a Scud missile was on its way in.

I was carrying a lot of electronics, so I had to keep unpacking everything and plugging it in and demonstrating how it all worked and I guess it did seem a little fishy, a lot of this stuff wakes up displaying LED program read-outs have names like "Atom Smasher" and so it took a while to convince them that they weren't some kind of portable espionage system.

So I've done quite a few of these sort of impromptu new music concerts for small groups of detectives and customs agents. I'd have to set all this stuff up and they'd listen for a while and then say "So what's this?" and I'd pull out something like this filter and say "This is what I like to think of as the voice of authority" and it would take me a while to tell them how I used it for songs that were about various forms of control and they would say:

"Now why would you want to talk like that?"

And I looked around at the swat teams and undercover agents and dogs and the radio in the corner tuned to the Superbowl coverage of the war and I'd say:

Take a wild guess.

Finally of course I got through. It was after all American-made equipment and the customs agents were all talking about the effectiveness, no, the beauty, the elegance of the American strategy of pinpoint bombing, the high-tech surgical approach which was being reported on CNN as something between grand opera and the Superbowl, like the first reports before the black-out when TV was live and everything was heightened, and it was so euphoric.

Night in Baghdad

Oh it's so beautiful, it's like the Fourth of July,
It's like a Christmas tree, it's like fireflies
On a summer night.

Here I'm just going to stick this microphone
Out the window and see if we can't hear a little better.
Can you hear it? Hello, California. Can you hear us?
Come in.

Oh it's so beautiful, it's like the Fourth of July
It's like a Christmas tree, it's like fireflies
On a summer night.

And I wish I could describe this to you better
But I can't talk very well right now 'cause I've
Got this damned gas mask on.

So I'm just going to stick this microphone
Out the window and see if we can't hear a little better.
Hello, California? What's the weather like out there?

And I only have one question:
Did you ever really love me?
Only when we danced.
And it was so beautiful. It was like the Fourth of July.
It was like fireflies on a summer night.

A series of arrests. Fraser Bresnahan, cameraman

Mamacitas, Caballeros,
Welcome to our city, the land of the free.
Welcome to the future,
Hablamos ingles aqui.
Hop in. We're gonna take you for a little ride,
We're goin' downtown.
La vida es un sueño.
Close your eyes now, we're gonna take you there.

I remember where I came from
There were tropical breezes and a wide open sea
I remember my childhood
I remember being free.

La vida es un sueño
Close your eyes now, we're gonna take you there.
La vida es un sueño
Close your eyes now, we're almost there.

Some say the future is written down in a book
And that you can't change a word of it.
And down in the street
They're talkin' on their radios
Gonna build a city that will never fall down.

I remember where I came from
There were burning buildings and a fiery red sea.
I remember all my lovers
I remember how they held me.

Hey, Mister Sandman.
Life is like a dream
But I remember it like a movie.

OK, amigo! Out of the car!
When my father died
We put him in the ground.
When my father died it was like
A whole library had burned down.

from "La Vida" 1992

Tilt

I find that a good place to think about the future is in airplanes and airports because time and place start to merge there and everything's in this constant unstoppable motion. Like the way things have seemed to speed up in the last couple of years, beginning with the fall of the Berlin Wall. And I remember we watched this on TV every night, over and over, and then one night I thought:

"Gee there's something really familiar about the expressions on their faces."

Then I realized that these were people desperate to shop. They couldn't wait. And somehow from the other side of the wall you got this eerie feeling that you knew exactly what all of this was going to lead to, but they were too far away to scream "GO BACK! GO BACK!" and you didn't know whether it was too early or too late to warn them and anyway they all looked so hopeful.

And ever since the wall fell, it seems like half the world has been pouring from one side to the other, through the train stations, the autobahns, the airports, moving back and forth across the old borders. Like the world had suddenly tilted on its axis and was pouring people from one side to the other. Like an enormous plane, tilting and banking, looking for somewhere to land.

The strangest thing about performing "Stories from the Nerve Bible" in Israel was the show in Tel Aviv. On the screen, there were pictures of buildings that had been blown up in the Gulf War. These buildings had been only blocks away from the theater.

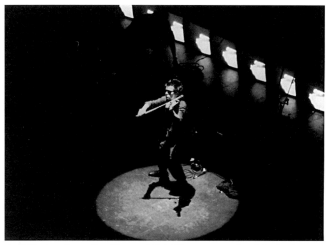

In "Stories from the Nerve Bible" I wore a pair of dark glasses with a tiny video camera attached to the side. During a taped monolog by Admiral Stockdale (an excerpt from the 1992 Vice Presidential debates), bright lights were turned on in the audience. The camera scanned the first several rows and projected the audience onto the screen.

(ON TAPE, THE VOICE OF ADMIRAL STOCKDALE)

"You know, I ran a civilization of three to four hundred wonderful men. We had our own laws. We had practically our own constitution. And I was the sovereign for a good bit of that. And I tried to analyze human predicaments in that microcosm…in the…in the world.

YOU'VE GOT TO HAVE LEADERS!

And they're out there…who can do this with their bare hands…working with people on the scene.

(SOUND OF HELICOPTERS)

Ladies and gentlemen, there will be four helicopters and the third one will be Marine One and the President of the United States.

At the end of the performance, a tornado was created from smoke and jets of air. The tornado was designed by Ned Kahn.

Wild White Horses

In the Tibetan map of the world, the world is a circle and at the center there is an enormous mountain guarded by four gates. And when they draw a map of the world, they draw the map in sand, and it takes months and then when the map is finished, they erase it and throw the sand into the nearest river.

Last fall the Dalai Lama came to New York City to do a two-week ceremony called the Kalachakra which is a prayer to heal the earth. And woven into these prayers were a series of vows that he asked us to take and before I knew it I had taken a vow to be kind for the rest of my life. And I walked out of there and I thought: "For the rest of my life?? What have I done? This is a disaster!"

And I was really worried. Had I promised too much? Not enough? I was really in a panic. And there were all these monks walking around. They had come from Tibet for the cere-mony and they were walking around midtown in their new brown shoes and I went up to one of the monks and said, "Can you come with me to have a cappuccino right now and talk?" And so we went to this little Italian place. He had never had coffee before so he kept talking faster and faster and I kept saying, "Look, I don't know whether I promised too much or too little. Can you help me please?"

And he was really being practical. He said, "Look, don't limit yourself. Don't be so strict! Open it up!" He said, "The mind is a wild white horse and when you make a corral for it make sure it's not too small. And another thing: when your house burns down, just walk away. And another thing: Keep your eyes open.

And one more thing: Keep moving. Cause it's a long way home.

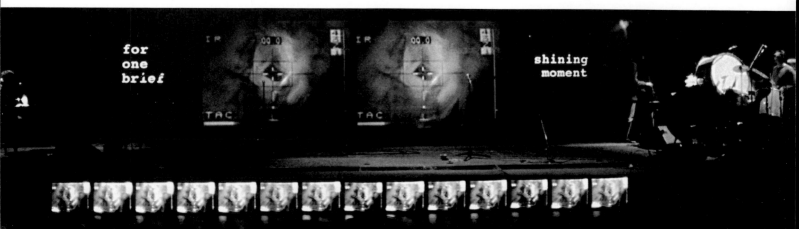

49. THIS STORM

My Grandmother's Hats

Lately I've been thinking about the future. Maybe because the end of the millennium is coming up and the year 2,000 is just so apocalyptic. When I think about the future I think about my grandmother. She was a Southern Baptist, a Holy Roller, and she had a very clear idea about the future and of how the world would end in fire, like in Revelations. When I was ten, my grandmother told me the world would end in a year. So I spent the whole following year praying and reading the Bible and alienating all my friends and relatives. Finally the big day came and absolutely nothing at all happened. Just another day.

My grandmother was a missionary and she had heard that the largest religion in the world was Buddhism so she went to Japan to convert Buddhists and to inform them about the end of the world. She didn't speak Japanese of course, so she tried to to convert them with a combination of hand gestures, sign language, and hymns in English. Basically, they didn't understand a word she was saying.

When she got back to the United States, she was still talking about the end of the world and I remember the day she died, she was very excited. She was sitting in her hospital room waiting to die and she was very excited. She was like a small bird perched on the edge of her bed near the window and she was wearing this pink nightgown and combing her hair so she would look pretty for the big moment when Christ came to get her. And she wasn't afraid but then just at the last minute something happened that changed everything.

After years of preaching and predicting the future, suddenly, she panicked. Because she couldn't decide whether or not to wear a hat.

And so when she died she went into the future in a rush, in a panic, with no idea of what would come next.

from "Stories from the Nerve Bible" 1992

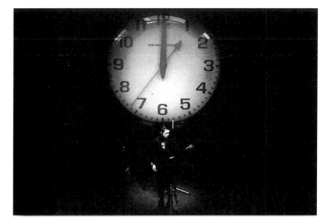

From "United States 2," 1980

Wild beasts shall rest there
And their houses shall be filled with snakes

And ostriches shall dwell there
And the hairy ones shall dance there
And sirens in the temples of pleasure.

Isaiah 13:21

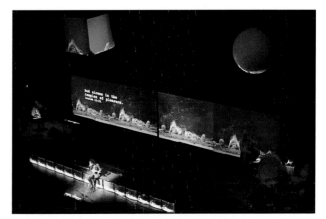

From "Stories from the Nerve Bible," 1992

She said: What is history?

And he said: History is an angel

Being blown backwards into the future

He said: History is a pile of debris,

And the angel wants to go back and fix things,

To repair the things that have been broken.

But there is a storm blowing from paradise

And the storm keeps blowing the angel

Backwards into the future.

And this storm, this storm

Is called

Progress.

from "The Dream Before" 1989

50. CHRONOLOGY

1972

studied Merleau Ponty with Arthur Danto, art history with Meyer
 Shapiro and printmaking with Tony Harrison
learned about *mudra*
spent the winter wearing no coat
graduated from Columbia University with an MFA in sculpture
 wrote art reviews for various art magazines: "Artforum,"
 "ARTNews," and "Art in America"
taught Art History at various colleges in New York City.
"AUTOMOTIVE," car concert, Rochester, Vermont
"INSTITUTIONAL DREAM SERIES," personal study of narcolepsy
 and dreams
included in "Story Show," John Gibson Gallery
met the artist Joel Fisher, who was making his own paper
wrote "October" and "Handbook"
began to work on "The Talking Book"
met Richard Nonas, who convinced me I was actually an artist
compiled "Ecotectural Fables," a series of collages about the
 relationship between animals and architecture

1973

"O-RANGE" a performance at Lewiston Stadium, City College.
 Megaphones were used as the sound system in a large empty
 sports stadium. Ten performers shouted stories across the field
took sculpture classes with Sol Lewitt and Carl Andre at the School
 of Visual Arts
made a series of talking boxes on stilts
collaborated with Alan Sondheim
included in "Thought Structures" at Pace University
met Vito Acconci and was struck by the intense emotion in his
 performances
met Phil Glass; joined other artists who sat in on Phil's rehearsals,
 which resembled meditation exercises (like Sol Lewitt said,
 "I do my best work at Phil's rehearsals")
wrote "Transportation Transportation'"

1974

"DEARREADER," 8 millimeter film; black and white; a film/perfor-
 mance, codirected with Bob George; starring Geraldine Pontius
"AS:IF," a performance at Artists Space
 received a CAPS grant
 lived in Chiapas, Mexico
 hitchhiked to the North Pole
"TALES FROM THE VIENNA WOODS," a performance at Projects
 Gallery Boston
 performed "How to Yodel" in "Soup and Tart" at The Kitchen
 performed various versions of works in progress
"OUT OF THE BLUE" and "TALES FROM THE VIENNA WOODS"
 were performed in the United States and Europe

*New York in the early '70's was Paris in the '20's. I was part of a group of artist/
pioneers that included Gordon Matta-Clark, Jene Highstein, Susie Harris, Tina
Girouard, Richard Nonas, Dickie Landry, Phil Glass, Keith Sonnier, and several
other sculptors and musicians. We often worked on each others' pieces and
the boundaries between art forms were loose.*

*Soho was pitch black at night, there were two restaurants ("Food" and "Fanellis"),
one gallery ("Paula Cooper Gallery") and there was still lots of usable wood on
the streets. Almost every night turned into a party. Collectors were just beginning
to sniff around, which meant that a lot of us began to go to Europe fairly often and
also that some of the parties were in the collectors' lofts, which meant we rarely*

*had to buy food. "Anarchitecture," a group show at 112 Greene Street summed
up the anarchistic obsessions of the group. We were very aware that we were
creating an entirely new scene (later known as "Downtown"). Gordon Matta Clark
was the center of this scene, which ended with his death.*

made story pillows, "Windbook" and "Self-Playing Violin"
my loft was broken into and almost all my possessions were
 destroyed
wrote "Light in August" and "The Rose and the Stone"
worked with Bob George at the Whitney Museum Cherry Street
 branch, supposedly teaching photography to kids, but actually
 just breaking up fights and cleaning up
joined the Holly Solomon Gallery
"IN THE NICK OF TIME," performed at The Clocktower
"DUETS ON ICE" performed on street corners in each bourrough
 of New York City, fulfilling the public service requirement
 of a CAPS grant

1975

moved into new loft
worked at ZBS Media, Fort Edward, New York; became a member
 of a communal group that had gone through every phase:
 alternative radio production, gurus, psychedelic drugs, natural
 foods, kids
met Bob Bielecki, audio engineer and designer who collaborated on
 many projects
began to record some of "The Talking Book"
"SONGS AND STORIES FOR THE INSOMNIAC" was performed
 at Artist's Space in New York, the Museum of Contemporary
 Art in Chicago and Oberlin College, Oberlin, Ohio
"OUT OF THE BLUE" performed at University of Massachusetts,
 Amherst, Mass; various performance pieces were toured in
 alternative spaces in the United States and Europe
"DUETS ON ICE" performed in Genoa, Italy; along with an installation
*I wrote my first dance score for Mary Overlie; she had requested a very slow
piece, so I wrote the slowest music I could imagine. When she heard it, she
said, "Well, that's about three times as fast as I move. Could you slow this thing
down?" I did and then began, for a while, to write music that was so slow that
the beat was barely perceptible.*

film installation "At the Shrink's" at the Holly Solomon Gallery
photos and audio pieces included in many group exhibitions
made The Viophonograph with Bob Bielecki
"FAST FOOD BAND" appeared at the Fine Arts Building, New York

1976

"FOR INSTANTS PART 3 REFRIED BEANS" performed in New York
 at the Museum of the Modern Art and the Whitney Musuem,
 and many colleges and alternative spaces in the United States
 and Europe
*During the mid-'70's I'm sure I performed in every single "alternative space" in
the United States. This was a great way to see the country. I traveled alone
with a big black case of violins, tapes, and various gadgets and gradually
began to feel more or less like a traveling salesman.*

received a grant from the Gallery Associaton of New York State
recorded songs at ZBS Media; Peter Gordon produced
worked with various downtown musicians, including Arthur
 Russell, Scott Johnson, and Rhys Chatham
"STEREO STORIES" performed at the M.L. D'Arc Gallery, organized
 by Jane Crawford

"ENGLISH" performed in Germany, Denmark, and Holland
 met and hung out with a lot of expatriate American artists in Europe
 toured Europe with Julia Heyward and Jana Haimsohn
"ROAD SONGS" performed at St. Marks Poetry Project
"SONGS" performed at Meet the Composer at the New School,
 New York
 included in many group exhibitions
 designed the Tape Bow Violin with Bob Bielecki

1977

"SONGS FOR LINES SONGS FOR WAVES" performed at The
 Kitchen, New York
"ON DIT" performed at the Paris Biennale
"THAT'S NOT THE WAY I HEARD IT" performed at Documenta,
 Kassel
"SOME SONGS" performed in Belgium, Italy, and Holland
"AUDIO TALK" performed at the New School, New York
"STEREO DECOY" performed at Art Park, Lewiston, New York
 received a grant from New York State Council on the Arts and
 the National Endowment for the Arts
 recorded several songs for "Airwaves" 110 records New York
 and "New Music for Electronic and Recorded Media"
 met Charles Amirkhanian who encouraged me to think of the
 sounds I was making in performances as music
 spent two weeks not speaking in Buddhist retreat
 worked with Tina Girouard
 published stories in "Individuals," edited by Alan Sondheim
 did "Jukebox," an installation of photos and records at the
 Holly Solomon Gallery
 made "Numbers Runners," an interactive phone booth
 made "The Acoustic Lens" and animated 3-D slide installations
 did workshops in various colleges
 shot slides and film on the road
 met Michel Waisvisz, the Dutch composer
 performed in many European avant garde music festivals

The avant garde music scene in Europe in the late '70's consisted of many electronic musicians and technicians struggling to get their instruments to actually produce sound. Most of these instruments were homemade and would only really work for short periods of time during the concerts. I enjoyed being in these festivals because I met a number of truly quirky European people.

1978

 worked as a migrant cotton picker with the Taylor family near
 Covington, Kentucky
 met Mister Spoons
 wrote "Notebook," a collection of scores and stories
 lived in Berlin
 performed at the Nova Convention; met William S. Burroughs
"DOWN HERE" performed at the Texas Opry House, Houston, Texas
"A FEW ARE…" "SONGS FOR SELF-PLAYING VIOLIN"
 "SUSPENDED SENTENCES"
"FOR INSTANTS…CON'T" performed at many alternative spaces
"LIKE A STREAM," a piece for orchestra and talking chorus performed
 in Washington D.C., New York, and Minneapolis
"SONGS" performed at various festivals in Europe
 made "The Handphone Table" for an installation in the Projects
 Gallery at the Museum of Modern Art, New York
 made "Quartet for Four Subsequent Listeners" ("Note/Tone"),
 an installation at the Holly Solomon Gallery, New York

sound installation at And/Or Gallery, Seattle, Washington
"Songs for the Night Driver," an installation of slides and audio
 at the Wadsworth Atheneum, Hartford, Connecticut
visited Benedictine Convent in Wisconsin to conduct a seminar
 with nuns on the spoken word
did some music for "Harrisburg, Mon Amour," a play by David
 Shapiro
worked as a straight man for Andy Kaufman in comedy clubs and
 Coney Island
taught at Cal Arts, Valencia, California

1979

 received a grant from the National Endowment for the Arts
 published "Words in Reverse"
"AMERICANS ON THE MOVE," presented Carnegie Recital Hall,
 New York

This piece was performed on a long European tour. On this tour, I often had to set up my equipment very quickly. I was usually part of a festival where at least three events were on every evening. In Vienna, I followed Herman Nietzsche who covered the floor with blood and then called the police, to create a little excitement. They arrived at the beginning of my piece. One member of the audience was so upset or drunk that she kept pounding me on the back during the first fifteen minutes of the show. The promoters didn't stop her because they thought it was part of the show.

 performed at the Customs House, New York, with Peter Gordon
 participated in the Cabrillo festival, Capitolo, California

This was the first performance I did strictly as a musician/composer rather than performance artist. I quickly realized that the music world had stricter interpretations of what was acceptable and I began to appreciate the art world even more.

 met the conductor, Dennis Russell Davies, who encouraged me to
 try to write works for orchestras
"BLUE HORN FILE" performed at the Mudd Club. This trio was
 Peter Gordon, David Van Tieghem, and me. The name was
 inspired by something from a Bob Wilson play
 performed in "New Music New York" at The Kitchen, New York
 met Perry Hoberman, who traveled with me doing projections
 did "Night Flight," an installation of slides in a window, Graz, Austria
 met Roma Baran, audio producer, who encouraged me to record
 recorded various songs for Dial-A-Poem series

1980

 performed in Anti-Inaugural Ball for Ronald Reagan at the Pension
 Building in Washington D.C., sponsored by D.C. Space
 appeared in "Fourteen Americans," a film by Michael Blackwood
 traveled to Ponape with other artists and recorded "Word of
 Mouth," a talking record of talks sponsored by Crown Point
 Press; met John Cage
 toured with William Burroughs and John Giorno
 European tour
"UNITED STATES PART 2" premiered at the Orpheum Theater,
 New York

This performance was sponsored by The Kitchen and was the first piece I did in a real theater. It ran for several days and I remember feeling guilty that it was more or less the same every night because I was so used to changing things around for every performance. This piece received a lot of media attention and toured the United States. Because I had an actual lighting designer for the first time, I really had to start sticking to "the script." However, on this tour the house engineer Bob Davis would always be doing something to break the

repetition. In the middle of a performance I'd look out at the mixing board and he'd suddenly be wearing an enormous duck head for example, or had changed into a tux and was waving a baton.

"BORN, NEVER ASKED," performed by the Oakland Youth Symphony, premiered at the Paramount Theater, Oakland, conducted by Robert Hughes

met Jacqueline Burckhardt and Bice Curiger in Zurich

"Dark Dogs / American Dreams," an installation of photographs and audiotape at the Holly Solomon Gallery, New York

1981

released "O Superman" on 110 Records New York; reached #2 on the British pop charts; met Bob Regehr and signed with Warner Brothers Records

recorded "Big Science," coproduced with Roma Baran

recorded several songs for "You're the Guy I Want to Share My Money With" (Dial-A-Poem series)

began to work with Greg Shifrin who organized tours and video shoots

received a "Villager" award

appeared in "Film du Silence," Catherine Lahourcade for Channel 3, Paris

"Scenes from United States," 3-D exhibition at Holly Solomon Gallery, New York

went on an extensive European tour, a combination of museums and performance spaces and ersatz music festivals

the United States / Canadian tour included rock clubs, universities, museums, alternative theater spaces, and converted movie houses

"New Music America," San Francisco

"IT'S COLD OUTSIDE" performed by American Composers Orchestra

met the British director Nigel Finch

1982

received Guggenheim fellowship

released "Big Science" on Warner Brothers Records

worked at the Anderson Art Ranch in Colorado with printmaker Bud Shark; produced prints and lithographs

worked in Abbey Road Studios in London; mixed score for Michael Mann's film, *The Keep*

"IT'S COLD OUTSIDE" performed by the Westdeutscher Rundfunk, Köln, Germany; directed by Dennis Russell Davies

European tour included many cities in Norway, Denmark, Sweden, Scotland, Holland, Switzerland, England, France, and Germany

recorded flexidisk ("Let x=x") for Artforum Magazine, February issue

1983

"United States" performed in its eight-hour version at the Brooklyn Academy of Music, Dominion Theater in London, and an all-night concert in Zurich

The European tour of "United States" included England, Switzerland, Italy and Austria, as well as many large venues— theaters and opera houses in the United States.

"Retrospective Works from 1969–1983," a multimedia exhibition organized by Janet Kardon at Institute of Contemporary Art, Phildelphia; traveled to Houston, Los Angeles, Berkeley, and New York, England, Scotland, and Ireland

recorded with Nona Hendryx on her album "Nona"

premier of "Set and Reset," a collaboration with Trisha Brown and Bob Rauschenberg; at the Brooklyn Academy of Music

1984

met Peter Gabriel and wrote and performed "This Is the Picture" for "Good Morning Mr. Orwell," a live video broadcast organized by Nam June Paik

recorded with Jean-Michel Jarre for his record "Zoolook"

worked in Paris on a concert for a large theater in the Les Halles district.

appeared on "The David Letterman Show" and "The New Show"

met Wubbo Occhels, the Dutch astronaut, and Gidon Kremer, the Russian violinist, while performing on "Beo's Bahnhof," a live TV show produced in Munich

worked with Nile Rogers in the studio. Nile played on "Mister Heartbreak" and produced a groove-oriented version of "Language Is a Virus" for the "Home of the Brave" soundtrack album

released "Mister Heartbreak" album; worked with Bill Laswell, Nile Rogers, Roma Baran, and Adrian Belew.

"MISTER HEARTBREAK" tour of the United States, Canada, and Japan.

The Japanese tech crew came to the concerts in New York City and decided it would be better to copy the set and rebuild in Japan rather than ship it from New York. They did a few quick measurements and left. When I arrived in Tokyo, the entire set—beams, large platforms with spinning turntables, screen rigging, and lighting grid—was sitting there perfectly intact, flawlessly copied.

met Rande Ouchi, the producer of the Japanese "Mister Heartbreak" tour

got a Grammy nomination for "Gravity's Angel"

began to look for financial backers for a film documenting the concert

met Jonathan Demme and tried to convince him to direct the film

group exhibitions included "Disarming Images," Art Museum Association of America, "National Video Festival" screened at the Olympics, and "Give Peace a Chance," The Peace Museum, Chicago

1985

shot "Home of the Brave," which was produced by Paula Mazur and shot by John Lindley

performed in the Serious Fun Festival New York

It seemed like a lot of things sort of broke apart in the mid-'80's. I understood for the first time that community comes down to real estate. Soho had become hot and the art market was exploding. My neighborhood had disappeared. I spent a couple of years commuting to California where (Surprise! Surprise!) there was even less of a coherent art community than in New York.

1986

"NATURAL HISTORY" tour of United States, Europe, Japan and Australia

This tour required the largest crew I'd ever worked with. The idea of the tour was to promote the movie, but because I had to put it together so fast, it never really became a performance. During rehearsals I had to do so many things at once that I kept losing my voice. I began to work with the vocal coach, Joan Lader, who taught me how to conserve my voice and how to use it in an entirely different way

met the Prince of Ubud in Bali and had a series of conversations which were recorded and published in Japan

met Wim Wenders in Berlin
shot "What You Mean We?" a half hour video for "Alive from
 Off Center"
went to the Rio Film festival where "Home of the Brave" was
 featured
met Linda Goldstein, who became my manager
wrote the score for "Swimming to Cambodia," a film of Spalding
 Gray's monolog, directed by Jonathan Demme
wrote score for "Bird Catcher in Hell" from "Alcestis"
 by Bob Wilson

1987

participated in many benefits for AIDS
hosted Ernie Kovacs special on PBS
shot "Introductions," a series of short video pieces with the Clone,
 to introduce artists' videotapes on "Alive from Off Center,"
 KTCA Minneapolis
went to Bora Bora and shot underwater video
received Honorary Doctorate from Philadelphia College of the Arts
interview with Abbot Reb Anderson at the Zen Center, Green
 Gulch Farm, San Francisco
benefit concert at Madison Square Garden for New York Children's
 Health project with Paul Simon and Bruce Springsteen
"Home of the Brave" was presented at Cannes
"TALK NORMAL" was presented at the Tokyo International Video
 Biennale

1988

Serious Fun Festival, New York
press conference with Bishop Tutu, New York
Audiovisual Lisboa, Lisbon, Portugal
began to record "Strange Angels"
played a duet with Gidon Kremer
worked with Arto Lindsay
taught first grade non-English-speaking kids at a school in
 Little Italy to write stories and make books

1989

test drove Mazda Miata for "Vanity Fair" product review
mixed "Strange Angels" in Woodstock
appeared on "The Eleventh Hour" interview on PBS
hosted New Music America Tenth Anniversary Gala at the
 Brooklyn Academy of Music
presented an early version of "Empty Places" in Rio. The perfor-
 mance premiered at the Spoleto Festival in Charleston, S.C.

1990

"EMPTY PLACES" toured the United States and Europe over a
 period of six months. There were 150 concerts. Fortunately,
 many of them were partially in other languages so there was
 always something new to learn.
appeared on "The Tonight Show" with Jay Leno
received an Honorary Doctorate of Fine Arts, Art Institute of
 Chicago
shot "Personal Service Announcements" video
performed in "One World, One Voice," BBC documentary
hosted "Aid and Comfort" benefit for PWA's at the Greek Theater
 in Berkeley; organized by Tom Luddy. This was the last project
 I did with the promoter Bill Graham

Composer-to-Composer Forum, Telluride, Colorado
International Conference on Art, Science, and Technology,
 Köln, Germany
shot video for "Beautiful Red Dress," directed by Christy Zia
Keynote speech for "New Music Seminar" on censorship and
 2 Live Crew
directed a video "Carmen" in Seville, a piece commissioned
 by Expo '92
taught a group of meditation students at the Lama Foundation,
 New Mexico
travelled around East Germany; wrote a film script
 "Neue Welt 2000"
began to meet with Peter Gabriel and Brian Eno to plan a
 theme park.

*These meetings were a lot of fun because you could say anything and the
park planners took you seriously. Such as; "How about if a giant black cloud
hovers over the park and triggers a forest of talking trees?" Someone would
then write down "Research black cloud to trigger talking tree forest..."*

1991

double bill with Cab Calloway, New Years Eve, at the Limelight
participated in Art Futura, Barcelona; met William Gibson
"VOICES FROM THE BEYOND" at the Museum of Modern Art;
 part of a series organized by Roselee Goldberg; traveled
 around the United States updating and expanding the talk
member of the jury at the Berlin Film Festival, chaired by Volker
 Schlondorf
traveled to China to meet musicians and work on a film score
worked on "The Human Face," a BBC documentary
met the Dalai Lama at St. John the Divine, New York
guest on Spanish TV, "Viva El Espectaculo"
Guest Director of the Telluride Film Festival, Telluride, Colorado
wrote score for "Monster in a Box," a film by Spalding Gray
book tour for "Empty Places"
keynote speech for National Association of College Broadcasters

1992

censorship debate on CNN's "Crossfire"
"STORIES FROM THE NERVE BIBLE" was premiered at
 Expo '92 in Seville; toured in Germany and Spain
began to work with Cyro Baptista, Brazilian percussionist
performed at premier of Arte TV, Strasbourg Opera House,
 Strasbourg, Germany
worked at Steim Studio in Amsterdam designing invisible instrument
met Lou Reed in Munich
collaborated with Michel Waisvisz in Munich and Rotterdam
interviewed John Cage
participated in a tribute to John Cage at Symphony Space, New York
hosted "Party for Change" with actor Rob Morrow
did a piece for National Public Radio on the presidential election
"STORIES FROM THE NERVE BIBLE" was presented in Jerusalem
 and Tel Aviv, Israel

PHOTO CREDITS

Chapter 1

Geraldine Pontius

Chapter 2

p. 15: bottom right: Annie Leibovitz

Chapter 3

p. 21: babies courtesy of Swedish Television, p. 23: Mark Garvin

Chapter 4

p. 24: top left: Anzai, series lower right: Allan Tannenbaum, p. 29 bottom: Yuri, p. 31: Annie Leibovitz

Chapter 5

p. 33: center top: John Cavanagh, lower left: Marcia Resnick, p. 34: Angelo R. Turetta, p. 36 top: Bob Bielecki, p. 37 inside film strip: John Lindley, center right: Mitchell Baum, bottom right: Monika Rittershaus, p. 38: top: Les Fincher, bottom: Allan Tannenbaum

Chapter 6

p. 39, 41 bottom, 44 & 45: Bob Bielecki, p. 41 top, 42 & 43: Paolo Rocci

Chapter 7

p. 46 & 47 ears: Perry Hoberman, p. 46 bottom: Robert Mapplethorpe, p. 47 upper right: Anzai, p. 49 top right: Anonymous, bottom left: Phyllis Bilick, p. 49 top right: Anonymous, p. 51: Anonymous, p. 52 bottom left & p. 54 top: Bob Bielecki, p. 54 bottom left: Kriste Halscheid

Chapter 8

p. 56 top right & bottom left: Harry Shunk, p. 58 bottom & 59 bottom: Anonymous, p. 60 top: Bob Bielecki, bottom: Anzai, p. 61: Anzai

Chapter 9

p. 63 center: Allan Tannenbaum

Chapter 10

p. 64: Cal Kowal

Chapter 11

p. 66 & 70 all left: Stephen Lovell-Davis, p. 67: Allan Tannenbaum, p. 73 top right: Tim Jarvis, center right: Fraser Bresnahan, bottom right: Anzai, p. 74 left: John Cavanagh, right: Les Fincher, p. 75 right: Kathan Brown, p. 76 left: Perry Hoberman, p. 77: Anonymous

Chapter 13

p. 81 large image: Monika Rittershaus

Chapter 14

p. 82 top: Rob Marinissen, p. 85 upper right: Eddie Marritz, p. 86 two shots upper left: Eddie Marritz, p. 87 right: Anzai, p. 88 bottom: Monika Rittershaus

Chapter 18

p. 98 upper left: Bob Bielecki, lower right two: Beth Wesson

Chapter 19

p. 104 upper left, p. 105 upper right, p. 109 bottom left: Bob George

Chapter 20

p. 110: John Cavanagh, p. 111 upper left: Hogers / Versluys, center right: Perry Hoberman, lower right: Les Fincher, upper right: Chris Harris, pp. 112 both lower right 113 & 114: Bob Bielecki, p. 115: Tim Jarvis, p. 116 bottom right: Egon Von Furstenberg, center right: Angel P. Castro, top right: Les Finchera, p. 117 both lefthand filmstrips: Bob Bielecki, bottom left: Paul McMahon

Chapter 21

p. 118, 119 bottom & 120 three left: Babette Mangolte

Chapter 22

p. 122 bottom image: from *The Human Face*, p. 124: Paula Court

Chapter 23

p. 128 top & p. 129 top: Anonymous, p. 128 bottom: Bice Curiger, p. 130 bottom: John-David Biggs and Co. Ltd., p. 131 upper right: Gerard Murrell, bottom left: Christian Baur, p. 132 center: Les Fincher

Chapter 24

p. 133: Chris Harris, p. 134 top & p. 135: Les Fincher, p. 134 center & bottom: Perry Hoberman

Chapter 25

p. 141 top left: James Dee, p. 142: Perry Hoberman, p. 143 top left: Greg Shifrin, top center: Anonymous, top right: Allan Tannenbaum, p. 144: clone shots: Eddie Marritz

Chapter 26

p. 148: Paula Court, p. 149: Marcia Resnick

Chapter 27

p. 150 top left & p. 151: Anonymous, p. 151: lower left: John Lindley

Chapter 28

p. 154 top: Geraldine Pontius, p. 157 top: John Lindley, p. 158: Les Fincher

Chapter 29

p. 159 top, p. 161 lower left, p. 170 top, p. 171 bottom right, p. 172 bottom left: Perry Hoberman, p. 159 bottom left: Bice Curiger, p. 160, p. 163 top, p. 164 top, p. 167 bottom left, p. 172 center left: Allan Tannenbaum, p. 162 top left: Anzai, p. 165 bottom: Marcia Resnick, p. 166: Chris Harris, p. 171 bottom left: Johan Elbers, p. 173 top: Paula Court

Chapter 30

p. 174 top: John Lindley, bottom: Allan Tannenbaum, p. 175: Anzai, p. 176 center left & p. 177 top left: Les Fincher, p. 176 bottom: Allan Tannenbaum, p. 178: Chris Harris, p. 180: Tim Jarvis, p. 181: Jack Vartoogian

Chapter 31

p. 182: Perry Hoberman, p. 183 both on bottom: James Dee, p. 184 top: John Cavanagh, p. 186 bottom: Allan Tannenbaum, p. 188: Perry Hoberman, p. 189 bottom: Paula Court, p. 192 top: Allan Tannenbaum, bottom: Perry Hoberman

Assistant Editor: Maura Reilly

Editor: Craig Nelson

Assistant Editor: Sara Guyer